Titian's Portraits
Through
Aretino's Lens

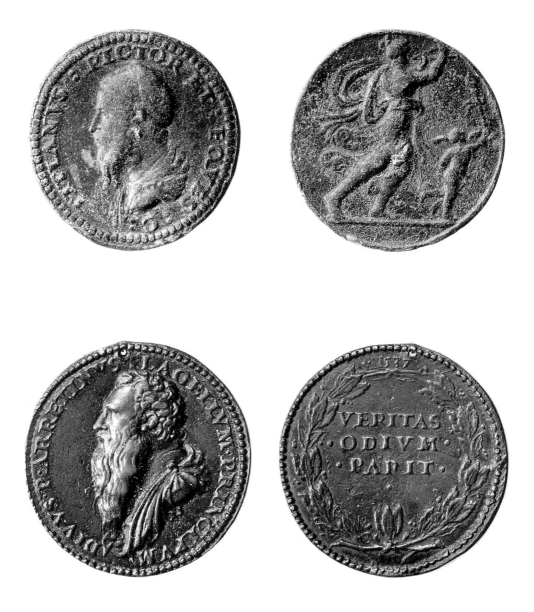

Luba Freedman

Titian's Portraits Through Aretino's Lens

The Pennsylvania State University Press
University Park, Pennsylvania

Library of Congress Cataloging-in-Publication Data

Freedman, Luba, 1953–
 Titian's portraits through Aretino's lens / Luba Freedman.

 p. cm.
 Includes bibliographical references (p.) and index.
 ISBN 0-271-01339-7
 1. Titian, ca. 1488–1576—Criticism and interpretation.
2. Portrait painting, Renaissance—Italy. 3. Aretino, Pietro,
1492–1556—Criticism and interpretation. 4. Art and literature
—Italy—History—16th century. I. Aretino, Pietro, 1492–1556.
II. Title.
ND1329.T54F74 1995
759.5—dc20 94-33450
 CIP

Published by The Pennsylvania State University Press,
University Park, PA 16802-1003

It is the policy of The Pennsylvania State University Press to use acid-free paper for the first printing of all clothbound books. Publications on uncoated stock satisfy the minimum requirements of American National Standard for Information Sciences—Permanence of Paper for Printed Library Materials, ANSI Z39.48—1984.

Frontispiece: (top) Leone Leoni, *Tiziano Vecellio,* 1537, bronze medal with a *bacchante* on its reverse. British Museum, London; (bottom) Leone Leoni, *Pietro Aretino,* 1537, bronze medal with his motto "VERITAS ODIUM PARIT" (Truth engenders hatred) on its reverse. By permission of the Trustees of the British Museum, London.

Contents

List of Illustrations vii

Preface and Acknowledgments xi

Abbreviations xv

Introduction 1

I Aretino as the Poet of Titian's Portraits 9

II The Image of Aretino in Titian's Paintings 35

III The Portraits of the Duke and Duchess of Urbino 69

IV Pope Paul III: The Problem of Likeness 91

V Charles V: The *Concetto* of the Emperor 115

VI "Pittore Divino": Aretino on Titian's "Self-Portrait" 145

Notes 161

Thematic Bibliography 193

 I Primary Sources 193

 II Secondary Sources 196

Index 207

List of Illustrations

Frontispiece: (top) Leone Leoni, *Tiziano Vecellio,* 1537, bronze medal with a *bacchante* on its reverse. British Museum, London; (bottom) Leone Leoni, *Pietro Aretino,* 1537, bronze medal with his motto "VERITAS ODIUM PARIT" (Truth engenders hatred) on its reverse. By permission of the Trustees of the British Museum, London

1. Titian, *Pietro Aretino,* c. 1537. Copyright The Frick Collection, New York

2. Giovanni Jacopo Caraglio, *Pietro Aretino,* between 1536 and 1539, engraving. The Metropolitan Museum of Art, Harris Brisbane Dick Fund, 1927

3. Albrecht Dürer, *Saints Mark and Paul,* 1526, detail of *The Four Apostles.* Alte Pinakothek, Munich

4. Raphael, *Fedra Inghirami,* c. 1514. Palazzo Pitti, Florence. (photo: Alinari/Art Resource)

5. Agnolo Bronzino, *Andrea Doria as Neptune,* c. 1540. Brera, Milan. (photo: Alinari/Art Resource)

6. Titian, *Allocution of Alfonso d'Avalos, Marchese del Vasto,* 1540–41. Museo del Prado, Madrid

7. Titian, *Aretino as a Soldier,* detail of Figure 6

8. Titian, *Pilate Presents Jesus Christ Before the People,* 1543. Kunsthistorisches Museum, Vienna

9. Titian, *Ecce Homo,* c. 1570. The Saint Louis Art Museum, Museum Purchase, St. Louis, Missouri

10. Hieronymus Bosch, *Pilate Presents Jesus Christ Before the People*, c. 1507. Museum of Fine Arts, Boston, William K. Richardson Fund, William Francis Warden Fund, and Juliana Cheney Edwards Collection

11. Titian, *Aretino as Pilate*, detail of Figure 8

12. Albrecht Dürer, *Pilate Presents Jesus Christ Before the People* (Large Passion), 1498–99, woodcut. Staatliche Graphische Sammlung, Munich

13. Albrecht Dürer, *Pilate Presents Jesus Christ Before the People* (Small Passion), 1509–11, woodcut. Staatliche Graphische Sammlung, Munich

14. Domenico Veneziano, *Saint Lucy Altarpiece*, c. 1445. Uffizi, Florence. (photo: Alinari/Art Resource)

15. *Trajan's Demonstration of Clementia Toward the Dacians*. Relief of the Column of Trajan, Rome. (photo: Deutsches Archäologisches Institut)

16. Raphael, *Madonna of Foligno*, c. 1511–12. Pinacoteca Vaticana, Rome

17. Quinten Massys, *Ecce Homo*, c. 1520. Museo del Prado, Madrid

18. Titian, *Pietro Aretino*, 1545. Palazzo Pitti, Florence. (photo: Gabinetto Fotografico, Soprintendenza per i Beni Artistici e Storici di Firenze)

19. *Della Valle Satyrs*, marble. Detail. Musei Capitolini, Rome. (photo: Alinari/Art Resource)

20. *Pietro Aretino*, c. 1536, bronze medal with phallic satyr on reverse. By permission of the Trustees of the British Museum, London

21. Titian, *Francesco Maria della Rovere*, 1536–38. Uffizi, Florence. (photo: Alinari/Art Resource)

22. Vittore Carpaccio, *Portrait of a Knight*, 1510. Thyssen-Bornemisza Collection, Madrid

23. Egidius Sadeler after Titian, *The Emperor Claudius* (1536–37), 1593–94, engraving. Staatliche Graphische Sammlung, Munich

24. After Parmigianino (?), *Allegorical Portrait of the Emperor Charles V*, 1529–30. Rosenberg & Stiebel, Inc., New York. (photo: Alinari/Art Resource)

25. Titian, *Eleonora Gonzaga della Rovere*, 1538. Uffizi, Florence. (photo: Alinari/Art Resource)

26. Titian, *Francesco Maria della Rovere*, drawing. Uffizi, Gabinetto dei disegni, Florence. (photo: Alberto Scardigli; Soprintendenza per i Beni Artistici e Storici per Province di Firenze e Pistoia)

27. Giorgio Vasari, *Alessandro de' Medici*, 1534. Uffizi, Florence. (photo: Gabinetto Fotografico, Soprintendenza per i Beni Artistici e Storici di Firenze)

28. *Francesco Maria della Rovere,* c. 1526, bronze medal. Museo Nazionale (Bargello), Florence. (photo: Gabinetto Fotografico, Soprintendenza per i Beni Artistici e Storici di Firenze)

29. *The Lion Impresa of Francesco Maria della Rovere,* xylograph from Paolo Giovio's *Dialogo de las empresas militares, y amorosas, compuesto en lingua italiana,* Lyon, 1562, p. 136. Courtesy of the Department of Rare Books, Cornell University Library, Ithaca, New York

30. Titian, *Pope Paul III Without a Hat,* 1543. Gallerie Nazionali di Capodimonte, Naples. (photo: Soprintendenza per i Beni Artistici e Storici di Napoli)

31. Titian, *Pope Paul III,* 1545. Gallerie Nazionali di Capodimonte, Naples. (photo: Soprintendenza per i Beni Artistici e Storici di Napoli)

32. Titian, *Pope Julius II,* 1545, copy after Raphael's portrait. Palazzo Pitti, Florence. (photo: Gabinetto Fotografico, Soprintendenza per i Beni Artistici e Storici di Firenze)

33. Raphael, *Pope Julius II,* 1512. The National Gallery, London

34. Titian, *Pope Paul III and His Grandsons,* 1545–46. Gallerie Nazionali di Capodimonte, Naples. (photo: Soprintendenza per i Beni Artistici e Storici di Napoli)

35. Titian, *Pope Paul III and His Grandsons,* underpainting, X-ray photograph. Gallerie Nazionali di Capodimonte, Naples. (photo: Soprintendenza per i Beni Artistici e Storici di Napoli)

36. Raphael, *Pope Leo X and His Nephews,* 1518–19. Uffizi, Florence. (photo: Alinari/ Art Resource)

37. Agostino Veneziano, *Anchora Inparo,* 1538, engraving. Museum of Fine Arts, Boston, Babcock Bequest

38. Giulio Bonasone, *Quod Sat Est,* engraving in Achille Bocchi's *Symbolicarum quaestionum de universo genere quas serio ludebat Libri V,* Bologna, 1574, Symb. LXVII. (photo: The Folger Shakespeare Library, Washington, D.C.)

39. Giovanni Britto after Titian, *Charles V in Armor,* 1532, xylograph. Graphische Sammlung Albertina, Vienna

40. Titian, *Charles V with a Hound,* 1533. Museo del Prado, Madrid

41. Jakob Seisenegger, *Charles V with a Hound,* 1532–33. Kunsthistorisches Museum, Vienna

42. Titian, *Federico Gonzaga,* c. 1525. Museo del Prado, Madrid

43. Titian, *Equestrian Portrait of Charles V,* 1548. Museo del Prado, Madrid

44. *Marcus Aurelius,* bronze. Rome, Piazza del Campidoglio. (photo: Deutsches Archäologisches Institut)

45. François Clouet, *Equestrian Portrait of Francis I,* c. 1540. Uffizi, Florence. (photo: Alinari/Art Resource)

46. Albrecht Dürer, *The Knight, Death, and the Devil,* 1513, engraving. The Metropolitan Museum of Art, New York, Harris Brisbane Dick Fund, 1943

47. *Decursio Augusti,* coin of Nero. By permission of the Trustees of the British Museum, London

48. Titian, *Charles V in an Armchair,* 1548. Alte Pinakothek, Munich

49. *The Liberalitas Scene,* detail of the Arch of Constantine, Rome. (photo: Alinari/Art Resource)

50. *Jove Enthroned,* lower half of colossal Roman statue, marble. Museo Nazionale, Naples. (photo: Soprintendenza Archeologica delle Province di Napoli e Caserta)

51. Agnolo Bronzino, *Stefano Colonna,* 1546. Galleria Nazionale d'Arte Antica in Palazzo Barberini, Rome. (photo: Archivio Fotografico, Soprintendenza per i Beni Artistici e Storici di Roma)

52. Titian, *Portrait of Benedetto Varchi,* c. 1550. Kunsthistorisches Museum, Vienna

53. Titian, *Portrait of Philip II in Armor,* 1551. Museo del Prado, Madrid

54. Titian, *Francis I,* 1538. Musée du Louvre, Paris. (photo: Service photographique de la Réunion des musées nationaux)

55. Giovanni Britto after Titian, *Tiziano Vecellio,* 1550, xylograph. Rijksmuseum, Amsterdam

56. Agostino Carracci after Titian, *Titian,* 1587, engraving. National Gallery of Art, Washington, D.C., Rosenwald Collection

57. Christofano Coriolano after Vasari, *Tiziano Vecellio,* woodcut from Giorgio Vasari's *Le Vite de' più eccellenti pittori, scultori, e architettori,* Florence, 1568, III, 805. Courtesy of the Department of Rare Books, Cornell University Library, Ithaca, New York

58. Jacopo Pontormo, *Alessandro de' Medici,* 1534–35. Philadelphia Museum of Art, The John G. Johnson Collection of Philadelphia

59. Raphael, *Self-Portrait with a Friend,* c. 1518. Musée du Louvre, Paris. (photo: Service photographique de la Réunion des musées nationaux)

60. Leonardo, *Self-Portrait,* c. 1512, drawing. Royal Library, Turin. (photo: Alinari/Art Resource)

61. Giorgio Vasari, *Self-Portrait,* 1571. Uffizi, Florence. (photo: Alinari/Art Resource)

Preface and Acknowledgments

Adopting the artistic focus of classical antiquity, the Italian Renaissance revived the art of portraiture. A novel aspect of this focus was introduced by drawing attention to the portrait as an important art form. Among painters of the period, it was mainly Titian who made various types of portraits; he imbued them with new meaning, establishing the patterns that his successors would follow in early modern times. Living in sixteenth-century Venice, he created a notable gallery of historically eminent personages whose likenesses, at the same time realistic and idealized, are preserved for modern viewers. Familiar as we are with Titian's portraits, we need to understand that in Renaissance Italy portraits had to be promoted and popularized. Titian's portraits were promoted by his friend Pietro Aretino, who addressed his letters and dedicated his sonnets to the same personages Titian portrayed. In many of these letters and sonnets, Aretino described both a specific patron and Titian's portrait of that patron, thus stimulating the reciprocal relationship between a verbal and a visual portrait.

In studying Titian's portraits while reading Aretino's writings, we experience a vivid dialogue between a painted image and its verbal equivalent, both creations of the same milieu with its respective conventional language. Neither Titian nor Aretino wrote a treatise on portraiture, but each of them was a master of his own medium. Their contemporaries eagerly acknowledged that the writings of Aretino were complementary to the portraits of Titian, something that might sound unusual to the twentieth-century reader. Through writing about portraits in his letters and sonnets, which were immediately published in the vernacular, Aretino's writings were easily accessible to the cinquecento literati. Gradually Aretino's letters introduced a vogue of writing about portraits to artists and sitters alike, compelling his contemporaries to develop a *new* approach to portraits.

During Aretino's time, following classical tradition, the pictorial portrait seemed to be important insofar as it manifested the sitter's position in society. More popular was the literary portrait, which was described in the rhetorical language of the encomium. Whenever a pictorial portrait was mentioned, a writer tended to disparage the painter's task of perpetuating the likeness of an eminent person for posterity. Aretino studied different types of encomia, from word-painting to eulogy, richly employing rhetorical devices and saturating his prose and poetry with hyperbole and other ornate figures of speech. Still, it was Aretino who began to employ this type of description differently from the classical tradition. He drew his reader's attention to the painter's identity and taught the reader to be aware of the diverse types of portraits and how to distinguish between different qualities in a portrait. The order of looking at the portrait became reversed; instead of just seeing a person portrayed, Aretino's readers began to think about how Titian represented this person.

Moreover, in his encomium of a portrait, Aretino used the ekphrastic method, which before him was used in visual art only to describe *istoria,* a painting with a narrative subject. Aretino began to discern that the portrait, with all its limitations, could nearly approach *istoria* in its variety of details. In noting disposition, coloring, or design, Aretino elevated the *portrait* to an artistic creation, making it more than merely a social document. In doing so, he inaugurated a *new* approach to portraiture that influenced the aesthetic tastes of his contemporaries and many generations to come.

This book has benefited from the stimulating responses and critical comments made by these encouraging and highly perceptive readers: Moshe Barasch, Paul Barolsky, Richard Brilliant, Bruce Cole, Rachel Davis, Philipp Fehl, Rona Goffen, Cherene Holland, Christiane Joost-Gaugier, William Kennedy, James Mirollo, Patrik Reutersward, David Rosand, Gavriel Shapiro, Webster Smith, Raymond Waddington, and Philip Winsor.

The following libraries provided me with the ideal environment for fruitful research: the National and University Libraries of the Hebrew University of Jerusalem, the Israel Museum Library, Biblioteca Apostolica Vaticana, the Hertziana Library in Rome, Biblioteca Marciana in Venice, Kunsthistorisches Institut in Florence, and the Olin Library at Cornell University in Ithaca.

My thanks are due the Internal Fund of The Hebrew University of Jerusalem for the help in acquiring the photographs together with the permission to publish them.

Certain portions of my manuscript profited from the discussions held at various conferences and seminars, such as the 25th Medieval and Renaissance Studies Conference in Binghamton, the Sixteenth-Century Studies Conference in Philadelphia, the 11th American Association of Italian Studies Convention in Ann Arbor, the Graduate Student Seminar at Rutgers University, the symposium "Venice in the Age of Titian and Aretino" at Indiana University in Bloomington, the Cornell Society for the Humanities, and the Renaissance Studies of America Annual Conference in Kansas City. I extend my gratitude to all those who attended my presentations and whose questions and suggestions sharpened my arguments and contributed to this book.

Special appreciation is due Professor Jonathan Culler, director of the Society for the

Humanities of Cornell University, for providing me with the humanistic shelter during the academic years 1990–92 that enabled me to think peacefully over my manuscript.

No words are sufficient for expressing my indebtedness and gratitude to my wonderful mother, Dr. Ella Leizerovsky. To my teenage children, Yitzhak and Dina, I dedicate this study of Titian's portraits.

Jerusalem, October 1994

Abbreviations

AB *The Art Bulletin.*

BM *The Burlington Magazine.*

BS Paola Barocchi, ed., *Scritti d'arte del Cinquecento.* Milan: Ricciardi, 1971, 3 vols.

BT Paola Barocchi, ed., *Trattati d'arte del Cinquecento fra Manierismo e Controriforma.* Bari: Laterza, 1960–61, 3 vols.

C Thomas Caldecot Chubb, trans., *The Letters of Pietro Aretino.* New York: Archon, 1967.

GBA *Gazette des Beaux-Arts.*

JHI *Journal of the History of Ideas.*

JWCI *Journal of the Warburg and Courtauld Institutes.*

P Rodolfo Pallucchini, *Tiziano.* Florence: Sansoni, 1969, 2 vols.

P-C *Lettere sull'Arte di Pietro Aretino,* commentary by Fidenzio Pertile, ed. Ettore Camesasca. Milan: Milione, 1957–60, 3 vols.

PT Mario Pozzi, ed., *Trattatisti del Cinquecento.* Milan: Ricciardi, 1978.

R David Rosand, ed., *Titian: His World and Legacy.* New York: Columbia University Press, 1982.

RD Mark Roskill, *Dolce's "Aretino" and Venetian Art Theory of the Cinquecento.* New York: New York University Press, 1969.

S *Le Siècle de Titien: L'âge d'or de la peinture à Venise. Catalogue.* Paris: Grand Palais, 9 March–14 June 1993.

T *Titian: Prince of Painters, Catalogue.* Venice: Marsilio, 1990.

V Francesco Valcanover, *L'opera completa di Tiziano.* Milan: Rizzoli, 1969.

V-H Giorgio Vasari, *The Lives of the Painters, Sculptors, and Architects,* trans. A. B. Hinds, ed. William Gaunt. London: Dent, 1980, 4 vols.

V-M Giorgio Vasari, *Le Vite de' più eccellenti pittori, scultori ed architettori* (1568), ed. Gaetano Milanesi. Florence, 1878–85, 9 vols.

W Harold E. Wethey, *The Paintings of Titian, Complete Edition.* London: Phaidon, 1969–75, 3 vols.

Introduction

Although the portrait in painting and sculpture can be simply defined as a representation of an individual with an emphasis on her or his facial features, it is in fact a highly complex form of art. It involves both the sitter's expectations, whether personal or social (or both), and the artist's ability to realize these expectations, with the artist and subject together being influenced by the conventions of their day.[1] In looking at portraits today, we may wish not only to understand the artist's attitude toward the depiction of a subject but also to know the subjects'—and, more generally, the contemporary audience's—responses to the portraits. With regard to sixteenth-century Italian portraiture in particular, we may consider ourselves fortunate that that era left us a rich written record of these responses in both prose (especially letters) and poetry. The aim of the present study is to show how the sixteenth-century Italian portrait painter and his works were perceived by his subjects and his contemporaries at large.

Among such sixteenth-century Italian poems are those by Bernardino Bellincioni on Leonardo's portrait of Cecilia Gallerani, by Pietro Bembo on Giovanni Bellini's portrait of his mistress, by Girolama Corsi Ramo on her portrait by Vittore Carpaccio, by Baldassare Castiglione on Raphael's portrait of himself, and by Francesco Maria Molza on Sebastiano del Piombo's portrait of Giulia Gonzaga.[2] The literati who wrote letters about portraits include, among others, Bembo (on Raphael's portrait of the poet Antonio Tebaldeo), Claudio Tolomei (on Sebastiano's projected portrait of himself), and Paolo Giovio (on Titian's portrait of Daniele Barbaro).[3] But by far the largest number of such poems and letters were written about Titian's portraits, and most especially by Pietro Aretino. In an attempt to understand the way the portrait was perceived in sixteenth-century Italy, I shall focus on this specific case and consider various portraits by Titian of his eminent contemporaries in conjunction with Aretino's letters and sonnets.

Although the period in which Aretino wrote about Titian's portraits was brief, between 1537 and the early 1550s, it was a time of intense portrait painting for Titian. Those were the years when Titian created the masterpieces depicting Emperor Charles V and Pope Paul III, the Dukes of Urbino, of Mantua, and of Ferrara, the Doges of Venice, and eminent humanists and statesmen—the most illustrious personae of his time. Titian's portraits, if assembled all together, form a gallery of historically important personalities not only of sixteenth-century Italy but also of Europe. During this time, Aretino's letters and sonnets, in part due to their sheer quantity, seem to take the mission of heralding contemporary response to Titian's portraits. Aretino undoubtedly strengthened Titian's resolve to undertake portrait commissions. He instigated several of these commissions, and this cinquecento man of letters also definitely influenced reactions to portraits by Titian (and others) of many of his contemporaries, including Giovio, Tolomei, Vasari, Giulio Camillo (Delminio), Sperone Speroni, Benedetto Varchi, Michelangelo Biondo, and of course Lodovico Dolce.

Part of the significance of Aretino's thoughts on portraits lies in their having been formulated a generation or two before the portrait received attention in contemporary theories of the visual arts and in their having influenced those theories. As is typical in the visual arts, the theory of portraiture was formulated after the major works had already been created. (The only exception to this sequence was with *istoria*, which was explained by Leon Battista Alberti in his *De pictura* of 1435 [or his *Della pittura* of 1436], at least forty years before *istorie* such as Botticelli's *Primavera* and *Venus*, Signorelli's *Pan*, or Piero di Cosimo's *Prometheus* were painted.) During the cinquecento, naturally, no treatise comparable to what Alberti wrote on *istoria* was written about portraiture, though close to the end of the period some eminent theoreticians did devote chapters to the subject. They include Gabriele Paleotti (*Discorso intorno alle imagini sacre e profane*, Bologna, 1582), Giovan Paolo Lomazzo (*Trattato dell'arte della pittura, scoltura et architettura*, Milan, 1585), and Giovan Battista Armenini (*De' veri precetti della pittura*, Ravenna, 1586).[4] These theoreticians (Lomazzo in particular, see page 27), who were familiar with Aretino's writings, expressed in a more systematic manner practically the same thoughts and ideas. Aretino's letters themselves can by no means be regarded as a substitute for a theoretical treatise on portraiture but rather as immediate reactions to the portraits just produced.

Studying Aretino's legacy, we witness how the portrait as a social document of the epoch comes gradually to be perceived as an artistic work with merit of its own and how a description as an encomium of a sitter turns into an expression of ideas on the mastery of the portraitist. Aretino's ideas about portraiture paved the way for theoretical thinking that in turn laid the foundations for the Baroque approach, manifested in such a notable example as Giambattista Marino's *Galleria*.[5]

Aretino also influenced his contemporaries' perception of Titian in the years from 1537 to the early 1550s mainly as a portrait painter. If before 1537 it was Sebastiano del Piombo who was often regarded as the major portraitist, with the publication of Aretino's letters it was Titian and Titian only who was identified as the portraitist *par excellence*. The literati mentioned him in their writings mainly in connection with portraits. Moreover, they

often linked the names of Aretino and Titian as representatives of two distinct groups, poets and painters, who united their efforts in glorifying the same subject in two different media.

Sixteenth-century Italian culture often correlated words and images. Treatises on emblems and hieroglyphs, dialogues on painting and on the woman's ideal beauty, and descriptions of paintings and encomia of imaginary portraits were popular forms in all the artistic and cultural centers—Florence and Venice, Urbino and Ferrara, Rome and Bologna, Milan and Naples.[6] In those cities it was common to view a poem as an eloquent painting and a painting as a mute poem. Literati would often look at a painting while listening to a poem written about it. The painted portrait and its verbal re-creation together demonstrated the then-current Horatian principle of *ut pictura poesis*. Both were used as a means of glorifying an eminent person, perpetuating his or her memory, demonstrating his or her virtues, and creating an illusion of his or her immediate presence. In short, both a painted portrait and its poetic counterpart performed the important task of giving a second life to the eminent contemporary's image. In this task the efforts of both Aretino and Titian were united. Titian would receive a commission to paint a portrait and Aretino would then use that commission as a pretext for establishing or further strengthening ties with their mutual patrons.

Studying the way Titian conceived a portrait that Aretino then celebrated brings us closer to an understanding not only of a particular portrait but also of the place and function a portrait must potentially have had at the time. Although Aretino followed the conventions of his time in thinking of the portrait as a social-historical document, as a means of preserving the sitter's likeness for posterity, and as a commemoration of noble character or virtuous deeds, he also initiated a new trend in responding to portraits; his letters and sonnets see portraits as works of art, as inventions thought out in terms of composition and executed in colors. In other words, he focused attention on these portraits as *paintings*.

Reading Aretino's letters while analyzing Titian's portraits will enable us to address and perhaps to answer various questions about Titian and his milieu. What was the specific milieu in which he worked like? What particular problems interested him as a portraitist? How did he solve the "eternal" problem of every portraitist, namely, rendering a lifelike image and at the same time creating a memorable work of art? How did his contemporaries perceive his portraits? What did they expect from them and what especially attracted their attention? To what degree was Titian influenced by the viewer's or his subject's expectations of the portrait? And what did Aretino contribute to the perception of the portrait as a work of art?

In Chapter I, I discuss the rhetoric of Aretino's letters and sonnets that concerns Titian's portraits, seeking to comprehend the ambience in which both of these art forms, verbal and visual, were created. In each subsequent chapter I coordinate a detailed viewing of specific portraits by Titian with a reading of Aretino's letters and sonnets that address those paintings. Each chapter is devoted to one particular problem that agitated the cinquecento literati, a problem illustrated by the selected portraits and the related letters (including sonnets) by Aretino, together with other contemporary responses.[7]

Both Aretino and Titian lived in Venice, both had many different patrons, both addressed their writings and paintings to the same patrons, and both belonged to a circle of intellectuals who shared their views on portraits and were all influenced by Aretino's ideas. It was this circle that witnessed a new emphasis on the idea of the portrait as a work of art rather than as merely a record of the subject's features. In fact, Aretino had not always seen the portraits he wrote about in his letters, and Titian had not always seen the sitter he was supposed to portray. Aretino never saw the imperial and papal portraits; his opinions about them were based on some idea he had of the paintings. Titian had not met the French King Francis I, Pope Sixtus IV, or Empress Isabella, or even Isabella d'Este, and yet his portraits provide us with trustworthy likenesses, realistic and ideal at the same time. Titian would often work from a medal or another portrait of the sitter. Even though Aretino may not have seen these paintings, his responses allow us enough insight to ask questions about these portraits, questions that enable us to understand better the message the paintings had for their contemporaries.

Unlike Michelangelo, who belonged to almost the same social stratum as Titian (a notary's family), Titian rarely took up his pen to write, and we have practically no record of what he said about art. He did not write sonnets and he did not have his Vasari or, rather, his Ascanio Condivi, who could transcribe his thoughts on art. Titian's letters are formal and mainly concerned with financial issues involved in his business as a painter.[8] Among his extant letters, there is only one lengthy letter to Aretino, in which he talks merely about his efforts to help his addressee obtain a cardinal's office (see page 141 below). Aretino, in his turn, was born into a humble family, unlike Varchi or Speroni, his fellow humanists. Also, unlike them, he never wrote a scholarly or theoretical treatise on the arts. Rather, his thoughts on painting, poetry, and other topics are dispersed mainly through some three thousand letters, some of which include sonnets.

In considering Titian's portraits and Aretino's sonnets and accompanying letters together, we encounter a genuine Renaissance dialogue between visual art and its verbal counterpart. To understand this dialogue we need to understand the rhetorical mode of Aretino's letters and sonnets. By the same token, we need to understand the iconographical conventions manifested in Titian's portraits. Titian and Aretino inhabited the same cultural milieu and both used the conventional language, verbal and visual, of their times. Fusing iconographical analysis of Titian's most famous portraits with a rhetorical analysis of Aretino's literacy legacy as compared to contemporary reactions, I will demonstrate that it is because of Titian's many portraits and Aretino's writings about them that the portrait ceased being primarily a social-historical document, preserving the sitter's likeness for posterity, and gradually became a work of art, the artist's invention, which gives its viewer aesthetic pleasure.

Titian's own approach to portraiture was rich and many-sided. By his time different formal types of portraits had been developed: the profile, full-face, three-quarter length, full-length, seated, equestrian, group portraits, and so on. Titian did not create a new type of portrait, but he experimented with each one, imbuing each particular portrait with a new meaning and significance. In painting so many different portraits, at least

from the formal point of view, Titian raised many questions pertaining to portraiture. How to blend the typical and the particular in portraying a person? How far should a painter go in idealizing the given features without losing their verisimilitude? How to convey the truthlike impression that a person in a portrait is a living being? To what degree is it possible to introduce some motion into a portrait? How can a painter tell as much as possible about the subject's social standing with the minimum of means? What is required for a portrait to become a work of art? Titian did not write a word about portraiture, but his portraits taken together express his thoughts about the subject. His portraits constitute some sort of the theory of portraiture that is *painted,* not written.

Titian's fame as a portraitist flourished in the cinquecento and beyond. Modern research has not neglected this aspect of Titian's oeuvre.[9] Every study on European portraiture, including Wilhelm Wätzoldt's monumental *Kunst des Porträts* (1909), Max Friedlaender's illuminating essay "Something of the Principles and History of Portraiture" (1947), and Keller's study, *Nachleben des antiken Bildnisses* (1970), pays tribute to Titian's contribution to the development of the genre. Every study of Renaissance portraiture, starting with Jacob Burckhardt's "Porträt in der italienischen Malerei" (written in 1895) and including John Pope-Hennessy's *Portrait in the Renaissance* (1966), as well as the most recent studies, Gottfried Boehm's *Bildnis und Individuum* (1985) and Lorne Campbell's *Renaissance Portraits* (1990), certainly includes Titian's portraits. Marianna Jenkins's monograph, *State Portraits* (1948), discusses contemporary reactions to Renaissance portraits and thus is relevant to my study, though it does not discuss Aretino's writings.

Also important in considering Titian's portraits are scholarly contributions to the so-called Titian problematics, including Titian's date of birth, his apprenticeship with the Bellinis and Giorgione, his work as an official master of the Venetian Republic, his visits to Florence and Rome, his relations with his patrons and his connections with other artists, the dynamic development of his style, the organization of his workshop, his acquaintance with ancient and medieval traditions, his familiarity with the works of Northern European painters, his letters and documents, and his connections with the humanists of his time. In his informative introduction to the catalogue of the exhibition in Venice and Washington, D.C. (1990), Francesco Valcanover surveys recent research on these problematics. And the recent exhibition in Paris in the spring of 1993, *Le Siècle de Titien,* set a task to see Titian's oeuvre in development as compared with that of his Venetian colleagues, and so also Titian's art of portraiture could be seen in such a fruitful comparison.

In the course of the last century, numerous monographs on Titian, from Crowe and Cavalcaselle's (1877) to David Rosand's (1978) and Charles Hope's (1980), have discussed the portraits in a traditional manner, chronologically, along with the mythological and devotional paintings. These studies have seldom treated the portraits as a separate topic, although they do emphasize Titian's unique contribution to portraiture as an art form.

Erwin Panofsky took a different approach. In his monograph *Problems in Titian, Mostly Iconographic* (1969), Panofsky grouped the paintings according to particular themes or

problems rather than treating them chronologically. He considered portraits such as those of Charles V and Paul III from the viewpoint of their iconographical and iconological tradition.

While there are numerous monographs on his art in general, Titian's portraits have seldom received attention in separate studies. The monographs that do concentrate on Titian's portraits, such as Irina Smirnova's *Titian and the Venetian Portrait of the Sixteenth Century* (published in Russian in 1964), Harold Wethey's volume on Titian's portraits (1969), and Cecil Gould's *Titian as Portraitist*, a catalogue of the exhibition in the National Gallery in London (1976), consider them only or mainly as part of his stylistic development. They do not consider the way these portraits were perceived by Titian's contemporaries.

Titian's portraits have frequently been viewed as historical documents. An innovative method in historical examination of one Titian portrait is manifest in Roberto Zapperi's recent monograph, *Tiziano, Paolo III e i suoi nipoti: Nepotismo e ritratto di Stato* (1990). While traditionally Titian's portraits were viewed as recording the historical events of his time, Zapperi regarded the changes Titian introduced in his papal portraits as reflecting the changes in the political climate of the period. Zapperi's study was encouraged by Charles Hope's scrupulous search for documents related to Titian's creative life, inaugurated in his dissertation, "Studies in the Sources and Documents Relating to the Life and Work of Titian" (1975).

Titian's portraits have long been considered from the traditional viewpoints of attribution, dating, and stylistic development, as well as iconography (in the original sense of the term). In my study, I will raise anew questions of the meaning of a composition or of coloristic arrangement, the iconological significance of the accessories, and the nature of the sitter's likeness, and will consider the contemporary viewers' responses to the portraits. Questions regarding certain portraits by Titian have certainly been raised here and there in modern research, but I contend that investigating these questions through a careful reading of Aretino's letters and sonnets will help us understand how the portrait as an art form was perceived in Renaissance Italy. Aretino's letters and sonnets are a necessary means to comprehending the specific demands Titian faced as a portraitist. At the same time, however, we should bear in mind that the letters and sonnets do have limitations. While they provide us with some information about the cultural milieu, they tell us little about the painter's own methods and theory of portraiture. [10]

In considering the way in which Aretino thought about the visual arts, one also has to be careful to avoid confusing the views of the historical Aretino and those of the Aretino whom his friend Dolce, in his *Dialogo della pittura, intitolato l'Aretino* (1557), turned into a apologist for Titian's methods. [11] This becomes more difficult because Aretino never wrote a dialogue, treatise, or oration on the visual arts. Rather, he expressed his views on art only here and there in his letters, and only to a degree in his sonnets, so that students of his aesthetics have to sift through his writings in order to get a more or less coherent idea of his thoughts on portraiture. Aretino's letters were assembled in the six-volume edition published in Paris in 1608–9. His letters on the arts were published in a two-volume edition by Fidenzio Pertile and Ettore Camesasca (1957). The latter edition greatly

facilitates the selection of the letters and sonnets that exclusively centered on Titian's portraits. Some of his letters were translated into English by Thomas Caldecot Chubb (1967) and George Bull (1976).[12]

A review of recent contributions to the growing bibliography on Aretino's works can be found in Giovanni Casalegno's "Rassegna Aretiniana (1972–89)"; a review of studies concerned with Aretino's thoughts on art can be found in Lora Anne Palladino's 1981 dissertation, "Pietro Aretino: Orator and Art Theorist."

Palladino's study makes an important contribution to our understanding of Aretino's innovative approach to literature and arts, including his evaluation of Titian's paintings. In addition, I should mention the essay by Ferruccio Ulivi (1969), "Pietro Aretino scrittore e critico d'arte." Every monograph on Aretino includes a section on the relationship between Aretino and Titian. This relationship was first given close attention by Fritz Saxl (1957) and then by Mina Gregori (1980) and, most recently, by Philipp Fehl (1992). Aretino's descriptions of Titian's narrative paintings have been examined by Norman Land (1986), while the rhetoric of Aretino's poetic portraits has been investigated by Margot Kruse (1987). Kruse's article "Aretinos Sonette auf Tizian-Porträts" is the only study that treats Aretino's poetic reaction to Titian's portraits. All of these studies elucidate many issues related to Aretino's thinking on poetry and art. They do not, however, focus on his thoughts about portraiture in general, and when they do consider his ideas on Titian's portraits, they are not discussed in connection with works of art themselves.

The main task of my book is to comprehend the meaning conveyed by the portrait as an artistic form in Renaissance Italy through studying this unprecedented phenomenon: Titian's portrayal of those personages to whom Aretino addressed letters and sonnets that themselves describe both an individual patron and Titian's portrait of that patron.

I

Aretino as the Poet of Titian's Portraits

"Pietro Aretino, the most celebrated poet of our day, having gone to Venice before the sack of Rome, became very friendly with Titian and Sansovino. This proved of great advantage to Titian, spreading his name as far as Pietro's pen reached, especially to notable princes, as I shall relate."[1] As Giorgio Vasari points out here, Aretino's presence in Venice and his literary activity had considerable impact on Titian's creative life, particularly his portrait painting. In the years following the publication of the first volume of Aretino's letters at the end of 1537 until the publication of the fifth volume in 1550, Titian's oeuvre was marked by an intense period of portrait painting of notable princes and others.[2] To this period belong the masterpieces of his portraiture.

Aretino's letters are a major source for documenting and identifying Titian's portraits, but they are equally significant in elucidating theoretical aspects of portraiture. Written at a time when no theoretical treatise on this subject existed, the letters help us understand what was expected of Titian as a portraitist and how his portraits were received by his contemporaries. His letters touch upon problems Titian faced as a portraitist: the impor- tance of achieving verisimilitude, the ability to express the essence of the person por-

trayed, and the choice of pose and gesture best suited to the personality and position of the subject. At the same time, the letters reveal questions the viewer or potential subject of a portrait may have had, such as whether the subject's likeness was in fact faithfully presented or whether the portrait successfully conveyed what the subject would wish his or her image to be for posterity. Aretino's letters and sonnets frequently elucidate the *concetto*—the concept of the subject—that the portrait conveys.

Aretino's letters and sonnets of course are saturated with rhetorical tropes and commonplace expressions. His writings nonetheless inaugurated a new approach to the portrait, treating it as a painting, as a work of art produced in the specific medium, rather than solely as a social document of an eminent person. His descriptions were unprecedented and added a new dimension to the viewer's perception of the portraits. Aretino sought to unveil the "hidden" plan of Titian's portraits, to help the viewer discover certain features that otherwise might have gone unnoticed.

Pietro Aretino: His Background

Pietro Aretino was born in 1492 into a cobbler's family in the Tuscan city of Arezzo.[3] Rebellious in temperament, he ran away from home at the age of fourteen and went to Perugia, where he became an assistant in the workshop of an unidentified painter. He was soon expelled for painting the Magdalen holding a lute while kneeling before Jesus, a detail that obviously deviated from established canons. Thus began and ended his career as a painter, but this early training no doubt sharpened his sensitivity regarding artistic quality and painterly effects in works of art. Wandering around Italy, even visiting Venice briefly in 1512, he published his earliest book there, a book of verses, calling himself a painter in the title: *Opera nova del fecundissimo giovene Pietro Pictore Aretino* . . . [4]

Four years later Aretino arrived in Rome, where Claudio Tolomei's uncle presented him to the famous banker Agostino Chigi, who facilitated his introduction into the elitist circle of courtiers. Chigi owned the celebrated villa later known as the Farnesina, built by Baldassare Peruzzi and decorated with frescoes by Raphael and his assistants. Aretino always recalled with gratitude those few years spent in Chigi's household while he served as "quasi garzone" in his bank.[5] He recalls in his later letters memories of the great artists he met there. In a letter to the miniaturist Jacopo del Giallo of May 23, 1537 (xxv), for example, Aretino declared that he was not "blind in regard to painting, and indeed Raphael, Fra Sebastiano and Titian often pay close attention to my judgments. I know in some part both the ancient and modern styles."[6] Aretino's mention of the venerated Raphael and his appreciation of Jacopo's work as "all design and all relief" attests that he was affected by those works of art that adhered to the Florentine tradition. This tradition, as is generally known, is characterized by emphasizing drawing and the statuary look of the painted figures so that they look relief-like. This letter hints at Aretino's nostalgic feeling for the cultural ambience of Rome in the 1510s. At the time Aretino spent his time in Chigi's household, the majority of Florentine or Tuscan artists worked in Rome.

In Rome, Aretino gradually established his fame as a pamphleteer and satirist. Indeed he can be considered the first journalist of the modern world—and a journalist par excellence.[7] Among other pieces, he wrote *pasquinatte* (satiric rhymes against popes), similar to those written by local poets. These writings were discontinued in 1522 with the election of the Flemish Pope Adrian VI, during whose short, repressive papacy many artists and intellectuals left Rome. Aretino went to Mantua as part of his service to the nephew of Lorenzo the Magnificent, Giovanni delle Bande Nere. Between 1520 and 1527 he wandered about Italy, serving Giovanni in Lombardy, visiting Urbino and Arezzo, and occasionally going to Rome. After the death of his cherished patron, Aretino went with hesitation to the Gonzaga Court in Mantua and from there to Venice.

Arriving in Venice as a poor man on March 25, 1527, Aretino eventually made his fortune there.[8] He lived in Venice until his death, on October 21, 1556, rarely leaving the city. He resided for most of those years in a modest house owned by the Bishop of Brescia, Domenico Bollani, on the Grand Canal in the vicinity of the Rialto Bridge, then from 1551 in a patrician house owned by the powerful landlord Dandolo.[9] It is difficult to determine what occupation brought him riches and fame. Unlike many contemporary writers, Aretino was not tied to any single patron. In fact he had many patrons, but his relationship with them was not one of dependence. What was common to all his patrons was that the more Aretino stung them with his venomous pen, the more money and precious gifts they gave him. Although he produced works in various genres, including versified eulogies (for example, *La Marfisa*), political satires (such as *pasquinatte*), comedies (*Lo Ipocrito, Il Filosofo, Il Marescalco*, and *La Cortigiana* among others), various dialogues known as the *Ragionamenti*, and religious compositions (for example, *Vita di Maria Vergine* and *Vita di Santa Caterina*), Aretino nonetheless should not be classified only as a writer.[10] He was a publicist and, one might say, a man of letters, even if it is hard to classify him as a humanist like Sperone Speroni or Benedetto Varchi; he encouraged patronage of the arts and promoted young talents (for example, the letter to Dolce about the painter Niccolò Gabrielli, the pupil of "il miracoloso Tiziano" [DCLXXI]). Aretino was one of the first authors, if not the first, in modern times to make a respectable living from his writing, something that Dolce, Anton Francesco Doni, or Niccolò Franco never achieved, all of whom tried to imitate Aretino's way of life.[11] Dolce, who wrote 112 books, died in abject poverty. Aretino was certainly not exaggerating when he wrote to Gabriele Cesano on December 21, 1538: "I live by the sweat of my ink."[12]

Titian as Aretino Knew Him

The part of Titian's life that primarily concerns us here is the period during which Aretino lived in Venice, or, more precisely, the years 1537–50, when Aretino wrote about Titian's portraits in his letters. By the time Aretino decided to settle in Venice in 1527, Titian already enjoyed the privilege of being the Official Painter to the Republic of Venice, which he chose to serve in 1513, forgoing an invitation to come to Rome.

Between 1513 and 1527 Titian was torn between his obligations to the Republic of Venice and his work at Ferrara for Alfonso d'Este. In addition, he carried out numerous commissions for altarpieces in the parish churches of his native Veneto. Among the altarpieces commissioned were such prestigious works as his stupendous *Assumption of the Virgin Mary,* inaugurated in 1519 in one of the central churches of Venice, Santa Maria Gloriosa dei Frari; his *Pesaro Madonna,* begun at the same time, was inaugurated there in 1526. He painted numerous votive paintings for the doge and worked on the *Battle* for the Sala del Maggior Consiglio in the Palazzo Ducale. Working under the patronage of Alfonso d'Este (his patron as early as 1514), Titian also painted various *poesie* for the *camerino d'alabastro* in Ferrara. He then portrayed Alfonso and, in 1523, his son, Federico Gonzaga (as recorded in contemporary correspondence; the painting has not survived),[13] though his work for Federico himself started only with Aretino's arrival in Venice. During this period Titian painted other portraits as well, mostly of the doges (which his status obliged him to do) and of the local noblemen.

Between 1527 and 1537, Titian continued serving the republic as well as painting altarpieces, such as the much admired *Martyrdom of Saint Peter Martyr* (today known from prints only) and *Madonna in Glory with Six Saints,* which is now in the Pinacoteca Vaticana. In that period his commissions came mainly from Federico Gonzaga and Francesco Maria della Rovere, the Duke of Urbino, Federico's brother-in-law. Aretino was certainly responsible for obtaining commissions for Titian from the emperor, which resulted in the 1533 patent bestowing on him the privilege of making imperial portraits, and then a decade later for obtaining the Farnese family commissions to portray the pope and his kindred. From 1537 until the early 1550s, the period during which Aretino's letters and sonnets praised Titian's mastery as a portraitist, Titian painted many more portraits than during his early years, and many more too than during the period from 1553 until his death on August 27, 1576.[14]

Titian's artistic activity can be divided into three periods: 1506–36, 1537–53, and 1554–76. During the first period Titian painted, or was commissioned to paint, 186 works, 64 of which are portraits; during the second period, 170 works, 115 of which are portraits; and during the third period, 156 works, only 24 of which are portraits. This rough analysis, which includes all the portraits that were commissioned regardless of whether they were actually executed, shows that during the second, and shortest, period (only sixteen years), Titian was commissioned to paint or painted nearly one and a half times more portraits than during the first and last periods together (fifty-four years). During this period Titian created a veritable gallery of eminent personages of sixteenth-century Europe, portraying the Gonzagas, Farneses, Habsburgs, the ministers of the imperial court, the ambassadors of the Venetian Republic, and notable humanists of the time—Pietro Bembo, Daniele Barbaro, Sperone Speroni, and Benedetto Varchi, among others. With these same figures Aretino carried on a correspondence in which he mentioned Titian and his portraits. It was probably this period of Titian's life that Dolce spoke of in his *Dialogo della pittura, intitolato l'Aretino* (Venice, 1557): "Nor was there ever a cardinal or other grandee in Venice who did not visit Titian's establishment to see his creations and have his own portrait painted."[15]

Titian's oeuvre during this time was not confined to portraiture; he painted other works—important works—such as the monumental *Presentation of the Virgin in the Temple* (Venice, Gallerie dell'Accademia), *Crowning with the Thorns* (Paris, Musée du Louvre), and the *Pentecost* (Venice, S. Maria della Salute) as well as various *soffitti* and *poesie*. Yet portraiture stands out as a significant enterprise of Titian's workshop. Evidently between 1537 and about 1553, most of Titian's commissions were for portraits. He was invited to Rome in 1545 by the Farneses to paint their portraits; in 1548 he was invited to Augsburg to portray the emperor and the members of the Diet. In 1550 he was again invited to Augsburg, this time by the emperor's son, Philip II, whom he portrayed; and only after that came the *poesie*.

Aretino the Advertiser

Aretino's open letters led to his notoriety among the public as the "Scourge of Princes." Once he realized that his letters could serve as a means for his own aggrandizement, with the support of his ever-faithful and knowledgeable publisher, Francesco Marcolini (who came from Forlì in 1527 to Venice, where he established his office in 1535), Aretino published six carefully edited volumes in 1537, 1542, 1546, 1550, 1556, and posthumously in 1557.[16] In collecting his letters, which were to be read as a book of miscellaneous essays (open letters), Aretino recalled a tradition of classical antiquity—the collections of letters by Pliny, Seneca, and especially Cicero—a tradition that was revived in Italy by Petrarch and Marsilio Ficino. Aretino was certainly influenced by Petrarch, who to his pride, like him, was a native of Arezzo. Aretino also was influenced by another great letter writer, Erasmus, whose *Opus de conscribendis epistolis*, published in Venice, became popular in Italy. (Erasmus's influence on Aretino is a subject that deserves special attention; I shall have occasion to return to Erasmus later.) Aretino, however, was the first to publish letters in the vernacular.[17] In doing so, he forestalled Bembo, the main apologist for the *volgare*, who expressed his wish to publish his epistles in his letter to Varchi of November 28, 1535.[18] (Bembo's letters in the vernacular were published by his nephew only in 1548, four years after his death.) The first volume of Aretino's letters was so popular that it was reprinted by Marcolini again in 1538 and then by six other publishers that same year.[19] (His example was followed by such illustrious figures as Doni [1544], Tolomei [1547], Bernardo Tasso [1549], Giovio [1560], and many others.) Of approximately 3,000 letters, some 682 contain references to works of art and literature, and 225 refer to Titian.[20] Of these, I shall focus on some three dozen that deal exclusively with Titian's portraits. His letters also included fifteen sonnets on Titian's portraits of illustrious members of society.

Aretino wrote to Michelangelo, Sebastiano del Piombo, Giorgio Vasari, Jacopo Sansovino, Lorenzo Lotto, Francesco Salviati, Giulio Romano, Jacopo Tintoretto, and Leone Leoni, as well as many others, including Giovan Paolo Pace, Baccio Bandinelli, Alessandro Moretto, Alessandro Schiavone, Giulio Clovio, and Danese Cattaneo.[21] (His

relations with artists, and in particular with Michelangelo,[22] were complex, and thus require separate research.) His relationship with Titian was especially close, as is evident from the sheer volume of his letters to and about the artist and from the number of occasions on which he addressed him.[23] Aretino invited Titian to gatherings and celebrations (CCCII, CCCLV, and CCCLXXX), and at other times chided him for neglecting him while portraying the members of the Diet in Augsburg (CCCIII and CDXXI). In several letters he reveals his concern for and intimate knowledge of Titian's family. For example, he addressed one letter to Titian's wayward young son Pomponio, offering his help (DLXXVIII), and one to his uncle Vincenzio, thanking him for sending provisions from Pieve di Cadore, Titian's native city (CCLXIII, October 1545). Later, he sent Titian and his older brother Francesco two letters of condolence on the death of their sister Orsola (DIL and DL). He also wrote to Titian expressing his admiration for the beauty of his fair-haired daughter, Lavinia (DCLXXVII).

Aretino mentions Titian's portraits frequently in his letters from 1537 to about 1550, the years during which most of Titian's commissions were for portraits. Aretino's recognition of Titian's powers as a portraitist had found expression even before 1537. In 1534, for example, in his *Cortigiana* (act III, scene 7), Aretino noted that Michelangelo, when shown the beautiful paintings in Ferrara by Alfonso d'Este, lauded only Titian's portrait of his host.[24] Michelangelo would certainly also have been shown the paintings by Titian in the *camerino d'alabastro*, yet for Aretino it was important to emphasize Michelangelo's praise for that portrait. Perhaps Aretino's mention of this portrait stemmed from his wish to flatter the Duke of Ferrara; nonetheless, that Michelangelo, who himself eschewed portraiture, so highly praised the portrait by Titian stimulated further attention on Titian's mastery as a portraitist. The same story was mentioned by Dolce and also by Vasari in his biography of Michelangelo, which testifies to the attention paid to Aretino's remark in that comedy.[25] In addition, in his dedicatory letter to his friend Bernardo Valdaura (LXVI) prefacing the second part of the *Ragionamenti* (1536), Aretino expressed a wish to portray his characters with the same vividness as does Titian.[26]

Aretino also occasionally referred to works by Titian other than the portraits; in 1531 he addressed himself to Titian's *Saint John the Baptist* (V), on October 29, 1537, to his *Martyrdom of Saint Peter Martyr* (XLIV), and on November 9 of the same year to the *Annunciation* (XLVIII). In two letters in 1548, he mentioned just one religious work, the devotional image of Jesus Christ known as *Ecce Homo* (CCCLXXXIII and CDXLVII). Certainly Aretino did not consider Titian merely a portraitist; his *ekphrases* on the *Martyrdom of Saint Peter Martyr* and the *Saint John the Baptist* eloquently testify to Aretino's mastery of narrative description as well as provide settings for his claims regarding Titian's unprecedented use of color in painting.[27] (In his dialogues, such as *La Cortigiana* and *Da "Le Carte Parlanti,"* Aretino also praised Titian's handling of color.)[28] In describing the *Martyrdom of Saint Peter Martyr*, Aretino focused on the background landscape. In this context we may recall the famous letter of May 1544 (CLXXIX), in which he described how, on a melancholy day, he leaned outside his window and suddenly discovered anew the beauty of the Grand Canal. Titian alone, Aretino declared, was capable of capturing on canvas

the beautiful scene from his window. "And so I, who know that your brushes are the very soul of her soul, cried out three or four times: 'O Titian, where are you now?' "[29]

Indeed Aretino apparently sensed the danger of promoting Titian only as a portrait painter. In his letter of November 9, 1537 (XLVIII), writing to Titian about his *Annunciation*, Aretino concluded by comparing Titian's mastery in this altarpiece with the *Battle* scene painted for the Sala del Maggior Consiglio in the Palazzo Ducale. He asserted that the latter painting was executed in order "to reprove those who cannot deny your genius and mine and so put you in the first rank as a mere painter of portraits and me there as a slanderer."[30] Aretino's parallel of himself with Titian is interesting in itself, but this letter aimed first of all at dissuading those who considered Titian to be only a portraitist.

Nevertheless, 1537 was the year Aretino began especially to single out Titian's portraiture. One reason could be that about this time (from November 1537 until the spring of 1538) Giovio had begun to assemble portraits of various celebrities for what he later called his *Museo* (a sanctuary of the Muses), his celebrated portrait museum in his villa at Como.[31] In his letter to Aretino of August 15, 1538, he asked him to help collect these portraits and, specifically, to order a portrait of the Duke of Mantua from Titian.[32] Giovio was influenced by the honorable tradition of the Italian humanists and princes to collect the images of *uomini famosi,* or cycles of famous men.[33] Moreover, Giovio was planning to write a book of eulogies of famous men, combining a prose description and a sonnet for each one. The book would include illustrious ancestors as well as his contemporaries. One such volume, *Elogia virorum bellica virtute illustrium,* was published as early as 1546 in Venice. Thus it could well be that Giovio's zest for collecting portraits for his *Museo* spurred Aretino's interest in portraiture. However, unlike Giovio, who considered first the merits of the person whose portrait he wanted and disregarded the quality of the artist portraying that person, Aretino was more interested in the mastery of the portrait painter. (Giovio's interest in portraits, unlike Aretino's, was first of all dictated by his occupation as a biographer and historian.)[34] It was probably because of Aretino that, in his later letters regarding his ordering further portraits, Giovio discussed which artist would be best suited for portraying this or that personage; for example, Agnolo Bronzino would be the best, he thought, for portraying Andrea Doria or Cosimo I de' Medici, and Titian the best for portraying Alfonso d'Avalos or Ippolito de' Medici.

In any case, on November 7, 1537, Aretino wrote a letter (XLVII) to Veronica Gambara, the poetess and ruler of Correggio, that has as its only subject a description of the Duke of Urbino's portrait. This was the letter in which Aretino first expressed his unique view that a portrait is a work of art full of color and light, and it inaugurated his series of similar letters and sonnets on portraits by Titian. (This letter and the sonnets will be discussed in Chapter III.)

It should be recalled that Aretino's acquaintance with Titian began when he had his own portrait painted. He sent that portrait to Federico Gonzaga, as is known from his letter to Gonzaga of October 6, 1527 (II). He thus used the portrait to strengthen his own ties with his patron and to secure further commissions for Titian, and he would continue doing so with other patrons as well. He used Titian's portraits as a means for establishing and

strengthening connections with various powerful and influential noblemen. Titian in turn also tried to strengthen the ties between Aretino and potential patrons; as one letter shows, Titian would speak to the emperor on Aretino's behalf about his aspiration to become a cardinal (see page 141). Aretino's relationship with Titian may well have been businesslike character, but this did not preclude its becoming a truly warm and sincere friendship.

It is doubtful that Aretino influenced Titian's methods in painting portraits (by the time Aretino came to Venice in 1527, Titian was a practicing portraitist), but he certainly influenced him in his readiness to paint them. It was Titian's genius that enabled him to experiment with different types of portraits, and it was Aretino's sensitivity that in turn enabled him to develop the rhetoric of description in such a way as to reveal the uniqueness of the portrait as a work of art.

Some artists were envious of the way Aretino helped Titian obtain commissions, and some tried to persuade him to help them as well. Francesco Terzo, a painter from Bergamo, wrote to Aretino on July 11, 1551, asking for his help, saying that "it is not enough to have laboured and given proofs of merit, if you are not by means of some intelligent person made known to those who can remunerate you." Further on, he stated: "It is entirely owing to the pen and favours of Aretino, that the works of Titian have their great reputation, and that he had obtained the rewards he so well deserves."[35] In his response (DCI, August 1551; this is one of the rare cases when we have not only a letter but also a response to it—it testifies also that Aretino was quick to respond), Aretino encouraged Terzo and promised his help, yet he pointed out that an artist like Titian is "now living like a lord, after having endured intolerable labour, study, and want."[36] Aretino's reputation for being able to help artists was so strong that later Armenini attributed to him the association between Giulio Romano and Federico Gonzaga,[37] which was wrong: Giulio has worked in Mantua long before Aretino arrived there, and that specific association was due to Castiglione.

Aretino emerges from many of the letters as Titian's impresario, often advising whom he should portray and to whom to send his paintings as gifts. (For example, he advised Titian to send his *Annunciation* mentioned above to Empress Isabella after it had been rejected by the convent of Santa Maria degli Angeli on Murano.)[38] As we shall see, he tirelessly promoted Titian's art of portraiture, suggesting to various rulers and noblemen that they order a portrait through him. He did so by direct appeals and by describing Titian's works in order to promote future commissions.

In a way, Aretino can be seen as a precursor of modern advertising, issuing a number of appeals and repeating those appeals over and over.[39] His method differed from modern advertising in that each time he composed his proposal anew, even if it involved some repetition, he directed it to a particular client, as, for example, in his letter of December 18, 1537 (LXVII), to Empress Isabella, who, he suggests, should order a portrait of Charles V from Titian. Aretino explained that the portrait would be like showing "Cesare istesso a Cesare proprio" ("Caesar himself to *the* Caesar"; see page 115). Another example is his letter to Elena Barozza. A famous beauty in her time, she had been first portrayed by Vasari, and Aretino had sent her a sonnet in a letter celebrating that event (CLI, July 29, 1542). Six years later, learning that Elena intended to commission another portrait of

herself from Vasari, Aretino wrote to her (CDXVII, May 1548), suggesting, though indirectly, that she order a portrait from Titian instead, and inviting her to imagine her portrait by Vasari alongside one by Titian. He shrugged off his "young compatriot," who was almost twenty years his junior: while he is "illustrious in art, the old man appears to me here [in Elena's theoretical portrait] to be divine."[40] This letter implies how important it was for Aretino to persuade Elena to commission a portrait from Titian in spite of the fact that she already had a portrait by Vasari (to which Aretino dedicated a sonnet), and that he did not scruple to use any means for propagandizing Titian's art of portraiture, even at the cost of disparaging Vasari's art. In propagandizing Titian's art of portraiture, Aretino often repeated the assertion that whoever ordered a portrait from Titian would project his own image into the future with the utmost verisimilitude and would preserve it for posterity.[41]

To be sure, Aretino wrote about portraits painted by artists other than Titian; often, however, his motivation had more to do with the subject's personality than the painter's skill. For example, in his letter to Pace on his portrait of Giovanni delle Bande Nere, the greatest soldier of his time and Aretino's most cherished patron (CCLXXIX), Aretino focused on praising the subject. As in many of his letters, his encomium was far from innovative; he repeated conventional slogans popular at the time, evident in particular in the sentence in which he addressed himself to the painter: Pace's "brush rendered life through colors, so he [the general] is no less similar to himself than to your [Pace's] painting."[42] This sentence resembles one of Bembo's in his letter to Cardinal Bibbiena of April 19, 1516, in which he exclaimed that "Raphael . . . made the portrait of our Tebaldeo so natural that he is no more like himself than he is the painting."[43] Aretino may or may not have been familiar with Bembo's letter (it could have circulated before its publication in 1548), but such an observation was commonplace at the time. The number of letters that Aretino wrote about Titian's portraits in itself shows that he associated himself with Titian more than with other artists.

The enormous popularity of the letters not only helped form the reverential, if circumscribed, view of Titian as a portraitist but also contributed to creating a new attitude toward portraits as works of art. Cinquecento connoisseurs followed Aretino in perceiving Titian primarily as a portraitist and also, as we shall see, acknowledged Aretino's contribution to this new way of perceiving portraits.

Between Tradition and Innovation

Before Aretino, portraits were seldom described in letters or prose. In his day, the sonnet, then the most popular form of poetry, was often the medium for describing a portrait.[44] As was customary, Aretino viewed his sonnet as a poetic description to be read aloud alongside the Titian portrait, the pictorial description of the subject.[45] The cinquecento was in general more attuned to audible rather than visual perceptions of beauty. Treatises on rhetoric and poetics were popular, while those on the visual arts had only a marginal

place and often were written by the same literati who wrote treatises on poetics. That is why poetic praise of a portrait or other painting had for the literati a particular significance. Aretino's audience, so different from the public today, assigned more importance to sonnets than to portraits. In his sonnets on Titian's portraits, Aretino was following a well-established tradition. Their innovative character resides in their hyperbolic descriptions of the subject's essential traits, in their frequent mention of the painter's name, and in the fact that they did not use a portrait in the customary way as a pretext for writing a love poem.

The tradition of writing sonnets on portraits originated with Petrarch, who dedicated two famous sonnets to Simone Martini's portrait of his beloved Laura.[46] One, "Quando giunse a Simone l'alto concetto" (LXXVIII), speaks more about Laura's beauty than about the artistic qualities of her portrait. It gives no details of her pose or of the palette used to render her likeness; Petrarch seems to ignore that it is a painting at all. What he sees is a lifelike image of his lady, but one that cannot respond to his amorous feelings. The poet sighs, contemplating the portrait of his Laura as if alive and yet forever mute. The other sonnet (LXXVII) is likewise Petrarch's hymn to the lady's beauty, surpassing anything created by the ancient Polyclitus. Here was a beauty that could not have been portrayed had not Simone seen the inhabitants of Paradise, so that he could suffuse his portrait with the celestial atmosphere. Those two sonnets of Petrarch, according to contemporary commentaries on his *Rime*, a popular one composed by Alessandro Vellutello as early as 1525, respectively manifested the Platonic and Aristotelian approaches to the artist's work. The poet's description of the woman's transcendental beauty is seen in either case as superior to the painter's visual depiction of the same woman. Here the artistic portrait recedes into the background, becoming a pretext for a poet to contemplate the beautiful features. Imitating Petrarch, other poets continued to use the portrait as a visual emblem of the beloved's soul, that is, the features are seen and are perceived as beautiful for they are endowed with indescribable grace, but this grace can never be attained in real life.

Sonnets on portraits were much in vogue in the cinquecento. Vasari cites sonnets on Titian's portraits by writers other than Aretino in his biography of Titian, as does Raffaele Borghini in his *Riposo* (Florence, 1584). Both Vasari and Borghini quoted the sonnet about Titian's portrait of Elisabetta Quirini written by Giovanni Della Casa, the author of the celebrated manual of good manners, *Il Galateo*.[47] Like Petrarch, he mentions the artist's name in the first line of the sonnet, "Ben veggio io, Tiziano, in forme nove / l'idolo mio,"[48] but the portrait only induces him to contemplate the beauty of his lady from Venice. He mentions it just in passing, as a reminder of her beautiful, beloved features.

Aretino deviates from Petrarch in that his own sonnets emphasize the artist's role over the poet's; he wants his addressee to visualize an *actual* portrait while reading his sonnet. Unlike Petrarch and his followers, Aretino never employed a Titian portrait of a woman just to point to the beauty of the woman herself. He composed only four such sonnets, three of which are on Titian's female portraits: of Isabetta Massola (CLXXXIII), Eleonora Gonzaga (XLVII), and Diego Hurtado de Mendoza's mistress (CLIII). The other sonnet is on Vasari's portrait of Elena Barozza (CLI). None of these sonnets is a love lyric; instead, Aretino

focuses on the artistic power that makes the subject appear so lifelike. He wrote sonnets mostly on the portraits of the eminent personalities of his day: Charles V, Philip II, Diego Hurtado de Mendoza, Francisco Vargas, Lodovico Beccadelli, Vincenzo Cappello—rulers, ambassadors, prelates, generals, and the like.

Another reason, besides the tradition inaugurated by Petrarch, for the popularity in the cinquecento of sonnets on portraits was the interest in Greek poems and epigrams, an interest rekindled by the widespread Aldine publications.[49] We shall see that Aretino's use of a portrait in his sonnets was in fact influenced more by Greek poetry than by Petrarch and his imitators.[50] The most admired examples of Greek poetry of this kind were a number of epigrams, as well as some poems commonly attributed to Anacreon.

In one of his poems, Anacreon asks a painter to make a portrait of his beloved. In the form of the poet's advice to the painter, the poem itself then turns into a depiction of the beloved's features. At the end of this poem the enamored poet, envisioning the completed picture of his beloved maiden, enthusiastically exclaims, "Enough! My girl herself I see; / Soon, wax [portrait], like her, you'll talk to me!"[51] These lines, in which poetic imagination endows the mute painting with a voice, profoundly influenced subsequent poetic verses on portraits, including Aretino's. Anacreon's poems were much admired in sixteenth-century Italy, and so the classic topos, that the effigy is so lifelike it seems to lack only a voice, enjoyed renewed popularity.

This topos was echoed in Plato's *Phaedrus* (275D), another source even more influential for the Italian humanists, with Socrates' assertion that the difference between images as seen in life and those represented in paintings is that the latter always remain silent.[52] Socrates' saying, which probably referred to all painted figures, was understood by Renaissance men of letters to refer only to portraits. (It was interpreted in this way, for example, by the erudite seicento physician Giulio Mancini in his *Considerazioni sulla pittura.*)[53] Petrarch recalled in his letters that the topos of *vox sola deest* (only the voice is lacking) was followed by his contemporaries as well as by his later imitators in their descriptions of works of art.[54] No doubt this ancient topos was revived because of Petrarch and then recognized by his followers in Anacreon's poems. This expression crept into almost every one of Aretino's sonnets about Titian's portraits.[55] In his sonnet on the portrait of Diego Hurtado de Mendoza, for example, Aretino says that the figure in the painting "in his [Diego's] silence seems to be talking."[56]

Among the Greek epigrams, I should note in particular the one by Asclepiades on Lysippus's portrait of Alexander the Great. The Greek poet highlights the "brave look of Alexander," and notes its unsurpassable verisimilitude, as if the bronze effigy were alive.[57] The theme of this epigram, the indirect, rhetorical praise of the ruler through the poet's commendation of the masterly portrait, appears in Aretino's sonnets on the portraits of Charles V (CDLXXX) and Philip II (XDVIII).

In the end, Aretino's sonnets offer less understanding than his letters as to what one should read into Titian's portraits; the sonnets are too much bound up with the traditional use of the portrait as the starting point for praising the subject of the portrait. Yet, unlike Della Casa's sonnet on Titian's portrait of his Venetian lady or Lodovico Beccadelli's sonnet on his portrait by Titian,[58] Aretino's sonnets do not entirely relegate a Titian portrait to the

background. On the contrary, they do not let the recipients forget their portraits; they impel them to compare their own image with the way Titian rendered it. In the letters and sonnets, Aretino describes the subject's features so as to demonstrate his or her virtuous character or heighten the value of the person's service to the emperor. This is a favorite theme, evident, for example, in the sonnet on Titian's portrait of Francisco Vargas, in which Aretino declares that "the beholders perceive how worthy a / Representative it is of the envoy of Caesar" (DCLX).[59]

Hyperbole: The Language of Aretino

Aretino's language is often hyperbolical.[60] He acknowledged the special character of his style, saturated with hyperbole, in his letter of August 9, 1538, to Pietro Bembo, by far the most refined stylist of the cinquecento: "With the stylus of my practical nature, I make up stories about everything and force myself to lift up the pride of princes with my great praises, keeping them forever in the skies upon the wings of hyperbole [con l'ali de le hiperboli (sic)]."[61] Aretino shortly added, pointing out his deliberate divergence from Bembo's style: "I have not learned your technique of using measured words to express conceits, of selecting sounding words, and of adorning the subject better." Aretino applied his own technique not only in praising princes but also in describing the works of "princes of art." Writing to Michelangelo, Aretino immediately used exalted expressions, which at least today sound like exaggeration, as in his letter of September 15, 1537 (XXXVIII).[62] Aretino pronounced that in Michelangelo's hands "is hidden the idea of a new nature, whereby the difficulty of [drawing] the outlines—the highest knowledge in the refinement of painting—is for you so easy, that you achieve in the edges of bodies the very ends of art, something which art itself admits cannot be brought to perfection."

In addressing Michelangelo, Aretino adopted Pliny's praise of Parrhasius, as has been pointed out elsewhere.[63] But Aretino's wording recalls more particularly a passage in Sebastiano Serlio's *Regole generali di architettura sopra le cinque maniere de gli edifici*, a sentence in praise of Titian: "Il Cavalier Titiano, ne cui mani vive la idea d'una nuova natura non senza gloria de l'Architettura."[64] Only a decade after Aretino used this conceit to praise Michelangelo, he would repeat it, particularly the idiom "l'idea d'una nuova natura" [the idea of a new nature], with slight changes, in references to Titian. In the June 1548 letter to Giovan Bernardino Ferrario, for example, Aretino exclaimed: "Tiziano, più tosto monstro d'una nuova natura, chè spirito di pittore divino" [Titian more impudently shows a new nature that is the spirit of the divine painter] (CDLXIV), and in a letter to Benedetto Cornaro in June 1549 he explained: "Mi dice Tiziano, nel cui stile (come ho detto altre volte) vive occulta la idea d'una nuova natura" [I was told this by Titian (as I said before), in whose style is hidden the idea of a new nature (DIX)].[65] The reason for this sequence is probably that in Aretino's time the rhetoric of praising Michelangelo's works was well established, while for Titian's it was not. After all, Michelangelo was older than Titian and early in his life was associated with a circle of literati who priased his sonnets as

well as his art (for example, Varchi's commentary on his sonnet; noted on page 26 below). If Aretino needed to explain his reasons for using hyperbole, he did so in another letter to Michelangelo (LXX, January 20, 1538): "You are divine, and anyone who writes about you must use more than human language [Certamente voi sète persona divina, perció chi ragiona di voi favelline con un dir sopraumano], unless he wants either to prove that he is ignorant, or to tell lies by talking in an everyday manner."[66] Later, the "more than human language" Aretino used regarding Michelangelo would also appear in his letters on Titian.

Superlatives occur frequently, as in the letter in which Aretino says that Titian "marvelously made a portrait of the marvelous Vincenzo Cappello" (CIX).[67] This language was in fact as conventional as it was ornate. Aretino appears to have been following the then-popular advice of the classical orators Cicero (*The Verrine Orations* II.v.161) and Quintilian (*Institutio Oratoria* VIII.iii.66–70), ascribing terms of glorification from Virgil's *Aeneid* to eminent contemporaries.[68] With such language he was able to "compose" the imagined portrait of Emperor Charles V without ever detailing his actual likeness. Aretino seems to have loaded his writings with superlatives intentionally in order to force a heightened response to Titian's portraits from his readers.

In humanist rhetoric, panegyric was used to demonstrate the merits of virtuous people. Aretino was aware of the rhetorical use of *demonstratio* in contemporary writings, as expounded in the first treatise written on this subject in the vernacular, *La Retorica* (1543), by Francesco Sansovino,[69] the son of his friend—and Titian's—Jacopo, the renowned sculptor and architect. Sansovino dedicated his treatise to Aretino, who responded cordially in his letter of January 1544 (CLXXV). In keeping with the principles of humanist rhetoric, as presented in Sansovino's treatise, Aretino's description of the emperor's countenance in the imaginary portrait was meant to draw attention to those virtuous qualities that Titian would delineate as well.

Hyperbole is the appropriate figure of speech for this specific rhetoric of praise. Quintilian, the major classical advocate of hyperbole, defined it as "an elegant straining of the truth" (VIII.vi.67), whose power lies in its calling upon the "innate passion for exaggeration or attenuation of actual facts," as "no one is ever contented with the simple truth" (VIII.vi.75).[70] Using hyperbole to this effect, Aretino says in his letter to Giovio that Titian's portraits were "a miracle of his hand" (CCVII), and in another he says that Titian "portrays a person so very naturally alive" (DCLXX).[71] In yet another letter, Titian was said to present the subject's likeness not simply as it is but as "the example of superhuman semblance" (CCLXXXII).[72] Aretino's sonnets are even more hyperbolical than his letters. In the sonnet on the portrait of Francisco Vargas, for example, Aretino says that Nature has told Titian that while she "made him [Vargas] with an earthly and mortal body," he "in painting made him divine" (DCLX).[73]

By these grandiose flights of language, "the wings of hyperbole," as Aretino told Bembo, he was interpreting rather than just describing the subject. Consequently, he was able to enhance the conception of a portrait as a work of art that transforms the subject's appearance. The primary perception of the subject's character, based upon the visible, factual aspects of Titian's portrait, was measurably deepened by the use of hyperbole. Aretino's praises enhanced the significance of a portrait, not only commemorating the

subject but perpetuating his glory for posterity. In a letter he praised Titian's mastery, while in the accompanying sonnet he poetically celebrated the same subject. In both literary forms, this hyperbolic language went far beyond mere factual description, and the letters and sonnets emerge as independent literary works, variations on themes the portraits themselves present.

Imaginary Portraits

In ancient times and in Renaissance poetics as well, *ekphrasis* meant a verbal depiction of practically anything that could be thought about, including works of art.[74] Descriptions of visages had a history of their own. In ancient rhetoric, a description of a person's appearance was meant to place the subject before the reader to allow the reader to communicate with that person.[75] This kind of description was used mainly in an encomium, a biography, or an epideictic oration. In the cinquecento, such a verbal portrait was used mostly to describe a woman's beauty. Aretino, however, used this method to detail the features of a person's countenance for its classical purpose: to reveal the person's character. In describing portraits by Titian, Aretino insisted on the affinity between his literary depictions of the persons portrayed and their pictorial representations. It may well have been Aretino's innovation to use *ekphrasis* for describing an extant portrait as well as inventing a verbal one, whereas his contemporaries confined themselves solely to inventing word-portraits.

Aretino's awareness of the rhetorical *demonstratio* is manifested in two letters in which he describes two "imaginary" portraits that Titian did not paint in the years when these letters were written. Both letters were addressed to august persons. Here the encomium itself becomes the work of art—a verbal, or potential portrait.

The first such passage is part of an expression of gratitude to Empress Isabella for sending him a golden chain, a sign of honor and esteem. Aretino's letter of August 20, 1537, is itself a verbal portrait of the empress, written within the rhetoric of female portraiture.[76] The verbal portrait emulates the pictorial even when Aretino mentions no specific image. The language is ornate, with accounts of the empress's virtues, which become ornaments to her image: "Adorned with grace and beauty and with the simplicity that shines upon your forehead. . . . Your eyebrows, which have been delicately touched in by the paintbrushes of seemliness, are radiant with that tranquillity. . . . Your cheeks are the fair flowers of our hope."[77] The description continues, yet it is clear how the "portrait" in Aretino's letter appears almost to stand before the real empress, who is invited to imagine her portrait as if it is real. The audio-visual relationship between sonnet and portrait is altered; the receiver of this letter hears the description and then, with attention still focused on the letter, "sees" the portrait. This imaginary portrait of the empress was probably influenced by Giovan Giorgio Trissino's *Ritratti* (written about 1507 and published in Rome in 1524),[78] a popular work in Aretino's time, itself derivative of Lucian's *Eikones* (*A Portrait-Study*), as is evident from the title and as was noted by his contemporaries, including Agnolo Firenzuola, a

friend from Aretino's youth. Trissino's *Ritratti* is a dialogue between Bembo and a certain Vicentio Marco, dedicated to the verbal depiction of Isabella d'Este, whose name evokes an onomastic association with the empress. (We may recall that Titian portrayed both of these women, even though he never saw either of them.)[79] Aretino's description is analogous to a visual portrait of the empress; his account, even if flowery and hyperbolical, gives a fairly accurate idea of her looks, while Trissino's is a word-painting of Isabella's virtuous qualities, her character perhaps, but without a hint at her actual appearance.

A second imaginary portrait appears in the October 1544 letter (CLXXXVII) to Emperor Charles V, in which Aretino invites him to imagine how Titian would portray him. This kind of imaginary portrait, as we shall see in Chapter V, was often used in biographies of rulers. However, Aretino's description differs from similar panegyrics of his contemporaries in that he refers to a specific painter—Titian—and intentionally draws a parallel between his word-portrait and the potential portrait. In this long letter, Aretino suggested that Titian paint a portrait of the emperor as an august gift, and that the emperor imagine himself standing before his own portrait. Then the world would see "one Charles V, belonging to God, the other—to Charles V."[80] Aretino tried to convince him that Titian was

> still sublime, still a worthy mind working with a new force of light and shadow, that makes people surrender their senses to this sanctified figure, moved by the veracity of gesture through which the beautiful effigy breathes: the vividness of the gold in the hair, the serenity in the forehead, the splendor in the eyes, the wantonness in the air, the grace in the likeness, the honesty in the countenance, all give delight in the gentle manner of Your vital excellence. Behold in beautiful relief a form, which—I do not know how—shows in its essence a composition of the countenance, an ensemble of simplicity and candor of purity which we would long to see in an angel.[81]

Later in this letter, Aretino exclaimed:

> But what a visible marvel it would be if Vecellio [Titian] were to make a portrait of You, what amazement would come out of his making an imitation of Your natural likeness! . . . But what joy to have You portrayed with brushes and to describe it [the portrait] with my pen for the sake of celebrating You.[82]

In concluding his letter, Aretino reminds the emperor that "nine years have passed since You ordered Titian, Your servant, to draw from the account in Naples and four more years have passed since You paid him a pension."[83] One of Aretino's purposes in writing was to remind the emperor that the payment to Titian had been delayed. Alongside this prosaic aim, however, he offered his verbal depiction of Charles V's imagined countenance for the sake of inducing him to order a portrait from Titian.

According to Aretino, if Titian were to portray the emperor himself, then his portrait would be, in panegyrical rhetoric, an imitation of the august likeness, as the emperor's

visage in itself is so sublime that the artist is left with nothing to invent. Although imaginary, the description emphasizes what Aretino deemed important in portraits. Veracity of gesture had great significance because it best characterized the subject. We also learn that a good portrait must transmit something indefinable that makes the sitter's image faithful to reality. Implicitly, the mere rendering of the emperor's physical features would not suffice to make a portrait a work of art in the same way that the literary description is a work of art.

This letter goes far to demonstrate that in the cinquecento the literary description of a portrait's subject was important in its own right. Aretino's description of the portrait Titian would paint if he were commissioned thus conferred greater significance upon portraits as works of art than they usually had in Italy of his day.

Aretino's Pen—Titian's Brush

Aretino did not think of himself as a poet, but he did remind his public that his letters and sonnets had merit in their own right and should not be treated merely as descriptions accompanying Titian's portraits, simply assisting, as they often did, in obtaining commissions. As we shall see, Aretino, and his contemporaries as well, regarded his letters, and above all the sonnets, as the "voices" of Titian's portraits. In the cinquecento view of art, Titian's portraits were regarded as pictorial descriptions operating through color and line; Aretino's sonnets, in their turn, were poetic descriptions operating through words and sounds.

Juxtaposing pictorial and poetic descriptions was commonplace in sixteenth-century Italy, and connoisseurs frequently affirmed an affinity between poetry and painting. In his letters Aretino relied on the common assumption, confirmed by often-cited quotations from Horace's *Art of Poetry* and Aristotle's *Poetics*, that the "sister arts" share a common end (the imitation of human actions) but differ in their means of expression (poetry is a verbal art; painting is figurative).[84]

One of the earliest, most eloquent contemporary expressions of the affinity between these two arts came from one of Aretino's friends, the Venetian man of letters Bernardino Daniello, who in 1536 published his *Della Poetica,* one of the earliest original treatises in the vernacular on the subject and a good example of the fusion of the Aristotelian and Horatian theories of poetry.[85] Aretino was prompt to respond to this treatise in his letter of December 22, 1536 (xvii), thanking the author for presenting him with a copy of his work. In his treatise, paraphrasing the famous aphorism attributed by Plutarch to Simonides of Ceos that "painting is mute poetry, poetry is a speaking picture," Daniello declared:

> Poetry was compared by the wise ancients to a picture; and the picture was said to be nothing other than a tacit and mute poem; and conversely, poetry [was] a speaking picture. Just as the imitation of the painter is done with styli and brushes,

and with diversity of colors . . . so, that of the poet, is done with the tongue, with the pen, with numbers and harmonies.[86]

When Aretino and his contemporaries linked his sonnets with Titian's portraits, they were aware of the new trend that had emerged between the 1530s and the 1550s—a search for a new correlation between word and image. In 1521 Andrea Alciati wrote his *Emblemata*, which was published a decade later; in 1555 Giovio published his *Dialogo dell'imprese militari e amorose*, and a year later Pierio Valeriano Bolzani published his *Hieroglyphica*.[87] These treatises relate to the interaction between word and image in a sophisticated, esoteric manner far more subtle than that reflected in Aretino's letters and sonnets. Yet this new trend undoubtedly influenced the way Aretino and his contemporaries viewed portraits. Indeed it is impossible to understand the iconographical subtleties of Titian's portraits without recalling that trend.

The assumed affinity between word and image enabled Aretino to equate his own eulogistic sonnets with the portraits, drawing parallels between *pennello e colore* (the painter's brush and paint) and *penna ed inchiostro* (the writer's pen and ink).[88] Aretino was not the first to draw these parallels. Explaining *pennello* as the painter's instrument, *Vocabolario degli Accademici della Crusca* cites as the earliest example of its usage Boccaccio's epilogue to the *Decameron*, where he claimed that "no less latitude should be granted to my pen than to the brush of the painter."[89] These parallels were certainly widespread in Aretino's time; for example, the parallel of pen and brush figures prominently in the then-popular sonnet by Tebaldeo on his portrait by Raphael,[90] to which Bembo, referring to this poet's words in the letter already noted (see page 17), brought still more attention. However, no other author besides Aretino used them so consistently, almost to excess. He employed them, for example, in his letter to Charles V, in which he described the august imaginary portrait, exclaiming: "But what joy to have You portrayed with brushes and to describe it [the portrait] with my pen for the sake of celebrating You." In another letter, to the Milanese nobleman Agosto d'Adda, Aretino again compares his poetic description of a portrait with the portrait itself, stating that he "describes the grace of [Agosto] with his pen in the same way that Titian depicts it with his brush" (DLIV, April 1550).[91] In still another letter, written in August 1552 to the Duke of Atri, Aretino declared that "the vividness which breathes in his [Titian's] color has the same sentiment as my ink" (DCXXXII).[92] And, last, in a letter to Niccolò Molino, the nephew of the Venetian senator Vincenzo Cappello, Aretino drew a parallel between his sonnet and Titian's portrait of Molino's uncle. Aretino said that "the verses and rhymes" he composed "should be perceived as if in the very style of Titian, who marvelously made a portrait of the marvelous Vincenzo Cappello" (CIX, December 1540).[93]

To Aretino, his sonnets and letters made Titian's mute portraits eloquent, as if giving them voice. In a letter of July 1552, which included a sonnet on Titian's portrait of Vargas, Aretino stated: "First of all I shall recite to you a recitation on the portrait, in which every sense and spirit of life that I composed is given in the divine style of painting unique to Titian" (DCXXXI).[94] Aretino was suggesting that his poem be recited while the viewer contemplated Titian's portrait, a suggestion to be understood in the context of his

often-repeated statement that Titian renders the sitter's likeness in the portrait so realistically that the subject appears as if alive, although mute. For Aretino, then, his sonnets took the place of an utterance on behalf of the sitter, who would otherwise remain forever silent.

In a letter to Marcantonio d'Urbino (xcvi, August 16, 1540), Aretino enclosed a sonnet on Titian's portrait of Diego Hurtado de Mendoza, saying that he had "sent a sonnet which had to persuade others that he was forced to compose it on the figure the marvelous Titian made marvelously in his portrait from nature."[95] In the sonnet itself Aretino affirms: "We see how Titian the Apelles created by art a taciturn nature, / showing Mendoza so vivid in a painting, / where through his silence he seems to be talking."[96] The sonnet skillfully blurred the distinction between the portrait as a work of Titian's brush and the portrait as a tangible image that left the spectator feeling as if he were communicating with the sitter, again in effect transforming a mute portrait into one that speaks.

Reading a Portrait

Aretino must have seen it as a main task of his descriptions to reveal to his readers the ideas embodied in Titian's portraits. His letter of 1549 (DIII) to the Duke of Alva declared that the accompanying sonnet was meant to uncover Titian's true intention, which the duke, after reading the sonnet, would discover while looking at his portrait. There in the portrait was his effigy, "which the divine Titian put into color and which, I know, surpasses [even] his talent. All of this I am expressing in the language of poetic style, whose proper effect my sonnet transmits to you."[97] His sonnet, Aretino suggests, discloses the portrait's message, as if the portrait were addressing itself through the sonnet to the living subject. The duke should see his own "effigy adored by Peace, / the image which frightens War, / the portrait in a sense is nought but / an example of your veracious soul."[98] Aretino was encouraging the duke to see beyond the surface of the portrait to the image the duke would wish to preserve for posterity.

In his sonnet, included in his letter (xlvii), Aretino states that Titian reveals "ogni invisibile concetto" of the Duke of Urbino in his portrait.[99] *Vocabolario degli Accademici della Crusca* defines *concetto* as "something imagined and invented by our intellect" and cites some lines from Dante's *Divine Comedy* as examples.[100] Yet in the sense of the fundamental notion through which a work of art is inspired, *concetto* was in fact used in Petrarch's sonnets, particularly in Sonnet LXXVIII (see page 18). In this Petrarchian sense the term passed into cinquecento poetry, where Michelangelo favored it over the more prevalent *idea*.[101] In his lecture on Michelangelo's sonnet, "Non ha l'ottimo artista alcun concetto," Varchi explained *concetto* as the notion that signifies the transformation of an image formed in the artist's imagination into the image presented in a particular work.[102]

On the whole, the *concetto* of a portrait denotes the subject's essential characteristics as conveyed in the portrait. Lomazzo used the term in connection with portraits in his

Trattato dell'arte della pittura, scoltura et architettura (Milan, 1585). (That Lomazzo was familiar with Aretino's writings is indicated by references in his *Libro dei sogni.*)[103] Lomazzo defines a good portrait as one that answers the requirements of art itself, in which "the good painter expresses his [subject's] *concetto.*"[104] Furthermore, he explains that the portrait should convey a dominant characteristic of the person portrayed; thus the portrait of Cato conveys his stability; of Caesar, his majesty; of Nero, his cruelty, and so on. Lomazzo called portraits that convey the *concetti* "intellectual"; they were of course superior to any other portraits.[105] This treatise, though written some fifty years later than Aretino's letters, allows us to comprehend what Aretino meant by the *concetto* in the portrait; it probably signified the essence of the person's social image. Then it becomes the critic's task to persuade the subject, who is at times also the recipient of his letter, that the artist succeeded in expressing the subject's *concetto* in his portrait. Just as Titian expresses the warlike character of his subject in the *Francesco Maria della Rovere,* so in his sonnet Aretino must make this same *concetto* manifest to the viewer. In that case, the task of the painter and his critic was facilitated by the subject himself, for the Duke of Urbino indeed was one of the bravest warriors of his time. A "correct" rendering of him would therefore reveal his courage. Hence Aretino accentuated the association between the way Titian conveyed the armored figure of the duke and the duke's militant spirit.

Another example is Titian's *Clarissa Strozzi,* about which Aretino wrote an open letter (CXLV, July 6, 1542) addressed to Titian himself but also helping others grasp the painting's message. He extolled the artist's device of showing Clarissa (the two-year-old daughter of Florentine patricians) cuddling her white puppy,[106] thus revealing the playfulness and childlike character of the little girl, who, dressed in a long gown and adorned with jewelry, would otherwise have been perceived as a miniature copy of a grand lady. In this case the portrait's *concetto* is Clarissa's childlike essence, shown by rendering her holding the puppy.

The *concetto* of a portrait, then, helps close the gap between the individual and his broadly perceived representative type. Thus the *Francesco Maria della Rovere* renders not only that specific duke but also the courageous warrior. Similarly, the *Clarissa Strozzi* portrays not only the youngest member of the Strozzi family but also the playful child.

One way Aretino discloses the *concetto* of a portrait is by pointing out characteristic features of the figure, including gestures. In the sonnet on the *Francesco Maria della Rovere,* Aretino underscores the duke's holding his baton, while in the letter on the *Clarissa Strozzi,* it is the child's cuddling her puppy. Sometimes Aretino merely suggests the importance of gestures in manifesting the *concetto* of the portrait and ultimately that of its subject. Even in the imaginary portrait of Charles V, Aretino stressed the emperor's lifelike gesture that Titian would certainly depict. In a letter of February 1545 (CCII) to the Tuscan grammarian Francesco Priscianese concerning the portrait of Alessandro Corvino (the secretary of Cosimo I de' Medici), Aretino also referred to the importance of showing the "resemblance in the true gesture of the [secretary's] pose,"[107] and in the sonnet on the portrait of Philip II, he again stressed that it was "the gesture of real majesty" through which Titian conveyed the divine and royal qualities of the subject's august being (XDVIII).[108]

Another way Aretino clarifies the *concetto* of a portrait is by describing the subject's countenance so as to reveal character. To this end, Aretino uses a rough version of the physiognomical method of deciphering a person's character through interpretation of the facial features. In ancient rhetoric the knowledge of physiognomy was taken for granted as a way to understand character. From antiquity to the Renaissance, books on physiognomy, beginning with the treatise attributed to Aristotle, were widely circulated.[109] Leonardo, who himself owned the book by Michael Scot, pointed out the usefulness of physiognomy for artists.[110] Pomponio Gaurico in 1504 included a chapter on physiognomy in his treatise on sculpture, an inclusion welcomed in Venice, as shown by remarks on its importance by the Veneto painter Paolo Pino in his *Dialogo di pittura*, published in 1548.[111] After Pino's treatise, knowledge of physiognomy was considered part of the artist's education.[112] Thus, in Aretino's time, the connection between physiognomy and the visual arts was widely accepted. Aretino's own interest in physiognomy is confirmed by his remarks in his comedy *Lo Ipocrito*, where he mentions in chronological order the most eminent practitioners from the past, "Aristotile, Scoto, Cocle, Indagine" (act III, scene 6).[113] Aretino applied a full measure of physiognomical lore while describing Titian's portraits.

In descriptions of the subject's countenance, Aretino focused on facial features, such as the forehead, the space between the eyebrows, and the eyes, and also on the sitter's general air. Aretino especially called attention to the forehead. Even in the sonnet on Titian's portrait of Isabetta Massola, he noted that the similarity between the lady and her portrait is manifested in the high forehead: "sembianza nel suo fronte altero" (CLXXIII).[114] Two sources in particular may have influenced Aretino's concentration on the forehead and the space between the eyebrows. One is a memorable line from Petrarch's Sonnet CCXXII: "E spesso ne la fronte il cor si legge" (line 12). (This line was quoted by Aretino the protagonist in Dolce's *Dialogo della pittura, intitolato l'Aretino*.)[115] The other and more important source is Pliny, who wrote in his *Natural History* (XXXV, 88) that the portraits of Apelles were "so absolutely lifelike that, incredible as it sounds, the grammarian Apio has left it on record that one of those persons called 'physiognomist' (hominem divinantem, quos metoposcopos vocant), who prophesy people's future by their countenance, pronounced from their portraits either the year of the subject's deaths hereafter or the number of years they had already lived."[116] In concentrating on the subject's forehead in Titian's portraits, Aretino revived the ancient tradition recorded by Pliny.

At the time Aretino was writing his letters, there was widespread interest in such "sciences" as chiromancy and metoposcopy. The latter, as set forth in Girolamo Cardano's richly illustrated *Metoposcopia* (written in 1550 and published in Paris in 1658), consists of the interpretation of the lines, general shape, and color of a person's forehead.[117] Aretino was metoposcopic in his poetic description of the Duke of Urbino: "He bears frightfulness between his eyebrows, courage in his eyes and pride on his brow, the place where honor and counsel rest together" (XLVII).[118] In describing the duke's features, Aretino interprets them as reflecting his noble character rather than as mere physical attributes. So too in his sonnet describing the portrait of the Duchess of Urbino, Aretino stresses the part of the face around the forehead, which he sees as reflecting the merits of

this virtuous lady.[119] By his "metoposcopic" approach to portraits, Aretino implies that he considers himself one of those endowed with a talent for reading and interpreting the human countenance: "homines divinates."

By drawing attention to the subject's features, or gestures and offering a physiognomical description, Aretino disclosed the *concetti* of Titian's portraits to the public. He was attempting to help the viewer gain a better understanding of the painter's "hidden" plan of the portrait.[120] The person Aretino addressed in his letter and sonnet, who was usually also the subject portrayed, would see his own spiritual image through Titian's portrait. As he viewed the portrait, he would be confronted with the mute rendition of his own visage.

Aretino's Influence

Titian's name appeared in a number of literary works prior to the publication of Aretino's first collection of letters in late 1537, but after that event references to Titian and his paintings appeared more frequently. As early as 1525, in "Fragmentum trium Dialogorum," Giovio had mentioned the diversity of the aspects of reality presented in Titian's paintings.[121] In the third and final version of his *Orlando furioso* of 1532, besides Michelangelo and Aretino,[122] Ariosto mentioned Titian as bringing fame not only to his native Cadore but also to Venice and Urbino. In 1537, in *Regole generali di archittetura,* published by Marcolini, Serlio asserted that in Titian's hands "lives the idea of a new nature," an assertion that Aretino would repeat in relation first to Michelangelo and then to Titian. Later that year Antonio Brucioli described a conversation that supposedly took place in Titian's house, naming him as a protagonist of the third book of his dialogues, *Dialoghi della natural philosophia, dello arco celeste,* together with Serlio and a certain Marco Visanti.[123] Although Titian, called "Tutiano" by Brucioli, was given a marginal role in that work, it is significant that it was he who started the conversation by asking Serlio about the nature of the rainbow. And in his dedication to Aretino of his 1536 translation of Horace's *Art of Poetry,* Dolce referred to the "gentilissimo Tiziano."[124] Somewhat later, in a letter of August 15, 1540, Priscianese described a feast in Titian's house, during which the conversation centered on problems of language, specifically Latin versus the vernacular.[125]

Probably the earliest mention of Titian as a portraitist prior to Aretino's letters was by Giulio Camillo (Delminio), who, in his small unfinished treatise "De l'humana deificatione" of c. 1537, compares the portrait Titian painted of him (now lost) with his own image reflected in the mirror.[126] He says that on seeing his portrait one would feel a desire to embrace him immediately, so vividly was he rendered by "il gran Tiziano."[127] Thus Camillo can be credited with this comparison of a portrait by Titian and its mirror image, a comparison later employed by Aretino, who, I should emphasize, was not always the original source of such responses to Titian's portraits. Camillo's acquaintance with Titian can be dated as early as 1532 through two letters of that year to Aretino.[128] Camillo, we

remember, was mentioned by Dolce in his dialogue on painting as accompanying Aretino to the Mass at the Church of Santi Giovanni e Paolo, where Titian's *Martyrdom of Saint Peter Martyr* was then located (painted in 1528–30, it was destroyed by fire in 1867).[129] Camillo, Marcolini, Serlio, Dolce, Brucioli, and of course Aretino formed part of a circle of intellectuals to which Titian belonged as well.[130] It was this circle that saw a portrait as a means of strengthening connections one with another.

From 1537 until the early 1550s, during the time Aretino was publishing his collections of letters, Titian's name was mentioned frequently by others also as a portraitist or in connection with portraits. In 1538 the same Dolce dedicated to "messer e cavaliere Tiziano" a small bizarre volume that contained his own dialogue on the qualities of spouses, his paraphrases of Juvenal's Sixth Satire, and a translation of Catullus's *Epithalamium on the Marriage of Peleus and Thetis*.[131] Addressing himself to Titian, Dolce stated:

> If the portraits produced by the perfection of art—which is so with you alone—approach the truth so closely that, with spirit added to them as well, Nature could reside there in vain, still life itself is lacking in them. But in the portrait I am speaking of [Juvenal's verse portrait] one sees only the similitude of that truth and of that life, though it be the same truth and life.[132]

Dolce here ventures on the comparison, so favored by Aretino, between a verbal portrait and a painted portrait.

How Aretino influenced his contemporaries to view Titian mainly as a portraitist also can be seen in the case of Giovio, whose influence on Aretino through the collection of portraits of their illustrious contemporaries for his *Museo* has already been mentioned. In Giovio's "Fragmentum trium Dialogorum," it was Sebastiano who was praised as a skillful portraitist and not Titian. Yet, later in his letters he mentions Titian only as a portraitist. Moreover, when Giovio wrote on August 14, 1548, to the emperor's chancellor to congratulate him on the completion of his memoirs of the "Germanic" war, he followed Aretino in drawing a parallel between the vividness with which these memoirs were written and the vividness with which Titian had painted the portrait of the emperor. In Giovio, to whom Vasari assigns responsibility for his idea of writing the *Lives*, it is possible to detect Aretino's influence not only in his perception of Titian exclusively as a portraitist but also in his approach to a portrait as a work of art. For example, in writing on March 11, 1545, to Aretino about Titian's portrait of Daniele Barbaro, which he wanted for his *Museo*,[133] Giovio, praising its coloristic effect, obviously emulated Aretino's similar *ekphrasis* of Titian's portrait of the Duke of Urbino. Before Aretino, *ekphrasis* was applied to paintings with a narrative subject; now it applied to portraits as well.

That Aretino was considered responsible for the perception of Titian primarily as a portraitist is evident in a letter the Paduan jurist Sperone Speroni wrote in 1537 to tell Aretino that he had composed a dialogue in which he mentioned him alongside Titian. In his new work, said Speroni, he would give a verbal account of some notable people of his time in a manner akin to Titian's pictorial style.[134] He shared this aim with Aretino,

who, we may recall in his dedicatory letter to Valdaura for his own *Ragionamenti,* asserted that he tried to depict his personages with the same vividness as Titian. Speroni in that letter wrote about the difficulty of distinguishing Aretino's name from Titian's. Aretino immediately responded (CLXII), joking that Speroni might like to add his own ear to the eye of Titian, but, he reminded him, Aretino's ear was already there.[135] Here we see another expression of the auditory dimension that, Aretino claimed, his sonnets added to Titian's portraits.

In his *Dialogo d'amore,* published in Venice in 1542, the dialogue referred to in the 1537 letter, Speroni praised Titian as a painter, mostly as a portraitist, and did so in Aretino's style, using his hyperbolical idioms: he qualified Titian's colors as "made of a miraculous herb."[136] Likewise, the portraits possessed something that was impossible for Speroni to define, and " 'I know not what' of divinity" (un non so che di divinità).[137] He mentioned Titian's portraits along with Aretino's sonnets and found them as beautiful as the sonnets themselves. One of the interlocutors in this dialogue even proclaims: "And I think that to be painted by Titian and praised by Aretino would amount to a new generation of the people."[138] Thus in Speroni's time the names of Aretino and Titian were closely linked. Even if it had by now become a cliché to mention poet and painter together in their united effort to glorify the sitter in two different media, still this quote shows that it was perceived as a great—and socially significant—honor to be portrayed by Titian and praised by Aretino. For Speroni, then, a portrait by Titian was akin to a sonnet by Aretino, being similar in its aim to glorify the sitter. Speroni explicitly affirmed that Aretino's sonnets served as the voices of Titian's portraits, thereby declaring his belief in the essential reciprocity between Titian's portraits and Aretino's sonnets, a belief reflecting how much their age was attuned to the spoken word as against the pictorial image or, rather, to both at once. From reading the *Dialogo* one infers that Speroni's contemporaries, the eminent participants in his dialogue (such as Molza or Bernardo Tasso), all perceived Aretino's sonnets as counterparts to Titian's portraits.

In his *Apologia dei dialoghi,* also published in 1542, Speroni gives further evidence of Titian's renown as a portraitist. To be sure, the subject of this dialogue, like that of the previous one, was not portraiture or Titian's painting in general. In his dialogue debating the power of love, Speroni had suggested, however, that some portraits might be capable of kindling a spark of amorous desire in an observer. Here he named Titian as the artist who could paint such a portrait.[139] Speroni's dialogue serves as added testimony that the connoisseurs of that time thought of Titian mainly as a portraitist.

Further confirmation of this view, which was especially characteristic of those who did not belong to the Venetian milieu, is found in Vasari's letter to Varchi of February 12, 1547, written in reply to Varchi's question as to which art form was superior, painting or sculpture. One of Vasari's arguments was that painting is better than sculpture at rendering a person as if alive. To illustrate this, Vasari cites the same example Varchi did, namely, Titian's *Portrait of Pope Paul III.* In his account Vasari, characteristically for an artist, added a few details; he related how, when the painting was set up to let its varnish dry on a sunlit terrace, passersby doffed their hats as if in reverence to the pope himself.[140] This story, like Speroni's dialogue, shows that it was a portrait by Titian that exemplified

the power of painting to render people persuasively. It is significant that they spoke of Titian's portrait of Paul III, rather than Raphael's of Julius II or Sebastiano's of Clement VII, as evidence of the power of illusion in painting. True, Paul III was the pope at that time, but it is nonetheless significant that it was a painting by Titian, a *portrait* by Titian, that was brought forth to prove that the art of painting is capable of achieving this persuasive illusion.

In the biography of Giorgione in the 1550 edition of the *Lives*, Vasari stressed that Titian excelled in portraiture, observing that he made "an infinite number of the most beautiful portraits from nature not only of all the Christian princes, but also of all the great people who live in our times."[141] In both versions of Michelangelo's biography (1550 and 1568), Vasari repeated Aretino's remark about Michelangelo's praise for Titian's portrait of Alfonso d'Este, thus lending further substance to Titian's reputation as a portraitist.[142] In his biography of Titian in the second edition (1568), Vasari noted Aretino's literary activity in Venice as an important factor in Titian's life. In the main, Vasari mentions the portraits that Aretino first commented on. Vasari's biography was certainly influenced by Dolce's *Dialogo della pittura, intitolato l'Aretino*, which included an encomium on Titian. (Dolce elaborated on the same remark by Aretino about Michelangelo's praise of Titian's portrait of Alfonso d'Este, repeated dryly in both versions of Vasari's biography of Michelangelo, when he added that Michelangelo "would not have believed that art could achieve so much, and that Titian alone deserved the title of painter.")[143] In spite of Dolce's demonstration in that dialogue of Titian's versatility, Vasari praised mostly Titian's portraits, while noting other works with less enthusiasm. After listing some of the most notable portraits, Vasari repeated Dolce's words almost verbatim: "There is scarcely a famous prince or great lady but has been portrayed by this artist, who was truly remarkable in this particular."[144] Vasari stressed that portraiture was the branch of painting in which Titian most excelled.

The Venetian physician Michelangelo Biondo (who also practiced in Rome, in the court of Pope Paul III), in his *Della nobillissima pittura et della sua arte*, a slim volume published in Venice in 1549,[145] characterized most of the famous painters of his day usually by indicating their multifaceted activities. He rarely mentioned portraits in discussing such versatile painters as Raphael, Parmigianino, Giovanni Bellini, or Leonardo. Yet, significantly, his chapter on Titian (chapter XVII) gives the impression that Titian's oeuvre consisted solely of portraits. Biondo particularly praised the portraits of the Duke of Urbino and Agostino Lando, stating banally that they "lack nothing but voice, so realistically are they painted."[146]

Vasari, Varchi, and Biondo, in addition to Speroni and other literati, frequently corresponded with Aretino, and the portraits they cited had previously been rendered famous by Aretino's letters. Biondo, for example, mentioned especially the portrait of the Duke of Urbino, about which Aretino had written both an open letter and a sonnet. The brief account Vasari gives of this portrait in his biography of Titian included the first two lines of Aretino's sonnet.[147] That the impact of the association between Aretino and Titian regarding portraiture was far-reaching is evident from a letter written as late as July 27, 1582. In this letter the poet and rhetor Luigi Groto (Cieco d'Adria) asked Tintoretto

to paint his portrait, which he eventually would praise with his own pen. The parallel between the painter's brush and the writer's pen led Groto to recall how "wonderful" it was when a portrait was painted by Titian and then described by "that famous Writer in his Letters."[148]

Aretino's contemporaries recognized how important his sonnets and especially his letters were in promoting Titian's fame as a portraitist, and the sheer quantity of letters and sonnets on Titian's portraits forced them to pay attention to Titian's portraits. The unique combination of description and demonstration heightened the viewers' receptivity to the portrait as an art form. Aretino's writings were influential in raising the portrait from the level of a documentary record of the subject to the status of an art form. In his treatment of Titian's portraits, Aretino also enhanced the importance of the description, which enabled the viewer to see beyond the surface of the representation—to see more than meets the eye—and thus served as an original means of interpreting the subject's appearance.

Aretino's letters and sonnets re-create for us the contemporary milieu in which Titian worked, as well as disclosing what Titian's clients expected to see in their portraits. Looking at these portraits from the standpoint of their historical and iconographical background as revealed in Aretino's letters affords us a better understanding of the methods Titian used in his portraits. Aretino's letters persuade us that the most important task for the cinquecento viewer was to perceive the portrait's *concetto*. It was also important for the subject to be convinced that the portraitist had successfully captured his or her likeness.

How the portrait was to embody both the subject's likeness and essence (*concetto*) is still not clear. It is as unclear as the simultaneous demands for truthfulness to nature and for beauty as well in the painting of *istoria* (voiced in Alberti's *On Painting*).[149] Aretino's letters show that, like Alberti nearly a century earlier, he sensed no contradiction between the two, and neither did his contemporaries.[150] They consequently expected to see the person rendered both realistically and beautifully. Viewing Titian's portraits through Aretino, his preeminent spokesman, we understand what society during the Renaissance wanted the portraitist to achieve.

Aretino's approach to portraits as works of color and light was truly innovative. To be sure, his discernment of the pictorial quality of Titian's portraits comes to the fore in only one letter (XLVII, to Veronica Gambara on the Duke of Urbino's portrait), but this letter is nonetheless important as a testament to one of the first conceptions of the portrait as a work of art. Aretino took aesthetic pleasure in highlighting painterly effects, such as the reflection of the helmet feathers in the duke's polished cuirass as well as the reflection of the vermilion velvet in his armored tassel and gauntlet. This letter certainly demonstrates the importance that Aretino attached to the medium of painting itself. He was one of the first critics to draw special attention to portraiture as an important branch of painting. Aretino, then, inaugurated a trend that recognized literary description as the effective means for bringing out the message of a portrait, including one painted by such a master as Titian.

II

The Image of Aretino in Titian's Paintings

Probably no other celebrity of the cinquecento had his image reproduced so often and in so many media: paintings, frescoes, sculptures, prints, medals. Aretino's desire to be commemorated became proverbial.[1] He himself boasted in a letter of May 1545 (CCXXXIV): "As I have often said, I now say again that besides the medallions stamped or cast in gold, bronze, copper, lead, plaster, I have had a lifelike copy made of my portrait which is on the facade of palaces and had it stamped upon comb boxes, on the frames of mirrors and on majolica platters just like Caesar, Alexander and Scipio."[2]

At various stages of his life Aretino was also portrayed by Sebastiano del Piombo, Alessandro Moretto, Francesco Salviati, Jacopo Tintoretto, and Giorgio Vasari. His portrait was engraved by Marcantonio Raimondi and Giovanni Jacopo Caraglio. His likeness was produced on medals by Leone Leoni, Francesco Segala, Alfonso Lombardi, and Alessandro Vittoria and his image was sculpted by Jacopo Sansovino and Danese Cattaneo.[3]

Titian painted several state portraits of Aretino; he also included his image in narrative compositions. Like Aretino's public letters, which were addressed to his contemporaries,

Titian's paintings communicated something of Aretino's public persona and position in society. I shall ask: To what extent does the state portrait reflect the significance of Aretino's public role in the society of his day? And does not the rendition of Aretino as a protagonist within at least one of the narrative paintings disclose more of his public role than could be shown in a portrait?

Like princes and nobles, Aretino successfully employed the visual arts as a means of propaganda. He himself devised the mottoes that accompanied his image on prints and medals, and almost every edition of his books contained a frontispiece portrait of him provided with a carefully-thought-out motto. The most famous one, "Ecco il flagello / de' principi, il divin Pietro Aretino," glorified by Lodovico Ariosto in his *Orlando furioso* (Ferrara, 1532: XLVI, 14), eventually became Aretino's own *concetto*.[4] In one of his letters to Titian, Aretino himself acknowledged that he was popularly called in Rome and Florence the "scourge of princes"—"il flagello dei principi" (CCIC, January 1546).[5]

Yet unlike princes and nobles, Aretino suggested to various artists (Titian, among them) that they use his portraits as means for securing commissions for themselves. In making this suggestion, Aretino of course pursued his other goal, to propagate his own likeness, but he tried to persuade the artists that they would profit from that as well. Thus he invited Titian to paint his portrait for the sake of sending it to Federico Gonzaga and to Cosimo I de' Medici. (Titian succeeded in obtaining commissions from Federico but failed with Cosimo I.) And in a letter of September 1544 (CLXXVI), Aretino advised Moretto to send his portrait to the Duke of Urbino to demonstrate what the artists of Brescia could do. Likewise he advised Salviati to send his portrait to Francis I, king of France, who, after seeing it, would invite the artist to his court.[6] Unfortunately, it is impossible to compare Titian's portrayal of Aretino with that by other artists, for Salviati's and Moretto's portraits have not survived and Sebastiano's portrait is in ruinous condition.[7] It is possible, however, to trust Marcolini, who, in his letter to Aretino of September 15, 1551, mentioning the portraits by Salviati and Sebastiano, remarked that only Titian's portrait, sent by Aretino to the Duke Cosimo I, could be compared to those of kings and emperors.[8] In Titian's portrait of Aretino, Marcolini thus recognized the imperial dignity with which his image was rendered.

The four recorded portraits of Aretino by Titian were painted for (1) the Marquis of Mantua, Federico Gonzaga, in 1527; (2) the Cardinal Ippolito de' Medici, not later than 1535 (the year he was poisoned); (3) the Venetian publisher Francesco Marcolini, most probably in 1537; (4) the Duke of Florence, Cosimo I de' Medici, in 1545.[9] Of these portraits, only those done for Marcolini and Cosimo I have survived; they are in the Frick Collection[10] and in the Pitti Palace,[11] respectively.

One of the two narrative paintings in which Titian incorporated Aretino's image depicted a contemporary event, the other an episode from the Gospels. In the first narrative painting, *Allocution of Alfonso d'Avalos, Marchese del Vasto* (see Fig. 6),[12] Aretino was represented as a nameless soldier in the crowd, a passive observer witnessing the historical event. In the second, *Pilate Presents Jesus Christ Before the People* (see Fig. 8),[13] he was represented as Pilate himself, the protagonist whose activity turns out to be

futile. The first was painted in 1541 and the second in 1543, both thus preceding the Pitti portrait of 1545.

I shall consider Titian's renditions of Aretino in chronological order and will start with the vividly described portrait of Aretino (now lost) that Titian painted in 1527.

The Portraits for Federico Gonzaga and Francesco Marcolini

Aretino was portrayed by Titian almost immediately after his arrival in Venice on March 25, 1527.[14] Six months later, on October 6, he informed Federico Gonzaga, his patron, that he was sending him a portrait of himself by Titian (II).[15] We know from another source how Aretino was represented in this portrait; it was described by the seicento Venetian painter Carlo Ridolfi in his *Maraviglie dell'arte*. According to Ridolfi's account, Aretino wore a black cap decorated with a gold medal (a gift from the Marquis of Mantua) and inscribed with the motto "FIDES," and he held a laurel wreath in his right hand.[16] The Gonzaga gift and the laurel wreath (symbol of a poet) both indicated Aretino's role as the court poet.

While the portrait flattered the patron by showing Aretino as his court poet, Aretino's sonnet on the portrait demonstrated his independence. In it he proclaims that, although he is shown with a laurel wreath, he is "neither poet nor prince" but the "censor of the proud world / And nuncio and prophet of truth."[17] Aretino ends the sonnet with the rhetorically impudent announcement that aside from Federico Gonzaga he respects no one at all. Thus the impression of the loyal courtier conveyed by Titian's portrait was offset by the outspoken sonnet, in which Aretino, though still flattering his patron, nonetheless declared his independence. While Titian's portrait represented Aretino as the court litterateur of the Marquis (as indicated by the motto "FIDES" on his black cap), in the sonnet Aretino depicts himself as not belonging to any social group but, rather, as embarked upon a prophetic mission. Titian showed him in precisely the role Aretino at this crossroads of his life had decided to renounce, that of court poet, while the sonnet reveals how Aretino saw himself: "censor of the proud world."

Some controversy exists regarding the provenance and dating of the portrait of Aretino in the Frick Collection (Fig. 1). It is generally believed, however, that this portrait is the one Titian painted for Marcolini and mentioned in his letter of September 15, 1551.[18] In that letter Marcolini told Aretino that anyone "who knew you at that age sees you present before him in flesh and spirit, so lifelike it is."[19] The letter does not indicate precisely when the portrait was painted, but there is reason to assume that the date was c. 1537. Certainly it could not have been painted before 1535, for that year marked the beginning of Marcolini's collaboration with Aretino, when he published Aretino's religious work *Humanity of Christ* (*Dell'Umanità di Cristo*), as well as his provocatively secular *Cortigiana*. At the end of 1537 Marcolini published the first volume of Aretino's letters, and this was the year that marked

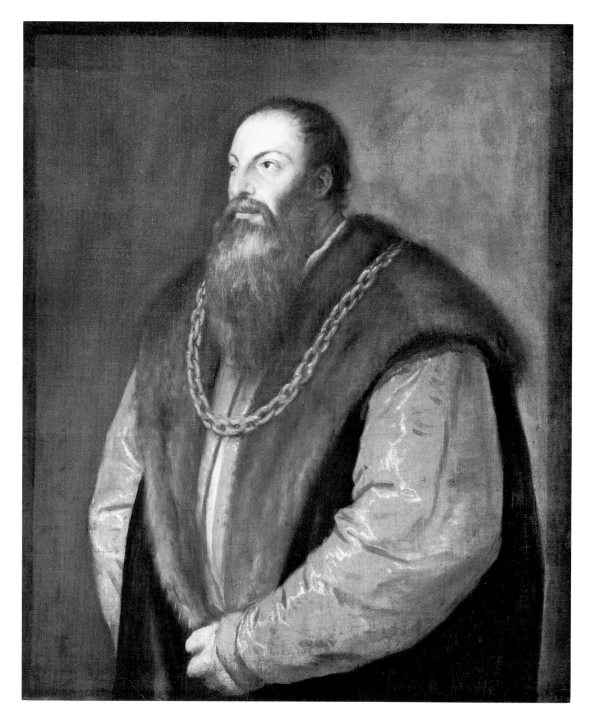

Fig. 1. Titan, *Pietro Aretino, c.* 1537. Copyright The Frick Collection, New York

the beginning of the acquaintance between Marcolini and Titian, as was testified by a certain Strozzo from Correggio in his letter to Aretino of July 14, 1537, the earliest evidence of this kind.[20] Possibly Marcolini commissioned Titian to portray Aretino in order to provide the basis for the etched portraits that served as frontispieces for his books. Nearly every edition included an engraved portrait in which the basic outline of Aretino's features approximates that in the Frick portrait, though these etched portraits show Aretino not as a half-figure, as in Titian's portrait and commonly in other cinquecento portraits, but as an oval bust figure, more compatible with the tradition of engraving in which the etched image resembled the medallion, as exemplified by Caraglio's (Fig. 2), one of the best-known print portraits of Aretino.[21] Further evidence for dating this painted protrait by c. 1537 is provided by Dolce's letter to Aretino of June 28, 1537, in which he expresses his wish to have Aretino's image portrayed by Titian.[22] Dolce's letter does not necessarily refer to the Marcolini portrait, but it clearly indicates the plan for such a painting. In addition, Franco mentioned it in *Rime . . . contro Pietro Aretino,* first published in 1541;[23] this verifies that the portrait (if the Frick portrait is identical to that painted for Marcolini) was done in the late 1530s. Franco mentions it in the sonnet addressed to Marcolini, who found a way to make a xylograph from the portrait, and also in a number of sonnets addressed to Titian,[24] in which the artist's mastery is praised and contrasted with the blasphemous personality of Aretino's image. From these indications one infers that the Aretino portrait was probably commissioned by Marcolini around 1537, quite soon after their collaboration had begun. In his letter of September 15, 1551, Marcolini stresses that he has been talking about the portrait that was done many years before while remarking that Titian executed it with remarkable rapidity—in a mere "three days."

In the Frick portrait, Aretino is depicted from the waist up, in three-quarters view, almost in profile. The bulkiness of his figure is emphasized by the outline of his sleeveless pelisse, which he holds closed with his gloved hand. A large golden chain with oval links stands out against the fur collar of his coat and the brocade of his vest. The massive head on the bull-like neck is framed by a thick, disheveled beard. Aretino's forehead is high and his hairline receding, while the back of his head is still covered with a mass of black curls. The line of his long, thin eyebrow merges with his long nose with its fleshy tip. His broad, powerful face and robust body are in striking contrast to the spiritual look of the upturned, almond-shaped eyes, whose dark pupils stand out against the whites.

Unlike the portrait made for Gonzaga, this one gives no indication of the sitter's occupation. The gold chain, fur-trimmed coat, and glove are general attributes of high social rank, but they do not point to the sitter's calling. Nothing in the portrait hints that the sitter makes his living by the "sweat of his ink."[25] In the 1530s Aretino received gifts of gold chains from King Francis I, Empress Isabella, and Cardinal Ippolito de' Medici.[26] The origin of the gold chain in this portrait, however, remains obscure. In sixteenth-century portraiture, a chain and glove were common attributes of nobility. Traditionally an attribute of the personification of Honor,[27] the chain was associated with virtuous deeds, supposed to characterize the patrician's life, while the glove, reminiscent of the aristocratic occupation with the hunt,[28] denoted noble ancestry. To portray Aretino, who was of low birth, Titian needed to develop a special language of composition, considering

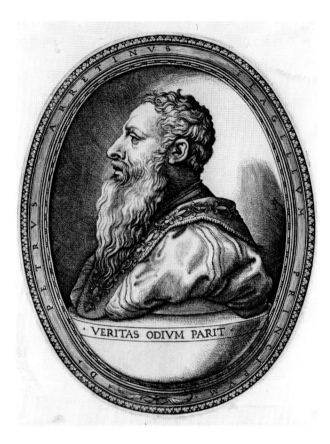

Fig. 2. Giovanni Jacopo Caraglio, *Pietro Aretino*,
Between 1536 and 1539, engraving. The
Metropolitan Museum of Art, New York

the pronounced hierarchy of contemporary society and hence the elaborate rhetoric of
costume and gestures.

The Aretino portrait brings up the complex question of decorum, which was raised in
every treatise on the arts and on poetics during the Renaissance.[29] This question was
inherited from the ancient treatises concerned with rhetoric. Aristotle raised it in his
Rhetoric (1408a.10–25) as well as in his *Poetics* (1454a and 1455a), and Cicero discussed
it in his *Orator* (21), acknowledging the difficulties involved in dealing with this issue,
which was far from being just rhetorical.[30] Horace incorporated a discussion of decorum in
his *Art of Poetry* (89–127), thus paving the way for its consideration in every later treatise
on poetics, starting with Daniello's.[31] In treatises on painting, Alberti raised the question
of decorum in discussing the appropriateness of gestures to the characters and ages of
protagonists in narrative paintings.[32] Leonardo also advised painters to carefully observe
decorum in every composition; he defined it as "the suitability of action, dress, setting
and circumstances to the dignity or lowliness of the things."[33] And Dolce in his *Dialogo
della pittura, intitolato l'Aretino* raised the question of the importance of decorum for both
painters and poets.[34] Alberti, Leonardo, and Dolce focused their attention on the appro-
priateness of certain gestures for certain characters and of that character for the composi-
tion as a whole.

The question of decorum in portraits was addressed explicitly in the *Trattato dell'arte*

della pittura, scoltura et architettura by Lomazzo, who discussed it in terms of the appropriateness of commemorating persons of one or another rank (LI). Thus for Lomazzo, decorum was an issue inseparable from the hierarchy of society. He suggested that persons of low birth should not be portrayed by artists, recalling the ancient custom of making effigies only of kings and sages.[35] Although Lomazzo wrote his treatise on the visual arts at the close of the cinquecento, he expressed ideas prevalent among Aretino's contemporaries. Significantly, Aretino himself raised the question of who could appropriately be rendered in a portrait. Although he was himself of low birth, in his letter to Leoni of July 1545 (CCXXXVII), he urged this sculptor to portray only those who are famous. "It is a disgrace of our age that it tolerates the painted portraits even of tailors and butchers."[36]

In this light, it is understandable that Titian needed to draw a line, no matter how subtle, between the portrait of Aretino and that of a nobleman. The main differences between the Aretino portrait and routine contemporary representations of noblemen are in the appearance of the subject's eyes and his pose. Aretino's eyes, their gaze directed heavenward, call to mind the eyes of Dürer's *Melencolia* or, even more, the eyes of Saint Paul (Fig. 3) from Dürer's *Four Apostles*.[37] They also call to mind Raphael's *Fedra Inghirami* (Fig. 4), in which the uplifted turn of the sitter's eyes, though produced by the artist's dexterous concealment of a defect (slanted eyes), hints at the divine nature of his calling.[38] The shape of Aretino's eyes and his stylized eyebrows are reminiscent of a certain hieroglyphic eye that, as noted by Alberti in his *Ten Books on Architecture* (Book VIII, chapter 4) and then repeated in Valeriano's *Hieroglyphica*, was a symbol of divine power.[39] Whether or not Titian intended this association with this particular hieroglyph, the brightness of the upturned eye, alluding to the divinely inspired seer, becomes a sign of spirituality hidden within this subject's fleshy figure.

When we compare Titian's portrait of Aretino (see Fig. 1) with his portraits of noblemen, as well as with the portraits of noblemen by other artists, such as Sebastiano, Salviati, Jacopo Pontormo, Agnolo Bronzino, or Vasari, what also stands out as unusual is Aretino's gesture in clutching his garment. The only other portrait in which a similar gesture appears is Bronzino's *Portrait of Andrea Doria as Neptune* (Fig. 5), painted probably around 1540.[40] In Bronzino's painting, Doria, half-naked and stylized in the fashion of a classical statue, holds a trident in his right hand and supports a loincloth with his left hand. It is striking to find this kind of gesture, later used in the portrait of this distinguished patrician, the admiral of the imperial naval fleet who fittingly wanted to be seen as Neptune, in the portrait of the fully garbed Aretino. It is as if Aretino acknowledges that his clothing, befitting a nobleman, is not really his; it serves him like the drapery on the ancient statue. Moreover, in comparison to the way noblemen were shown in contemporary portraits, Aretino's garments fit his body loosely, concealing rather than emphasizing its lineaments. Although he is dressed in patrician garments, which betray his fascination for costly textures, the gesture of his hand implies his plebeian origins.

Aretino's pose calls to mind the pose of ancient rhetors, usually draped in spaciously hung togas.[41] The gesture of his left hand holding the garment somewhat resembles a gesture prescribed by Quintilian in his *Institutio Oratoria;* he advised that the orator, when making his argument, should have his left hand "raised so far as to form a right angle at

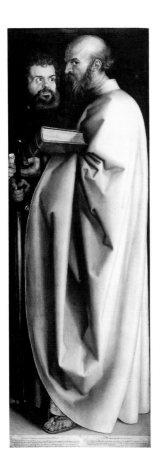

Fig. 3. Albrecht Dürer, *Saints Mark and Paul*, 1526, detail of *The Four Apostles.*
Alte Pinakothek, Munich

the elbow, while the edge of the toga should fall in equal lengths on either side"
(XI.iii.141).[42] This venerated teacher of rhetoric further recommended that the "knees
should be upright, but not stiff, the shoulders relaxed, the face stern, but not sad,
expressionless or languid" (XI.iii.159). Quintilian's precepts were elaborated upon by
John Bulwer, whose treatise on gestures, entitled *Chirologia . . . Chironomia*, first pub-
lished in 1644, was based on earlier manuals of gestures, such as Giorgio Bonifacio's *L'arte
delle cenni.* Bulwer specified that a gesture such as we see in the Aretino portrait becomes
those who "*affirm anything of themselves*" (the emphasis is Bulwer's).[43] Aretino's upright
posture and austere expression fit Quintilian's description of the rhetorician's ideal pose;
Aretino's bearing and the way he gazes from the portrait accentuate the *affirmatio* of his
persona. But the gesture of his left arm, lower than that prescribed by the classical author
and yet fitting its later descriptions as elaborated by Bulwer, emphasizes the opposite
traits, the lowly elements in his personality. This deviation from the required pose
diminishes the aristocratic effect produced by the chain and rich garments. Another
deviation from the rhetor's pose typically used for portraits of noblemen is Aretino's right
hand, which remains inactive, out of sight. It is the right hand that is active when the
rhetor makes a speech, and in their portraits noblemen typically employ their right hand
for holding an object (a book, a glove, or a sword) or for making an imperative gesture.

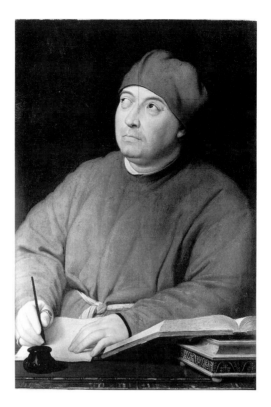

Fig. 4. Raphael, *Fedra Inghirami*, c. 1514. Palazzo
Pitti, Florence

Also, in Aretino's portrait the objects like the chain and the glove typically associated
with noble status are rendered less conspicuously than in portraits of subjects who are
noble by birth. The glove on his left hand is hardly articulated; only its beige color
conventionally indicates that it is a glove. The origin of this chain, in the view of the
indefinite shape of its links, remains obscure. Its particular meaning, however, besides the
association with nobility, can be inferred from Dolce, who remarked in his book *Dia-
logo . . . de i colori* that Francis I gave Aretino a golden chain worth seven hundred scudi
in order to indicate by flattering Aretino that his power lay in his ability to be a powerful
slanderer.[44] Hence, the chain Aretino wears in the Frick portrait is indicative of his power
as the "scourge of princes" rather than of his being a noble ruler himself. Thus in every
detail of the painting Titian finds a way to make a slight deviation from the standard
canons in order to avoid violating the rules for portraying men of noble blood and at the
same time to emphasize the distinctly unusual character of his subject, Pietro Aretino.

Titian, then, objectively recorded Aretino's specific features, which were to become
familiar to his readers from the woodcut frontispieces of his books. He showed Aretino's
bulky figure, round head, and bull-like neck, and with the costly garments portrayed his
patrician pretensions. At the same time, the painter made it clear how dissimilar Aretino
was from ordinary noblemen by emphasizing the shape and setting of the eyes.[45] Except
for the eyes, he did not spiritualize any other feature or try to present a flattering image.
Rather, he accentuated Aretino's sensual nature and plebeian origin by leaving the right

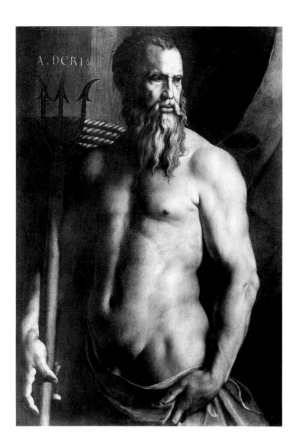

Fig. 5. Agnolo Bronzino, *Andrea Doria as Neptune, c.* 1540. Brera, Milan

arm inactive and by lowering the left slightly, in defiance of Quintilian's prescript for the orator's gesture. The portrait conveyed Aretino in all his complexity, faithfully rendering his image.

Aretino as a Nameless Soldier

In Renaissance Italy it was a common practice for painters to include portraits of their associates in historical compositions. Assuming this practice of his own day to have been customary two centuries earlier, Vasari pointed to Taddeo Gaddi's inclusion of "portraits of his master Giotto, the poet Dante, Guido Cavalcanti, and some say of himself" among the crowd in the Santa Croce fresco with the miracle of Saint Francis reviving the dead boy.[46] Yet it is improbable that a trecento painter would actually have inserted portraits of his contemporaries into a crowd of bystanders. Quattrocento painters, however, often did portray their contemporaries in their multifigured compositions; Domenico Ghirlandaio, for example, in his Florentine frescoes, depicted members of the Medici, Sassetti, and Tornabuoni families with their friends as though they were present at the ancient historical events portrayed.[47] The custom became especially widespread after Alberti recom-

mended that a young painter insert into his painting "the face of some well-known and worthy man [so] that a well-known face will draw to itself first of all the eyes of one who looks at the *istoria*."[48]

In the following century, too, as Vasari's biographies testify, artists continued to portray their contemporaries within their multifigured compositions. Titian was among those who followed this custom: he depicted the members of the Scuola di S. Maria della Carità as witnesses at the apocryphal scene of the Virgin mounting the steps of the temple toward the high priest (Venice, Galleria dell'Accademia).[49] And he represented Pietro Aretino as one of the soldiers in the crowd in the *Allocution of Alfonso d'Avalos, Marchese del Vasto*.[50] This painting (Fig. 6), commissioned by Alfonso d'Avalos in 1539–40, commemorates his feat, as imperial commander in chief, of persuading his mutinous soldiers to advance against the Turks in the Hungarian campaign of 1532. In that year Alfonso d'Avalos was one of Aretino's patrons; Aretino dedicated the *Marfisa* to him and praised him in the *Marescalco*. It comes as no surprise that Aretino appears in this painting.

Aretino spoke of Titian's *Allocution* in his letter to his patron of November 20, 1540 (c). He notes the crowd of soldiers, which surprised him with the variety of their vestments, gestures, and facial expressions, and yet he does not mention his own image, perhaps because his presence in the picture was well known to all. In his letter to Aretino of September 15, 1551, Marcolini noted that people ran to view the painting precisely in order to see Aretino's image: "And who would think me a flatterer, let him look at your [likeness] armored and awful in the picture, where your more than brother Titian naturally depicted Alfonso Davalos [sic], marchese del Vasto, who addresses himself to the army like Julius Caesar in act and form. Be surprised with this *istoria*, that Milan runs in the person of all its inhabitants to look at you as a divine image, and the most worthy."[51] Aretino can readily be recognized in the soldier (Fig. 7) with his unkempt hair, thick neck, and beard. Aretino's beard optically touches a red patch reflected on a metallic cuff of a soldier, who is brandishing a halberd in the foreground. The red patch draws the viewer's attention to Aretino, who is shown in the characteristic three-quarters pose familiar from the etched images, the medals, and the Frick portrait.

From the early 1530s to 1540 Aretino profited from the generous patronage of Alfonso d'Avalos; in turn, Aretino gave significant support in his letters and pamphlets to the military campaign that included the event commemorated in the Prado painting. Aretino's presence in the painting cannot have been accidental; it means that Titian recognized the immediate importance of Aretino's attitude toward a historical event of their own time. Although Aretino was never a soldier, the painting, by showing him as a thoughtful, passive observer at a recent historical event, acknowledges his self-styled role of "censor of the proud world." Aretino's face stands out from the "infinitude" of mutinous soldiers that he so vividly described in his letter,[52] not only because of the red patch reflected on the soldier's metallic cuff in the foreground but also because of his calm expression. While the other gesticulating soldiers vividly demonstrate their feelings, Aretino alone stands listening attentively to the commander's appeal. His meditative attitude carries with it something of a reminder that Aretino commemorated this event in his writtings in much the same way Titian did in his paintings.

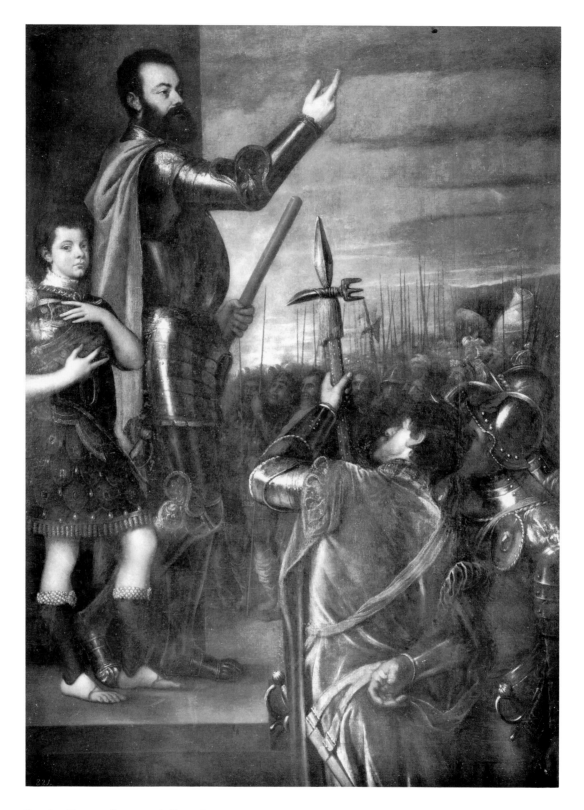

Fig. 6. Titian, *Allocution of Alfonso d'Avalos, Marchese del Vasto*, 1540–41. Museo del Prado, Madrid

Fig. 7. Titian, *Aretino as a Soldier*, detail of Figure 6

Aretino as Pontius Pilate

Italian Renaissance painters sometimes represented their acquaintances and clients not just as passive observers but as *dramatis personae* in their historical compositions. Vasari records a fresco by Masaccio (which has not survived); Vasari noted in Saint Paul the likeness of the Florentine citizen Bartolo di Angiolino: "Decidedly he exhibited extraordinary ability in this painting, the saint's head . . . expressing such vigor [una terribilità tanto grande] that it seems only to lack the power of speech. Anyone who was not acquainted with Saint Paul would recognize in this figure the Roman citizen [civiltà romana] joined to that invincible and divine spirit all intent on the cares of the Faith."[53] The concrete image of the real Florentine citizen imparts its own nobility to the otherwise remote and vague image of the saint. Vasari also once related how Leonardo was so irritated by the prior's importunity while working on the *Last Supper* in Milan that he rendered his features in the visage of Judas, "making him a veritable likeness of treason and cruelty."[54] Depicting familiar features in an implicit *vendetta* is diametrically opposed to Titian's purposes in portraying Aretino in narrative compositions.

As with Masaccio's Saint Paul, depicting the features of an actual person generally tends to enrich the image, making the character in the painting more persuasive and lifelike. It may also serve other purposes (and not only a personal *vendetta*). A painter sometimes deliberately employs the disguise to convey certain aspects of the sitter that could not be expressed in the static image of a regular state portrait. This, I believe, is what happens in *Pilate Presents Jesus Christ Before the People*. Using Aretino's features for Pilate was indeed intended to reveal an aspect of his character that could not have been shown in a state portrait, as is evident from the Pitti portrait.

The Vienna painting (Fig. 8) was done in 1543 for Johannes De Hanna (son of a Flemish merchant, Martinus De Hanna, who emigrated from Brussels to Venice and whose likeness is known from Leoni's medal of 1544).[55] It illustrates the episode from the Gospel of Saint John when the Roman Procurator of Judea, Pontius Pilate, presented Jesus, scourged and derided, to the Jews of Jerusalem, proclaiming "Behold the man!" (John 19:5).[56] By tracing the origins of this theme in Renaissance painting, we can reach a better understanding of the iconographical significance of relevant details in Titian's work and of his presenting Aretino in the guise of Pilate.[57]

This theme is of two types, generally known as "Ecce Homo,"[58] and both originated in Northern Europe. One shows Pilate presenting Christ before the crowd; the other is a smaller composition, a derivative of the first, condensed to three or more figures, with Christ flanked by Pilate and a soldier. Usually this second type, resembling a devotional image more than a narrative painting, is the one we today call "Ecce Homo." This type was much more popular than the first in Italian art, most specifically in Northern Italian art. The finest examples of this second type belong to Andrea Mantegna, Andrea Solario, and Antonio Correggio, who added the unprecedented figure of the fainting Madonna.[59] Titian himself contributed to both types. Several paintings of the smaller "Ecce Homo," now lost, are recorded as having been painted for the Farnese pope and the emperor; Aretino praised the version painted for the emperor (CCCLXXXIII).[60] A later version of the

Fig. 8. Titian, *Pilate Presents Jesus Christ Before the People*, 1543. Kunsthistorisches Museum, Vienna

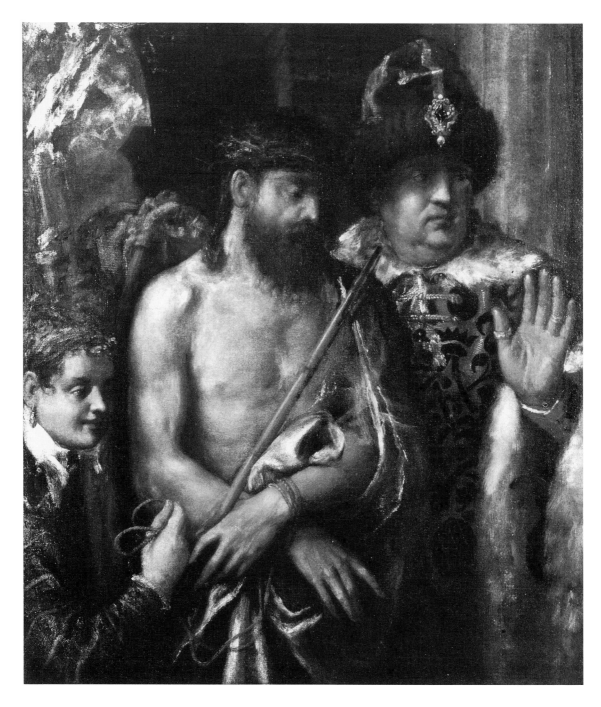

Fig. 9. Titian, *Ecce Homo, c.* 1570. The Saint Louis Art Museum, St. Louis, Missouri

Fig. 10. Hieronymus Bosch, *Pilate Presents Jesus Christ Before the People*, c. 1507. Museum of Fine Arts, Boston

Ecce Homo, at the Saint Louis Art Museum, though only a sketch, nonetheless offers an idea of what the devotional image might have looked like.[61] This painting (Fig. 9) shows Christ flanked by a beardless mocker and Pilate, who in this later work is shown in contemporary dress and includes a pelisse very dissimilar from the dress *all'antica* in the Vienna painting.

The first type of scene, showing Pilate presenting Christ to the crowd, was hardly represented at all in Italian art. The few recorded instances were much earlier: Duccio's *Maestà* (1312) and the Passion cycle of the Verona workshop (c. 1390).[62] In the tradition of the trecento painters, this episode appeared in both instances as part of the Passion series, not as a subject in its own right.

In transalpine Europe the scene was also initially rendered as part of the Passion series, as exemplified by Albrecht Dürer's woodcuts. In 1498–99 Dürer included it in his Large Passion series; later, after his visit to Venice, he rendered it again in the so-called Small Passion of 1509–11, and then once more in the Engraved Passion of 1513.[63] (Dürer's woodcuts and engravings were widely known to Italian painters, as is evident from Vasari's and Dolce's assessments.)[64] In Northern Europe, however, under the influence of the *devotio moderna,* the scene was presented as a separate theme by several artists. One of the first painters to render this scene per se, without any connection to the Passion cycle, was Hieronymus Bosch, who painted numerous versions. In his painting (Fig. 10), Pilate,

dressed in contemporary costume and holding a wand in his left hand, points with his right hand at the frontally rendered Christ, without looking at him, as both of them stand before a city house facing a large crowded square.[65] In 1510 Lucas van Leyden engraved this episode as a scene in itself.[66] Standing on the platform before the courthouse, Christ is supported by soldiers; Pilate, in fancy but contemporary costume, addresses himself to the crowd, whose diverse reactions are the focus of the artist's attention. The three versions by Quinten Massys manifest the evolution of the scene. In his first treatment, of 1514–17, Massys rendered the episode as part of the Passion triptych. On the right wing, the upper level of which shows the main protagonists, Pilate, dressed in a tall hat and pelisse, gently supports the nearly swooning Christ, while the lower level concentrates on the crowd's grimacing expressions and vivid gestures. In a second version, of about 1520, Massys presented the scene per se, while later, in a third version, by eliminating the balustrade and moving the main figures closer to the viewer, he condensed the scene into a devotional image, "Christ Presented to the Beholder."[67]

In cinquecento Italy, Titian was likely the only painter who depicted this scene on a monumental scale (or on any scale). That it was commissioned by a Flemish merchant reflects the northern predilection for the theme.[68] The manner in which Titian presented Pilate and Jesus, the latter supported by a soldier on the landing at the head of the stairs, does not, however, necessarily derive solely from the northern tradition. In Flanders, Germany, Italy, and other countries, painters saw this episode dramatized in liturgical church plays. In Italy the *sacra rappresentazione* of the *Passione* was played most often in Rome, where the Colosseum, the site of martyrdom of the early Christians, was considered the appropriate place for its staging.[69] In his *Cortigiana* (act III, scene 2), Aretino mentioned the Colosseum in passing as a stage for the *Passione*.[70] When the scene was staged in other Italian cities, the background was often a house with rudimentary columns and a portico,[71] not dissimilar from the renditions by the painters in transalpine Europe. Titian, unlike his northern predecessors, wanted to display this scene more or less in its original historical setting, against the imagined background of an official building in Roman Judea. His protagonists therefore stand in front of rustic masonry interspersed with remnants of pagan sculpture (see Fig. 8). The massive wall may have been meant as an allusion to the Roman amphitheater, though it is more reminiscent of the sixteenth-century buildings of Serlio and Giulio Romano.[72] Titian wished to show the procurator's office in the ancient style and instead represented a typical Renaissance palazzo decorated with pseudo-antique marble ornamentation. As the building in this painting comprises both classical and modern elements, so the crowd there is shown dressed in contemporary fashions, while Pilate wears pseudo-antique dress.

The massive stairway leading toward the entrance door next to which Aretino–Pilate stands against the dark, heavily rusticated building is reminiscent of Aretino's description of the stairway into his own dwelling. He offered this description in making an analogy between his character and his dwelling on the Grand Canal in his letter to its owner, Domenico Bollani, of October 27, 1537 (XLIII). After relating what he could see on the canal from his windows, he turns his attention to the gateway, exclaiming: "[T]he land

entrance of the house I have described, being dark, lop-sided, with many stairs, was like the terrible name [la terribilità del nome] I have acquired through airing the truth."[73] A correlation between a man's character and his dwelling was taken for granted in Renaissance culture, and yet it is nevertheless remarkable to find this analogy between the *terribilità* of Aretino's character and the entrance to his house.[74] I shall return to the notion of *terribilità*; here I may note that visually the coarseness of the building suits the figure, whose function is not just to proclaim the human nature of Christ but also to mediate between the Roman government and the crowd.

In northern paintings of this scene, the mob consists of the agitated Jews who, according to the Fourth Gospel, demanded that Pilate have Jesus crucified. In sharp contrast to the northern convention, the crowd in Titian's painting is far from being hostile (see Fig. 8).[75] It includes a number of recognizable personalities of his own time, presented almost life-size (242 by 361 cm) and dressed in contemporary fashions. Aretino was recognized in the countenance of Pilate by Ridolfi, who designated him by the anagram Partenio.[76] Besides Aretino, Ridolfi saw Emperor Charles V and Sultan Süleyman the Great in the two horsemen at the extreme right. The Turk is easily recognizable by his predatory profile and his white turban. Ridolfi's identification of the armored rider to the left as the emperor is probably incorrect, for this figure closely resembles Alfonso d'Avalos, whose features we know from Titian's *Allocution*.[77] Ridolfi also mentions that Titian rendered his own image in this painting, yet his identity has not been established. The man Ridolfi thought to be Titian is probably Johannes De Hanna; standing at the foot of the ladder, he addresses himself to the doge, easily recognizable by his official red robe adorned with ermine. (Since the painting was done in 1543, this doge was Pietro Lando, who then presided over Venice.) The fair-haired girl in the white dress strikingly resembles the painter's own daughter, Lavinia, whose face we know from her portraits.[78] This artistic interpretation of the evangelical scene in terms of his own contemporaries may have been requested by the Flemish merchant or his advisers, who lived in Venice during the turbulence of the Reformation. All the contemporary personages except Aretino remain themselves in this painting; that is, the doge is easily recognized by the costume of his office and Süleyman by his profile and turban. Only Pietro Aretino is disguised.

It is especially significant that Titian represents Aretino not among his illustrious contemporaries in the crowd at the bottom of the stairs but as Pontius Pilate. We do not know whether it was Aretino himself, Titian, his Flemish client, or someone else who suggested that he be portrayed as Pilate. However, it was most appropriate. To understand the meaning of Titian's presenting Aretino in the guise of Pilate, we need to inquire about Pilate's place in contemporary thought, more particularly in Italian liturgical plays, and, furthermore, look into what Aretino himself wrote about Pilate.

The Synoptic Gospels as well as the Gospel of Saint John laid most of the blame for sentencing Jesus to death on the Jews rather than on Pilate. The Gospels portray Pilate as a weak, insignificant person who lacked the courage to make a decision himself or to influence others. They do not justify his behavior, but among the officials Pilate is depicted as the only one aware of Jesus' mission. The Italian sacred dramas with the

Passione Christi likewise depict Pilate's role as insignificant in the trial of Jesus; he is usually shown as the mediator between Jesus and the crowd, incapable of persuading the people to release him.[79]

A comparison of two *sacre rappresentazioni* of the *Passione,* one staged in Piedmont in 1490 and the other in Florence in 1568, reveals that, despite the considerable span of time separating them, the treatment of Pilate's role in the trial was similar in both instances. In the earlier play Pilate does not accept the guilt of Jesus and is portrayed as if the Roman and Judean authorities had forced him to hand down this verdict. The anonymous author of this earlier *sacra rappresentazione* conveyed Pilate's state of mind in one brief remark: "Pilate *pitifully* proclaimed the verdict."[80] Similarly, in Luise Serafino's *Tragedia,* staged in Florence on August 28, 1568 (modeled on the traditional Italian liturgical dramas), Pilate openly declares that he regards the condemnation of Jesus as totally unjust and therefore refuses to assume any responsibility for the consequences of the trial.[81] Pilate appears again in Serafino's drama when he permits Joseph of Arimathea to bury Jesus, and he repeatedly states that he, personally, never found Jesus guilty and moreover confesses his pity for him. On the Italian stage, then, Pilate appears as incapable of influencing the course of events, and yet, at the same time, as full of compassion for Jesus.

As already mentioned, one of the first of Aretino's books to be printed by the Marcolini press was *Humanity of Christ* (1535).[82] In this book Aretino attempts to give a comprehensive picture of Christ's life by combining the various evangelical narratives. He concentrates on the protagonists' reactions to the sacred drama and suggests his own interpretation of their motives. In his account of the episode in question, his assessment is no different from that in the liturgical plays; he too perceives Pilate as a rather sympathetic figure, unlike Judas or Herod. Aretino's version devotes more attention than the plays to Pilate's state of mind. The procurator stands, in Aretino's words, "between the sacred and profane."[83] Aretino endeavors to explain why Pilate, who in his heart was on the side of Jesus, was unable to persuade others of his innocence: Pilate could not reverse the decision of the majority (or more correctly, the order of Divine Providence), even though he foresaw the terrible consequences of the trial. Aretino follows other writers on the *Passione* in portraying the procurator as incapable of changing the course of events, but then, unlike them, he goes on to give a detailed analysis of Pilate's remorseful spirit, disclosing his own sympathy for this unfortunate personage in the sacred drama. Aretino's analysis of Pilate's character thus helps us understand why Titian used Aretino's features for this specific figure in the Vienna painting.[84] It was befitting, and it satisfied decorum, to represent the author of the *Humanity of Christ* as Pontius Pilate.

Titian's Pilate (Fig. 11) closely resembles Aretino: he has the same characteristic three-quarter turn of the head set on the short, thick neck. While preserving permanent features such as the long, thin eyebrows with the deep-set almond-shaped eyes, the fleshy tip of the nose, and the unkempt beard, Titian coarsened them somewhat. This is especially apparent in the treatment of the eyes, which are averted in this painting and thus lacking the spirituality characterizing them in the Frick portrait (see Fig. 1). It is significant that Pilate, unlike the crowd, was not represented in contemporary dress with a pelisse but in a pseudo-antique costume, to indicate the office of Roman Procurator of

Fig. 11. Titian, *Aretino as Pilate*, detail of Figure 8

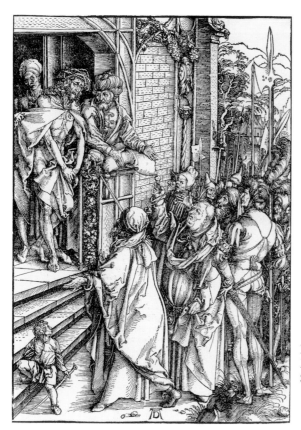

Fig. 12. Albrecht Dürer, *Pilate Presents Jesus Christ Before the People* (Large Passion), 1498–99, woodcut. Staatliche Graphische Sammlung, Munich

Judea. Outlined by this clinging garment, Pilate's full-length figure with its bulky form and stumpy legs contrasts markedly with the well-shaped, muscular body of Jesus. Pilate–Aretino casts his gaze toward the crowd below. His twisted posture, the outstretched left hand pointing to the humiliated Jesus while the open right hand hangs down feebly, conveys his conflicting feelings.

For comparison, we may recall representations of Pilate in the northern renditions of this Gospel episode. In Bosch's painting (see Fig. 10), Pilate holds both hands upward, a wand in his right hand; in Massys's paintings, Pilate either gently touches Jesus' elbow or lifts his right hand in a solemn *silentio*. (Titian himself was to present Pilate with lifted hand in the devotional painting; Fig. 9). In Dürer's woodcut of 1498–99 (Fig. 12), Pilate's right hand rests on the balustrade while he stretches his left hand toward the crowd.[85] In Dürer's woodcut of 1509–11 (Fig. 13), Pilate points the thumb of his left fist toward Jesus, as if pointing, while his right hand stretches above his head toward Jesus' body.[86] In rendering Pilate's gestures, Titian comes closest to Dürer. Both painters have Pilate use his left hand, despite Quintilian's warning to rhetors against using their left hands (XI.iii.114).[87] However, while Pilate in Dürer's engravings points with indignation and directly demonstrates his mercy before the crowd, Pilate in Titian's painting points at Jesus with respect and demonstrates his mercy toward no one, thereby eloquently hinting that Christ's fate is predestined.

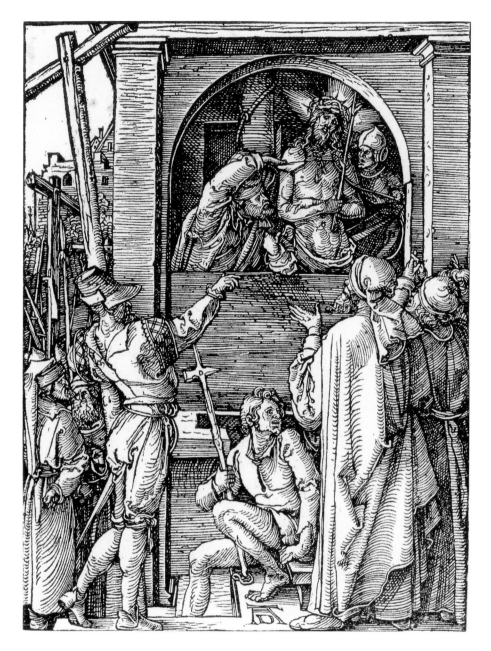

Fig. 13. Albrecht Dürer, *Pilate Presents Jesus Christ Before the People* (Small Passion), 1509–11, woodcut. Staatliche Graphische Sammlung, Munich

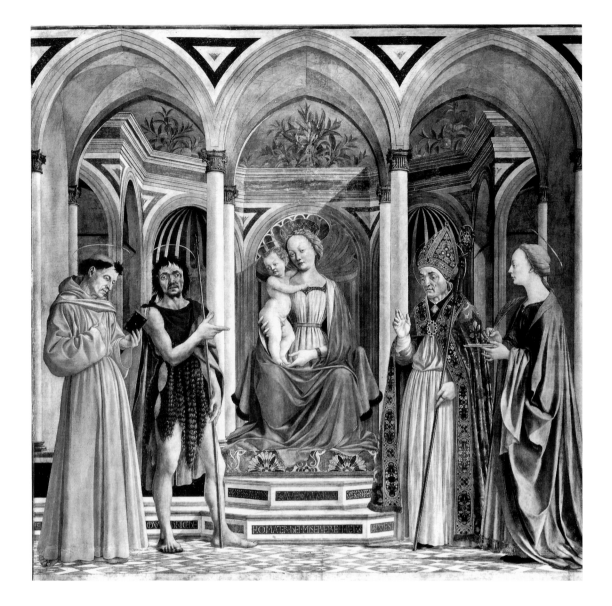

Fig. 14. Domenico Veneziano, *Saint Lucy Altarpiece, c.* 1445. Uffizi, Florence

Pilate's respectful gesture in Figure 11 is reminiscent of Saint John's gesture in the conventional multifigured altar paintings, of the type known as *sacra conversazione*. For instance, in Domenico Veneziano's *Saint Lucy Altarpiece* (Fig. 14),[88] Saint John the Baptist, facing the spectator, stretches his right hand with the index finger pointed across his breast toward the Madonna, a gesture repeated by Pilate's left hand.[89] Pilate's other gesture, connoting clemency, ultimately derives from renditions of Roman emperors' stretching out their hand, palm up, toward their captives. In this manner Trajan demonstrated his *clementia* toward the Dacians on the column bearing his name (Fig. 15).[90] This

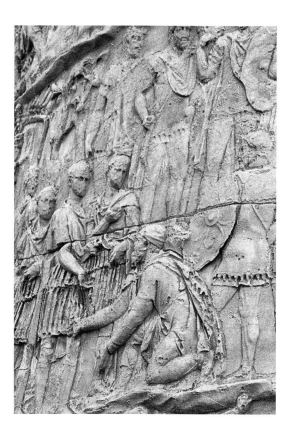

Fig. 15. *Trajan's Demonstration of Clementia Toward the Dacians.* Relief of the Column of Trajan, Rome

imperial gesture passed into devotional painting, where it was used by the patron saint demonstrating *clementia* toward his protégé, usually the donor of the painting; for example, Saint Jerome is shown with this gesture, eloquently directed at the Madonna, in Raphael's celebrated *Madonna di Foligno* (Fig. 16).[91] Unlike the emperor or the patron saint, Titian's Pilate directs an actual gesture of clemency to no one. Thus, his gestures further emphasize Pilate's divided loyalties, for he is simultaneously on the side of the crowd and of Jesus. His ambivalent attitude is in part forced on him by his role as mediator between the Judean population and the Roman government. As depicted by Titian, Pilate discloses that his feelings as a Roman official conflict with his own emotions, and this conflict, emphasized in the painting, is the chief reason for his inability to influence the decision of the mob.

Like Pilate, Aretino had to contend with the folly of the crowd all his life. *Stultitia,* as the church theologians interpreted it, was an attribute of unbelievers who denied Christ's divine mission.[92] Folly, the essential quality of the crowd (they are sympathetic to Jesus but do not recognize him as endowed with divine power), is represented by the crouching youth in the left-hand corner of the painting,[93] shown fondling his dog, turning his back to the rest of the figures, and directing his attention somewhere outside the picture frame. The youth's face, with disheveled hair, frowning forehead, and open mouth, is directly below the tragic mask and therewith enhances the note of the inevitable tragedy about to unfold.

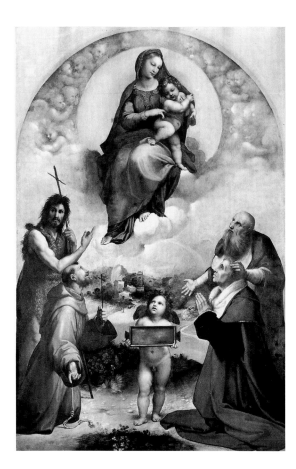

Fig. 16. Raphael, *Madonna of Foligno, c.* 1511–12.
Pinacoteca Vaticana, Rome

 This figure has parallels in Northern European representation of this Gospel episode. It occurs in Dürer's woodcut from the Large Passion (see Fig. 12), where the youth standing at the stairs twists his neck backward to face the main protagonists. Also, in Dürer's woodcut from the Small Passion (see Fig. 13), a youthful beggar, recognizable by his ragged clothing, appears on the stairs of the house in which Jesus is seen flanked by Pilate and a soldier. This beggar anticipates Titian's posture of the youth in the twist of the body and similar disposition of the legs. Dürer's beggar is turned entirely toward the crowd; Titian's youth turns in that direction but averts his face. In Massys's two earlier depictions there is at least one figure with an open mouth as if screaming. In the earlier panel, at Coimbra,[94] it is that of a tall soldier, who by lifting his hand attracts the viewer's attention. In the panel in the Prado (Fig. 17),[95] it is that of a soldier in a pointed helmet seen on Jesus' left side. His masklike expression stands in sharp contrast to Jesus' serene face. Massys's soldiers seem to be just screaming, but Titian's youth seems to be screaming as if trying to dissolve fear.
 The crouching youth is contrasted with the muscular soldier standing at the bottom of the stairs, leaning on the Habsburg shield decorated with the two-headed eagle.[96] While the youth's attention is directed elsewhere, outside the painting, the soldier's figure with

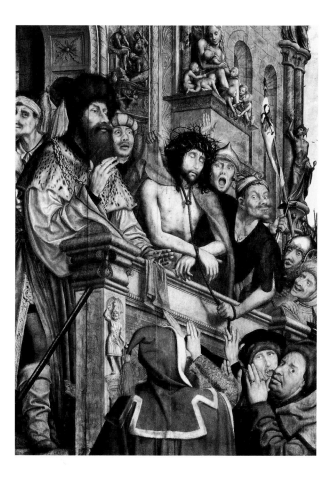

Fig. 17. Quinten Massys, *Ecce Homo, c.* 1520.
Museo del Prado, Madrid

its back to the viewer helps direct attention to the main scene (see Fig. 8). A figure seen
from the back was a typical device in Titian's painting, yet in this case it bears icono-
graphical significance. Like the viewer of the painting, this soldier witnesses the revela-
tion of Christ's human nature. This "same" soldier reappears as a witness of Christ's
Resurrection, painted by Titian in 1544 for the Compagnia del Corpus Domini.[97] In that
painting, leaning on the "same" shield, he lifts his hand to protect his eyes from Christ's
radiating glory. The later use of the same soldier's figure could imply that Titian interprets
the crowd in the Vienna painting as standing along with the soldier perhaps in a futile
attempt to understand the humanity of Christ, pointed out by Pilate and tragically
perceived by the youthful beggar.

Composed of some of the most eminent personages of Titian's time, this crowd is
shown reacting vividly to the scene at the top of the stairs; they appear agitated, express-
ing their excitement through vivid gestures. In contrast, the soldier's posture is still,
contemplative; he makes no gesture at all with his hands. The passivity of the soldier
along with the symbolic demeanor of the crouching youth sets off the folly that seems to
seize the crowd around them. If Titian's contemporaries had seen the Messiah, they
would not have recognized or acknowleged him and so too Aretino, like Pilate, for all his

vehement pamphlets and letters, would not have been able to persuade his contemporaries of the authenticity of His presence. Even though Aretino's fame was based on his boldness as the "scourge of princes" (commemorated in *Orlando furioso*), and even though rulers feared his venomous letters and pamphlets, his literary activities ultimately proved futile, for they had no real influence on events. By bestowing Aretino's features on Pilate, Titian portrayed a remote yet familiar event in terms of the contemporary political situation: Aretino is seen standing before the crowd of his correspondents, whom he could influence no more than Pilate could save Jesus from the folly of the mob.

Masaccio's use of Bartolo's features for Saint Paul assisted, as Vasari pointed out, in expressing the "civiltà romana." Titian's lending Aretino's features to Pilate had a completely different purpose—to convey more of Aretino than of Pilate. Aretino's coarsened features and the stoop of his squat, twisted body are perhaps meant to be indicative of his cynicism regarding mundane as well as church affairs. His ambivalent stance reveals that Aretino–Pilate feels mercy for Jesus; at the same time, he just leaves him to the will of the crowd. Aretino's complex personality had many contradictory features. Titian brings these features to light by showing him as Pontius Pilate.

The portrayal of Aretino in the Vienna picture of 1543 indirectly assists us in making sense of the unusual composition of Titian's later portrait of him, painted in 1545, as Aretino's gift to Cosimo I de' Medici, Duke of Florence.

The Portrait for Cosimo I de' Medici

The *Pietro Aretino* in the Pitti (Fig. 18) is the culminating portrayal by Titian of his friend.[98] A befitting gift for the powerful Cosimo I de' Medici, Duke of Florence, the portrait represents Aretino as a monumental figure. It conveys Aretino's conception of his own ideal image more than it does the way he actually looked.

As in the Frick portrait (see Fig. 1), Aretino is shown in three-quarters view, holding his coat closed with his gloved left hand. Here the coat is not trimmed with fur; it is of the same brocade as the vest, producing a more unified effect. The chain is different, too; made of fancifully shaped links, it is the chain given to Aretino by Francis I.[99] Nearly covered by the coat, it is emphasized much less in this portrait than the simpler chain in the earlier one. It is merely a decorative element. As in the Frick portrait, in this last portrait Titian did not include any object that might indicate the sitter's profession.

The excellence of the Aretino portrait painted for the duke was noted by his contemporaries. Marcolini (in the letter cited above) compared it with Titian's portraits of kings and emperors.[100] Later, Vasari remarked that the portrait of Aretino done for Marcolini was "not so fine as that which Aretino sent to Duke Cosimo."[101] The clearly visible difference between the two derives from the imposing stance and the nobility of the facial features in the Pitti portrait. While in the Frick portrait the torso and the head are both turned in the same direction, in the Pitti portrait the head is turned to the left, in contrast to the massive frontality of the broad, powerful chest. The turned head is unusual in

Fig. 18. Titian, *Pietro Aretino*, 1545. Palazzo Pitti, Florence

Fig. 19. *Della Valle Satyrs*, marble.
Detail. Musei Capitolini, Rome

Titian's portraiture of the 1540s; the sitter's head and chest usually face the same direc-
tion.[102] Titian may have borrowed the pose from his earlier image of Pilate–Aretino in
the Vienna painting (see Fig. 11), in which the figure is shown in contrapposto, with the
head turned to the left and the body turned to the right. As already noted, the features of
Pilate–Aretino are coarser than Aretino's in the Frick portrait, in which the painter
emphasized the spirituality of Aretino's almond-shaped eyes. In the Pilate–Aretino image
he stressed the fleshy tip of the nose and the unkempt beard. In the Pitti portrait (see Fig.
18), the emphasis is on the forehead and on the man's unique aura; Aretino's counte-
nance is nobler than it is in the Frick portrait.

Aretino's complex personality is manifested through his posture and the color of his
garments, both unusual for contemporary portraits, as well as through some physiognomic
allusions. (Here too Titian needed to obey the rules of decorum.) His lascivious nature is
emphasized not only by the fleshy satyrlike mouth but also by the shape of the eyes and by
the long nose,[103] which are changed somewhat as if to reflect the eyes and nose of the
Della Valle Satyrs (Fig. 19). Since Titian painted the Aretino portrait before he went to
Rome, he could not have seen those statues himself, but they had been known since
1490.[104] In the artistic tradition, the satyr, a hybrid of animal and human being, was of
course rendered as a low creature, with a flattened nose and narrow eyes, though there
had been some attempts to ennoble its features, as in the Della Valle statues.[105] In Venice,
images of satyrs were made popular through bronze statuettes by Andrea Riccio, who,
familiar with the Della Valle statues, sometimes tried to render their images as noble as
possible without losing their characteristic traits.[106] The similarity of Aretino's visage to
one of the two *Della Valle Satyrs* is striking and most likely intentional. In Aretino's time,
the etymology of satyr and satirist was linked,[107] and to commemorate Aretino the
satirist, a medal was issued with the satyr's head, composed of phalli, on the reverse.[108]

Fig. 20. *Pietro Aretino, c.* 1536, bronze medal with phallic satyr on reverse. By permission of the Trustees British Museum, London

On that medal (Fig. 20), Aretino's features are so idealized, as if to avoid an open connection with the usual satyr image, that he does not look like himself; his identity is made clear only by the inscription of his name and his mottoes. Perhaps the reason the medalist did *not* liken Aretino to the satyr was because of the existence of another medal portraying the subhuman, barbarous Attila as a satyr.[109] With thin, elongated features and hooked nose, Attila as satyr looks very different from the noble images seen in the Della Valle statues. Linking Aretino's image with the satyr's was by no means perceived as deprecating him but rather as hinting at his role as satirist.[110] In the Pitti portrait (see Fig. 18), the shape of Aretino's eye and brow differs from the Frick portrait (see Fig. 1) and the Pilate–Aretino image (see Fig. 11), but the fleshy tip of his nose is emphasized as in the famous Roman *Satyr* statues. Only the high, broad forehead, of the kind Aretino never forgot to praise in other portraits,[111] is in radical contrast to the lower part of the face, so strikingly like that of one of the *Satyrs*.

In representing Aretino in the guise of Pilate and then in this later portrait adducing traits of the satyr image, Titian intended to express the extraordinary quality of his subject. As Pilate is not a negative character, neither is a classical satyr; both have an ambivalent function in the narrative tradition. Titian used both images for different purposes: the first for disclosing Aretino's societal significance and the second for revealing his physiognomic temperament. Using the mask of Pilate, Titian could disclose Aretino's ambivalent position toward worldly and church affairs, and alluding to the satyr image Titian could reveal other aspects of Aretino's personality. Through these images Titian could better express the ambiguous character of Aretino, manifesting his remarkable divergence from his ambience.

Aretino's figure is slightly foreshortened, as if elevated on an invisible pedestal, with the massive, seemingly sculpted head crowning the body.[112] The portrait is designed as if to be viewed from below. The silky coat of dark purple creates the unifying effect of the portrait, thereby calling the viewer's attention to the face, where a wide beam of light accentuates the forehead. The use of purple (of even darker hue in the Aretino portrait) was more suitable for the portraits of kings and popes, as can be seen, for example, in *Francis I* (see Fig. 54) and *Pope Paul III Without a Hat* (see Fig. 30).[113] The use of this color further underscores the grandeur and uniqueness of the personality portrayed.[114] In sixteenth-century Italy dark colors, especially black, were thought to be fitting for noblemen, as Castiglione noted in his *Book of the Courtier* (ii, 27). The color of Aretino's costume stands in sharp contrast with contemporary fashion and hence with renditions of noblemen of his time, which paradoxically are closer to the portraits of rulers, both worldly and ecclesiastical. The sitter's image seems detached from the surrounding world, for his face, turned sharply to the left, avoids all contact with the viewer. By means of the powerful turn of the head to the left, along with his uplifed eyes and penetrating gaze, the figure is imbued with dynamic, expressive force. The face depicted asymmetrically, with the right side in the dark, suggests conflict in the sitter's soul.[115]

The Pitti portrait in itself (see Fig. 18) embodies Aretino's main perceptions concerning Titian's portraiture. It not only renders his physical traits but also brings to light the essential characteristics of his personality. Without flattery, Titian nonetheless transformed the sitter's features, emphasizing only those that a physiognomist would interpret as reflecting this subject's character, in all probability the so-called sanguino-choleric type.[116] The sharp turn of the head to the left, as if responding to some personal challenge, is an allusion to his predominant *concetto* as the "scourge of princes." With his arrogant pose, Aretino personifies contempt for human folly, superiority to worldly rulers, and confidence in his own destiny.[117]

In the Vienna painting, Aretino, as Pilate, appears hesitant and powerless, while in the Pitti portrait he looks ready to challenge the whole world. If the Vienna painting shows Pilate–Aretino attempting to reconcile himself to the vanity of human affairs, the Pitti portrait reveals his contempt for this folly and his active reaction against it. This portrait epitomizes the cobbler's son from Arezzo who raised himself to the ranks of nobility. He was made a Knight of Rhodes by Pope Clement VII, and Pope Julius III named him a Knight of Saint Peter.[118] With some justification he had once warned Michelangelo: "But do not forget that I am one to whom kings and emperors reply."[119]

"Una Sì Terribile Meraviglia"

Immediately after Titian completed the Pitti painting, Aretino reacted favorably in three open letters. In April 1545 (ccxviii), he wrote to Giovio, who at that time was collecting portraits of his eminent contemporaries, and promised to send him a copy of his portrait by Titian, which, as he said, was to be seen in Florence. Aretino called his portrait "una sì

terribile meraviglia" (such an awesome marvel).[120] According to him, this portrait is the manifestation of "the miracle that was issued from the brush of such marvelous spirit." He went on to claim here that the portrait competed with nature, so truthfully was his image represented in it; in his own words, it "celebrates the figure of my natural semblance."[121] In the second letter (ccxliii), written in July 1545 to Marcantonio Morosini, the city lawyer of Treviso, Aretino said that his portrait was like a "continuous mirror of my very self."[122] And, finally, in October of that year, in a letter to the recipient of the portrait, Cosimo I de' Medici himself, Aretino declared that the portrait was impressive because it exhibited his very being—"it breathes, the pulses beat, and it is animated by the same spirit which I am in real life (cclxv)."[123]

This was the only portrait Aretino ever called a "terribile meraviglia," and there is indeed something of Michelangelo's *terribilità* here.[124] The notion of *terribilità* (and also *meraviglia*) became commonplace in Aretino's time. First used in connection with celestial affairs, then with mundane rulers, later it was applied to artists and their works. In the sixteenth century the adjective *terribile* was used to express an unusual quality in a work of art: to designate the unique personality, the artist's style, or the quality of invention.[125] (We should recall Vasari's description of Masaccio's Saint Paul, whose head, he said, expressed "una terribilità tanto grande"; see page 48.) Living in an age when Pope Julius II, Michelangelo, and Charles V were all called *terribile*, Aretino described himself as "un terribile uomo" in his letter to Marcolini (cxcvi, January 1545) and as possessing *terribilità* (in his letter to Bollani; see page 53). The notion of *meraviglia* was also used frequently in Aretino's time, and Aretino himself did not spare this word. To cite just one instance of many: in his letter to Molino (cix) accompanying his sonnet on Titian's portrait of Molino's uncle, Aretino remarked that Titian "marvelously made a portrait of the marvelous Vincenzo Cappello."[126] In this letter the "marvelous" as a quality of the painter's skill is conflated with the "marvelous" as a quality of the sitter's persona.

In the context of Aretino's letter to Giovio, the adjective *terribile*, especially used in conjunction with the noun *meraviglia*, connotes the extraordinary and the excellent. A penetrating observer of his own portrait, Aretino made others see it as a great work. Proclaiming his portrait an "awesome marvel," Aretino meant that Titian had achieved more than a record of his physical appearance; in this portrait Titian had succeeded in bringing out his essential, complex being—his *concetto*. The "marvel" of the portrait consisted in Titian's revealing the very essence of Aretino's personality without destroying his likeness. All the same, Aretino was not contradicting himself when he said in the same letter to Giovio that the portrait conveyed his "natural semblance." He also accepted the portrait as true to his appearance. Titian's portrait of Aretino was exactly what Aretino expected his portrait to be.

The Pitti painting thus exemplifies what Aretino and the cinquecento connoisseurs believed a portrait should contain: a faithful likeness of the subject blended with the subject's *concetto*. Titian's *Pietro Aretino* harmonizes the accurate representation of the subject (his particular self) with the portrayal of the character's essence (his ideal self). This harmony is what raises the portrait to the level of a lasting monument to the "Scourge of Princes."

III

The Portraits of the Duke
and Duchess of Urbino

On November 7, 1537, Aretino wrote to Veronica Gambara about the portraits of the Duke and Duchess of Urbino (xvii).[1] This letter is one of the earliest examples in which a portrait is viewed as a work of art and not just as a pretext for an encomium of the sitter. The letter became known to the public almost immediately as part of Aretino's first collection of letters, dedicated to the Duke of Urbino and published by Marcolini at the end of 1537, even before the paintings were delivered to the duke and duchess on April 14, 1538. Aretino's letter gives a fairly good account of the duke's portrait, which may mean that Aretino saw the painting while it was still in Titian's workshop.

Aretino told Veronica Gambara that he was sending her a sonnet about Titian's portrait of the Duke of Urbino. In the letter he drew attention only to the portrait of the duke; he described the portrait of the duchess in another sonnet included with the letter. In writing to Veronica, Aretino's primary aim was to eulogize the duke, patron of the first volume of his letters. Nonetheless, he devoted a great deal of attention to the artistic

merits of the duke's portrait, and thus the letter inaugurated a novel mode in perceiving a portrait as a work of art.

Aretino's observations on this painting in the letter and the sonnet were of different kinds. In the letter, he concentrated on the portrait's pictorial qualities and the lifelike way in which Titian portrayed the duke's countenance and his accessories. The depiction of his countenance and of the accessories were equally important. Aretino noted the accessories as reminders of the duke's valorous deeds, but he also noted the variety of textures of the accessories. Aretino presented another way of viewing the portrait in his sonnet. The sonnet, Aretino's poetic portrait of the subject, was intended to be read aloud as the viewer contemplated Titian's portrait, or, in the case of Veronica, as she imagined the portrait. In the sonnet Aretino does not mention the coloristic qualities of Titian's work. Instead, after speaking about the setting of the figure, he refers to the painting only insofar as it helps him present his own interpretation of the duke's physiognomy.

Thus the letter and the sonnet together suggest that Aretino drew a distinction between two levels of perception. In the letter, he noted the pictorial details in the portrait in order to remind Veronica and the public of the duke's great military deeds. In the sonnet, he described the duke's countenance, which in turn gives his interpretation of the duke's character. In both the letter and the sonnet Aretino pursues two goals: to eulogize the duke, his patron, and to advertise Titian's mastery as a portraitist.

For the commission, Titian at first planned a full-length portrait of the duke, as is evident from the preparatory drawing, which shows the armored model standing as if in a niche. Before he completed the painting, he had portrayed the duchess in her portrait in three-quarters view. That the portraits were not originally conceived as pendants may explain their deviation from standard representations of couples in Italian Renaissance painting.[2] Husband and wife were generally shown in similar poses against nearly identical backgrounds (frequently landscapes), as, for example, in Piero della Francesca's *Federico da Montefeltro* and *Battista Sforza*[3] and Raphael's *Agnolo Doni* and *Maddalena Strozzi*.[4] Of this convention Titian retained only the similarity in size. In all other respects the portraits differ from each other: the Duke and Duchess of Urbino appear in different poses and against different backgrounds. Significantly, Titian's example was to be followed by Bronzino, who presented the Panciatichi couple in different postures against different backgrounds.[5] Thus Titian's deviation from the standard practice set a precedent.

The Duke and Duchess of Urbino

The Duke of Urbino, Francesco Maria della Rovere (1490–1538), was one of the ablest *condottieri* in sixteenth-century Italy, an innovator in the art of fortification and in the strategies of warfare.[6] His military feats were recorded by Niccolò Machiavelli and Francesco Guicciardini. He came from an eminently noble family. On his father's side he was

a nephew of Giuliano della Rovere, the future Pope Julius II; on his mother's side he was the nephew and adopted son of Guidobaldo da Montefeltro. In 1508 he inherited the dukedom of Urbino from his childless maternal uncle. That same year he was appointed captain-general of the papal forces. In 1516 the Medici Pope Leo X unjustly stripped him of his dukedom and granted it instead to his own nephew. After five years of military campaigns, Francesco regained the dukedom upon the death of the pope. In 1522 he accepted the command of the troops of Florence and the following year was named captain-general of the Venetian land forces. Francesco remained in the service of Venice; even when Emperor Charles V sought to make him captain-general of the imperial force, the duke declined, remaining loyal to the Venetian Republic.

There is little to be said about the public role of the duke's wife, Eleonora Gonzaga (1493–1550),[7] the eldest daughter of Francesco Gonzaga and Isabella d'Este. It was to her brother, Federico, we recall, that Aretino sent his own portrait by Titian. In her youth, Eleonora was praised for her beauty by the Petrarchist writers Bembo and Mario Equicola; Castiglione depicted her virtuous character in *The Book of the Courtier* (IV, 2), written between 1508 and 1518. Betrothed to Francesco in 1505, Eleonora became his wife and the Duchess of Urbino on Christmas Eve, 1508, the year he inherited the dukedom. As a patron of poets and artists, she was overshadowed by her mother and brother and by Elisabetta Gonzaga (her mother's sister-in-law), represented by Castiglione as the presiding figure in the debates about the Ideal Courtier.

The Duke and Duchess of Urbino began to commission works by Titian in 1532, when Titian was also working for Eleonora's brother. In 1536 they commissioned Titian to paint a portrait of the duke (Fig. 21). From the preparatory drawing, Titian apparently planned to render a full-length state portrait similar to that done of Charles V three or four years earlier. The decision to do a pair of portraits was probably made to commemorate the couple's thirtieth wedding anniversary. When Titian completed his work in April 1538, the duke invited him to visit his villa near Pesaro, but the visit never took place, for Francesco died in October.[8]

Titian's rendering of the parade armor, the parade helmet, and the command batons designates Francesco as the ablest *condottiere* of his time. His mailed right hand firmly grips the baton of Venice, the emblem of the captain-general, while his left hand supports his sheathed sword. Shown almost down to the knees, he stands against a dark crimson velvet screen. His helmet, decorated with white plumes and a dragon-crest,[9] hangs on his right, while on his left are two command batons flanking a forked oak branch. One of these batons was granted him by his uncle, Pope Julius II, as Captain of the Church (indicated by the keys of Saint Peter), the other by the Governor of Florence as a token of gratitude for the duke's service there in 1522. The oak branch ("rovere") indicates that he was a member of the Rovere family.[10] It is draped with a white banderole inscribed with the motto "SE SIBI" (By himself alone).[11] This motto, together with the other symbols of military honors, succinctly sums up his career as a preeminent *condottiere* of Italy.

The portrait's composition, with the standing figure in armor, in which some velvet is reflected, and with the helmet set to the side, is Titian's invention.[12] No doubt he profited from the examples of earlier Venetian artists in their portrayals of men in armor,

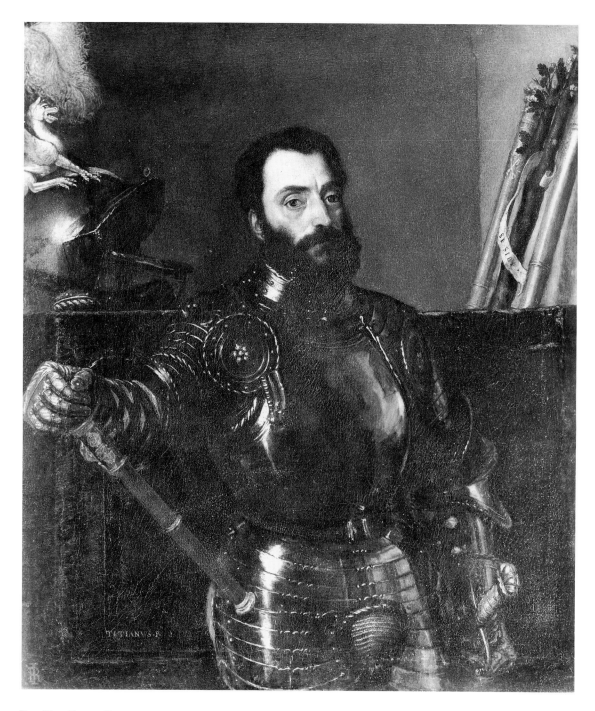

Fig. 21. Titian, *Francesco Maria della Rovere*, 1536–38. Uffizi, Florence

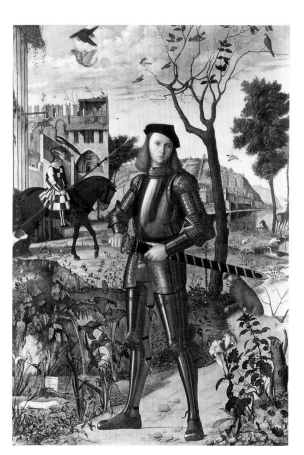

Fig. 22. Vittore Carpaccio, *Portrait of a Knight*, 1510.
Thyssen-Bornemisza Collection, Lugano

most likely spurred by Giorgione's experiment in portraying Saint George in such a way that the armored figure could be observed from all sides, in this case reflected in a river, a mirror, and in his shield.[13] Soon thereafter, Carpaccio represented a full-length knight in bright armor against a variegated landscape (Fig. 22),[14] and Sebastiano painted a half-length figure of a bareheaded knight, inspired also by Giorgione's portrayal of himself as David, probably done in 1513. Sebastiano paid particular attention to the glint of armor.[15] In the early 1530s, Girolamo Savoldo portrayed a male subject as Saint George, and then presented himself (probably) in armor in the portrait known as *Gaston de Foix*,[16] which repeated Giorgione's experiment by showing the armored man reflected in a mirror. These artists, however, aspiring to paint the glint of armor, did not render the reflection of textiles in the armor's polished surface. Titian himself, before he painted the Duke of Urbino, had on a number of occasions rendered a man in armor. For example, in 1536 he was asked by Federico Gonzaga to paint a series of Roman Emperors, a series now known only from Egidius Sadeler's engravings, done about 1593–94. One of the portraits of the fully armored Emperor Claudius with a baton in his mailed hand (Fig. 23), is seen in a posture similar to that in the duke's portrait.[17] (Earlier, in 1530, the year of Charles V's coronation by Pope Clement VII, Parmigianino painted the allegory with the armored

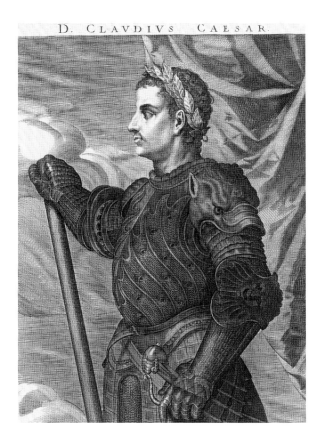

Fig. 23. Egidius Sadeler after Titian, *The Emperor Claudius* (1536–37), 1593–94, engraving. Staatliche Graphische Sammlung, Munich

figure of Charles V, attended by the infant Hercules, who offers him a globe, while winged Fame, holding a laurel and palm branch, hovers above.[18] That painting [Fig. 24] is not precisely a state portrait of a man in armor but an allegory of the emperor's rule, hinting at his *impresa* with the motto "PLUS ULTRA.") In 1532–33, Titian was commissioned to portray Charles V with a sword raised in his mailed hand, known now from Britto's woodcut (to be discussed in Chapter V). The portrait of the duke was made after Titian's conception of the imperial portrait had already crystallized, and he sought out a new one for a *condottiere*.

Francesco's wife, Eleonora, is naturally represented differently, suffused with domesticity (Fig. 25). She too is portrayed in three-quarters view, but she is seated in a leather armchair in a room with a breathtaking view of the countryside. She wears a black brocade dress and an elaborate cap, befitting her status as a grand matron. The black cap with the golden threads and the black dress with golden ornamentation were not chosen arbitrarily but rather were derived from the Montefeltro crest, reflecting the fact that the dukedom was inherited from this illustrious family.[19] In his book, Castiglione warned noble ladies against ornamenting their faces, saying that he preferred to see their natural colors (i, 40). Eleonora's face is in keeping with this advice, and so are her hands, delicate and gloveless and modestly adorned with only a few rings. In her right hand she holds a *zibellino*, a sable purse or muff decorated with a jeweled golden clasp,[20] while her left hand

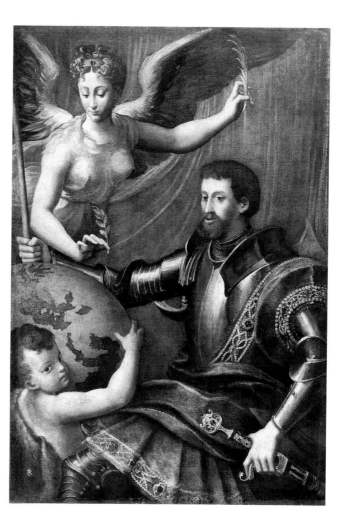

Fig. 24. After Parmigianino (?), *Allegorical Portrait of the Emperor Charles V,* 1529–30. Rosenberg & Stiebel, Inc., New York

rests on the rounded arm of the comfortable chair. Near her, on a chest, covered with a green velvet cloth, is a lapdog, and behind it an elaborate table clock. Her virtuous appearance, the proper accessories, and the country view, dominated by a tower or an obelisk seen through the window, are all in keeping with Eleonora's role as the ladyship of the dukedom.

This portrait, with its fenestrated background, belongs to the type Erwin Panofsky designated a "corner-space" portrait.[21] Derived from the North (we may recall for instance the portraits by Petrus Christus and Dirk Bouts), this type of portrait entered the Florentine tradition and became popular in Giorgione's circle.[22] The conception of Eleonora's princely seated figure could have been influenced by the posture of Raphael's *Joanna of Aragon.*[23] In the same year, 1538, Titian used the same composition in the portrait of Gabriele Tadino,[24] the Maltese commander-in-chief of Charles V's artillery. Titian painted another portrait of this type later, in 1545, of Pope Paul III in his *camauro* (see Fig. 31).

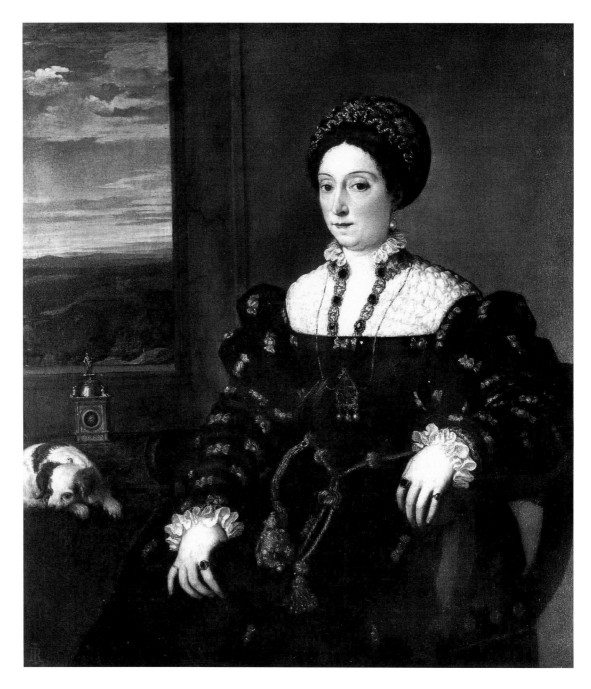

Fig. 25. Titian, *Eleonora Gonzaga della Rovere*, 1538. Uffizi, Florence

Aretino on the Portrait of the Duke

In a significant portion of his letter to Veronica, Aretino recounts the duke's notable deeds. His remarks, like tesserae from which the mosaic of a visual description can be assembled, convey the effect of the painting impressionistically, its vivid colors merging with the symbols of the duke's career. Wondering how faithfully Titian rendered the duke's likeness, Aretino often exclaims over the coloristic qualities of the portrait, thereby focusing attention on its aesthetic beauty.

Although short, the letter has four clear divisions. First, Aretino tells Veronica that he has enclosed a sonnet on the portrait by Titian. He wrote that when he saw the portrait of the duke he "cited nature to bear witness and made her confess that art was turned into herself."[25] Next, Aretino explained how Titian transmitted the lifelike image through the use of color, emphasizing that the artist did not use colors to demonstrate the "firmness of the flesh but [to] discover the virility of the soul."[26] Aretino singled out coloristic effects such as the reflection of the "vermilion screen" in the breastplate, the tassels and gauntlets of the armor, the effect of the helmet's plume and its reflection in the polished cuirass, and the metallic glitter of the armor. Third, Aretino mentions the tactile quality of the duke's batons, which, in his words, really look as if they were made of silver (actually, they were of lead). The mention of the batons bestowed on the duke by "Church, Venice and Florence" was meant to highlight the duke's brilliant military career. Aretino reminded the poetess of the duke's war against Pope Leo X, an event that astounded all Italy.[27] Aretino rhetorically expresses his admiration for the way in which the portrait bestows longevity on its subject, reminding his reader that the emperor himself recognized this quality of artistic mastery while posing for Titian in Bologna. Concluding the letter, Aretino asks Veronica to read the sonnet he had composed in celebration of the Duke of Urbino.

One detail in this letter calls for elucidation. This detail recalls Aretino's error in describing the batons as made of silver. Aretino speaks of the "vermilion" velvet screen in the background of the painting,[28] while it is clear to the modern visitor to the Uffizi that this screen is dark crimson, that is, deep wine red. Contemporary analysis of the painting's underpainting reveals no repainting; Titian definitely painted it crimson. Cinquecento authors of treatises on color themselves acknowledged the difficulty of understanding what was meant by a certain color term.[29] These authors also recognized that the various hues of the same color may have different significance. A distinction was made in literary discussions between "vermiglio" (fiery red), "cremisi" (deep wine red), and "purpureo" (dark bluish red). Moreover, Dolce in his *Dialogo . . . de i colori* drew a distinction between colors as they were used by the literati and by painters, naming Titian as an obvious example of the latter.[30] Specifying that he was discussing colors not as a painter but in the sense used by the literati, Dolce connected vermilion (but, significantly, not crimson) with the Latin "sanguis ruber."[31] Vermilion, a bright scarlet, was based on red mercuric sulfide, one of the most opaque pigments. According to the strict definition, the background drapery is far from being vermilion; it is indeed a crimson-colored lake pigment.[32] Titian used vermilion in the duchess's portrait for coloring her cheeks.

Aretino himself distinguished between vermilion and crimson in an earlier *ekphrasis*, of *Saint John the Baptist*, in his letter to Massimiliano Stampa of October 8, 1531 (v). He asked his reader to "observe the flesh-tints so beautifully painted that they resemble snow streaked with vermilion. . . . I will say nothing of the crimson of the garment nor of its lining of lynx, for in comparison real crimson and real lynx seem painted, whereas these seem real."[33] Thus, given his awareness of the difference between vermilion (which could be used for painting garments as well) and crimson, it is not clear why Aretino called the color of the hanging in the duke's portrait vermilion.[34]

We may speculate that Aretino used the word "vermilion" because of its rich literary associations. Vermilion is mentioned more frequently than crimson in Dolce's book, and it was frequently noted by Dante and Petrarch, as can be seen in the entry for the term in *Vocabolario degli Accademici della Crusca*.[35] Another explanation may have been the association of vermilion as a fiery red with the warrior's spirit, an association the color crimson does not have. Aretino not only described the hanging as vermilion but also stressed its reflection in the mirrorlike surface of the duke's glittering armor. Aretino's mention of the batons as made of silver is perhaps analogous, because, like the "vermilion," the "silver" enhances the festive mood of the description, certainly adding to the eloquence of the encomium.

The emphasis that Aretino places on the medium of portraiture—painting—is in itself significant. Its particular quality for him was the painter's use of color, which, among other properties, enables the artist to show the reflection of one texture in another, something a sculptor cannot do. In a portrait, he believed, the purpose of color is to achieve verisimilitude in the sitter's image. A lifelike effect can be attained both by capturing the essentials of the sitter's character and by transmitting the tactile values of the accessories. Aretino stressed Titian's handling in capturing the brilliant shine on the duke's armor,[36] seeing this as proof of the naturalism of the portrait. He thereby reveals his awareness that an artist may sometimes have a problem in depicting textures convincingly.

Aretino paid much attention to the way Titian rendered the duke's armor in the portrait as captain-general of the Venetian land forces. The duke had lent his armor to Titian and asked that he return it with a drawing.[37] The drawing (Fig. 26) shows Titian's painstaking care in delineating with his pen every detail of the armor.[38] It is improbable that the drawing represents the duke himself, as he would never have posed before Titian barefooted and with unkempt hair. Thus the only preparatory drawing for a portrait that we have from Titian is actually a drawing of an *object* (a suit of armor) and not of the sitter. Aretino's mention of the suit's various parts (breastplate, tassels, and gauntlets) further underlines how important it was that the duke's armor be rendered accurately.

To better understand the difficulties involved in painting the metallic glitter of the armor, we may turn to Vasari's account of his own work on the portrait of Duke Alessandro de' Medici (Fig. 27), which he painted in 1534.[39] In 1568 Vasari confessed in his own *Vita* that the most difficult problem in painting this portrait was for him, an inexperienced young painter, to get "the right polish of the armor." In despair, he turned to Pontormo, who advised him not to look at the real armor, for "so long as the real armor is alongside, your work will always look like paint, as although white lead is the strongest

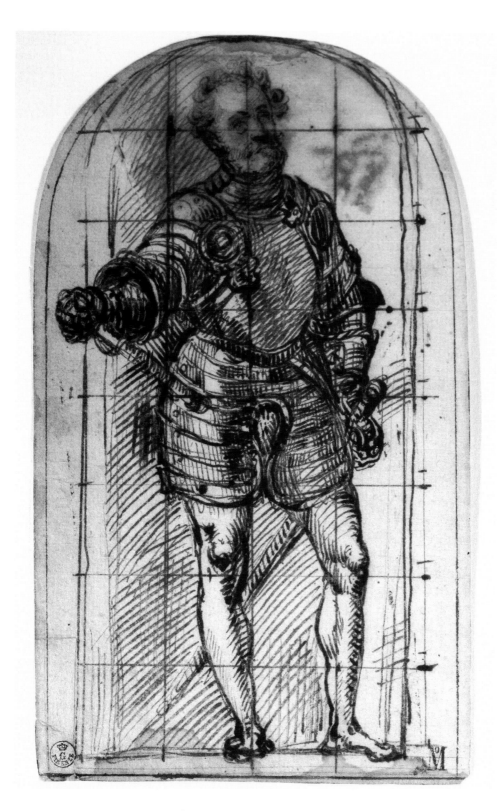

Fig. 26. Titian, *Francesco Maria della Rovere*, drawing. Uffizi, Gabinetto dei disegni, Florence

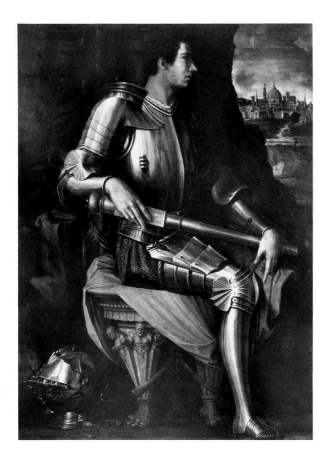

Fig. 27. Giorgio Vasari, *Alessandro de'Medici*, 1534. Uffizi, Florence

colour known in art, polished steel is stronger and more brilliant."[40] Vasari's confession shows how difficult it could be for an artist to capture successfully the effect of polished steel. In light of this story, Aretino's appreciation of Titian's artistic skill appears not merely as rhetorical praise but as genuine understanding of a common artistic problem. He singled out not only the effect of the polished armor but also the reflection of one texture, velvet, in another, metal.

For Aretino these effects were a significant demonstration of the qualities of color in portraiture and achieving them proved the painter's skill.[41] Aretino emphasized the painter's capability in a letter to Ferrante Montesse of July 1543 (CLXXII). There, to demonstrate the masterliness of Titian's portraiture, he playfully suggested that they imagine Francesco portrayed in sculpture. The sculptor would not have been able to render the duke's true likeness in marble, Aretino claimed, but only some general traits, which would have made the duke appear "too brutal."[42] Aretino was convinced that the painter alone had the power to render a true likeness by imitating nature through his colors.

Aretino's letter preceded by several years the famous debate on the *paragone* between painting and sculpture inaugurated by Varchi's lectures at the Florentine Academy.[43] In the artistic theories of the cinquecento, the ability to render subtly the textures of

appurtenances was considered the exclusive property of painting. For example, comparing the possibilities latent in the arts of painting and sculpture in his *Book of the Courtier*, Castiglione enthusiastically enumerates the diverse aspects of the material world that can be faithfully rendered only by painters. Among the properties he lists are "the grace of black eyes, shining with amorous rays . . . the color of blond hair . . . the gleam of weapons . . . the dark night" (I, 51).[44] This list is reminiscent of Pliny's remark about Apelles' ability to render the things "that cannot be represented in pictures—thunder, lightning and thunderbolts" (*Natural History* XXXV.96).[45] The rendering of textures was part of the painter's ability to show the diversity and richness of the material world. It is significant for our purposes that among the things the painter is able to represent Castiglione listed "the gleam of weapons."

Some thirty years after the publication of Castiglione's book in Venice in 1528, in his *Dialogo della pittura, intitolato l'Aretino* (a dialogue among connoisseurs from Venice and Florence, Aretino, and a professor of rhetoric, Giovan Francesco Fabrini, one of Aretino's correspondents),[46] Dolce attributed to Aretino this definition of the painter's purpose in using color: "The main problem of coloring resides, then, in the imitation of flesh, and involves diversifying the tones and achieving softness."[47] Dolce broadened his thesis on the purpose of color by having Aretino say that "the painter should also pay attention to the matter of quality; for velvet and watered silk, a fine linen and a coarse cloth all produce folds of different kinds."[48] In other words, it is the task of the painter to display materials in all their diversity. Aretino in the *Dialogo* continues his long speech on the use of color by stating that painters "should know how to simulate the glint of armor, the gloom of night and the brightness of day, lightning flashes, fires, lights, water, earth, rocks." This recalls Castiglione's list. Yet these authors discuss the painter's ability to portray the richness of the surrounding world in different contexts: for Castiglione this ability is merely one of the features that distinguish the painter's medium from the sculptor's, while for Dolce this ability is an absolute requirement for the painter. Dolce has his fictionalized Aretino overemphasize the importance of the painter's task of imitating the textures of objects.

Aretino contended in his letter to Veronica that the painter did not use colors only to convey "the firmness of the flesh" but in fact used them also to reveal the subject's true character, "the virility of the soul." As we recall, Aretino asserted hyperbolically that "art is turned into herself [nature herself]," and this is proved by the artist's "every fold, in his every hair, in his every mark."[49] Aretino's words "fold," "hair," and "mark" point to costume, countenance, and accessories, respectively, in the portrait—all of which concern him. Details such as the suit of armor, the duke's bearded, resolute face, and the symbols of his military distinction express the sitter's essential—in this case martial—spirit: his *concetto*.

It is relevant here to recall that the term "color" originated in classical rhetoric, meaning an embellishment of speech (Quintilian, *Institutio Oratoria* IV.ii.90–100).[50] Although at the time the word "color" was a prerogative of painting, for Aretino it may have been a literary term as well. He was undoubtedly familiar with Trissino's *Poetica* of 1529, in which "color" was used as a rhetorical term in glossing poetical writing.[51] Indeed his references to Titian's use of color in his letter to Veronica blend in unprecedented

fashion the rhetor's usage of the term "color" with the painter's, thus endowing the term with a new significance.

Aretino, then, viewed the painter's ability to render the material quality of the objects in a portrait not as an end in itself. The accurate depiction of the subject's surroundings by means of color heightens the expression of the character and spirit of the person portrayed. From Aretino's deep fascination with the coloristic quality of the portrait, we can grasp his view of it as a true work of art.

The Sonnet: The Poetic Portrait

While in his letter Aretino approached Titian's portrait from the standpoint of its artistic qualities, in his sonnet he showed how the portrait succeeded in revealing the duke's character. His sonnet aimed to demonstrate the accord between the duke's character and the way Titian rendered it in the portrait, to persuade his reader that the painter indeed used his colors to reveal "the virility of the soul." In the sonnet, Aretino dealt with the duke's physiognomic traits, leaving aside the painterly aspects of the portrait. The sonnet becomes the duke's versified portrait, which, according to Aretino, should be juxtaposed with the painted portrait.

Aretino paid special attention in the sonnet to the duke's forehead and eyes: "He bears frightfulness between his eyebrows, courage in his eyes and pride on his brow."[52] Similar physiognomic descriptions appear in other sonnets by Aretino relating to other portraits, not necessarily by Titian. However, in this, Aretino's first sonnet on a Titian portrait, the description closely corresponds with the way the duke's face is represented in the painting (see Fig. 21). The duke does indeed have a high, wide forehead with a clear-cut furrow, interpreted by Aretino as "some frightfulness [il terror] between his eyebrows."[53] His eyes glitter with yellow lights, which may signify to Aretino "courage in his eyes." To round out Aretino's description, we may add that the duke's nose is straight but slightly blunted at the tip and his cheeks are sunken.

In the first quatrain Aretino mentions the portrait of Alexander the Great by Apelles. In the next, he not only compares Titian's portrait of the duke with it but plainly states that Titian outdoes the ancient master. In his words, Apelles painted "with the hand of art," while Titian "has a larger endowment from heaven." Titian succeeds in doing what Apelles failed to do, to depict through the exterior features the subject's inner character. It was common for the cinquecento intelligentsia to assert that contemporary artists surpassed their illustrious ancestors. What is significant here is that Titian is identified as having succeeded in revealing the invisible traits of the duke's personality.

From antiquity on, in Italy and throughout Europe, the name of Alexander the Great was synonymous with warrior.[54] Although like Aretino's juxtaposition of the names of Titian and Apelles, comparing a military leader to Alexander the Great was indeed an artistic cliché. The duke's character was first described by Castiglione, who was in his service when he became duke in 1508. His first words convey the impression of a

formidable, energetic personality. The duke, Castiglione says, entered the court suddenly, accompanied by a band of mercenaries, capturing the attention of those present; at the same time, however, he was polite and courteous. He noted that the duke, who was then no more than sixteen years of age, "in his every movement showed a greatness of spirit together with a certain veracity of temper" (I, 55).[55] Vivacity, alertness, fortitude, courage—all these qualities characterized the choleric temperament and martial spirit personified by Alexander the Great.[56]

Although it was routine to compare contemporary artists with Apelles, no other painter in Italy was compared to Apelles as often as Titian.[57] One of many reasons for this was the conviction that both Titian and Apelles excelled in representing the physiognomic likeness of their subjects. Some ten years after Aretino wrote this sonnet, his friend Doni in his *Disegno* (Venice, 1549) repeated Pliny's assertion that among the ancients only Apelles could render such a remarkable likeness of the sitter in a portrait that professional physiognomists viewing it could even interpret the subject's age. Of all contemporary painters, in this Titian was, he thought, closest to Apelles.[58] Titian, who took special care to render the duke's forehead with its characteristic furrow, and Aretino, who emphasized the forehead in his sonnet, were no doubt familiar with Pliny's remark about Apelles' portraits—that they were so realistic the metoposcopists could pronounce "from [his] portraits either the year of the subjects' deaths hereafter or the number of years they had already lived" (*Natural History* xxxv.88).[59] Was it pure coincidence that the duke, who appears so exhausted in the portrait, died only a few months after Titian had sent it to him?[60] Could it have been that, in his perceptive portrayal of his subject, Titian foresaw the duke's untimely death?

There is another reason for Aretino to compare Titian with Apelles here. In the sonnet he refers to Titian's showing the duke with hand thrust forward, holding a baton. By reading Aretino's line "in his armored torso and ready arms burns the valor" and then looking at Titian's portrait, one inevitably associates Aretino's words with the duke's gesture. Aretino knew from Pliny that this gesture appeared in Apelles' portrait of Alexander the Great. Pliny stated that Alexander held a thunderbolt in such a way that the "fingers have the appearance of projecting from the surface and the thunderbolt seems to stand out from the picture" (xxxv.92).[61]

Apelles' painting was also noted in Plutarch's *Life of Alexander*, in which the writer criticized the artist for making Alexander appear "too dark-skinned and swarthy," when in reality the king was fair.[62] It would seem that Apelles rendered his complexion not as it was in real life but as he thought appropriate, given Alexander's choleric temperament. Titian too showed Francesco with honey-colored skin, whose hue contrasts with the paleness of his wife's face. The duke's complexion and facial features thus correspond exactly to those of the choleric personality as delineated in the treatises on physiognomy. In Renaissance Italy, the choleric type came to be associated with Alexander the Great. Whenever physiognomists mentioned the features of the typical choleric, they used Alexander's countenance as their example. For instance, in the section on physiognomy in his treatise *De Sculptura*, Gaurico cited Alexander's square forehead, shining yellowish eyes, straight nose with blunt tip, prominent cheekbones, and honey-hued skin as exem-

plifying the choleric type.[63] These features are all present in Titian's portrait of the duke as well. Thus Titian not only took Pliny's description of Apelles' portrait of Alexander as his model for the composition of the painting but also took the physiognomical account of Alexander's countenance as the model for depicting the ideal warrior's face—the face of his subject, the duke. Physiognomists, as is well known, in their aspiration to detect the typical in the individual, look for the permanent features in the countenance. This search is precisely what enables Titian to transcend the particularity of his sitter, to reveal his *concetto*.

"Ogni Invisibile Concetto"

In the sonnet Aretino characterizes the "*concetto*" as invisible, meaning that it is not directly evident in the portrait itself. From the motto "SE SIBI" (By himself alone) seen in the background of the painting, the duke could identify his *concetto* as that of the ablest *condottiere*. Aretino was no doubt aware of Pliny's account of Apelles' portrait of Alexander the Great and of Plutarch's judgment of it. While Plutarch criticized Apelles' inaccuracies, Aretino, by contrast, praised Titian for portraying the duke faithfully and especially for having conveyed the hidden qualities of his character. Plutarch's criticism implies that Apelles changed the hue of the skin in order to capture Alexander's martial spirit. Analogously, when Aretino says that Titian "expresses every invisible concept," he may have been hinting at Titian's methods as a portraitist, which enabled him to introduce certain changes in order to emphasize the duke's choleric temperament.

The duke may have posed for Titian during his frequent visits to the lagoon city in the capacity of captain-general of the Venetian land forces.[64] As far as it is possible to tell, the duke's image in the portrait differs slightly from that on his medal (Fig. 28),[65] which was struck not earlier than 1521 and probably later. The medal shows a somewhat broader face framed in a curly beard and sparse curly hair. The duke indeed had a physiognomy typical for the warrior, as we know from biographical descriptions.[66] Titian's task was to highlight features that would characterize him as a true warrior even at the cost of strict accuracy.[67] This practice was by no means unusual; there are many examples among Titian's portraits in which the subjects were rendered not so much as they appeared at that time but rather as they wanted to see themselves or were thought of by their contemporaries. Since his contemporaries would have found the real look of the duke if so rendered in the portrait of him as unconvincing and unimpressive, Titian deviated slightly from faithfulness to his likeness.

Alexander the Great was believed to be endowed with a leonine physiognomy, and traditionally the lion was associated with the choleric temperament.[68] As it was standard practice to compare any gifted soldier with Alexander, so too it was usual to assume that he was lionhearted (and, by implication, somewhat leonine in look). For example, in the Italian liturgical play *Nabuccodonosor* (1434), the general Nabuzathan was described metaphorically as possessing a lion's heart: "Però Nabuzathan, cuor di leone, / Contra

Fig. 28. *Francesco Maria della Rovere, c.* 1526, bronze medal. Museo Nazionale (Bargello), Florence

Jerusalema ti dò il batone."[69] (This comparison of course evokes an association with the twelfth-century King Richard, *Coeur de Lion.*) This tradition, known from Pliny, who cited Aristotle that there are "two kinds of lions, one thickset and short, with comparatively curly manes—these being more timid than the long, straight-haired kind; the latter despise wounds" (VIII.XVII.46),[70] may well have led Titian to portray the duke's head as relatively lean (cheeks sunken), with straight hair and beard. Italian connoisseurs, familiar with Pliny's and Aristotle's works, would have found the slightly plumper image with curlier beard unconvincing.

The duke was closely associated with the courageous lion, as illustrated by a story told by Giovio in his *Dialogo dell'imprese militari et amorose* concerning Francesco's own *impresa* (Fig. 29), which showed a heraldic lion holding a sword in its paw and had as its motto: "NON DEEST GENEROSO IN PECTORE VIRTUS" (Generosity is not lacking in the virtuous breast).[71] This *impresa* was devised by Castiglione; as Giovio explained, it was inspired by Plutarch's description of the personal seal that belonged to Pompey.[72] According to Giovio, the motto alluded (though it is not clear how) to a violent deed from the duke's youth, when at the age of twenty-one he stabbed Cardinal Alidosi (the pope's most trusted confidant) to death for daring to accuse him of cowardice in front of his uncle, Pope Julius II, and a surrounding crowd, including Castiglione himself. Giovio admired the duke for his military feats and talents, but as the Bishop of Nocera he had strong reservations about this murderous deed in the duke's youth. He stressed that "the duke did not want to show this [lion] *impresa* in order to avoid the hatred and revenge of the Cardinals,"[73] but preferred instead to use his other one, which had a palm tree with one branch depressed by a square stone, and the motto "INCLINATA RESURGIT" (Bent, it rises up again). This is the one that appears on the reverse of the duke's medal (see Fig. 28).[74] When devising the *impresa* with a rampant lion, Castiglione clearly perceived the duke as the ferocious lion rather than the timid one. Yet this characterization in no way detracted from the duke's admirable character in the eyes of his contemporaries.

Fig. 29. *The Lion Impresa of Francesco Maria della Rovere,* xylograph from Paolo Giovio's *Dialogo de las empresas militares, v amorosas, compuesto en lingua italiana,* Lyon, 1562, p. 136. Courtesy of the Department of Rare Books, Cornell University Library, Ithaca, New York

Titian rendered the duke the way his contemporaries thought of him, expressing the essentials of his character, emphasized in the motto "SE SIBI" (By himself alone) inscribed on the white banderole encircling the forked oak branch. Titian portrayed him with thick, straight hair and for this reason made him look perhaps coarser and leaner than in reality. Hence the *Francesco Maria della Rovere* (see Fig. 21) was and is an enduring monument to a courageous soldier.[75] Indeed, as Giovanni Guidiccione once said in his laudatory poem, the fiery duke spent his whole life in the sphere where "lives a spark of Mars."[76] In his aspiration to portray the duke correctly, to express his *concetto,* Titian represented him in a manner similar to that in which Apelles rendered Alexander the Great, with the honey-colored skin of the choleric man and with a leonine physiognomy. This merging of the features traditionally associated with a warrior was what made the portrait so eloquently persuasive.

A final touch that would have made the image in the painting appealing and convinc-

ing to the Renaissance literati is the color of the velvet screen in the background, discussed earlier. The screen is crimson to us, but in Aretino's day, because of his letters, it was considered to be vermilion. The color red was most often associated with warfare. Equicola, the secretary of Isabella d'Este, explained in his *Libro di natura d'amore* (Venice, 1526) that red symbolized "revenge and anger" and was "appropriate to ferocious Mars."[77] Similarly, Fulvio Pellegrino Morato in his treatise on the symbolism of color, *Del significato de' colori* (Venice, 1535), said that red signified "suspicion, jealousy, fear and respect."[78] For Titian it made sense to place the duke against this specific background, which is reflected, as Aretino noted, in the polished metal of his suit. Even if considering the coloristic unity of the painting Titian chose to paint the screen as crimson, a less vivid red than vermilion, still he could make its reflection in the metallic suit vividly red. Titian knew that in this case, too, he had still achieved the desired impression. The reflected red patches on the suit seem like small flames, thus evoking warlike associations.

By endowing the duke's image with a choleric complexion and leonine physiognomy, surrounding him with insignia of military honor, and placing him against a red velvet screen, Titian projects the subject's *concetto*. The portrait brings to life not only the duke as *condottiere* in all his glory but also as the quintessential warrior. Titian's ability to reveal the duke's individual traits may have been what Aretino meant when he said in his sonnet that in the portrait Titian expresses "every invisible concept" of the duke. Proclaiming that Titian's portrait instills trust in the viewer, Aretino sums up by saying that the painting clearly shows the duke as able to protect "sacred Italy with her famous virtues."

The Portrait of the Duchess

In the *Eleonora Gonzaga della Rovere* (see Fig. 25), Titian seemingly faithfully rendered the duchess as she looked in her mid-forties, her oval face bearing the traces of her faded beauty.[79] Her permanent features—the prominent forehead, thinly outlined eyebrows, almond-shaped eyes, long, slightly pointed nose, small delicate mouth and round chin—all correspond to the conventional formula for feminine beauty, particularly familiar from the writings of Bembo and Firenzuola.[80]

In his sonnet, the poetic portrait of Eleonora, Aretino interprets the duchess's demeanor in the portrait as an embodiment of her spiritual virtues: decency, chastity, gentleness, modesty, honor, and prudence. His sonnet adds eloquence to the painting's muteness. Aretino would later apply the same vocabulary to several other portraits of women by Titian and others regardless of the actual character of the woman in question. In this case, however, the character emerging from the sonnet does accord with that of Eleonora, known as a virtuous wife. Castiglione, who knew Eleonora from her early youth, confirms Aretino's favorable description of her character. In his *Book of the Courtier*, he described her as endowed with "wisdom, grace, beauty, intelligence, discreet manners, humanity" (IV, 2).[81] In his sonnet Aretino says that her forehead is adorned

with prudence, amiability, and other inward virtues, while "betwen her eyebrows one sees the throne of the Graces."[82]

At the time Aretino sent Veronica the sonnet on Titian's portrait of the duchess, the artist had not begun work on the painting. The sonnet consequently proffered purely rhetorical expressions and little about the actual composition of her portrait, unlike the sonnet on the portrait of her husband. Aretino nonetheless may have been familiar with the artist's conception of the duchess's portrait and could therefore convey an accurate impression of it.

Aretino opens the sonnet with the statement that "the harmony of colors, which Titian's brush has spread, renders visible from without the concord which, in Eleonora, the hand-maids of the noble spirit govern." In other words, the "harmony" of colors expresses a salient characteristic of the duchess, namely, *concordia*. This assertion is faintly reminiscent of the later rhetoric of the Renaissance on the symbolic correspondence between harmony of colors and the "concord" of the world, but to my knowledge Aretino's poetic affirmation that the colors of the portrait manifest a dominant characteristic of the subject was unprecedented at that time.[83] Familiar with Titian's methods, Aretino felt free to declare that regardless of the portrait's composition, its coloristic arrangement would express "concord," the air that emanates from the duchess's countenance; thus he anticipated that the painting would convey her ethos. Looking at the portrait, one need not expect to see it precisely reflecting Aretino's expectations. At the same time, it must be admitted, the portrait does give the overall impression Aretino foresaw.

The arrangement of the colors in the portrait is dominated by the black of the duchess's dress and the green of the cloth that covers the chest in the background. Besides being the heraldic color of the Montefeltro family, black was imbued with various symbolic meanings. According to Morato's *Del significato de' colori*, black denoted "prudence and seriousness."[84] According to Equicola's *Libro di natura d'amore*, green was associated with the planet Venus and denoted hope and serene joy.[85] Morato also noted in passing that green and black were popular with Italian ladies of the time.[86] These two colors, connoting prudence and serenity, convey the same overall impression of Eleonora as does Aretino's sonnet.

Not only the major colors but the accessories as well have symbolic significance. On the chest near the window is a clock, in the form of a tiny house decorated with mechanical figures. Often seen as a status symbol, clocks were traditionally associated with *memento mori* or, more important in the context of this portrait, with temperance.[87] An obelisk in the background aperture that offers a view of the well-governed dukedom is symbolic of wisdom.[88] The duchess's little white and tan spaniel, lying on the forward edge of the chest, is symbolic of fidelity. "Dogs mean fidelity" was categorically stated in Alciati's influential *Emblemata*, first published in 1531.[89] Thus the accessories as well as the colors in the painting helped Titian express Eleonora's virtuous character.

Eleonora is portrayed holding the only luxurious object in the painting: a *zibellino*—part purse, part muff—made of sable fur, believed to offer protection from chills and fleas.[90] Its clasp, shaped like a gold head with amethyst eyes, strikingly resembles the head of Eleonora's dog and was probably a jeweler's "portrait" of the real dog. By juxtaposing this "portrait" with the "real" dog in the painting (see Fig. 25), Titian may have wished to

draw attention to the practical power of art not only to render a likeness but to immortalize its subject in the object created. The jeweler's work of "portraiture" is shown alongside the "real" creature, just as the real Eleonora would probably be seen one day standing beside her own portrait. Aretino in many of his letters praised Titian's skill in bestowing a certain immortality on his sitters. To Gonzalo Perez of December 20, 1536 (xvi), Aretino wrote that "with your effigy Titian cancelled the reasons which induce you to thinking of yourself after death."[91] Much earlier, Dürer too had stated that the portrait's function is to preserve "the likeness of men after their death."[92] Dürer himself was echoing the well-known classical topos, *vultus viventes* (living faces), which is as traditional as *vox sola deest* (only the voice is lacking), the topos that was mentioned in Chapter I.

It was a quarter of a century later that the motto "NATURA POTENTIOR ARS" (Art is more powerful than nature) was coined for Titian's own *impresa,* most probably designed by Dolce.[93] Solely on the basis of the portraits of 1537, Titian already merited this praise. The duchess's portrait not only presented her likeness, not only displayed art "turned into herself [nature itself]," as Aretino said of the duke's portrait, but, more than that, lent posterity to her features and therewith to her spiritual essence, her *concetto.*

The courtier Giovanmaria della Porta wrote to the duchess of his response upon the portrait's arrival. When beholding the "marvellous likeness," he said, "I could scarcely refrain from kissing your hand, so lifelike did it appear to me; and I said more than once, 'My dear lady, you are indeed she'; and, wishing to speak to the picture, I went close to it, but saw that it did not attend to what I said."[94] This letter contains many notions familiar from Aretino's letters. Certainly they can be regarded as the rhetorical commonplaces of the flattering courtier, but the immediate response nonetheless attests to the lifelike portrait and the goal it achieved.

A Union of Polarities

The portraits of the Duke and Duchess of Urbino were intended to be seen together and compared with each other, even if at first they were not designed as pendants. As has already been observed, they deviate from the conventional scheme for portraits of married couples, where the man and his wife were customarily shown in the same posture and against the same background, Titian presented the duke and the duchess in different postures and with different backgrounds. Only the nearly identical size of the portraits is traditional. Yet despite the differences, the portraits do complement each other. The armored duke is surrounded with military insignia, while the duchess is seated in a domestic environment. The two portraits taken together represent a union of polarities.[95]

In his sonnets, Aretino took pains to delineate the husband as spirited, forceful, and ardent and the wife as gentle, modest, and quiet. The *locus classicus* of this perception of a married couple and their respective qualities was Aristotle's *Politica* (1260a.20), where it was clearly stated that "the courage of a man is shown in commanding, of a woman in obeying."[96] So the duke thrusts forward his baton, demonstrating the power and honor of

a general, while his wife sits tranquilly, warming her hand in her luxurious *zibellino*. Their duties were also specified by Aristotle in *Oeconomica* (1343b.25, 1344a.5), where he explained that "nature has made the one sex stronger, the other weaker" so that "the one may acquire possessions outside the house, the other preserve those within." Aristotle went even further, stating that while nature "made one sex able to lead a sedentary life," the other is "well constituted for outdoor activities."[97] Titian's portraits represent this couple in their respective roles—one as a military figure, the other as the gentle wife.

The duke and duchess both appear almost knee-length; both turn three-quarters toward the viewer, gazing outward as if meeting the glance of the viewer, who supposedly stands between them. The duke is dressed in armor, the duchess in a black winter dress and adorned with jewelry. He is of dark complexion, while she is fair, her paleness underlined by a pearl earring. They both have the attributes of their respective duties: he wields a baton and sword, she holds a *zibellino* and rests her hand on the arm of her chair. Both are represented against a velvet backdrop, red and green, respectively. His portrait, painted in bold strokes, radiates energy in the glitter of the metal armor; hers, painted in minute detail with an accent on the brocade of her dress and the warmth of the summer landscape, bespeaks serenity. The duke is representative of masculine qualities, while the duchess manifests the feminine virtues. If the *concetto* of the duke is the warrior, hers is the lady of the dukedom.

Aretino's letter to Veronica Gambara is thus an invitation to discuss and judge Titian's portrait of the duke and the projected portrait of the duchess. His letter draws the observer's attention to the beautiful effects of the coloring and the skillful rendering of diverse textures. It goes on to recall memorable episodes in the duke's life. Aretino shows the artist fully employing the possibilities inherent in the art of painting, and that Titian used color not only to convey textures but to reveal the individual spirit of the duke.

In contrast to the letter, the sonnet is a poetic portrayal, meant to complement Titian's. By evoking Apelles and Alexander the Great, Aretino offers an explanation for the details of the portrait's composition; he is saying in effect that Titian was translating the description of Apelles' renowned portrait of Alexander holding a thunderbolt into the pictorial language of his time. Aretino interprets the duke's character by describing his facial features selectively. When he states that Titian demonstrates "every invisible concept [*concetto*]," he no doubt meant that the artist elaborated the duke's actual features for expressive purposes but without sacrificing their essential lifelike quality. Aretino's sonnet on the projected portrait of the duchess, like that on the portrait of the duke, helps us comprehend what Aretino saw as the meaning of the portrait; he translated the data of physical attributes into poetic idioms expressive of the duchess's inner qualities. Moreover, the sonnet serves as the key to understanding how the coloring of the portrait is symbolic of the duchess's ethos. The two sonnets taken together confirm that the portraits represent the couple in terms of their respective duties. The sonnets help us understand the meaning for Titian—and for Aretino—of their different poses and backgrounds. The portraits of the duke and duchess do represent a union of polarities and enhance our comprehension of the *concetti* of the ducal couple of Urbino.

IV

Pope Paul III: The Problem of Likeness

Between 1543 and 1546, Titian painted several portraits of Pope Paul III: the bareheaded pope, done in Busseto in 1543; in a papal hat, done in Rome in 1545; and the group portrait with his grandsons, done in Rome in 1546.[1] These portraits have in common the conventions that had always been imposed on papal portraits:[2] the holder of the loftiest ecclesiastical rank in the Roman Catholic world had to be represented in specific liturgical vestments and seated in the setting designated for a public audience.

Conveying the pope's image in different ways, the three paintings are readily identifiable as likenesses of Paul III. They may appropriately serve as a focus in discussing the problem of likeness, one of the main issues in portraiture. Analyzing them and surveying contemporary reactions to them (particularly those of Aretino, one of the first to respond) may further our understanding of what likeness in portraiture meant for Titian and his contemporaries.

Alessandro Farnese, Pope Paul III, belonged to a noble family that could trace its origins as far back as the early twelfth century. Born in Rome in 1468, the future pope received

an exceptional education under the tutelage of the renowned humanist Pomponio Leto.[3] Appointed cardinal by Pope Alessandro VI in 1493, he remained in the cardinalate for nearly forty years, retaining the favor of six successive popes, from Alessandro VI to Clement VII. He was elected pope at last in 1534 at the age of sixty-six after a long illness, the oldest pope to be elected since Callistus III, who had been elected in 1455 at the age of seventy-eight.[4] After his election, he disappointed his enemies by recovering from his illness,[5] and continued to wear his tiara in good health until his sudden death on November 10, 1549.

Pope Paul III ruled in the brilliant style of the Renaissance Popes Julius II and Leo X, who embellished Rome with their patronage of the liberal and the visual arts. Contemporary reports testify to this pope's tremendous popularity, especially among the people of Rome.[6] In external politics he tried to maintain a policy of neutrality in relations with Francis I and Charles V. In religious matters he was the first pope since Leo X to recognize the urgent need for reform, and he took the practical step of summoning the Church Council in Trent. Most Renaissance popes indulged in nepotism, but in this matter Paul III went to extremes.[7] He spared no effort to aggrandize the Farnese family, especially his eldest son, Pierluigi, whose two sons, Alessandro and Ottavio, appear in the group portrait.

Onofrio Panvinio gave an amicable description of Paul III in his *Historia delle Vite de i Sommi Pontefici*, first published in 1568. Of middling stature with a medium-sized head, he had sparkling eyes, a long nose, slightly protruding lips, and an ample beard.[8] This verbal portrait corresponds well with his representations by Titian. Although the pope, when a cardinal, was portrayed by various artists (according to Vasari, he was portrayed by Sebastiano del Piombo and Marco Venusti, but these portraits have vanished; one of his youthful portraits is attributed to Raphael), during his papacy he decided, thus certainly styling himself after Alexander the Great, that only Titian would paint his portraits and only Guglielmo della Porta would sculpt them.[9] The sculpted images were dependent on Titian's portraits as well, so Titian's portraits remained the only original visual records of the pope's likeness.[10]

The Portraits: "Official" and "Public"

At first glance the portraits of Pope Paul III painted in Busseto in 1543 (Fig. 30) and in Rome in 1545 (Fig. 31) look similar, except that the pope is, unconventionally, bareheaded in the earlier one. In both portraits, his stooping figure is deeply seated in a pontifical chair upholstered in red velvet.[11] The pope is seen in three-quarters view, slightly turned to the left. He is dressed in liturgical garments: the *rochette*, the white pleated tunic (alb), covered with the *mozzetta*, the purple velvet cape of the same color as the *camauro*, the hat.[12] During audiences he was supposed to cover his head,[13] as in the 1545 portrait. In both paintings his left hand rests on the rounded arm of the chair, his right hand in his lap.

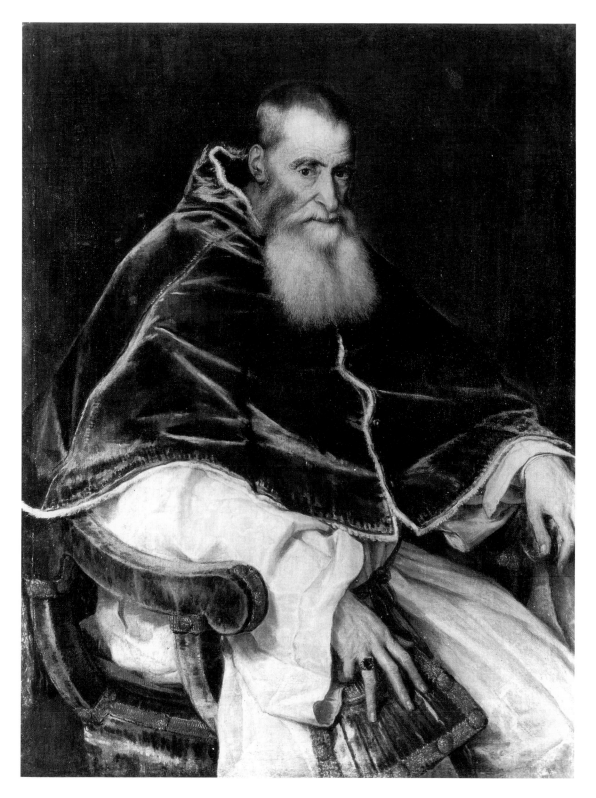

Fig. 30. Titian, *Pope Paul III Without a Hat*, 1543. Gallerie Nazionali di Capodimonte, Naples

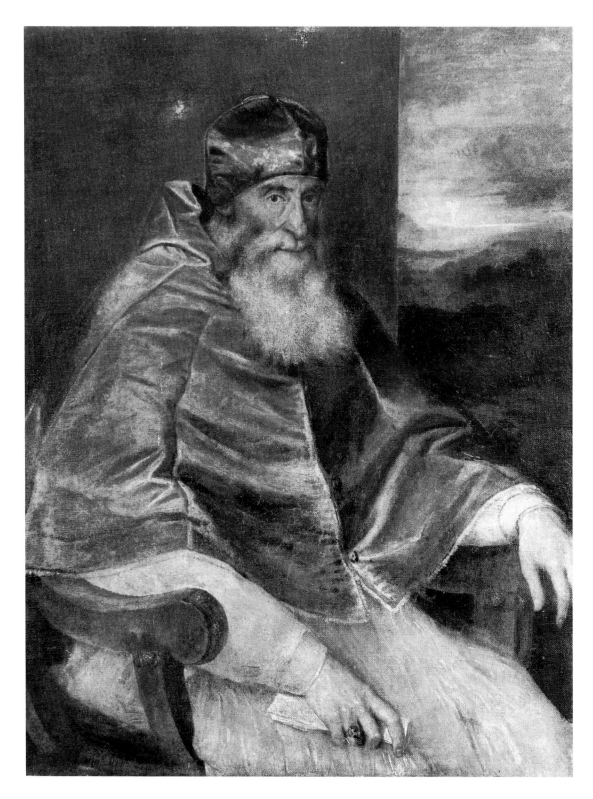

Fig. 31. Titian, *Pope Paul III*, 1545. Gallerie Nazionali di Capodimonte, Naples

In the earlier portrait Paul III's right hand partially covers a purse; the placement of his hand on the purse is reminiscent of the position of the elegant fingers in Sebastiano's portrait of a cardinal, known as the *Portrait of Reginald Pole,* in the Hermitage.[14] In the later portrait the pope clutches a sheet of paper. The backgrounds also differ: neutral in the earlier portrait, and fenestrated in the later one, disclosing a country view with a cloudy sky. The two portraits differ most significantly in the conceptions of the sitter's image.[15] In the earlier portrait the pope's face is more vigorous, his cheeks less sunken, his eyes more piercing, and his bony right hand more powerful than in the later portrait. His beard too is distinct in each portrait: in the earlier one (Fig. 30) it is spade-shaped, while in the later (Fig. 31) it is shapeless. Before Paul III, bearded popes were not common. Contemporaries of Pope Julius II were disturbed by his beard,[16] but by Paul III's time a bearded pope was not a novelty; a decade earlier, in January 1531, Clement VII had issued a bull allowing priests to dispense with shaving.[17]

With the spade-shaped beard and the close-cropped hair, which makes him appear almost bald, Titian's *Pope Paul III* of 1543 evokes the image of Saint Paul, as known from descriptions. In the *Acts of Paul and Thecla* (II.iii), the saint is described as a man of short stature, bald, with a long, somewhat hooked nose, and an ample spade-shaped beard.[18] That the pope should wish to style his own image in accordance with that of Saint Paul can be partly explained by the fact that he himself chose this name. Yet historical circumstances may also have influenced him. In March 1543, while Titian was working on his portrait in Busseto, Paul III was there to meet with Charles V. In Rome, less than a year earlier (on May 22, 1542, the Feast Day of Saints Paul and Peter), the pope proclaimed the establishment of the Church Council. Thus, in Busseto he may not only have felt that he was on the threshold of reforming the Church but also may have hoped to make peace between France and the Holy Roman Empire.[19] It appears that he believed himself to be taking on a mission similar to that of Saint Paul, and for this reason he may well have wanted Titian to present him in his image. The absence of the *camauro* and the accentuation of the vigorous outline and shape of the beard suggest that the pope indeed aspired to be immortalized as a Church reformer, a worthy descendant of Saint Paul.

Titian's later portrait of Pope Paul III offers an image conceptually different from the earlier one. Not only is he shown in a *camauro,* but he also looks much older. The difference in the pope's appearance cannot be explained by any physical circumstance, since nothing unusual had occurred in his life to affect his health in just the two and a half years from March 1543 to the autumn of 1545. It can be better explained by the fact that in painting the earlier portrait Titian made use of the conventional image of Saint Paul, while in the later portrait, painted in Rome, he adopted the model of Raphael's portrait of Julius II.

On his way to Rome, Titian had been asked by Guidobaldo II della Rovere (the son of Francesco Maria and Eleonora) to copy Raphael's *Pope Julius II* and to paint a portrait of Pope Sixtus IV, both members of the Rovere family.[20] (No portrait of Pope Sixtus IV existed per se, so Titian painted it as if anew, representing him in profile, probably using a medal as a model.) Titian could have copied Raphael's *Pope Julius II* when it was exhibited in Santa Maria del Popolo during his stay in the Belvedere Palace in October 1545;[21]

this copy is now in the Pitti as part of the Rovere collection (together with his *Pope Sixtus IV*). Titian's copy (Fig. 32) is so faithful to his model that for a long time it was mistaken for the original. Relatively recent work in restoration has proved that Raphael's *Pope Julius II* (Fig. 33) in the National Gallery in London is the original, while the work in the Pitti is Titian's copy.[22]

Done in Rome after Titian made his copy of Raphael's painting, Titian's later *Pope Paul III* (see Fig. 31) reflects its influence in the overall compositional arrangement: the position of the chair and the sitter's pose. In Raphael's portrait, though, the silky cloth-of-honor with Saint Peter's keys adduces to the image an iconlike quality, thus noticeably distancing it from the viewer,[23] while in the Titian portrait the fenestrated background, by contrasting interior and exterior spaces, makes the image seem closer to the viewer. Titian's portrait deviates from Raphael's also in the impression of the figure, and particularly in his demeanor. While in Raphael's portrait the pope is shown contemplative and introverted, with his gaze averted to avoid direct contact with the beholder, in Titian's portrait the pope appears an extrovert, scrutinizing his unseen visitor. Raphael imparted to his figure a royal demeanor that underscores his self-control; Titian's figure has the look of an inquisitor demanding a confession from a visitor. The "royal" effect of Raphael's figure is enhanced by his wearing variegated rings, while Paul III wears just one ruby ring (an *annulus*),[24] the ring that every pope was supposed to wear and that appears in all three of his portraits. Another detail that adds to the "royal" impression of Julius II is the way he holds the white cloth (*mappa*),[25] whereas Paul III holds a sheet of paper in a manner similar to that of the preceding Pope Clement VII as seen in his portrait by Sebastiano.[26] In Raphael's portrait, the *camauro*, looking more like a royal crown, is set slightly above the pope's brow, thereby emphasizing the broad, well-shaped forehead. In contrast, in Titian's work the bottom line of the *camauro* nearly meets with Paul III's eyebrows, thereby directing the beholder's attention to his eyes. These "sparkling eyes" ("occhi scintillanti"), as Panvinio described them in his *Historia,* indicate the intellectual vigor of the pope, who appears to be looking searchingly at the beholder, thereby creating an illusion of immediate contact. These are eyes, according to an often-quoted expression from an anonymous *Physiognomoniae Liber Latinus* (once attributed to Apuleius), where "summa omnis physiognomoniae constituta est."[27]

Thus, while both of Titian's portraits faithfully represent Pope Paul III's countenance and in both he is shown in basically the same pose and attire, they nonetheless convey different conceptions of his likeness. Both are obviously state portraits, presenting the pope's image in the way it should be perceived by state dignitaries. However, the portraits served different purposes. Although the location in those years of each of these portraits is unknown, the many replicas done from them testify to their importance for pontifical propaganda. More replicas were done after the earlier portrait than after the later one. For our purposes we may classify the earlier portrait as "official" and the later one as "public," meaning that the earlier portrait depicted the pope as a reformer, while the later portrait was for juridical purposes, as a substitute for the actual presence of the pontiff. The "official" character of the pope as a reformer is enhanced by the resemblance to the conventional portrayal of Saint Paul. In contrast, the later portrait endows the pope with

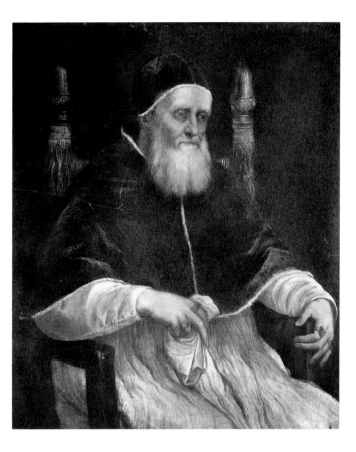

Fig. 32. Titian, *Pope Julius II*, 1545,
copy after Raphael's portrait. Palazzo Pitti,
Florence

an authoritative public or social character, presenting him as a figure receptive to visitors: the pope is about to grant a private audience to the viewer, whom he first studies inquisitively with his piercing eyes. The "public" character of the portrait is achieved primarily by means of the "casual" setting (a fenestrated room) and the sheet of paper in his hand (apparently the document the pope ordinarily bestows upon a visitor during an audience). The difference between the images in these portraits seems especially striking when we recall that Titian painted them within the short span of two to three years.

Aretino and Others on the Portraits of Paul III

Among the responses to Titian's portrayal of the Farnese pope, Aretino's was the first. He wrote to Titian in July 1543 (CLXXI), and Titian received the letter in Venice upon his return after finishing the portrait in Busseto. As Aretino gives no details of the pope's pose, the colors, or the background of the painting, only the date of the letter indicates which of the two papal portraits he was referring to. Most likely Aretino had not seen the portrait of the bareheaded pope (he would not see the other portrait either); however, he wrote that the painting rendered the pope in a most vivid and

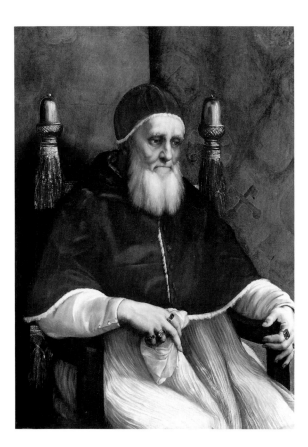

Fig. 33. Raphael, *Pope Julius II*, 1512. The
National Gallery, London

lifelike way. That Aretino expressed his opinion of the portrait even though he had not
seen it is interesting in itself.

According to contemporary evidence, after choosing Venice as his permanent resi-
dence, Aretino traveled for brief periods only to Rome, Arezzo, Urbino, and Verona; he
never went to Busseto (and he did not go to Rome during or after Titian's visit there). No
print was ever produced of the papal portrait, and even if replicas were later made of both
of Titian's portraits, Aretino's 1543 letter certainly antedates them. In effect, Aretino did
not need to see the papal portraits in order to write about them, for it was not the artistry
of the portrait but the papal effigy itself that attracted him.

By 1543, six years after writing his first letter on Titian's portraits, those of the Duke
and Duchess of Urbino, on November 7, 1537 (XLVII), Aretino had already determined
his approach to Titian's portraiture. In the 1543 letter about a picture he had not seen,
Aretino thus proclaims once more that the most important quality of Titian's portrai-
ture was its extraordinary transmission of likeness. In his own words, his own "enig-
matic" lady Fame would never be tired "of trumpeting how living it [the portrait] was,
and how animated and true to life."[28] Aretino praised those qualities—animation,
lifelikeness, and truth to nature—that were most important to him in portraiture,
qualities that make the image in the portrait seem to have a life of its own. Aretino
emphasized its verisimilitude in exactly the same terms he used for portraits that he had

seen, but in this case, somewhat paradoxically, he perhaps emphasized it more strongly than usual.

The main aim of his open letter, addressed to Titian, was to draw the public's attention to this "miracle," the papal portrait, which had been accomplished by a Venetian rather than a Roman painter.[29] Here Aretino was alluding to the portrait of the previous pope, Clement VII, painted by Sebastiano, who was a native of Venice but went to Rome in his early youth and was associated with Raphael's workshop and then with Michelangelo's.[30] (According to Vasari, Sebastiano drew a likeness of Pope Paul III after his election as well, but he did not finish it.)[31] Aretino praised Titian for bringing glory to the Venetian school of painting with this important work. Aretino also saluted Titian's refusal of the office of Keeper of the Papal Seal, commending him on his decision to stay in Venice.[32] This letter represents a remarkable contrast to his letter on the portrait of the Duke of Urbino (see Chapter III). While in the earlier letter Aretino focused on the coloristic qualities of the portrait (for example, the reflection of the screen in the duke's suit of armor), in this letter to Titian (and in the other letters on the portraits of Paul III as well), he draws the reader's attention to the masterly conveying of the pope's likeness. Aretino never felt compelled to discuss every portrait by Titian as a work of art. He chose freely whether to approach a Titian portrait as a work of art or as a social document, or both. In the case of the papal portraits, Aretino left aside questions of painterly qualities.

His letter of June 1544 (CLXXXI) to Carlo Gualteruzzi, a member of the papal court and an ardent admirer of Michelangelo, refers to the same portrait done in Busseto. It too gives no detail of the painting's composition, concentrating on the rendition of the pope's likeness. In writing this letter Aretino pursues one of his typical tasks: to remind the minister to send Titian the much-delayed payment for the portrait. Aretino also briefly eulogizes the portrait itself, acknowledging that he is bestowing on the portrait an unusual epithet: "*immortal*, because the sacred portrait [il sacro ritratto] is not only a mirror in which the Holy Father appears as if himself facing himself, but he there beholds also a heavenly image [simulacro celeste] which breathes from the style and spirit given to it by the pencil of the painter, so that soul and body seem to be there perpetually alive."[33] Aretino adds, moreover, that "death" will find it difficult "to distinguish the truth of nature from the counterfeit of art." Aretino frequently drew parallels between nature and art, resulting in the *paragone* between the sitter and his representation: the mortal reflected in the mirror and the supernatural (in this case) semblance endowed with eternal life. Titian's portrait of Paul III is not a mere mirror reflection, Aretino claims, but a "sacred portrait" that goes far beyond that to become a miraculous likeness that will live forever.

This striking characterization of Titian's portrait of the pope contrasts markedly with Aretino's comments on the artist's portraits of others, including himself. In his letter to Morosini (CCXLIII, July 1545), Aretino compared his own portrait with a mirror reflection, claiming that it looked like "a continuous mirror of my very self."[34] In saying that the pope's portrait transcended a mirror image while claiming that his own portrait *was* a mirror image, Aretino was in effect distinguishing between different kinds of portraits, implying a pronounced hierarchy of their sitters. His approach to Titian's portrait of the

pope, determined primarily by the sitter's elevated social status, necessarily involved some disregard for the particulars of color and composition, the artistic quality of the finished painting. It was most of all the subject's exalted rank that endowed the portrait with its extraordinary presence. This is one reason Aretino did not give any clue that would identify the specific portrait, since the portrait's significance resides in the pope's likeness itself and not in the painter's methods of rendering it.

Five years later, in a letter written shortly after the pope's death on November 10, 1549 (DIXL), Aretino speaks of the portrait of Paul III that Titian painted in Rome. In this letter, addressed to the influential Cardinal Niccolò Pio Ridolfi, renowned patron of the visual arts, Aretino was apparently replying to his remarks on Titian's portrait of the late pope.[35] Here Aretino uses the portrait more as an opportunity for writing an encomium of the late pope than for discussing the painting as a work of art. He elaborates on the comments made in his earlier letter to Gualteruzzi (CLXXXI). He again dwells on the extraordinary quality of the papal portrait: it is the "portrait of the soul" (ritratto d'animo); in it one may "comprehend his [the pope's] virtue, his greatness and his excellence." Here Aretino's usual hyperbolic style reaches new heights: the likeness in the pope's portrait reflects "the grace of God which impressed and coined his [Titian's] hand." Aretino appears unaware that here he strays from his usual mode of praising Titian's mastery, suddenly characterizing the artist as a vehicle in God's hands, making what God wills him to. In this assertion, quite strange for Aretino's ideology, he becomes an apologist of Platonic notions about the artist's frenzy. The portrait owes its extraordinary quality not so much to Titian, whom Aretino designated at the beginning of his letter as "spirit of flesh" (spirito de la carne), as to divine intervention in the artist's work.

Aretino evoked the pope's portrait yet again in July 1550, in his sonnet on Britto's xylograph of Titian's self-portrait. In this sonnet, part of a letter to Britto (DLXV), Aretino treats the portrait of Paul III as one of the major achievements of Titian's painting career, along with those of the Emperor Charles V, his son Philip II, and his brother Ferdinand.[36] Aretino finds an appropriate formula of praise for each of the royal portraits, admiring mostly the painter's ability to transmit remarkable verisimilitude. The papal portrait, however, is addressed in the final, culminating lines of the sonnet, showing that for Aretino it was the most important. Again Aretino gives no specific details of the painting's composition except to indicate the pope's seated pose, which is a standard feature of all papal portraits. Of the four portraits mentioned in the sonnet, the papal portrait alone is said to be so lifelike a likeness that it lacks only the ability to speak.[37] This sort of observation regarding a portrait was trite in Aretino's time. That here the topos was applied only to the portrait of Paul III, however, is a further sign of this portrait's importance to Aretino.

These three letters and the sonnet, then, show that Aretino's attitude toward Titian's portraits of Paul III was determined by the sitter's lofty status. His judgment of the specific artistic qualities of the papal portraits ceased to be of any significance, for they are first and foremost representations of the Supreme Pontiff and only afterward works of art. Aretino considered Titian's portraits of the pope to possess an absolutely super-

natural quality, not so much because they were painted by the great master but rather because their subject was of the most exalted ecclesiastical rank. The sitter's position in the social hierarchy completely overshadowed any evaluation of these portraits as works of art.

Titian's portrayal of Paul III was commented on not only in Venice but also in Florence. As mentioned in Chapter I, the Florentine critics noted the extraordinary likeness that Titian's portrait of Paul III displayed. Again it is not clear which of the two portraits was referred to, but most likely it was the portrait Titian painted in Rome in 1545. At that time Varchi stated in his lecture on the comparison (*paragone*) between the arts of painting and sculpture that painting is a more universal art than sculpture because it can imitate everything generated by nature. Moreover, by means of color a painting captures the essence of natural things in such a way that, if done with superb skill, it often deceives living beings. To confirm this statement, he gave the two classical examples of artistic illusion so frequently cited in his time, Apelles' grapes and Zeuxis's curtain, and also an example from contemporary art—Titian's portrait of Paul III.[38] Adding no further details, Varchi simply declared that painting, by virtue of its use of color, depicts a person in such a way that he or she appears lifelike, thereby causing the beholders much delight.

Varchi's choice of example was doubtless influenced by this pope's holding the seat of Saint Peter in the year he lectured. Nonetheless, to consider a portrait of the pope as an appropriate example of *trompe l'oeil,* along with paintings of inanimate objects, seems strange to a modern reader and calls for explanation, especially as Varchi's choice was followed not only by his immediate contemporaries but by those who lived after the Farnese pope died, such as Bocchi or Armenini.

Before he published this lecture, Varchi sent the text to a number of artists with the request that they give their opinion on the *paragone* between painting and sculpture. In his reply (February 12, 1547), Vasari spoke of Titian's portrait of Paul III along the same lines as Varchi, but he added some anecdotal details. Vasari started from the assumption that only in painting can a subject look so natural that even the beholder may be deceived. Without mentioning the artist's name, Vasari cited this portrait, relating that when it was put out on a sunny terrace for the varnish to dry, it deceived passersby, who mistook the image for the real pope and reverently doffed their hats.[39] It is significant that both Varchi and Vasari agreed on using Titian's portrait of Paul III to exemplify the ability of painting to render an image so lifelike that it could deceive the spectator into believing it to be a real person. True, the Farnese pope himself had a forceful character that would impress the beholder. Yet, it was the illusionistic quality of the portrait, and not the specific character of the sitter, that so impressed both Varchi and Vasari.

Some twenty-five years later, the Florentine ecclesiastic Francesco Bocchi, in his *Eccellenza della statua del San Giorgio di Donatello* (written in 1571 and published in Florence in 1584), mentions Titian's portrait of Paul III in the same context, presenting the same account as Vasari, though with slight modifications: the deception occurred because the portrait was placed in sunlight in such a way that the pope's image seemed to be alive; passersby paid their respects to the image because the portrait showed the pope

in all his majesty, "sacred in his living body."[40] Bocchi's use of the word "sacred" here recalls Aretino's in his letter to Cardinal Ridolfi.

That Aretino, Varchi, Vasari, and later Bocchi focused on a papal portrait rather than on any nonclerical portrait, however noble the subject, as an example of true likeness, reflects the reverence paid to sacred images ever since the beginning of Christianity. During the Renaissance, debates on the necessity for and the role of images in Church decoration rekindled an interest in sacred images and resulted in the proclamation at the final assembly of the Church Council of Trent on December 3, 1563, of a special decree in defense of the use of images as an effective form of ecclesiastical propaganda.[41] Following this decree, several supportive treatises appeared, written mostly by clerics (such as Bocchi). The two most influential were Paleotti's *Discorso intorno alle imagini sacre e profane* (Bologna, 1582) and Gregorio Comanini's *Figino* (Mantua, 1591). Although they were written some decades after Titian portrayed the Farnese pope, these treatises nonetheless reflect an approach to images similar to that of Titian's contemporaries. Paleotti and Comanini refer to the Decree of the Second Council of Nicaea in defense of images as well as to similar arguments of the early church fathers.[42] In confirmation of their views, they both cite the account given in Eusebius's *Ecclesiastical History* of the image of Christ that miraculously healed King Abgar of Edessa.[43] Paleotti also adduces the example of the image of Saint Paul that was venerated by Saint John Chrysostom as if it were the living saint.[44]

In their discussions, Paleotti and Comanini drew a distinction between images of saints and those of rulers. Royal images, they said, are revered because they substitute for the actual presence of the king, but they cannot work miracles like the images of saints. The only example of a royal image endowed with magical power was the statue of Constantine, an instance also cited by Paleotti in his chapter on statues of the Christian rulers.[45]

Recognizing this long-established tradition sheds light on the reaction of Titian's contemporaries to this portrait of Paul III. It shows that they all viewed the papal portrait as a sacred image with a dimension of the venerated *royal* image, whose task it was to represent the king during his absence.[46] The papal portrait was far from being regarded as the image of a saint, since there was no report that this particular painting had worked any miracles.[47] Rather, it was seen as the pontiff-ruler's revered image that, like the portrait of a king, would stand in for the actual presence of the pope, all the more because of its sacred identity. Vasari's story of how Titian's *Pope Paul III* moved passersby can be better understood in this context. The critics' choice of a papal rather than a worldly ruler's (or anyone else's) portrait to highlight the artistic achievement of verisimilitude can be understood as a consequence of the combined importance of the sacred and the royal. It also shows that the subject's high rank, in this case both worldly and sacred, rather than the portrait's artistic merits, still largely determined how Renaissance viewers reacted to the portrait. Yet the Renaissance connoisseurs' response to the lifelike image was at the same time different from that of the early Christian icon worshipers. For the latter, a lifelike royal image was important because it evoked respect, whereas for the Renaissance connoisseurs it was proof of the unique power of the medium of painting.

The Problem of Likeness

Theoretical thinking on portraiture did not crystallize until the end of the sixteenth century,[48] but the demand for verisimilitude had always played a part in the evaluation of any portrait. In the *Vocabolario degli Accademici della Crusca* (in preparation since the late 1570s, published in Venice in 1612), the very definition of a portrait as a rendition of "a figure [drawn] from nature" involved the matter of likeness.[49] The figure in the portrait should look like one in nature or in real life. At a time when one of the most important tasks of the painter was to imitate nature, the lifelike representation of the sitter in the portrait was seen as a demonstration of the painter's ability to display the natural world in all its variety.

In 1435–36, Alberti proclaimed that a picture is endowed with the power to show a person as if he were present and thereby perpetuate his memory. In Alberti's words, "The face of a man who is already dead certainly lives a long life through painting."[50] Yet at the same time, Alberti demanded that the skillful painter impart beauty to the figures in his paintings. He did not sense any contradiction in the demand that the painter imitate reality faithfully and also render it beautiful. A century later this was recognized as one of the most difficult tasks of the painter.

In a letter to Varchi (February 18, 1547), Pontormo revealed the painter's dilemma of having to make the figures on his flat canvas appear real and at the same time enhance their appearance, since art should add grace and correct natural blemishes. Pontormo even considered that what the painter does is "too bold . . . because he wishes to outdo nature, seeking to breathe life into his figures and making them seem like living things, although they are depicted on a flat surface."[51] Although not specifically concerned with portraiture, Pontormo's letter shows that by the middle of the sixteenth century painters were becoming aware of the complexities of achieving a lifelike—and more-than-lifelike—appearance. In the context of portraiture Vasari clearly stated the problem in his biography of Domenico Puligo, which appeared in the first edition of the *Lives* in 1550. Vasari asserted that only when "portraits are like and beautiful, then they may be called rare works, and their authors truly excellent craftsmen."[52]

Venetian artistic theory, too, as Dolce formulated it in his *Dialogo della pittura, intitolato l'Aretino*,[53] accepted that the painter's task was to render figures not only truthfully but also beautifully. Aretino's circle went further, arguing that the artist's aim was not just to imitate nature but to impart beauty to the figures rendered in his paintings. Aretino, we must admit, never defined what he meant by likeness; in that he was no different from the other literati, who stressed that the most important quality in a portrait is verisimilitude. None explicitly defined what he meant by likeness. However, some members of Aretino's circle wrote treatises on poetics and rhetoric in which they expressed indirectly what they meant by likeness. One was Speroni, who frequently corresponded with Aretino (see page 30), and who was portrayed by Titian in 1544.[54] (Incidentally, Speroni mentioned this portrait in the letter he wrote in Padua on September 15, 1579, to Francesco I, the Duke of Tuscany, in which he said that even if the portrait was done "dal naturale" many years ago, and even if now he was half-blind and half-deaf, still that portrait was truthful in

expressing his vigor to serve the duke.[55] In other words, the portrait was no longer important because of its physical likeness, but because it expressed the spiritual likeness of the person who claims to be always loyal to his patron.)

In his *Dialogo sopra Vergilio: Fragmento* (c. 1564), Speroni affirmed that "imitation is not proper to man, as art is. Therefore art is always conjoined with reason, and imitation is not always so; it is a thing not proper to us, but to rooks and monkeys."[56] Much earlier, in 1542, when Speroni wanted to illustrate an important point in his *Dialogo della retorica*, namely, that the good rhetorician has to make a speech that is both truthful and intelligible, he exemplified it with a portrait by Titian.[57] Unfortunately, Speroni did not explain this somewhat odd use of a painting as an example; he simply seemed to assume that any portrait by Titian was a self-evident example of the combination of truthfulness and intelligibility, that is, an accurate likeness and also a thoughtful impression of the subject's character. Later in the same dialogue, as part of a simile for a badly written speech by a rhetorician, Speroni mentions the portrait that an unnamed painter made of him, in which the "drawing is correct, but not of truthful semblance."[58] In other words, the portrait was well executed technically, but it failed to transmit his likeness fully. In this it is like a poor oration that may be clearly enunciated but does not clearly convey its message to its listeners. Interestingly enough, Speroni's *Dialogo* was written at the time Titian was working on the papal portraits. Speroni disagreed that imitation should be the ruling principle for an artist, a rare position to take at the time, but nonetheless he acknowledged how important it was for the portraitist to capture the sitter's likeness.

The cinquecento theoreticians claimed that a portrait must be true to the appearance of the subject.[59] In his biography of Domenico Puligo, Vasari said that if the portrait represents a beautiful figure without any resemblance to the sitter, it cannot be considered a portrait. "To tell the truth," Vasari confessed to the reader, "he who executes portraits must contrive, without thinking of what is looked for in a perfect figure, to make them like those for whom they are intended."[60] Almost two decades later, Lomazzo in his *Trattato dell'arte della pittura, scoltura et architettura* defined the act of portraying as "making the images of persons similar to themselves" (LI), that the persons "should have been recognized by themselves."[61] Thereafter "being recognized" became a quality inseparable from the definition of a portrait. Thus Comanini in his *Figino* specified that a good portrait represents such a true likeness that the subject can be "immediately recognized."[62] In the artistic theories of the time this criterion of likeness was compatible with the whole Renaissance doctrine of art as the imitation of nature. The question of likeness does not appear to have been treated independently of the doctrine of imitation, nor did the sixteenth-century Italian theoreticians propose their own definition of likeness in regards to portraiture.

In his *Discorso intorno alle imagini sacre e profane*, Paleotti cited Thomas Aquinas's definition of likeness: "Ubi imago ibi continuo similitudo, non continuo aequalitas."[63] This definition is itself an obvious paraphrase of Aristotle's in the *Metaphysics*: "Things are like if, not being absolutely the same, nor without difference in respect of their concrete substance, they are the same in form" (1054b).[64]

Let us look at the two portraits of Paul III in the light of Aristotle's definition of "being like." These two portraits, painted in 1543 and 1545, are similar in form, but, to cite

Aristotle, are not the same "in their concrete substance." In making a papal portrait, the artist emphasized features of the sitter's personality that would convey, in Speroni's words, "truthful semblance." Both portraits represent the pope's physical traits: his features, his pose, and his attire. The earlier portrait, however, presents the pope as ruler and reformer of the Church, whereas in the later portrait he is the patriarchal sage granting a public audience. Thus the pope's likeness depended on which aspect of his personality the painter wanted or was perhaps requested to project. To achieve the desired likeness in each instance, Titian emphasized the appropriate features, creating two different works— the "official" portrait and the "public" portrait—no doubt intended for different audiences and different occasions.

The Group Portrait

In November 1545, the Farnese family invited Titian to Rome to portray the pope with Cardinal Alessandro and Prince Ottavio, his two natural grandsons. This portrait (Fig. 34) remained unfinished, for Titian's work was interrupted in March 1546 by an imperial call to Augsburg to portray Charles V and the members of the Diet.[65] Despite its unfinished state, the portrait was favorably mentioned by Titian's contemporaries: by Armenini, for example, in his treatise De' veri precetti della pittura (On the true precepts of the art of painting) of 1587.[66] This group portrait was never mentioned by Aretino. However, iconographical analysis of it contributes to an understanding of Titian's attitude toward the problem of likeness.

An X-ray photograph made some twenty years ago of the portrait (Fig. 35) reveals some changes that Titian introduced directly onto the canvas.[67] The photograph of the underpainting further elucidates Titian's approach to the question of likeness in portraiture. It reveals that at first Titian may have conceived of this triple portrait as an allegory of the Three Ages: the prince and the pope were to embody the beginning and the end of human life, while Alessandro was to represent its middle stage. In this conventional allegory, Old Age was personified by the pope as defenseless and feeble, Middle Age by Cardinal Alessandro as melancholy and pensive, and Youth by Prince Ottavio as aggressive and predatory. This convention accords well with the account of the triple scheme of man's development in Aristotle's Rhetoric (1389a).[68] In reality, however, the difference in age between the two young men was not so great: in 1546, when Titian painted this portrait, Alessandro was twenty-six and Ottavio twenty-two.[69] The underpainting shows that Titian initially made Alessandro appear somewhat older, though his noble features remained basically the same, while Ottavio's profile was sharper than in the final version. Thus we see how Titian adjusted the grandsons' facial features slightly to fit the overall conception of his work. Then, abandoning the idea of the portrait as an allegorical representation of the Three Ages, he depicted the figures more or less as they were at that time: the pope in his seventy-seventh year; his grandsons in their twenties. This highlights the polarity between old and young, end and beginning.[70] With this new idea in mind, Titian changed the grandsons' facial features, as represented in the underpainting,

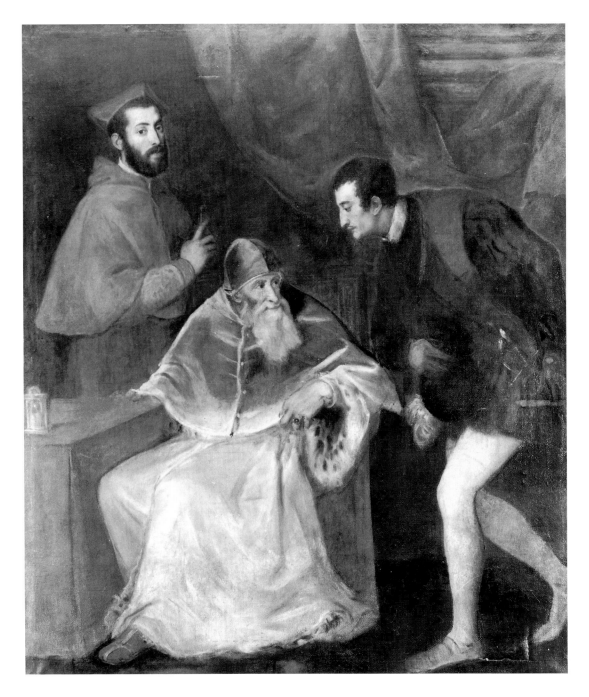

Fig. 34.　Titian, *Pope Paul III and His Grandsons*, 1545–46. Gallerie Nazionali di Capodimonte, Naples

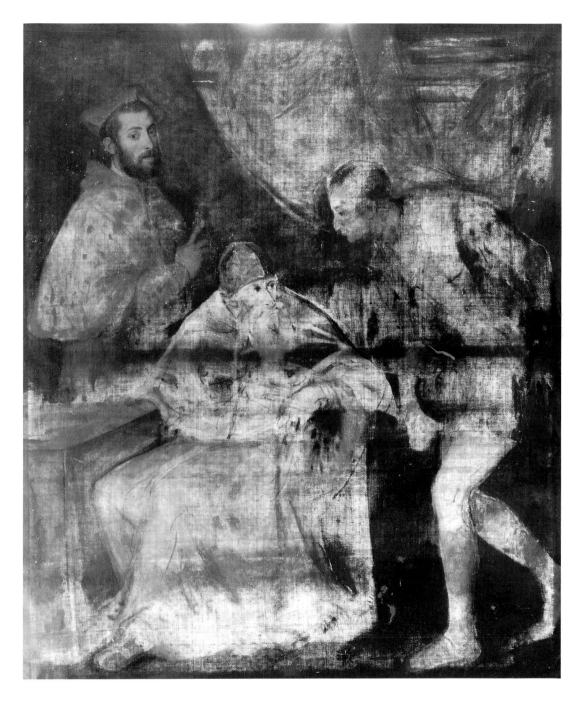

Fig. 35. Titian, *Pope Paul III and His Grandsons,* underpainting, X-ray photograph. Gallerie Nazionali di Capodimonte, Naples

to bring them closer to their real age, ennobling them somewhat—so Ottavio's nose is less hooked and Alessandro's face is better proportioned. A comparison between the underpainting and the final version confirms how much the subjects' likeness depended on the artist's overall plan. Titian did not just reproduce the subjects' countenances; he changed them in accordance with what he wanted to express, without destroying the surface resemblance between the images in the portraits and the real-life figures.

On immediate consideration, in the triple portrait the pope looks much the same as in the earlier paintings, especially that of 1545, where he is also shown wearing a *camauro*. He is in the same attire and in almost the same pose, with his left hand characteristically placed on the rounded arm of his chair. The major difference between the pope's figure in the single portrait of 1545 (Fig. 31) and in the group portrait is that in the latter he is seen full-length, with his head turned not toward the spectator but toward his princely grandson, approaching in the foreground. The full-length figure of the pope thus seems to recede partly into the background, while in the previous portrait his knee-length figure seems closer to the spectator. Here a new dimension of his personality is expressed: in the group portrait he is shown not only as the Supreme Pontiff of the Catholic Church but also—and even more important to him—as the head of his large family.[71]

Significantly, the pope and his grandsons are shown as if in motion. The portrait in which a sitter seems to have been caught in a momentary motion was introduced to Venice by Giorgione; this was a half-figure representation.[72] Sebastiano, Palma Vecchio, and of course Titian followed Giorgione's fashion, mostly also with half-figure compositions. These productions formed a new category, falling between standard portraits and allegorical images or action paintings. In standard portraits the subject poses before the spectator in static calm; he seems to be enveloped in an aura of eternity. A state of inactivity is likely to be more appropriate for expressing the permanent features rendered in the standard or state portrait.[73] External motion might invest the sitter's figure with a sense of transience and change, while the calm, still pose imparts a sense of permanence and stability. Yet, by presenting full-length figures in the group portrait as if in motion, Titian raised the "action" painting itself to the monumental scale (literally) of the state portrait. He invented the state "action" portrait.

Titian was almost certainly aware of an earlier papal portrait, Raphael's *Pope Leo X and His Nephews* (Fig. 36).[74] He may have been acquainted with Raphael's painting through Andrea del Sarto's copy, which was bought by the Duke of Mantua, who believed it to be Raphael's. The copy was so precise that even Giulio Romano believed it to be his master's genuine work.[75] Like Raphael, Titian represented the pope flanked by his two relatives; in both paintings, one of the pope's relatives clasps a chair finial. While Raphael's figures pose statically before the viewer, Titian's seems to interact one with another, thereby endowing his painting with an unprecedented sense of change and instability. While Raphael's portrait is somewhat reminiscent of the composition of a classical triptych, with the main figure flanked by two subordinate figures, Titian's is reminiscent of a stage scene, in which the main figure is the focus of attention of the two subordinate figures. Notably, in the background of Titian's portrait is a billowing brocade curtain, a detail lacking in Raphael's, further likening this portrait to a theatrical scene. Also, the scale differs: Titian's figures are

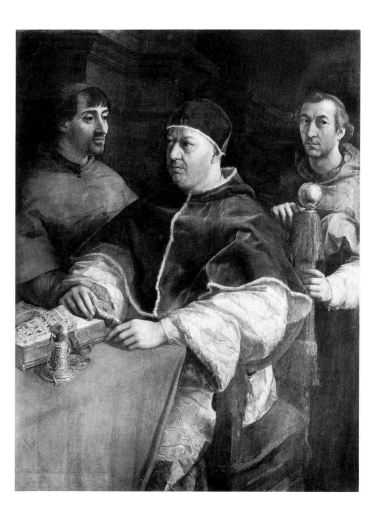

Fig. 36. Raphael, *Pope Leo X and His Nephews*, 1518–19. Uffizi, Florence

life-size and shown full-length (2.10 by 1.74 m); Raphael's are less than life-size and are shown to the knee (1.54 by 1.19 m). The two group portraits stem from different traditions, religious and secular: Raphael's portrait ultimately derives from the type of painting known today as *sacra conversazione* (an example of which, Domenico's *Saint Lucy Altarpiece* [Fig. 14], was mentioned in Chapter II, page 58); Titian's portrait derives from the Italian group portrait done mostly in a different medium—fresco. In a *sacra conversazione* painting, the main figure is symmetrically flanked by the others, while in the monumental group portrait (one recalls examples of Ghirlandaio and Mantegna), the members of a social gathering are grouped around an event. In Venice, both types of paintings of course existed; though there is no record of a group portrait in fresco, one may recall Gentile Bellini's and Carpaccio's narrative paintings in which, as in Tuscan and Northern Italian frescoes, the individuals are seen as united by a common interest.[76]

Thus, although Titian likely had Raphael's painting in mind when portraying the Farnese pope's family, his own conception was very different; he aspired to reinvent the state portrait. Titian's conception, with its life-size figures interacting in front of a

curtain, became axiomatic for such portraits in the Baroque period. In Titian's own time, this painting was unprecedented, as a portrait drama "almost Shakespearean in its intensity";[77] it is intended to immortalize the members of the Farnese family and at the same time to record one specific moment in the life of the great family.

The impression that the portrait conveys tension between the pope and the prince stems from outside knowledge of historical events involving the Farnese family at that time; there is no evidence beyond the portrait itself that Titian actually knew of the situation in the family.[78] In August 1545, before Titian's arrival in Rome, the pope withdrew the dukedom of Parma and Piacenza from papal territory held in fee in order to bestow it on his eldest son, Pierluigi, the father of Alessandro and Ottavio. Shortly thereafter, Prince Ottavio came to Rome to protest and demand that the pope grant the dukedom to him instead. Later the pope granted him another dukedom (Camerino), which nevertheless turned out to be inadequate to maintain his social position as the emperor's son-in-law.

Carlo Ridolfi once claimed that it was Cardinal Alessandro himself who commissioned Titian to paint the group Farnese portrait;[79] if so, it could have been his intention to show his brother the prince, as a representative secular ruler, paying his due to the pontiff. Nonetheless the painting is saturated with such a hitherto unknown sense of drama that historians of the period look at it as something of a historical document,[80] as though anticipating the events that were to result from the meeting between the pope and the prince. The pope's appropriating dukedoms from papal fee and presenting them to members of his own family embittered his supporters, as is revealed in a letter of August 23, 1545, from Cardinal Ercole Gonzaga to the Duke of Ferrara, in which he said that "the dear old man raises new dukes in his family."[81] As early as June 1546 the emperor communicated with Ferrante Gonzaga, the Imperial Governor of Milan, giving him to understand that it had become impossible to wait passively for the aged pope's death. In order to weaken him, a plot to murder his favorite son, Pierluigi (who himself aspired to govern Milan), was carried out in the spring of 1547. Rumors were circulated that Prince Ottavio had been involved in his father's murder. This family strife caused the aged pope much grief and might indeed have hastened his death.

Titian's painting could well refer to a specific meeting between the pope and the prince: perhaps the very meeting in which Prince Ottavio protested the pope's action regarding the dukedom of Parma and Piacenza—a protest that was to provide the impetus for the later violent events. The painting itself, to be sure, does not show the prince as protesting; rather he seems to revere his grandfather, though with a sly expression on his face as their glances do not meet. Seeming to have just entered the scene, he bows ceremoniously to his grandfather,[82] clasping a sheathed sword in his left hand, a plumed hat elegantly held in his right hand. The graceful figure of the prince seems to be moving closer to the pope, his aggressive profile with lowered lids thrust forward.

As he enters the room, the pope turns toward him. Cardinal Alessandro, who knows well the treacherous character of his brother, stands there as a witness to the scene.[83] Looking with a penetrating glance at the spectator, he stands erect behind the table, to the right of the pope, with his right index finger lifted as if in warning, in a gesture that

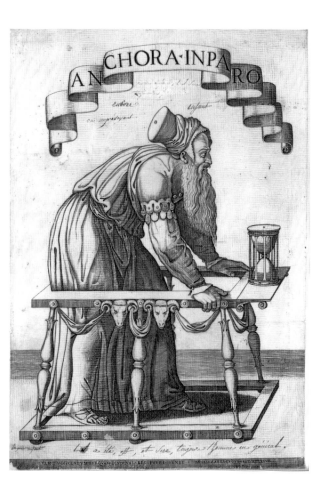

Fig. 37. Agostino Veneziano, *Anchora Inparo*, 1538, engraving. Museum of Fine Arts, Boston

attracts the spectator's attention. The zigzag-like figure of the pope is ill at ease between his two young relatives, Alessandro's pose echoing an exclamation mark and the prince's a question mark. The pope's figure seems even weaker, thinner, and smaller beside those of his vigorous grandsons. Only his air of wisdom and the powerful grasp of his left hand on the chair show that he is still in control.

On the table near the pope is a single object, a clock. This mechanical clock without a dial is almost identical in shape to the clock in the *Portrait of Eleonora Gonzaga della Rovere* (see Fig. 25). The X-ray photograph (Fig. 35) shows, although not very clearly, that Titian at first put an hourglass there but then replaced it with a mechanical clock.[84] A timepiece, whether hourglass or clock, had long been taken as an allusion to temperance, or, more significant in the context of this group portrait, as a *memento mori*. The emblematic literature often pictured an old man with an hourglass;[85] therefore Titian may have felt that the painting would evoke too strong an association between old age and mortality if he placed an hourglass near the gaunt old pope. Agostino Veneziano's print of 1538, for example, shows an old man trundling a child's cart with an hourglass on it. The print (Fig. 37) is inscribed "ANCHORA INPARO" (And still I learn), an allusion to Seneca's

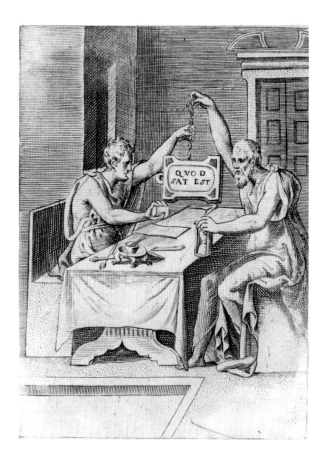

Fig. 38. Giulio Bonasone, *Quod Sat Est,* engraving iin Achille Bocchi's *Symbolicarum quaestionum de universo genere quas serio ludebat Libri V,* Bologna, 1574, Symb. LXVII

advice to learn "as long as you are ignorant, even to the end of your life."[86] A somewhat similar example is seen in the book of emblems of 1555 by Achille Bocchi, whose other work, *Annali di Bologna,* Aretino mentions in one of his letters (XXIV, 1537). Bocchi's book of emblems contains a drawing engraved by Giulio Bonasone (Fig. 38) representing a young man and an old man seated across a table.[87] Together they hold up in one hand a tablet with the motto, "QVOD SAT EST" (For it is sufficient). With the other hand, the young man pours sand on the written page to dry the ink, while the old man grasps an hourglass. The substitution of the mechanical clock for the hourglass is not surprising; Titian often includes a clock of this sort in his portraits. Nonetheless, the substitution may have been pointed: in contrast to the hourglass with its strong emblematic associations, a mechanical clock could be perceived as a status symbol as well, thereby becoming a less explicit symbol of mortality and vanitas. Be that as it may, the presence of the clock on the table along with the aggressive, imperious profile of Ottavio helps to heighten the dramatic tension in the Farnese group portrait.

The attire and the pose of the pope in the group portrait are similar to those in the 1545 portrait (see Figs. 31 and 34), but his appearance is quite different. In the single portrait the pope seems to be granting an audience to an unseen visitor; in the group portrait he is

shown receiving a particular visitor, his grandson, Prince Ottavio. In the single portrait, his questioning look is serene, not directed to any specific person; in the group portrait he may appear suspicious and fearful, to reflect the state of mind aroused by his conflict with the prince. The pope's powerful image in the single portrait is replaced by a weary, enfeebled one. In the earlier painting the pope's advanced age connoted wisdom and experience. In the group portrait the impression conveyed is one of enfeeblement. All this emerges clearly, yet the pope's likeness is easily recognizable in both paintings made by the master in the same year.

In Titian's oeuvre, then, the pope's likeness becomes something flexible, subject to change, depending on the idea of the personality the artist wants to convey. The three portraits together embody the many-sided role of the pope. In the "official" portrait, the pope has the unmistakable look of a ruler, pope even without his papal hat; in the "public" portrait, with his hat, he is reminiscent of an inquisitor; and in the group-portrait drama, he is the head of his large family. In each portrait, the likeness is the result of Titian's emphasis on certain personal features of his sitter, in accordance with his conception and purpose.

V

Charles V:
The *Concetto* of the Emperor

Pietro Aretino wrote to Empress Isabella, wife of Charles V, that Titian "is inflamed with the desire to show by the power of his hands Caesar himself to *the* Caesar" (LXVII, December 18, 1537).[1] He thus rhetorically declared that the painter's intention was not merely to represent the physical features of Charles V but to portray them so that they would convey true imperial majesty. For a successful portrait was one in which the painter conveyed both the likeness and the *concetto* of the subject. Aretino implied this same requirement in his letter and sonnet (XLVII) about the *Portrait of Francesco Maria della Rovere,* in which he claimed that Titian had transmitted both the lifelike image of the duke and his *concetto*—in that case, the Ideal Warrior.

Aretino was familiar with the portrait of the duke, but he had never actually seen the portraits of Pope Paul III or Charles V.[2] Thus his descriptions lack the specific details he offered about the paintings he knew firsthand. As his letters testify, however, he knew how Titian conceived the portraits, and thus his letters assist us in understanding the contemporary issues surrounding the portraits as well as the tasks Titian faced in their creation. In writing about the papal and imperial portraits (in letters addressed mostly to

members of the papal and imperial courts), Aretino emphasized those specific features he knew his audience would wish to see. He emphasized Titian's remarkable achievement in painting so extraordinary a likeness of Pope Paul III, and he stressed Titian's success in conveying the imperial essence of Charles V (the emperor's *concetto*). The double problem of portraiture discussed in Chapter II with regard to the Pitti *Pietro Aretino* in these cases is displayed in its two distinct, though in practice, inseparable, aspects: the problem of likeness (see Chapter IV) and the problem of *concetto*, illustrated by the imperial portraits.

In writing to the empress about Titian's intention to portray Charles V, Aretino claimed that Titian was the only master who was able to manifest visually Charles V's *concetto*, which obviously would have to be that of an emperor who wields absolute power. Aretino wrote this letter four years after Titian had finished the two portraits of the emperor done in 1532–33, *Charles V with a Hound* (see Fig. 40) and *Charles V in Armor* (see Fig. 39), known only from Britto's xylograph.[3] Yet Aretino did not mention either of these earlier portraits of Charles V, both of which had resulted from the first meeting between the emperor and Titian in Bologna in 1532.[4] Almost all of Aretino's letters about the actual portraits of the emperor date from 1548, when Titian painted both *The Equestrian Portrait of Charles V* (see Fig. 43) and *Charles V in an Armchair* (see Fig. 48).[5] It appears from Titian's extant works that he probably portrayed the emperor only during the years 1532–33 and 1548.[6] He depicted the emperor in two major roles: military and civilian. Analyzing Titian's portraits of Charles V, complemented by Aretino's letters, may cast light on the problems involved in transmitting the emperor's *concetto*.

Charles V and Titian's Commissions

Titian's task in portraying Charles V was facilitated by the fact that the emperor was "imperial in word and deed, in look and gesture, even in the greatness of his gifts," as Martin Bucer told Heinrich Bullinger in 1541.[7] Charles V was born in Ghent in 1500 to Philip the Handsome of Habsburg, the son of Maximilian I, and Joanna of Castile, the daughter of Ferdinand and Isabella. He was raised in the splendid Burgundian Court and educated in the tradition of princely knighthood. In 1516 he became a Knight of the Order of the Golden Fleece, to whose precepts he remained faithful all his life. In that same year, Erasmus dedicated to him his treatise *Institutio principis Christiani (The Education of a Christian Prince)*.[8] Deeply religious, Charles aspired to govern all the nations of Europe unified by the Erasmian ideal of *Universitas Christiana*. He became Holy Roman Emperor in 1519 and was crowned by Pope Clement VII in 1530. His ideal conception of his empire reached public recognition through the efforts of his chancellor, the Italian Mercurio Gattinara,[9] whose dream, passed on to the young Charles, was to revive the Christian monarchy of Charlemagne or Frederick II. Gattinara was inspired by this ideal, as propounded in Dante's *Monarchy*, which he

requested that Erasmus translate for the king. Charles's personal *impresa,* showing the two columns of Hercules, boundaries of the antique world, and the motto "PLUS ULTRA," testifies to his imperial aspirations; the *impresa* became familiar to his subjects through triumphal pageants all over Europe.[10]

To retain his hold on the vast territories, Charles was constantly involved in negotiations over dynastic marriages, and to keep the monarchy unified in the Christian faith, he was also frequently engaged in warring against infidels and heretics. He conducted his *bellum justum* in 1522 against the Moriscos in Spain, in 1532 against the Turks for hegemony in the Mediterranean, and in 1546–47 against the Protestants. Disenchanted by his subjects' shortcomings of faith and virtue, wearied by constant and fruitless negotiations, and suffering from severe attacks of gout and asthma, Charles often contemplated retirement long before his actual abdication in 1556. Two years later he died in the Monastery of San Jerónimo at Yuste, where he kept Titian's portrait of his beloved wife, Isabella, who died young, in 1539, along with other paintings by Titian.[11]

Charles's appearance and character are familiar from descriptions left by his contemporaries at various stages of his life.[12] He was well proportioned, neither short nor tall, and had a fair complexion. He had an irregular jaw that made his mouth appear always half-open.[13] His blue eyes seemed often to stare distractedly into space, with something of a fixed gaze. His nose was slightly bent sideways, and his blond beard was curly but scant. He had a melancholy temperament and was subject to frequent choleric outbursts, which he nevertheless brought under control. Although he was not handsome, his facial features had a majestic dignity that made him readily recognizable as the emperor.

In the contemporary panegyrical biographies of the emperor, the writers made an effort to eulogize his features as reflecting imperial majesty.[14] Influenced by the earliest description of this kind, Giovio's *Historiae sui temporis* (Book XXVII), Alfonso de Ulloa, in his more detailed *Vita dell'invittissimo e sacratissimo imperatore Carlo V,* describes Charles's features in the following way: "His face was all cheerful [tutto allegro]; he had blue eyes, suave and full of virile modesty. He had to a degree an aquiline nose, which signified greatness of soul in the Persian kings, as was observed already by the ancients; he wore a short beard and he so cut his hair that it reached to the middle of his ear, as was customary among the Roman emperors."[15] Charles's biographers repeatedly described him as having an aquiline nose (an important sign of imperial character according to physiognomists), even if in the portraits his nose does not always look to be of that shape. In his description Ulloa, following Giovio, looks for parallels in the ancient repertoire of eulogistic descriptions, seeing in them proof of Charles's noble ancestry and his manifest destiny to continue the ancient tradition.

Vasari claimed that Titian received the initial commission to portray the emperor through the influence of Aretino.[16] However, Aretino's letter to Isabella (LXVII), cited above, suggests that Charles decided to commission Titian when he saw Titian's portrait of his host, Federico Gonzaga (to whom Aretino had sent his own portrait by Titian in 1527), during an august visit to Mantua in 1532.[17] Further evidence is provided by

Federico's letter to Titian of November 7, 1532, urging the artist to come to Bologna as soon as possible in order to portray the emperor. Titian went to Bologna and remained there at least until March 10, 1533.[18] On May 10 of that year, Charles granted Titian a patent of nobility, in which, modeling himself on Alexander the Great, he proclaimed that Titian deserved "to be called the Apelles of this century," and granted him the sole privilege of making imperial portraits.[19]

The next invitation to portray Charles V reached Titian in Rome in 1546, when he was working on the portraits of the Farnese family. This imperial request was probably the main reason he interrupted his work for the Farneses, leaving the group portrait of Paul III and his grandsons unfinished.[20] Aretino alludes to the emperor's intention to commission his portraits from Titian in his letter dated March 1546 (cccxxxv, probably dated erroneously, for it was included in the fourth volume of Aretino's letters, published in 1550, and not in the third one, published in 1546) to the emperor's chancellor, Louis d'Ávila y Zúñiga.[21] In 1546, however, Charles was too busy preparing for war against the Protestants to pose for his portrait. Only later, after his decisive victory at Mühlberg on April 24, 1547, did he have the time to sit for Titian. In a letter of December 1547 (ccclxxix), Aretino congratulated Titian on his finally setting out for Augsburg. Titian arrived there in January 1548 and stayed until December of that year, as we know from Aretino's December letter (xdii) to Giovanni Onale, reporting Titian's return to Venice.[22] The precise dates of Titian's work on the imperial portraits are not documented, yet it is clear that in Augsburg that year he also portrayed most of the members of the Diet, and the emperor rewarded him with a double life pension.

The 1548 portraits are intensely perceptive. This final mastery resulted in part from the skills Titian had gained as a portraitist since his work on the first two portraits of Charles V in 1532–33. More important, by 1548 Titian's conception of how to portray the emperor had evolved further; the emperor's image, his *concetto*, had become clarified. Those early portraits, nonetheless, already contained at their core Titian's perception of the twofold function of the emperor on behalf of his people.

The Early Portraits: Military and Civilian

Titian likely received his patent of nobility for executing *Charles V in Armor* because of its importance for the emperor's fame and his hold on the affection of his people.[23] Vasari mentioned this painting but erroneously dated it 1530, the year of Charles's coronation by Pope Clement VII in Bologna.[24] Although Charles granted Titian the patent of nobility, he did not express great enthusiasm for the portrait, but conveyed a preference for the portrait done by Francisco de Hollanda's brother in Toledo.[25] Despite his predilection for non-Italian artists, however, Charles bestowed upon Titian the sole right to portray him, and it is chiefly due to Titian's portraits that Charles's image is so familiar today. Judging from Britto's xylograph (Fig. 39), this portrait represented the half-figure of Charles in armor, but without a helmet, holding a long sword in his mailed right hand.

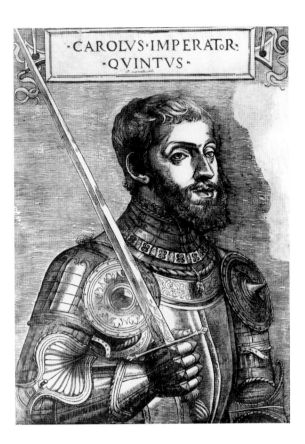

·CAROLVS·IMPERAToR·
·QVINTVS·

Fig. 39. Giovanni Britto after Titian, *Charles V in Armor*, 1532, xylograph. Graphische Sammlung Albertina, Vienna

He is shown as the "Defender of the Faith" (Diffensore de la Fede),[26] which he was proclaimed to be at his 1530 coronation. When Titian was commissioned for this work two years later, Charles had already earned the title by his victory over the Muslims.[27]

The sword in Charles's hand is an obvious allusion to imperial power, but its fuller meaning is to be inferred from Erasmus's *Education of a Christian Prince*, written for Charles in 1516, when he was sixteen years old.[28] Erasmus advised the young prince to ponder the meanings of the royal trappings; he asked rhetorically what the meaning was of holding a sword, and replied that it signified that "his country ought to be safe under the protection of this man, safe both from outside enemies and those within."[29] Erasmus then added that if the prince himself does not have virtuous qualities, "these symbols are not ornaments to him." Later the great humanist asked: "What is it that distinguishes a real king from the actor?" His answer was, "It is the spirit befitting a prince," an answer that is indeed relevant to these portraits.[30] Incidentally, Erasmus warned the prince against commissioning portraits, remarking that "if there is anything praiseworthy in them, it is due to the artist whose genius and work they represent."[31]

As the xylograph shows, Titian ennobled Charles's physical features, slightly correcting his natural blemishes in order to convey his princely spirit. Besides idealization, the other important sign of the royal figure in this portrait is the paucity of appurtenances. The battle armor and the unsheathed sword are the only accessories that indicate the

sitter's imperial identity.[32] We may recall that a few years later, around 1537, Titian was to portray the Duke of Urbino against a background rich in accessories (see Fig. 21). But at the same time, Titian was also at work on images of the Roman emperors for Federico Gonzaga's palace; these ancient rulers, all in stylized dress, notably held only marshals' batons (see Fig. 23). The presence of only a few external signs is one of the main attributes of imperial representations.

After Titian completed this painting, Charles may well have requested that he copy Jakob Seisenegger's painting *Charles V with a Hound* (Figs. 40 and 41), made shortly before by this Austrian painter for Charles's brother Ferdinand I.[33] The precise history of these two paintings—Seisenegger's and Titian's—is not known, however, and so we can only speculate. Perhaps the emperor commissioned a copy of this painting after seeing Titian's portrait of Federico Gonzaga, in three-quarters view, with his right hand firmly on the back of a pet dog (Fig. 42).[34] (Aretino's letter to Empress Isabella suggests that this was indeed the case.) Or perhaps Charles wished to be seen again with his favorite dog (according to Marin Sanudo, Charles owned a large dog).[35] There must also have been a political motive because in the cinquecento a dog, especially a hound like the one in the emperor's portrait, was commonly associated with a ruler.

According to the widely circulated ancient treatise on Egyptian hieroglyphs, the so-called *Horapollo* (known at least since 1415 and published in Venice in 1505), the hieroglyph with the canine figure may indicate a "sacred scribe, or a prophet, or an embalmer, or spleen, or odour, or laughter, or sneezing, or a ruler, or a judge."[36] Although the Italian humanists knew of the wide range of its symbolic meanings, usually the hound symbolized a ruler. Piero della Francesca, for example, placed two hounds, one black, one white, near the kneeling Sigismondo Malatesta, the local ruler, in the fresco in Rimini in 1451.[37] In Titian's time, Valeriano, in the section about rulers in his treatise *Hieroglyphica, sive de sacris Aegyptiorum* (1567), explained that according to the Egyptians dogs signify priests, rulers, and legislators.[38] His explanation was accompanied by a picture of a hound somewhat resembling that in the Seisenegger portrait.

One of the sources for Seisenegger's portrait could have been Hans Burgkmair's woodcut that shows the artist being visited by Maximilian I (Charles V's grandfather),[39] who is accompanied by a hound in a collar. It seems unlikely, however, that Seisenegger included the hound merely to indicate that the person portrayed was a ruler. He may have intended more specific associations with the Tudor dynasty. In this portrait, as in Titian's, the large white hound is shown fawning upon Charles, who is holding it by the collar. When presenting his report to Ferdinand I about the portrait, Seisenegger designated the dog as an "English water dog."[40] The Tudor dynasty in the sixteenth century in fact regarded the white hound with gold-studded red collar as the family's special mascot.[41] On Henry VIII's military expedition to Tournai in 1513, the image of a white hound with a gold-studded red collar decorated his royal banner.[42] At the time Titian portrayed Charles V, Henry VIII cherished the hope that the emperor would help him secure the pope's permission to divorce; Charles, for his part, dreamed of bringing the kingdom of England under his dominion. This sophisticated diplomatic game, begun in 1529, ended in 1533, when Henry VIII, disappointed with Charles, sought an alliance with the king of

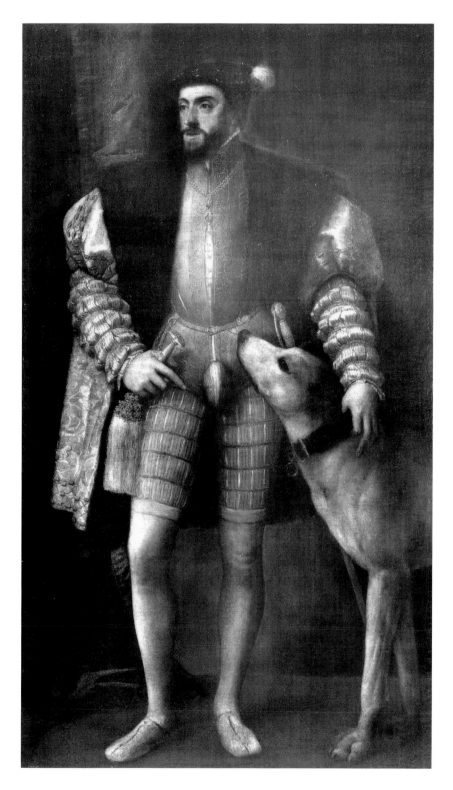

Fig. 40. Titian, *Charles V with a Hound*, 1533. Museo del Prado, Madrid

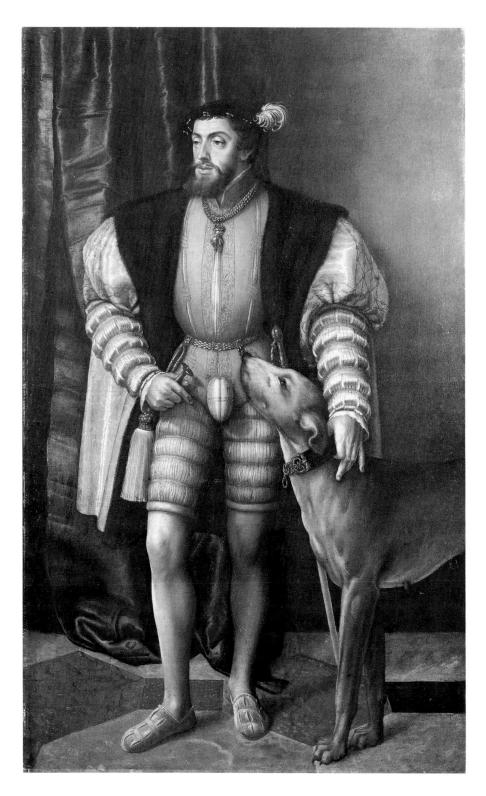

Fig. 41. Jakob Seisenegger, *Charles V with a Hound*, 1532–33. Kunsthistorisches Museum, Vienna

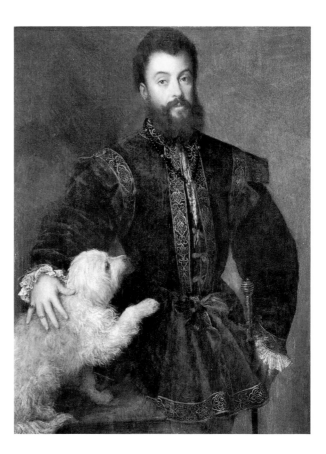

Fig. 42. Titian, *Frederico Gonzaga, c. 1525.*
Museo del Prado, Madrid

France, the emperor's rival.[43] Charles could well have had political reasons for requesting that Titian copy Seisenegger's painting: in 1532–33 the presence of a fawning white hound in Charles's portrait may have been meant to evoke an association with the Tudor dynasty and the emperor's English ambitions.

In copying Seisenegger's painting, if that is indeed what he was supposed to do,[44] Titian encountered the full-length portrait, the type of state portrait favored in Northern Europe and to some extent in Northern Italy. The two earliest-known Italian examples were Carpaccio's *Portrait of a Knight* of 1510 (see Fig. 22) and Moretto's *Portrait of a Man* of 1526.[45] (In Florence this type of portrait practically did not exist.) Titian thus was not deviating from the northern tradition when in 1532 he began to employ and develop this type of state portrait, adducing to it a hitherto unknown grandeur. The full-length portrait has by definition a statuary quality, making it possible to emulate ancient statues as well as to rival contemporary sculptures. (As for the portrait with the dog, it too gained a certain popularity at the time; not only had Titian portrayed Federico Gonzaga with a dog, but Bronzino was to render the muzzle of a hunting dog in the portrait of Guidobaldo II della Rovere.)[46] Through "copying" Seisenegger's portrait Titian explored the possibilities latent in this type of painting, and in so doing he transformed the model. The aspects of Seisenegger's portrait—the standing full-length figure, a long-bodied hound, a curtain

in the background—all became part of Titian's heritage to the Baroque artists; Rubens, Van Dyck, and Velázquez, to name the greatest portraitists, would each be indebted to Titian. Titian and his Baroque followers would use the full-length state portrait for creating numerous other imperial portraits; Titian himself was to revert to it while portraying Charles V's son, Philip II.

In comparing Titian's painting (Fig. 40) and Seisenegger's (Fig. 41), one can easily detect the changes Titian made that turned the model into a masterpiece. Both painters represented Charles V in full height against a dark green brocade curtain. Charles wears a plumed beret and is dressed in the parade suit with a pelisse that was customary for royal ceremonies. Seisenegger seems to reproduce faithfully Charles's features as recorded in contemporary accounts. In copying the portrait, however, Titian slightly changed the emperor's asymmetrical features, spiritualizing them somewhat. The figure in Titian's portrait is taller and leaner than in Seisenegger's; with the blue eyes and penetrating gaze radiating authority, he embodies the ruler's strong will. Titian counterbalanced the standing figure with a broadly treated curtain that resembles a slender column. He paid little attention to particular details of the costume, thereby giving a unified overall impression of the painting. Also, Charles's shoes and the floor are quite plain, without any of the intricate patterns depicted in Seisenegger's painstakingly detailed picture. The plainness of the surroundings and the uniform further focus the viewer's attention on the majestic visage of the emperor. An air of dignity and imperial serenity emanates from the whole painting, achieved by Titian's masterly idealization of the emperor's features and the skillful consonance with his dress and surroundings.

The portraits of 1532–33, the one showing Charles V with a sword and the other with a hound, correspond to the twofold nature of the emperor's function: defensive and legislative.[47] These two early portraits marked the first stage in the painter's setting out to evolve an effective way of portraying the distinctively imperial character, a development that reached its culmination in the Augsburg portraits fifteen years later. For example, the early *Charles V with a Hound* (see Fig. 40) is notably larger than the portrait of Federico Gonzaga (see Fig. 42). In addition, Charles's imperial identity is communicated by his pose and dress, which includes a plumed beret and a splendid pelisse. The scale of the portrait, the full-length posture, and the magnificence of the costume together indicate his imperial character. In *Charles V in Armor* (see Fig. 39), the paucity of appurtenances actually assists in identifying the subject as the emperor.

These two early portraits, then, show Titian already beginning to portray the emperor by idealizing the figure, using a grand scale, and minimizing the number of attributes—all these were to remain part of the painter's repertoire, which he used again in the later portraits of 1548 to reveal the imperial essence of their subject. At the same time, the two early portraits point to the overall conception of the emperor's twofold function, which Titian would broaden in 1548 with pictorial allusions to its Roman imperial origin. The painter would also add the specific medieval conception of the twofold nature of the king's being, both mortal and eternal.

The Equestrian Portrait

Titian's *Equestrian Portrait of Charles V* (Fig. 43) was intended to commemorate the emperor's victory over the Schmalkaldic League of the united Protestant forces at the decisive battle of Mühlberg on April 24, 1547.[48] The painting accords well with the contemporary historian Ulloa's description of Charles V during the glorious days of the Mühlberg battle. In his *Vita dell'invittissimo e sacratissimo imperatore Carlo V,* he noted that Charles was dressed in splendid armor,[49] adorned with a red sash over his shoulder, as we see in Titian's painting. He was mounted on a black "cauallo Spagnuolo" covered with a crimson saddle cloth.[50] The color red was emblematic of the Catholic group in the sixteenth-century religious wars.[51] In the section of his book dealing with Charles's tastes and habits, Ulloa emphasized not only the king's love of horses but also the indescribable grace with which he handled a horse, especially when dressed in armor.[52]

Renaissance equestrian monuments, statues, and frescoes were generally modeled on the bronze statue of Marcus Aurelius (Fig. 44),[53] as can be seen in a work done shortly before Titian's, the equestrian portrait of Francis I (Fig. 45), attributed to François Clouet;[54] though this work is small in scale, it is clear that the French artist closely followed the ancient model. Titian departed from this tradition: instead of showing the horse and rider in a seemingly static position with the horse standing on three legs, one foreleg slightly lifted (or as it looks unnatural in Clouet's work, where both one foreleg and one hindleg are lifted), he rendered Charles's horse as if in motion, somewhat reared up on its hind legs and prancing with its forelegs. Moreover, the way the emperor holds himself on his prancing steed demonstrates his fine horsemanship. Titian underlines his princely origin by showing him sitting lightly on his mount, holding the reins casually, while his horse obediently lowers its graceful head, adorned with a red plume.[55]

Since antiquity, accomplished horsemanship had been regarded as a pursuit of the nobleman. Xenophon presented the precepts of good horsemanship in his treatise *Hipparchicus,* known in the sixteenth century from the Giunti edition of 1516. In this treatise Xenophon recommended that the rider loosen his grip on the reins as soon as the steed "prances in fine style" (xi.7).[56] This may explain the lightness with which Charles holds the reins in his mailed left hand and the lance in his right hand. Moreover, Xenophon considered the prancing steed as "the attitude in which the artists represent the horses on which gods and heroes ride" (xi.8). He then added that "men who manage such horses gracefully have a magnificent appearance" (xi.8). There is no other equestrian portrait before Titian's that fits this description of the ideal pose for a rider as precisely as does this image of Charles V.

Titian shows Charles against a landscape background, as if emerging from a wild dark forest (*selva oscura*) into an open field.[57] On the horizon the sun's rays disperse the clouds of night. Ulloa describes that memorable day, when the battle started one hour before midday and ended an hour after sunset. He particularly emphasizes that the victory came on Sunday after Easter, thus reading into it symbolic significance.[58] The king was supposed to observe the battlefield before the battle started, so Titian could appropriately (following contemporary accounts) present the emperor early in the morning.

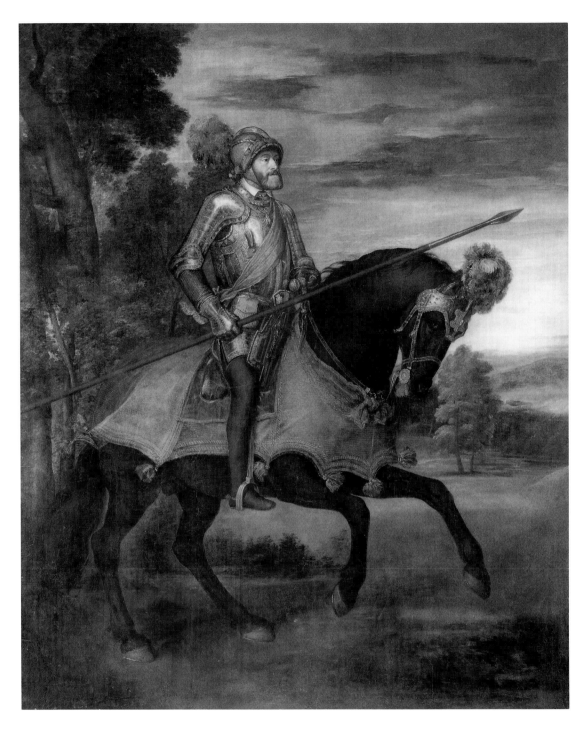

Fig. 43. Titian, *Equestrian Portrait of Charles V*, 1548. Museo del Prado, Madrid

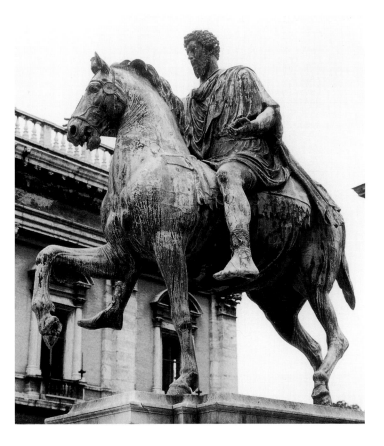

Fig. 44. *Marcus Aurelius*, bronze.
Rome, Piazza del Campidoglio

A landscape at sunrise evokes associations with the first Christian emperor, Constantine. In sixteenth-century Europe, Constantine was thought to be a model for contemporary monarchs, which perhaps encouraged artists such as Giulio Romano to paint him and which might in turn have strongly influenced Titian's conception of the emperor's image.[59] Historians of the time frequently drew parallels between Charles V's battle with John Frederick, the head of the Schmalkaldic League, and Constantine's battle with Maxentius. Just as Constantine's victory in 312 signified the triumph of Christianity over the pagans, Charles's victory in 1547 signified the triumph of Catholicism over the Protestant faith. Charles was always mindful that first and foremost he must be the Christian prince, whose most important task was to protect the Christian faith from heresy.[60] Titian's equestrian portrait noticeably alludes to the imagery employed in Erasmus's *Education of the Christian Prince*, itself inspired by the ancient theories of statecraft. Paraphrasing Plutarch's *Discourse to an Unlearned Prince* (3.780E), Erasmus drew a metaphorical parallel between the sun in the heavens and the king among the people: "God placed a beautiful likeness of Himself in the Heavens—the sun," said Erasmus, and so among "mortal men he set up a tangible and living image of himself—the king."[61] The landscape at sunrise in this portrait of Charles therefore not only recalled Constantine's victory but also symbolized the unique role of the Christian monarch as Erasmus envisioned it.

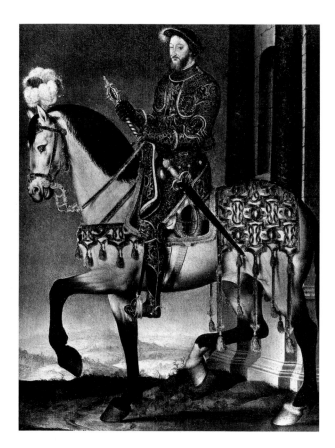

Fig. 45. François Clouet, *Equestrian Portrait of Francis I, c.* 1540. Uffizi, Florence

Ulloa underlined the difference between Charles V, the Christian emperor, and Julius Caesar, the pagan ruler, in their attitudes toward military victory: unlike his pagan counterpart, Charles attributed his victory to divine will, exclaiming in Spanish: "Vine y vi, y Dios vencio" (I came, and I saw, and God conquered)[62]—how different from Julius Caesar's "Veni, vidi, vici." Charles's exclamation was also recorded by Aretino in a letter to Louis d'Ávila (cccxxxv), which is probably erroneously dated March 1546.[63] Most likely this letter was written in 1547, for in it Aretino praised the chancellor's memoirs of the battle, which were completed in that year.[64] Noting the chancellor's mention of Charles's exclamation, Aretino quoted it again, underscoring the emperor's Christian conduct and, like Ulloa after him, contrasting the Christian emperor's *umiltà* with the pagan ruler's *superbia.*

The image of Charles mounted on a black steed and holding a long lance, set against a landscape at sunrise, thus bears a dual meaning (see Fig. 43). It is reminiscent of the first Christian emperor, Constantine, and also of the traditional image of a military knight-saint, such as Saint George.[65] The connection between Charles and the knight-saint is implied by the Order of the Golden Fleece, which Charles wore during battle. His upright posture and his face, covered down to the eyes by his helmet, are reminiscent of the *Miles Christianus* in Dürer's famous engraving of 1513, *The Knight, Death,*

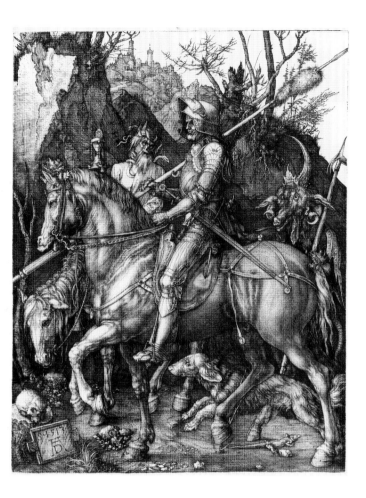

Fig. 46. Albrecht Dürer, *The Knight, Death, and the Devil,* 1513, engraving. The Metropolitan Museum of Art, New York

and the Devil (Fig. 46), itself inspired by Erasmus's *Enchiridion Militis Christiani* (The handbook of the Christian soldier).[66] At the same time, the depiction of Charles in battle armor and holding a lance, the ancient Roman *hasta,* instead of the common marshal's baton (anachronistically held by Titian's *The Emperor Claudius* [see Fig. 23]; this detail attracted Panofsky's attention)[67] while riding a prancing horse, recalls the traditional formula of the *decursio* of the Roman emperor, familiar during the Renaissance from imperial coins.[68] The *decursio,* the emperor's ritual of surveying the field before a battle, was part of the broader subject of the *profectio,* the inauguration of a military campaign.[69]

It should be noted that the equestrian images of the knight-saint or the Roman emperor on a prancing horse were seldom represented on their own. Saint George was usually shown battling the dragon; Dürer's *Miles Christianus* was depicted riding alongside Satan and Death. Then, too, on the Roman coins with a *decursio* of Trajan or Marcus Aurelius, the ruler was often pictured amid an entourage of soldiers, as on a coin from Nero's reign (Fig. 47), one of the earliest of this kind.[70] In divorcing the equestrian image from any narrative context, Titian probably followed the example of Burgkmair's chiaroscuro

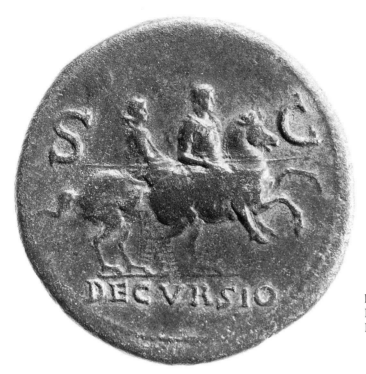

Fig. 47. *Decursio Augusti*, coin of Nero.
By permission of the Trustees of the
British Museum, London

woodcut of 1508, which showed Emperor Maximilian I mounted on a horse.[71] By showing
the rider against the background of the Habsburg cloth-of-honor seen in the span of the
triumphal arch, Burgkmair's woodcut evokes an almost theatrical impression of the rider
as if on the stage. Although Titian may have borrowed from Burgkmair the conception of
the emperor as a lone rider, he created a quite different impression—that of an active
dramatic episode.

Alone on horseback against the open field at sunrise, as if about to confront an unseen
enemy, Charles appears to be under divine protection. The portrait is imbued with a deep
sense of spiritual renewal. Titian's painting seems to be influenced by Dante's prophetic
image of the monarch-savior, who was to enter the land of Italy on a horse.[72] For Dante
the image of the monarch-savior was an allegory of the good ruler, who leads his people
without force, just as the horse willingly obeys his rider's command (*Convivio* IV.ix.10).[73]
So Titian's image of Charles V becomes the pictorial embodiment of the Christian Ruler
leading the Christian people of his Universal Monarchy toward spiritual rebirth.

Aretino on the Equestrian Portrait

Aretino almost certainly had no firsthand acquaintance with Titian's *Equestrian Portrait of
Charles V*, for, as we know from his letters, he never traveled to Augsburg, where the

painting was kept.[74] Aretino spoke nonetheless of the (prospective) painting as early as 1547 in the above-mentioned letter to Louis d'Ávila. In this letter Aretino drew a parallel between the chancellor's vivid picture of the battle and the painting Titian was commissioned to paint at that time.[75] Giovio also alluded to Titian in his own letter, of August 14, 1548, to the chancellor regarding those memoirs, probably following Aretino's example in this comparison (he could have been familiar with Aretino's letter before its publication in 1550), though it is not clear whether he is referring to this specific portrait.[76] (We may recall in this context the parallel drawn in Chapter II [page 36] between Titian's visually recording the historical event in the *Allocution of Alfonso d'Avalos, Marchese del Vasto* [see Fig. 6] and Aretino's commemorating it verbally.) Both Aretino and Giovio related the *energeia* with which the chancellor's text is written to the vividness of the pictorial representation; even if such a comparison was traditionally rhetorical, it is nonetheless indicative here of the reputation for the special lifelike qualities that Titian's portrait had.

The earliest letter in which Aretino mentions the equestrian portrait as such was written in January 1548, when Titian had barely begun work. He addressed this letter (CCCLXXXV) to Nicola Perrenot de Granvelle, the emperor's minister, who became especially influential after Gattinara's death. Here again Aretino states what the viewer could expect to see in Titian's work. Calling Titian the Apelles of the emperor, Aretino points out the unusual aspect of this painting—its outward simplicity. He states that Charles is seen alone, without people or military machines. Charles's fearless look infuses the portrait, says Aretino, with something "terribile," the look that made his people believe he was acting according to divine will.[77] That Aretino's letter lacks specific details is not surprising, because he had not seen the portrait. Nonetheless, he knew how to persuade the minister to see in Titian's painting an enigmatic personality endowed with innate royal dignity.

In the same spirit of persuasion, Aretino wrote to Antonio Castriota, the Duke of Ferrandina, a distinguished nobleman from Charles's retinue, on February 17, 1548 (XCDV), shortly before the duke was killed in a duel on Murano. Aretino wrote that Titian expressed the quality of majesty and dignity so convincingly that the portrait produced an exceptionally strong response from its viewers. The painting manifested both the human and divine qualities of the imperial image. The glorious light emanating from Charles's brow made his image resemble "semideo ed eroe" (half-deity and hero).[78] Aretino's assertion demonstrates his knowledge of the panegyric lexicon of divinity used in ancient writings regarding renditions of the Roman emperors, as in Martial's epigram that describes Domitian's portrait as radiating glorious light (*Epigrammata* VIII.lxv.3–4).[79] Aretino went on to say that Titian showed the emperor's grandeur with a skill worthy of Apelles and that the painting conveyed the sense of faith, glory, and magnificence always associated with the monarch as he was in reality.[80]

These two letters addressed to members of the court suggest that Titian was charged with the important task of making a portrait of Charles V that would satisfy the needs of imperial propaganda. Often speaking in his letters of a parallel between Titian and Apelles, Aretino also invoked a parallel between Charles V and Alexander the Great.

Moreover, though praising Titian's mastery, Aretino attributes the greatness of the por-
traits to the grandeur of the emperor himself. So the letters reveal how Aretino, equally
familiar with the traditional rhetorical lexicon and with public expectations, prepared his
audience to receive Titian's painting: to see it first of all as the representation of imperial
majesty.

Besides writing to the members of the imperial court, Aretino wrote to Titian himself
(CDXII, April 1548) regarding his work on the emperor's equestrian portrait.[81] This is by
far Aretino's most famous letter on Titian's portraits, partly because it is addressed to the
artist himself. In writing to the imperial courtiers, Aretino admired the simplicity of the
painting, altogether implying that what infused the painting with its utmost significance
was its imperial glory. These courtly letters are encomia on the emperor's victory rather
than on Titian's mastery. In writing to Titian himself—and in the open letter (published
in the fourth volume of his letters in 1550)—Aretino had a different purpose. He
addressed him first of all as "Vecellio Apelle," thus implying that Titian's task was to bring
out parallels between Charles V and Alexander the Great. He then suggested what
sometimes is called his program for the painting. By April 1548, however, Titian most
likely had not only decided how he wanted to portray the emperor but also already had
the emperor's approval to represent him in the way he did. By April 1548 the painting
was far from complete, but its idea was clear, as Aretino's letters to the courtiers testify. In
all probability Aretino's letter to Titian provides an *ekphrasis* of a painting Titian never
thought or would have thought to paint, a painting that existed solely in Aretino's mind,
influenced probably by imperial pageantry. Let us look closely at this letter.

As in his letters to the courtiers, Aretino mentioned the documentary precision of
Titian's painting, remarking that he presented the emperor in the same armor and on the
same steed he had actually used during the battle. (Louis d'Ávila described the steed in
detail,[82] and the description was repeated by Ulloa.) Although basically approving the
rendition of the emperor as a single rider and admiring Titian's historical precision,
Aretino nonetheless proposed that two allegorical figures be added to make the painting
more meaningful: Religion, holding a chalice and a cross, and Fame, holding a trumpet
and a globe.[83] He implied that the message of the portrait would thereby become more
explicit and persuasive for the contemporary audience. Only in this way would the work
"continue in the mind the ancient mode of imperial action."[84] Thus Aretino indirectly
hinted at the source of his inspiration: Pliny's description of a painting by Apelles in
which Alexander the Great was shown in a chariot accompanied by the figure of War
with its hands tied behind its back (*Natural History* XXXV.93). Aretino expressed his wish
that the painting, besides commemorating Charles V's victory at Mühlberg, should be a
Christian allegory. His proposal was perhaps inspired by the decorations of the pageantry
that were inseparable from imperial propaganda. He was well acquainted with such
displays; one of his letters to Vasari (XI) describes the *Triumph of Charles V* in Florence,
where the colossal statue of the emperor was surrounded by allegorical figures of Piety,
Faith, Justice, and Victory.[85] Aretino of course was familiar also with the other no less
proverbial painting by Apelles, in which Antigonus was represented seated on horseback,
for Pliny remarked that "connoisseurs put at the head of all his [Apelles'] works the

portrait of the same king" (xxxv.96).[86] Yet in stressing the desirability of adding the allegorical figures, Aretino was probably hinting that Titian's equestrian portrait should be modeled only on that of Alexander and not on that of Antigonus. Even though Apelles' contemporaries believed his portrait of Antigonus to be his finest painting, Charles V evoked an image of Alexander in the eyes of Titian's (and Aretino's) contemporaries. Most probably this association was Aretino's main reason for expressing his wish to add the allegorical figures in the equestrian portrait of Charles V.

Later, in November 1548, Aretino sent a sonnet on a portrait of the emperor to Louis d'Ávila. This sonnet (which offers no clue as to the portrait's composition) most likely does not refer to the equestrian portrait but to Titian's other portrait, *Charles V in an Armchair* (see Fig. 48),[87] to be discussed shortly. In his sonnet Aretino puts the panegyric lexicon to utmost use; his accompanying letter (CDLXXXI) indicates that in writing this sonnet he presents his own compositon in which he feels obliged to speak about the emperor.[88] In his verbal portrait Aretino implicitly suggests that the painting is infused with great spirit, the spirit of the emperor. The sonnet's language is so ornate that it is hard to see the painting behind the rhetorical veil. Aretino speaks loftily, using, for example, in the first quatrain "idea" and "spiritual disegno," "il santo essempio" and "sacra pittura." In the second quatrain he claims that Titian demonstrated in the "tacit figure" (tacita figura) the same power with which the ruler rules and incites hope and fear. By calling the image in the portrait the "tacit figure," Aretino reminds his listeners of the visual-audible connections between the portrait and his sonnet, which makes the mute figure eloquent. In the concluding tercets Aretino turns to a laudatory description of the emperor's visage. His description has hardly anything to do with the painting; rather, he imagines how the face in the portrait *ought* to look. His choice of words—"giustizia" and "clemenza" in the emperor's eyes, "virtù" and "fortuna" between his brows, "alterezza" and "grazia" in his whole presence—demonstrates his familiarity with the lexicon of imperial praise.

Charles V in an Armchair

Titian portrayed Charles V at least twice in 1548: first in a suit of armor and then in civilian dress, analogous to his work of fifteen years before. His first painting, the equestrian portrait, became familiar to the public and, as we have said, it may have served as an effective means of imperial propaganda. The second portrait, *Charles V in an Armchair* (Fig. 48), seems more private, for the emperor is depicted almost without imperial insignias.

The composition of the portrait may have been inspired by one of the panel reliefs on the Arch of Constantine, which Titian could have observed *in situ* during his visit to Rome in 1545–46.[89] Charles's stooped posture is reminiscent of the Roman emperor's in the panel relief with a scene of *Liberalitas* (Fig. 49).[90] At the same time, the placing of Charles's legs and the heavy folds of his coat convey the same majesty and dignity as in the well-known fragmentary statue of Jove enthroned, which at that time stood near the

Fig. 48. Titian, *Charles V in an Armchair*, 1548. Alte Pinakothek, Munich

Fig. 49. *The Liberalitas Scene,*
Detail of the Arch of Constantine,
Rome

Villa Madama (Fig. 50).[91] I should note that a statue of Jove similar to this served as a
prototype for representing Alexander the Great seated. Charles's figure imparts a sense of
both dignity and weariness; its eloquence is in part due to its clear allusions to the well-
known ancient statues.

In Roman imperial imagery, the emperor seated and in civilian dress appeared only in
scenes of *Liberalitas,* the ritual that concluded a time of warfare and inaugurated an era of
peace;[92] the emperor appeared in public to discharge his soldiers and promise security for
the citizens. These acts were regarded as a display of the emperor's civic virtues, such as
clemency, justice, and beneficence. The conception of the prince's liberality in this
classical sense was treated intensively by Erasmus; in the fifth section of *The Education of a
Christian Prince,* he drew Charles's attention to its particular importance.[93] Roman repre-
sentations of *Liberalitas* as a rule showed the emperor in a toga, seated in the *sella curulis*
(an attribute of high legislative office).[94] In later centuries he was presented in the same
scene seated in the *sella castrensis.* In Titian's painting, Charles's chair resembles the *sella
castrensis* rendered in the *Liberalitas* relief on the Arch of Constantine.[95] In this kind of

Fig. 50. *Jove Enthroned,* lower half of colossal
Roman statue, marble. Museo Nazionale, Naples

scene, however, the emperor was never displayed alone but was surrounded by people seeking benefits.

In Titian's painting, Charles V is seated in a wooden chair upholstered in fringed red cloth and on a red carpet. At his left is an aperture through which is seen a cloudy landscape with a few scattered poplar trees, one of which stands alone in the foreground. (This view was probably completed by Lambert Sustris.) An aperture in the background had by this time become a standard feature of Titian's portraits, like those of Eleonora Gonzaga (see Fig. 25) and Pope Paul III with a hat (see Fig. 31). In this painting Charles is shown against a wall with a purple cloth-of-honor (the only sign of the imperial regalia), flanked by a column.

In Roman imperial coinage the column was associated with the personification of *Securitas.*[96] In his panegyrical ode to Augustus, Horace expressed his confidence in the imperial patronage with the simile of a column (*Carminum Liber* II.xvii.3–4: "Maecenas, mearum / grande decus columenque rerum").[97] In the mind of the Renaissance connoisseur, as is evident from Dolce's *Dialogo . . . de i colori,* a book on all sorts of useful knowledge, a column signified fortitude.[98] A feature that will become standard in seventeenth-century portraiture, the column only rarely appeared in portraiture in Titian's time. It was first employed in Northern European portraiture, as, for example, in Justus of Ghent's portrait of Pope Sixtus IV, who is seen blessing people on the balcony flanked by a column. That

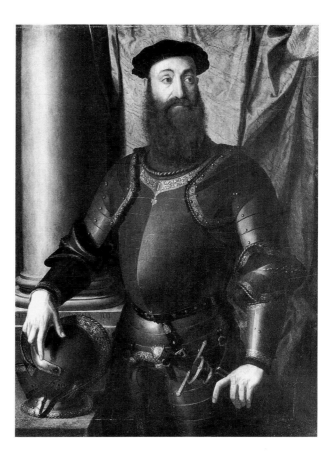

Fig. 51. Agnolo Bronzino, *Stefano Colonna*,
1546. Gallerria Nazionale d'Arte Antica in
Palazzo Barberini, Rome

painting was part of the *Famous Men* series done for Federico da Montefeltro and so was
familiar to artists in Italy.[99] The motif of the figure beside an aperture flanked with a column
was introduced into Italian painting by Leonardo, who presented Mona Lisa in that way,
though the columns that flanked the loggia are now barely seen, as that painting later was
cut.[100] The presentation of a person beside a column on a pedestal began with Moretto's
full-length portrait, dated 1526. Bronzino in turn rendered Stefano Colonna against a
column (Fig. 51), but in that case the column was justified as emblematic of the sitter's
name.[101] (Incidentally, Colonna, fully armored and placing his hand on the helmet set at
the base of the column, wears a square beret not unlike that of Charles V.) Titian himself
placed a column in the background of the *Portrait of Benedetto Varchi* (Fig. 52);[102] Varchi,
shown in three-quarters length and holding an open book, rests his left arm on the column.
Titian used a column again in a princely portrait, the *Portrait of Philip II in Armor* (Fig.
53),[103] although here it can barely be seen.[104] In *Charles V in an Armchair* (Fig. 48), Titian
placed the column on a pedestal as a visual counterpoise to the seated emperor, enhancing
the feeling of tranquillity and security, while the distant poplar tree in the cloudy landscape
imparts a sense of loneliness. A walking stick placed diagonally alongside Charles adds a
hint of physical frailty.[105]

Again from Erasmus we learn the meaning of the ruler's seated pose. The great human-

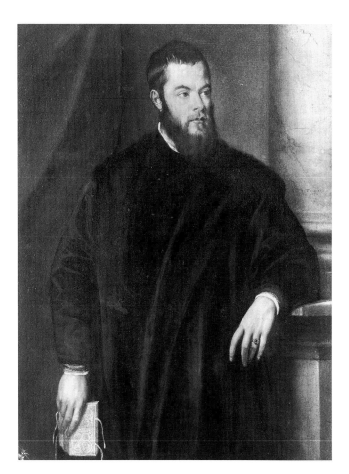

Fig. 52. Titian, *Portrait of Benedetto Varchi,*
c. 1550. Kunsthistorisches Museum, Vienna

ist once reminded Charles V of the ancient Theban custom (known from Plutarch's *Isis and Osiris* [10.355A]) of portraying state figures seated. Erasmus explained that their seated pose "means that magistrates and judges ought to be of a stable character not disturbed by any personal emotions."[106] The meaning of the purple cloth-of-honor hanging on the wall can also be inferred from Erasmus's treatise, according to which "the warm rich purple" signifies "ardent love towards his subjects."[107]

In the armchair portrait (see Fig. 48), Charles is dressed in black and wears a dark pelisse. His only adornment is the Order of the Golden Fleece, suspended on a dark green ribbon. (He wears it in the equestrian portrait [see Fig. 43] as well.) With dignity, Charles rests his right hand, holding a glove, on the arm of his chair, while his gloved left hand rests in his lap. The placing of his hands, one bare, the other gloved, is associated with a princely figure.[108] Titian rarely portrayed his sitters wearing gloves. When he did so, the sitter either holds a glove in his gloved hand or holds both gloves in one hand. Only Charles holds a glove in his bare hand. Moreover, in contrast to the earlier portraits (in the Louvre and the Pitti),[109] here the unused glove is painted in such a way that it is not clear that it is a glove, for its leather fingers are not visible. The way Charles holds his glove is reminiscent of the way the Roman consul holds a ritual cloth, a *mappa,* the well-

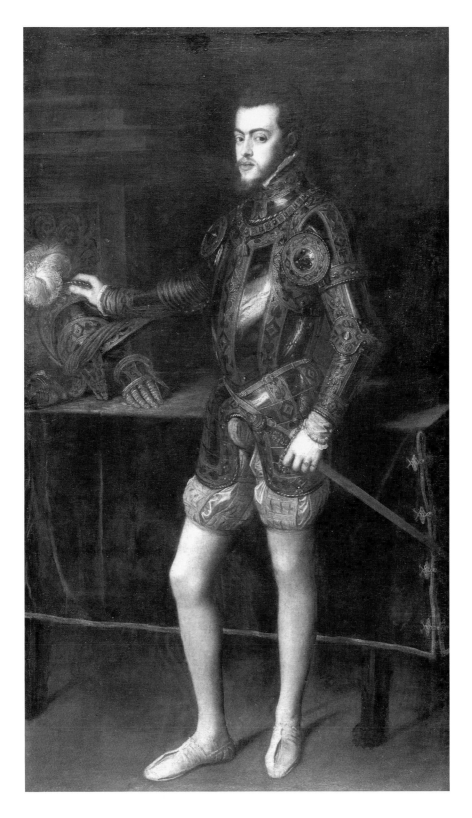

Fig. 53. Titian, *Portrait of Philip II in Armour*, 1551. Museo del Prado, Madrid

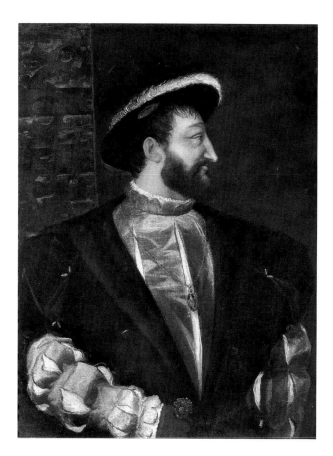

Fig. 54. Titian, *Francis I*, 1538. Musée du
Louvre, Paris

known symbol of authority.[110] Often the emperor held a *mappa* during the *Liberalitas* ritual. Titian could have been familiar with the Renaissance visual tradition in which the *mappa* was pictured not overtly, as in some ancient statues and ivory carvings, but implicitly, as in Michelangelo's *Pensieroso*[111] or Raphael's *Julius II* (see Fig. 33). Thus, with implicit allusions to the Roman tradition, Titian found subtle ways of conveying the image of the emperor as the magisterial authority.

As in the early portrait with a hound of 1533, in this 1548 portrait Charles also wears a squarish black beret, this time without a plume. Ulloa once described Charles's ceremonial costume, mentioning a square beret "with a fold behind decorated with a muslin and black hatband."[112] Curiously enough, this detail of the Munich portrait was indirectly criticized in Lomazzo's *Trattato dell'arte della pittura, scoltura et architettura*. He regarded the presentation of an emperor wearing a beret as an artistic error: "[T]he emperor with a beret on his head resembles a merchant rather than a ruler."[113] Although Lomazzo did not name Titian or Charles, and although his remark could also have been directed at other portraits (because many rulers were portrayed wearing this kind of hat), he was probably thinking of this specific portrait. (Commissioned by Aretino in 1538 to render Francis I as a gift for the king, Titian portrayed him wearing a beret [Fig. 54], as Jean Clouet had done in 1525, in a portrait unknown to Titian.)[114] Perhaps Lomazzo's criticism referred to the

Roman custom that associated this type of hat, called a *pileus*, with that worn by liberated slaves.[115] This Roman custom was noted in Gaurico's *De Sculptura*, a treatise known to artists in Venice.[116] The beret, however, was not always associated with plebeians; for Dolce, for example, not only a beret but a hat in general alluded to freedom, *libertà*.[117] Lomazzo's reaction may have been understandable at that time, but Titian's painting viewed today conveys a quite different impression. The beret does not detract from the dignity of this emperor, because his imperial demeanor makes him seem always to be wearing an "invisible crown."[118]

The theologian Bernardo Navagero reported to the Doge of the Venetian Republic, upon his return from diplomatic service in Augsburg in July 1546, that he had "been told by one, intimately acquainted with his [Charles V's] sentiments, that his wish and intention is to retire into Spain for the rest of his life, and to resign all public affairs to his son."[119] Ten years later, in 1556, Charles indeed abdicated and retired to the distant Spanish monastery at Yuste, but it would appear that his wish to do so was known long before, for as Navagero added, "the Emperor finds himself much distressed and perplexed in mind."[120] Part of his distress may have been caused by his poor physical condition; he suffered from asthma and gout, which aged him considerably in body and spirit, despite his successful conduct of the Mühlberg battle.[121]

Charles's affection for Titian was common knowledge.[122] Certainly Titian was not the only artist ever to have been admitted to the court and to have become a favorite of rulers, but his close relationship with the emperor was unusual for the time and was remarked upon by his contemporaries.[123] In his letter to Titian of May 1548 (CDXXVIII), Aretino could not conceal his wonder at how frequently Titian was admitted to converse with Charles.[124] Aretino opines that this privilege was bestowed on Titian not only because of his talent in painting but also because of his virtuous qualities. Besides Aretino, an agent of the Duke of Urbino, in his letter of April 7, 1548, also reported that Titian had become the august favorite and even had a room near the emperor so he could converse privately with his patron.[125] That this privilege was exceptional can be seen in a letter of November 10, 1548, addressed to Alessandro Farnese by the skeptical Giovanni Della Casa: "Messer Titian has spent a long time with His Imperial Majesty painting his portrait, and seems to have had plenty of opportunities to talk with him, while he was painting and so on. In short, he reports that His Majesty is in good health, but exceptionally anxious and melancholy." Further on he remarks: "Since Your Reverence knows the gentlemen of this court you will be able to judge whether it is customary to tell people like Messer Titian what His Majesty does or does not intend to do."[126]

Two years later, on November 11, 1550, Titian wrote to Aretino from Augsburg about one of his conversations with Charles, during which Titian spoke on Aretino's behalf about his aspiration to become a cardinal. The letter conveys the emperor's favorable response to Aretino's letter, which Titian presented to him after having him look at his paintings. Titian noted that the emperor "shewed [sic] signs of pleasure in his countenance," hearing about Aretino's eagerness to serve him.[127] Titian's reference to the "allegrezza" in Charles's face is reminiscent of Ulloa's description of the face as "tutto allegro" (see page 117), and may suggest his familiarity with the tradition of panegyric descriptions.

In thinking about the relationship between Titian and Charles V, one should keep in mind the great disparity in their social positions and be cautious in evaluating the accounts by contemporaries. Nonetheless, the painter would certainly have been aware of the emperor's moods and of his intention to retire. It should be remembered that he had priority over most persons in attendance upon the emperor, for he was an independent citizen of the Venetian Republic and as such served Charles only by special invitation. Titian was in no sense a court painter dependent on imperial favor. His independence may have played a part in his unique approach to portraying the emperor.

Titian's 1548 Portraits of the Emperor

When juxtaposing the two portraits painted in 1548 (see Figs. 43 and 48), one feels that Titian probably conceived of them together, though they were not designed as pendants to each other. Despite the difference in size and compositional arrangement, the portraits form a pair spiritually. The renditions of the emperor, clad first in armor and mounted on horseback and then dressed in civilian costume and seated in an armchair, convey the king's two principal and complementary functions: protector and provider. These symbolic suggestions are reinforced by the evocation of the Roman imperial rituals that marked the beginning and end of the full cycle of a king's activity for the good of his people. Seen in poses reminiscent of those in ancient representations of the *Profectio Augusti* and *Liberalitas Augusti,* the emperor is visually associated with his ancestral roots in the Roman imperial tradition. These portraits of 1548 constitute a Renaissance transformation of the traditional Roman renditions of the twofold function of the king.

Both portraits are painted in Titian's characteristic colors, a gamut of warm red and black tonalities, which visually strengthens the pictorial connection between them. Then too, they complement each other in the sophisticated interplay, involving similarities and contrasts, between their main pictorial components. In the equestrian portrait, the armored figure of Charles V is mounted on a black steed; in the civilian portrait, he is seated and wears a dark costume. In the former portrait he wears a rounded iron helmet, and in the latter, a squarish black beret. In the equestrian portrait, the emperor's figure is counterbalanced by a stately, spreading oak tree; in the seated portrait, he appears against a wall with a brocade cloth-of-honor, next to a column. The long lance in the equestrian portrait is replaced in the seated portrait by a black cane with a golden point. In both portraits Charles wears the Order of the Golden Fleece, reminding the viewer of the knightly essence of his kingship.

Besides alluding to the ancient classical imperial image adapted to that of the Christian emperor, each portrait reveals the sharp contrast between Charles's private and public persona. Titian masterly brought out the contradiction between the drawn face of Charles in private life and the stoic face lost among the ceremonial trappings of his public image. The paintings reflect the twofold nature of the Christian king: as a public figure, he conveys the eternal dimension of the royal function, but at the same time, as an individ-

ual, he is subject to the ravages of time and human frailty. In the equestrian portrait, his face contrasts with his glittering helmet, golden collar, and crimson sash, while in the civilian portrait it contrasts with his severe black costume and the gleaming purple of the cloth-of-honor on the wall. In the equestrian portrait, Charles rides toward a new day; in the other, he anticipates twilight. Asserting the emperor's double function, military and civilian, the two portraits separately and together also disclose his twofold nature as sovereign of the world and vulnerable individual.[128]

Both portraits reveal the artist's comprehension of the dual role and dual nature of the Holy Roman Emperor. In neither painting did Titian produce a flattering image of the emperor's personal appearance. Yet with tact and skill he ennobled his physical features and softened his natural defects, transmuting them into signs of his virtues. Titian retained the basic traits of his subject's distinct physiognomy, while generalizing them in order to produce a persuasive image of the emperor. In both portrayals, in military as well as in civilian attire, Titian modeled his representations on the conventional formulas of imperial Roman imagery, but, in order to emphasize the uniqueness and distinctiveness of his subject as a royal figure, the painter abstracted him from any narrative context.

In the equestrian portrait of Charles, as Panofsky concluded, Titian "intended to show him in the double role of a *Miles Christianus* and of a Roman Caesar *in profectione.*"[129] In the civilian portrait (see Fig. 48), with its reminiscences of the ancient legislator and of the Roman Caesar in the act of discharging his soldiers after war, Charles's seated figure speaks of his intention of self-liberation. To create the proper ambience for his emperor, Titian subtly employed natural backgrounds. The sunrise landscape in the equestrian portrait, where Charles is shown emerging from a wild forest into an open field, suffuses the painting with the hope of renewal. In the civilian portrait, the cloudy landscape with the solitary poplar adds a note of sadness. The landscape backgrounds provide a musical accompaniment, as it were, which helps set the mood for the paintings.

With his aspiration to reveal fully the *concetto* of Charles V—his role as the Christian monarch—Titian evolved a distinctive method of portraiture, involving a generalization of the subject's physical features, the use of Roman imperial patterns to endow the image with an aura of tradition, the isolation of the royal figure from any narrative context, making it eloquently persuasive in its own right, and the use of specific landscape backgrounds to provide tonality and mood. This method enabled Titian to convey the uniquely imperial image of Charles in his portraits, showing the two natures of the Christian king merging into one, as the private persona of the man merges with the public image of the emperor.

VI

"Pittore Divino":
Aretino on Titian's "Self-Portrait"

In July 1550 Aretino sent a letter (DLXV) and sonnet to Giovanni Britto, who had made a xylograph after Titian's self-portrait (Fig. 55).[1] Britto, a German woodblock cutter, had been working at the Marcolini Press since 1536 and had produced xylographs of various works by Titian, including *Charles V in Armor* (see Fig. 39). Because his woodcut is considered a "somewhat mechanical, graphic translation of the painted image," it can be considered a genuine portrait of Titian only in a limited sense.[2] (As is well known, Titian painted a number of self-portraits, two of which survive and at present are in Berlin and the Prado.[3] Since Titian painted these self-portraits long after Aretino's death in 1556, discussing them here falls outside this study. The self-portrait from which this woodcut was presumably made has *not* survived.) The woodcut shows Titian in an unconventional way: standing under the billowing curtain, he holds a tablet and a pen, and his eyes gaze pensively but penetratingly. This manner of representing the artist might have resulted from discussions in Marcolini's workshop; the print illustrates the way Titian was perceived by his admirers. We may consider it as revealing Titian's *concetto*, namely, the Divine Painter (Pittore Divino).

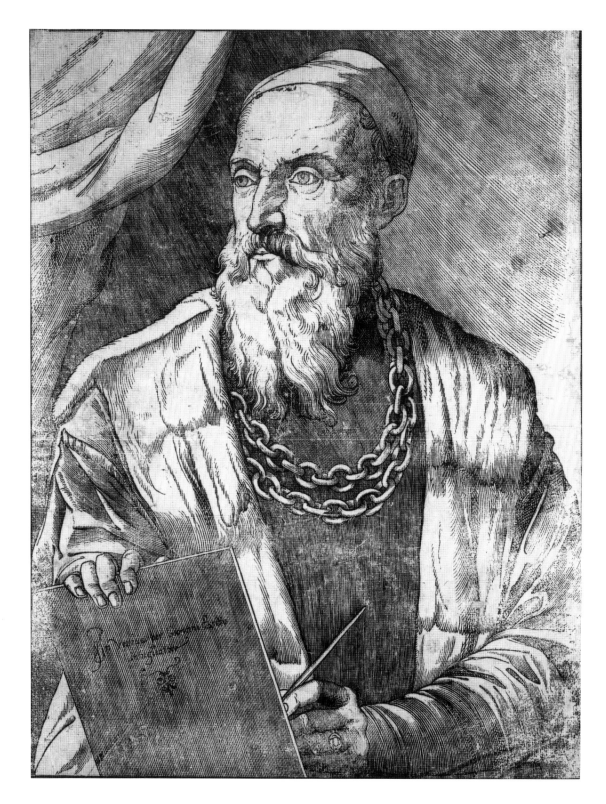

Fig. 55. Giovanni Britto after Titian, *Tiziano Vecellio,* 1550, xylograph. Rijksmuseum, Amsterdam

In his letter to Britto, Aretino indicates that he composed the sonnet at his addressee's insistence.[4] Designed to accompany the woodcut portrait, the sonnet has the characteristics of a piece written on order rather than inspired by genuine motivation to praise Titian. And as Aretino's talent as a poet was by common consensus mediocre, the sonnet contains the rhetorical clichés of its time. Nonetheless, aiming as it does to celebrate Titian before the public, the sonnet in a sense summarizes Aretino's opinions regarding Titian's role as a painter. In it Aretino speaks only of Titian's portraits, and he names only those of rulers: Charles V, Philip II, Ferdinand, and Pope Paul III. By singling out one aspect of Titian's art, Aretino in effect proclaims that the painter's significance for posterity lies in his being a portraitist of rulers, secular and ecclesiastical.

The traditional association of artists and rulers, and the consequent elevation of the artist's social status, of course goes back to antiquity.[5] Most exemplary in this respect was Apelles, who portrayed Antigonus and Alexander the Great. In the Renaissance, too, Florentine painters, for example, associated themselves with rulers, as Botticelli, Vasari, and Bronzino, to name just a few, worked for the Medicis. And in Venice the primacy of the Bellini family was recognized by Emperor Frederick III, when he conferred on Gentile the order of knighthood.[6] So, in seeking commissions from rulers, Titian followed an established tradition, which included Apelles and the Bellini as well.

If we remove its rhetorical praises, this sonnet does shed any light on Aretino's evaluation of Titian's art. To better understand his remarks, we may consider them in the context of the cinquecento humanists' concept of the artist.

Aretino's Sonnet and Its Connotations

When Aretino wrote this poetic encomium of Titian in 1550, more than a decade had passed since the publication of his first letters and sonnets. In the first lines of this latest sonnet, Aretino succinctly characterizes Titian the painter and then notes what was to him the most representative aspect of his oeuvre: his portraiture.

The sonnet begins with Aretino's familiar claim that Titian was the "wonder of the century."[7] In his earlier letters he had reiterated his usual praise: that the marvel of Titian's portraits consists in their subject appearing there as though alive. In this sonnet he develops this notion further, stating that Titian "transforms nature into art."[8] Thus any figure, he continued, as perceived in terms of flesh and bone, is translated on Titian's canvas into terms of drawing and color. This parallel between flesh and bone and color and drawing is striking in itself.[9] In emphasizing the verisimilitude of the rulers' portraits, Aretino points to this quality as sufficient proof of the miraculousness of Titian's mastery. He claimed that in his rendering of the ever-elusive likeness of his subject, Titian surpassed even Apelles, the greatest portraitist of antiquity.

Aretino's rhetoric of praise actually depended on the social status of the addressee of his sonnet. In sonnets sent to imperial courtiers, he affirmed that the rulers' greatness endowed the portraits with lasting life; in the sonnet sent to Britto, a woodcutter, he

asserted that Titian's artistic ability would preserve the rulers' images for posterity, endowing them with another life. Aretino wanted to assure the viewer of Britto's xylograph that he was beholding the image not just of a painter named Titian, but of the preeminent artist who by his miraculous art glorified the mightiest personae of this world.

This message recalls the well-known topos of cinquecento artistic theory according to which the painter's ability to render a lifelike image of a sitter was perceived as a divine gift. This idea originated with Alberti's assertion, in his influential *On Painting* (1436), that the painter is "un altro iddio" (another god).[10] Alberti explained that this is so because the "painting possesses a truly divine power in that not only does it make the absent present . . . , but it also represents the dead to the living many centuries later."[11] That Alberti's ideas were well known in Venice was attested to by Pino and Dolce.[12]

The sonnet that Aretino wrote to accompany Britto's woodcut attempts to reach an apogee in exalting Titian the painter. We know that Aretino had for some years been declaring Titian's mastery in numerous sonnets and letters and on various occasions reformulating his ideas about his paintings. Following Aretino's example, Dolce wrote an open letter to the Venetian connoisseur Gasparo Ballini, drawing the comparison much favored at the time (Aretino also composed a verse in which these names are juxtaposed)[13] between the styles of Raphael and Michelangelo. Demonstrating that Titian was superior to both these artists because of the power of the colors he exclaimed: "Titian in his supreme excellence is not just divine, as the world takes him to be, but absolutely godlike and without equal—like a man who backs up the liveliness of his coloring with the consummation of draftsmanship in such a way that his creations look as though they were not painted, but real."[14] This sentence, especially the assertion that the figure in a portrait by Titian looks "real" owing to the sophisticated combination of color and drawing, elucidates the opening of Aretino's sonnet on Titian. The critics took it for granted that portraits such as Titian's, by realistically capturing the subject's likeness, proved the painter to be "divine."

The epithet "divine" was so banal in Aretino's time that one seems to forget that it ultimately derives from the Platonic "mania," or "furor divinus," as it was further propounded in Ficino's letter "On divine frenzy."[15] The epithet was preserved in the medieval "deus artifex," which in turn had prepared the way for Alberti's affirmation of the painter as "un altro iddio." In ancient Greece and Rome the poets and their *opera*—but certainly not painters or sculptors—were called divine.[16] In Italy in the fifteenth and sixteenth centuries this epithet was gradually applied to painters as well. Moreover, not only poets, but also painters, started to write verses in which they could call other painters "divine." Thus, in his versified laudation of painters, the painter Giovanni Santi (Raphael's father) called Perugino "un divin pittore."[17] Raphael's father is probably the first writer (or certainly the first painter) who joined the adjective "divine" with the noun "painter."

And half a century later, it seemed to be a casual tribute to a tradition when, in the third and final version of *Orlando furioso* (1532), Ariosto called in one line both representatives of the two media, Michelangelo and Aretino, "divine."[18] In the sixteenth century, parallels were often drawn between poets and painters (or sculptors), characterizing them as divinely

inspired. Vasari, observing Donatello's *cantoria,* was reminded of Bembo's verses, as they both are "composed in a poetic fervour."[19] Thus when Francisco de Hollanda, addressing Michelangelo, claimed that in Italy "great princes as such are not held in honour or renown; it is a painter that they call divine,"[20] he was in fact describing what had already become a cliché. In the same sentence he pointed to Aretino as being responsible for popularizing the epithet: "as you, Michael Angelo, will find in the letters written to you by Pietro Aretino, who has so sharp a tongue for all the lords of Christendom."

The epithet "divine" no longer carried a sincere expression of admiration for an artist's supernatural talent. Thus when Titian was called divine by his admirers, they were not necessarily implying that he was lofty or godlike. Titian in turn used the epithet in a letter to Aretino of November 11, 1550, mentioning that the "Duke d'Alva never passes a day without talking to me of the divine Aretin [sic]."[21] The epithet's trivialization is demonstrated in the postscript to Aretino's letter to Michelangelo of November 1545, a letter he never sent. Aretino makes fun of the word "divino": [W]hile you are divine [punning on *di vino;* my emphasis], I am not of water [d'acqua]."[22] Aretino made puns with this word even earlier: he ended his letter of November 11, 1529, to Girolamo Agnello with the following: "There is nothing else to say except that, with all due respect to my immortality, I would become of *wine* as well as *divine* if you would visit me at least once a year with such a pressing."[23] Aretino especially overused the epithet in his letters; he not only addressed Michelangelo, Raphael, and Titian as "divine," but also Moretto, Leoni, and Sansovino. Nearly every friend of his (and some who were not his friends) he generously called "divine": Dolce, Bembo, Speroni, Della Casa, Giovio, Tolomei, and Bernardo Tasso (the father of the famous poet).[24]

To his *Dialogo della pittura, intitolato l'Aretino* (1557), Dolce added an encomium, calling Titian "divine" in the lengthy title to his work.[25] And in his *Vita dell'invittiss e gloriosiss Imperador Carlo Quinto,* written in 1561, Dolce explicitly calls Titian a "Pittore Divino," thus adopting Aretino's idiom.[26] Aretino was the first to call Titian the "Divine Painter" ("Titiano Pittore Divino") in a letter (DCXLIV) written in January 1553 (but published posthumously in 1557, the same year that Dolce published his *Dialogo*).[27] Before this, Aretino had often called Titian divine, stupendous, great, or marvelous in his letters, and also asserted that his works reflected his spirit as a divine painter. In time this appellation in effect became Titian's own *concetto* and was perpetuated in his self-representation. Insofar as it had a specific meaning among Venetian connoisseurs, the "divinity" of Titian meant particularly his genius for employing a gamut of color that rendered a subject's appearance so lifelike.[28]

Although it was Aretino who originally applied the phrase "Pittore Divino" to Titian, it was Dolce who explained this appellation, even if only by implication, in his *Dialogo,* using Aretino as the main spokesman of the principles of Venetian art as embodied by Titian. "[Painters] surpass the rest of humanity in intellect and spirit, doing as they do to imitate with their art the things which God has created, and to put the latter before us in such a way that they appear real," Dolce had Aretino declare.[29] This sounds like a paraphrase of his earlier statement on Titian's mastery in his letter to Ballini. Indeed Dolce reverted more than once in his dialogue to Titian's miraculous ability to represent

the subjects in his paintings in such a way that "every one of his figures had life, movement and flesh which palpitates."[30] Titian's portraits "are of such great excellence," Dolce said, "that there is no more life in the life itself."[31] He ended his dialogue with the statement that "our own Titian, therefore, is divine and without equal in the realm of painting; nor should Apelles himself refuse to do him honor, supposing he were alive."[32] Thus, according to Dolce, the divinity of Titian's art lay in his ability to capture his subjects on canvas so realistically that they seem alive, that they seem to have been born anew under the artist's hand. The semblance seems even to surpass the prototype, for the paintings enjoy a longer life than their human subjects. In Alberti's words: "Through painting the faces of the dead go on living for a long time."[33]

In Venice, the literati gave rational explanations, such as hard work, for the divine nature of artistic genius, but they also admitted that hard work and application are doomed to failure without innate talent.[34] Aretino fostered this idea in his writings; in his letter to Franco of June 25, 1537, he claimed, in quite crude terms befitting his "unpolished" style, that "if a man who was not given genius when he was a babe in swaddling clothes thinks he can write poetry, he is an arrant fool."[35] Attempting in his letter to Francesco Coccio (CCCLXVIII, September 1547) to answer the question "What is art?" Aretino wrote: "The truth is that art is an innate gift for considering the excellencies of nature that comes to us when we are babes in swaddling clothes."[36] The so-called Horatian aphorism *poeta nascitur non fit* was applied to painters as well;[37] Dolce said, "[T]he painter is born that way."[38] In support of this general thesis, Dolce offered a particular case: Titian. He said that Titian's talent for painting had revealed itself while he was still a child.[39] During the Renaissance it was a popular thesis, influenced by hagiographical literature, that the special gift for painting emerges in childhood.[40] Vasari wrote in his biography of Perino del Vaga that his future was forecast when he was a child, and the biography of Michelangelo started with prophetic predictions that this child's destiny was determined.[41] In asserting that Titian's talents revealed themselves in childhood, Dolce undoubtedly followed the pattern Vasari established in his 1550 edition of the *Lives* (which did not include Titian's). In turn, Dolce's writing led Vasari to include Titian's biography in the expanded edition of 1568. And in this Vasari repeated, though notably without enthusiasm, Dolce's thesis concerning the manifestation of Titian's talent in his childhood.

Still, Dolce tried to explain the divine essence of Titian's art rationally while at the same time noting the conviction that the nature of genius cannot be explained rationally. Dolce's explanation is rooted in the Venetian tradition of regarding the painter's talent as an inexplicable marvel. The same explanation is presented earlier in Speroni's *Dialogo d'amore* of 1544. Speroni eloquently exclaimed that Titian was not merely a painter but a marvel, because the subjects of his portraits were rendered in colors "made of some miraculous herb." In turn, so explicitly referring to Titian's portraiture, Speroni, like Dolce, was influenced by Aretino. In one of his most quoted remarks, Speroni said that a Titian portrait contained "un non só che di divinità" (an "I do not know what" of divinity).[42] This phrase is as difficult to interpret as the elusive, though much discussed, concept of *grazia,* which was defined in Venice as indefinable "un non só che" (by Dolce, for example).[43] Ancient tradition had allowed that a work might possess that divine

"something," transcending explanation; now the creator of the work, the master Titian, is considered godlike as well.

Writing in his sonnet on Britto's xylograph that Titian was "the wonder of the century, because he transforms nature into art," Aretino in fact implied that the xylograph shows Titian as a godlike artist, "Pittore Divino." That is, Britto's xylograph presents an image of a godlike artist and only afterward that of Titian the individual.

The Divine Painter

It seems at first glance that in Britto's xylograph (Fig. 55) the sitter's occupation is not clear. In one of the impressions of the print there is an inscription on the back of the tablet, held in Titian's hands, that gives just the name of the "engraver": "In Venetia per Gioani Brito / Intagliatore" (In Venice by Giovanni Britto / Engraver). As Bembo remarked in a letter written in Venice in August 1525, if artistic works represent "gladiatori, e Dei e Muse e Bacche e Satiri," no caption is needed to identify the image, but if they are figures drawn from life (Immagini [sic]—"Augusti, Aurelii, Domiziani, Traiani e somiglianti"[44]—then the subject's identity can be known only from the name inscribed. Only from Aretino's letter do we know who is represented in this xylograph.[45] Britto's inscription, omitting any indication of the effigy's identity, is unusual. From the inscription on a print made by Agostino Carracci in 1587, for example, it is clear that he made it to present to his patron, Cardinal Caetano, the effigy of Titian.[46] That print (Fig. 56) portrays Titian from the shoulders up, in his unforgettable cap and in magnificent costume. The print in its third impression has one more inscription, which clearly reads: "The true likeness of Titian Vecellio, the celebrated and famous painter."[47] The lineaments of Titian's face suggest that Carracci drew it after Titian's self-portrait in Berlin, even if the details of the costume with the pelisse do not match the costume adorned with a chain as seen in that painting.

Harold Wethey has suggested that the source of Britto's xylograph was the painting that shows Titian (adorned with a chain) in the act of drawing, with the Medici Venus in the background.[48] Whether or not Britto followed this painting is not clear, because the xylograph with its single figure is quite different from that more narrative composition. In any case, the xylograph's poor draftsmanship makes it hard to perceive a close connection with Titian's work. The rectangular format of Britto's print, though, gives a viewer some reason to think that it was made after a painting by Titian, for it resembles that of a painted portrait. Usually, as with Caraglio's etched portrait of Aretino (see Fig. 2), such prints were made in the shape of a medallion. Britto's format is similar to the xylograph he made after Titian's portrait of *Charles V in Armor* (see Fig. 39). It resembles that print also in that the painter holds his tablet and pen in the way the emperor holds his sword. Etched portraits of royal personages were typically rectangular in format, and as a rule they showed the person holding his or her royal insignia.[49] Britto's print, in sharing this format, bears something of a stamp of royal significance.

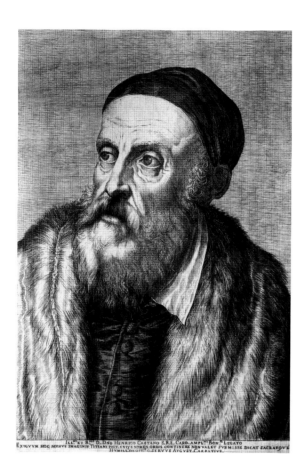

Fig. 56. Agostino Carracci after Titian, *Titian*, 1587, engraving. National Gallery of Art, Washington, D.C.

In inscribing for posterity only his own name, Britto seems to take it for granted that Titian's visage is well known to his public. Carracci's print presents Titian the inspired artist realistically, offering, as the inscription states, a "true likeness" (*vera effigies*); Britto's xylograph presents not so much the specific likeness of Titian as his contemporaries knew him, but rather a general, perhaps ideal image.

Britto gave Titian a noble look and stately appearance. Holding a tablet in his right hand, he touches it with the thin instrument he holds in his left hand, adorned with a ring. Titian was not left-handed like Leonardo, and that he is shown that way has to be attributed to the reverse image produced in the print from the woodcutter's carving. Titian does not look directly at the viewer; his face is turned to his right in three-quarters view, while his eyes gaze beyond the tablet in his hands. His sculptured face is touched with nobility in the aquiline nose, wavy beard, and lofty forehead.

The broadness and nobility of Titian's forehead, a feature frequently mentioned in Aretino's sonnets (see page 28), is emphasized by a neatly set cap. Titian's forehead calls to mind Statius's verse, in which the *frons* of a deity was often described as *serena* or *grave*.[50] For Statius, as for Aretino and probably for Titian as well, the shape of the forehead was an important indication of character. The cap draws attention to the

nobility of Titian's visage, imparting dignity and an almost royal demeanor. This cap constitutes one of the important signs in recognizing Titian's visage elsewhere.[51]

Titian's costume in Britto's xylograph suggests not only the wearer's fine taste but also his high social status, that he is an honored artist. Moreover, the sparkling brocade of the vest and cloak accentuates the sculptural monumentality of his figure. On his chest there is a massive chain, a gift from the Emperor Charles V, when in 1533 he bestowed on the painter the knightly rank of Count Palatine as well as the Order of the Golden Spur;[52] this royal gift for the painter's service indicates his high social status and is equally a sign of the artist's voluntary servitude.

Titian sought to retain his independence by living in Venice, where he owned a princely house on the Biri Grande in San Canciano.[53] With his brush he served the most eminent families of his time: The Habsburgs and the Farneses, the Gonzagas in Mantua and Urbino, the Pesaros, the Vendramins, and of course the doges. Throughout his long life Titian never lacked for recognition and awards.[54] Besides being generously honored by the emperor, he was granted Roman citizenship by Pope Paul III, and he even stayed in the Belvedere (a special honor bestowed on a chosen few) during his visit to Rome in 1545–46.[55] Dolce and Vasari after him cite evidence of Titian's fame not only in Italy but all over Europe. He was also rich, and throughout his life was adept at managing his financial interests.[56] Indeed, judging from the emphasis on his dress and chain in the xylograph, he was a man who was not indifferent to worldly success.

The Woodcuts by Britto and Vasari

Let us compare Britto's woodcut with the portrait of Titian in the second edition of Vasari's *Lives* (1568), a portrait (Fig. 57) that probably was based on the drawing Vasari made when he visited Titian in Venice in 1566. Vasari's drawing was engraved by a certain Cristofano Coriolano,[57] and the result is a traditional print in medallion form, similar to Caraglio's (see Fig. 2). In his preface to the second edition of the *Lives*, however, Vasari warned the reader not to rely too much on woodcut portraits, for "portraits in black and white are never so good as those which are colored, besides which the engravers, who do not know design, always take something from the form."[58] The woodcut portrait of Titian at the beginning of Vasari's biography renders the artist's countenance in a fashion both similar and dissimilar to Britto's xylograph. Vasari's complaint against engravers could also have been applied to Britto, who would seem to have presented only a general impression of the master's effigy, even though he ennobled and enhanced his main features. That Titian looks older in Vasari's portrait is not surprising, as sixteen years had passed since Britto made the xylograph. In the same preface Vasari addressed yet another warning to the reader: "[I]t is necessary to reflect that a portrait of a man of eighteen or twenty years can never be like one made fifteen or twenty years later."

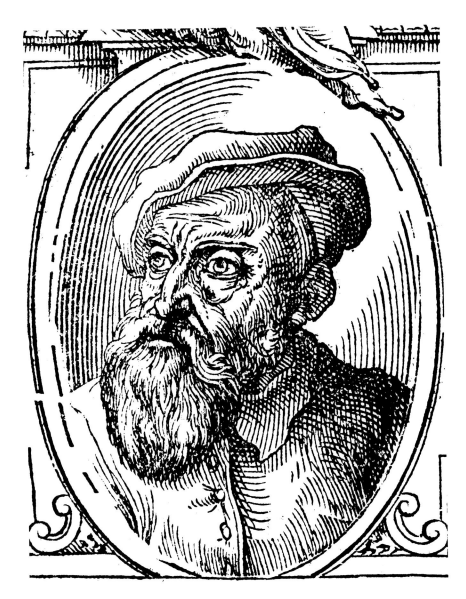

Fig. 57. Christofano Coriolano after Vasari, *Tiziano Vecellio*, Woodcut from Giorgio Vasari's *Le Vite de' più eccellenti pittori, scultori, e architettori*, Florence, 1568, III, 805. Courtesy of the Department of Rare Books, Cornell University Library, Ithaca, New York

The wrinkled face, sunken cheeks, and bent nose in Vasari's portrait offer a less lofty and noble look than Britto's, even though Titian's features are similar in both portraits: the sensitive, intelligent eyes, hooked nose, long face, and ample beard. Vasari's portrait emphasizes the ravages of age, while Britto's is much less detailed and less realistic. Moreover, the hat shown by Vasari, which Titian wears diagonally, diminishes the effect of nobility. Vasari's portrait is probably closer to the artist's true appearance, whereas

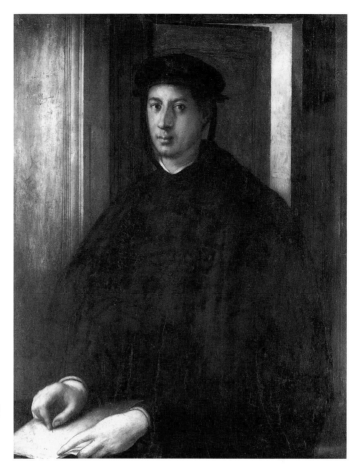

Fig. 58. Jacopo Pontormo, *Alessandro de'
Medici*, 1534–35. Philadelphia Museum of
Art

Britto's xylograph represented an idealized image of the artist. It may be said that the
main difference between Vasari's portrait of Titian and Britto's is that the latter was
intended as a portrait of a godlike painter.

One might object that the way Titian is rendered in Britto's xylograph is not specifi-
cally as a painter, because it is not clear from the way he holds the tablet and the pen
whether he is drawing or writing. The thin pen he touches to the tablet might belong to
a painter or a poet; it looks like a *stile*, which the *Vocabolario degli Accademici della
Crusca* identifies with the Latin *stylus*, meaning both the pen of a poet and the pen or
brush of a painter.[59] The drawing made after the Duke of Urbino's armor (see Fig. 26),
for example, was done mostly with a pen. Moreover, owing to the wide dissemination of
Castiglione's *Book of the Courtier*, it was considered appropriate during Titian's time for
rulers and courtiers to know how to draw and paint.[60] This is also attested to by
Pontormo's *Portrait of Alessandro de' Medici*, which shows him drawing a female head
(Fig. 58).[61] Thus the act of drawing would not in itself have been sufficient to identify
the subject as a painter.

Britto's xylograph, then, does not so much render a particular painter as it strives to

fit the painter's features to the formula of the inspired genius familiar to Renaissance connoisseurs. Titian's instantly recognizable features—the noble forehead and aquiline nose, shining eyes and ample beard—were long thought of as part of the conventional image of the holy person, *theios anēr*.[62] The turn of his stately head to the right, away from the tablet, implies an inner spirit, a divine spark, which guides and illuminates him. The composition of Britto's woodcut could have been influenced by the Ficino monument, which Titian could have seen in S. Maria del Fiore on his way from Rome to Venice. In this monument Ficino was shown by the sculptor as holding a bulky volume of his *Theologica Platonica* as if it were an Apollonian lyre.[63] In a similar manner Titian holds a tablet in his hands. And the way the sculptor presented Ficino, whose head was covered with his square canonical cap and whose eyes were cast heavenward, could have served as a precedent for Titian's own effigy in Britto's woodcut.

Britto's woodcut is evidence that it was more important in Marcolini's circle to emphasize the divine origin of Titian's artistic nature than to portray him as a specific individual, as was done, for instance, in Vasari's portrait of him drawn for the *Lives*. This may sound paradoxical, but clearly it was important then to reveal the permanent and the eternal in Titian's image even if it meant neglecting his individual features.

Titian as an Old Man

Britto's xylograph of 1550 is the first recorded portrait of Titian. We cannot be certain of Titian's exact age at the time, for the date of Titian's birth still remains open to controversy.[64] However, whether we accept the year 1476, judging from Titian's mention of his age as ninety-five in his letter of 1571 to Philip II (supported by Raffaele Borghini and Carlo Ridolfi), Vasari's date of 1480, or the years 1488–89, indirectly suggested by Dolce (as is thought by scholars today), Titian in 1550 was between sixty-one and seventy-four.[65] Yet regardless of his precise age at the time of Britto's xylograph, he would have been considered very old by the standards of his time. In Renaissance Italy, where the average lifespan was far shorter than today, a man was thought to be old at fifty.[66] Eight years earlier, in his letter to Titian on July 6, 1542 (CXLV), regarding the portrait of Clarissa Strozzi, Aretino already treated this work as a marvelous manifestation of the "maturity of old age."[67] Titian explained to the emperor in his letter of October 5, 1545, that he was reluctant to present the portrait of the empress to him in person because of his difficulty in traveling in his old age.[68] Whether or not this explanation was rhetorical, Titian used his age as an excuse. His age certainly did not preclude his taking a difficult trip in the winter of 1548 to Augsburg. Nonetheless, by 1550 Titian did consider himself, and was thought by others, to be an old man.

Thus Britto's xylograph represents Titian as "perpetually" old in the same way the image of Raphael remains "forever" young.[69] Why Titian was reluctant to paint self-portraits when he was young is no clearer than why he chose to portray himself later, though Renaissance artists in general tended to render themselves as older than their real

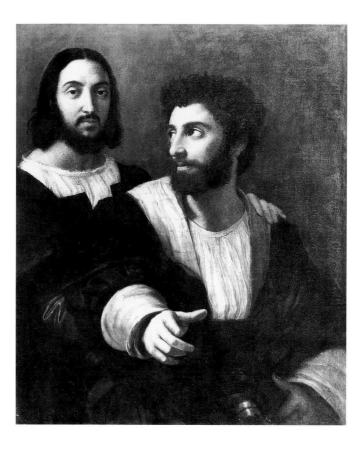

Fig. 59. Raphael, *Self-Portrait with a Friend, c.* 1518. Musée du Louvre, Paris

age. Raphael, too, in the Louvre double portrait (Fig. 59),[70] represented himself as older than his thirty-five years. Leonardo as well, in the famous drawing attributed to him (Fig. 60), looks a great deal older than his age of sixty at that time.[71] And Vasari, who was a most self-conscious painter, represented himself in an independent work only after reaching the age of sixty (Fig. 61).[72]

Perhaps the artist's wish to portray himself in the likeness of an old man can be explained by the conventional association of age with maturity and wisdom. This could be inferred from Comanini's *Figino,* in which he explained that in paintings of the Holy Trinity artists depict God the Father in the likeness of an old man because this expresses "the eternity of God and . . . his infinite sapience."[73] Analogously, on a more mundane level, the appearance of old age imparts the demeanor of a godlike sage to the likeness of an artist, whether Leonardo or Titian. In Britto's xylograph the likeness of an old man indeed enhances the impression of Titian's godlike appearance. It may have been a compromise between Titian's actual appearance and the conventional formula for the representation of the godlike artist.

Britto's woodcut accords with the way Titian was thought of by others and perhaps how he wanted others to see him. Titian's features are idealized, without violating their likeness, in order to reveal the *concetto* of the "Pittore Divino."

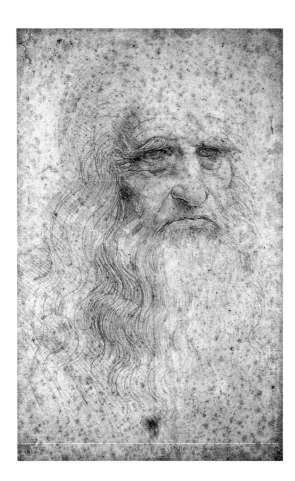

Fig. 60. Leonardo, *Self-Portrait, c.* 1512, drawing. Royal Library, Turin

Titian stands aloof, his gaze not meeting that of the viewer. This representation corresponds to the image of his personality that emerges from his letters and from records by his contemporaries. Although they describe him as a superb conversationalist, affable, polite, and hospitable, they offer no hint of an anecdote about him. We may recall Priscianese's letter that describes a *ferrare Agosto* celebrated in the garden of Titian's house on August 15, 1540. Noting the superb hospitality and generosity with which the evening was transformed into a memorable feast, Priscianese remarked that "the noble and grave Titian kept all the time a certain restraint."[74] From a recollection like this as well as from this "self-portrait," there emerges the sense of an exalted genius, a man who knew how to deal with people and how to distance himself from them at the same time.

Britto's print implies that Titian was far from perceiving his self-portrait as a medium for confession or self-interrogation. His self-representation was rather the expression of his pride as an honored painter, whose portraits, to cite Dolce's words once more, "are of such great excellence that there is no more life in the life itself and are all of Kings, Emperors, Popes, Princes or other men of stature."[75] It is indicative that Dolce, like Aretino in his sonnet that accompanied Britto's woodcut, finds it important to mention only rulers who were portrayed by Titian, thus elevating the artist's status. Perhaps Pino

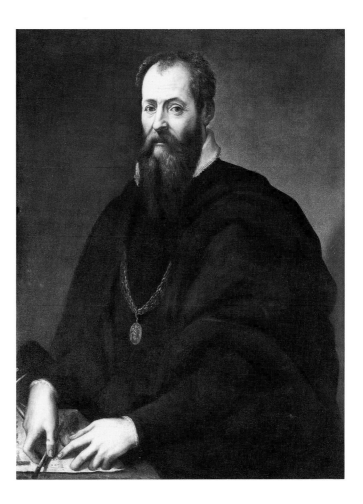

Fig. 61. Giorgio Vasari, *Self-Portrait*,
1571. Uffizi, Florence

was not being purely rhetorical when, in his *Dialogo di pittura*, he mentioned Titian among artists who "enjoy three lives—one natural, one achieved by artifice, and one eternal—on account of their virtues." Such artists, Pino added, are "worthy of being called mortal deities!"[76]

Notes

Introduction

1. See the most recent study on this subject by Richard Brilliant, *Portraiture* (Cambridge: Harvard University Press, 1991).

2. Marianne Albrecht-Bott lists the poets' reactions to portraits in *Die bildende Kunst in der italienischen Lyrik der Renaissance und des Barock* (Wiesbaden: Steiner, 1976), 200–234.

3. The literati's letters or other prose discussions concerning portraits have been studied less than the sonnets. Bembo's letter is included in Giovanni Bottari, *Raccolta di lettere sulla pittura, scultura ed architettura*, ed. Stefano Ticozzi (Milan, 1822–25), v, 206 (no. LVII), and see Roger Jones and Nicholas Penny, *Raphael* (New Haven: Yale University Press, 1983), 155; Tolomei's letter appears in his *De le lettere* (Venice, 1547), 75v, and see the comments by Michael Hirst in *Sebastiano del Piombo* (Oxford: Clarendon Press, 1981), 119; Giovio's letter is included in Bottari, *Raccolta*, v, 231–32 (No. LXXIII), and see the comments by Lora Anne Palladino, "Pietro Aretino: Orator and Art Theorist" (Ph.D. diss., Yale University, 1981), 137–38.

4. The chapters of these treatises that shed some light on current ideas about portraiture are to be found in BS, III, 2715–52 in chapter XVI: "I Ritratti," with Paola Barocchi's valuable introduction and annotations. See also Marianna Jenkins, *The State Portrait* ([New York], College Art Association of America, 1947), 16–44, and Luigi Grassi, "Lineamenti per una storia del concetto di ritratto," *Arte Antica e Moderna* 13/16 (1961): 477–94.

5. See Albrecht-Bott's *Die Bildende Kunst*, which notes Aretino's influence on Marino's approach to portraits.

6. I will elaborate on this point further in Chapter I; see page 25, where relevant examples are cited, and note 87.

7. My choice of portraits to be analyzed in detail in each chapter was influenced by a number of other factors: they sufficiently attracted Aretino's attention; none of them poses crucial problems of authenticity, with dates or sitters' identity well established, thus enabling us to concentrate on the poetics of the portrait itself; and these were works widely known at the time, thus raising the issue of Aretino's influence on contemporary perceptions of them.

8. About Titian's letters, see Erica Tietze-Conrat, "Titian as a Letter Writer," AB 26 (1941): 117–23; Gianfranco Folena, "La scrittura di Tiziano e la terminologia pittorica rinascimentale," in *Miscellanea di studi in onore di Vittore Branca* (Florence, 1983), III, 821–43, and Giorgio Padoan, "Titian's Letters" in *T*, 43–52, with further up-to-date bibliographical references.

9. For full references, see Thematic Bibliography.

10. On the rhetorical conventions of Renaissance art criticism, see Carl Goldstein, "Rhetoric and Art History in the Italian Renaissance and Baroque," AB 73 (1991): 641–52, even if Aretino's letters are scarcely mentioned there.

11. Consider Mark Roskill's introduction to his translation of Dolce's dialogue on painting in *RD*, 5–61.

12. The letters of Aretino to which I refer in this study are designated by the roman numeral given in P-C. In the notes I provide the original text only when the translation is my own.

Chapter I

1. V-M, VII, 438; quoted from V-H, IV, 203.

2. Cf. Mina Gregori, "Tiziano e l'Aretino," in *Tiziano s il Manierismo Europeo*, ed. R. Pallucchini (Florence: Olschki, 1978), 289: "Non si può pensare all'attività del Tiziano dal 1530 al '50 senza rivolgere l'attenzione in primo luogo alla serie dei ritratti." This observation was supported by Charles Hope, "Titian and His Patrons," in *T*, 80.

3. The biographical data on Aretino have been culled from Count Giammaria Mazzuchelli's *Vita di Pietro Aretino* (1741), reprinted with annotations in P-C, III, 21–106, as well as from other studies: Alfred Semerau, *Pietro Aretino: Ein Bild aus der Renaissance* (Vienna: König, 1925); Thomas Caldecot Chubb, *Aretino, Scourge of Princes* (New York: Reynal & Hitchcock, 1940); Giuliano Innamorati, "Aretino," in *Dizionario biografico degli Italiani* (Rome: Istituto della Enciclopedia Italiana, 1960–), IV, 89–104; and Cesare Marchi, *L'Aretino* (Milan: Rizzoli, 1980).

4. On Aretino's youthful career as a painter, see Alessandro Luzio, *Pietro Aretino nei primi suoi anni a Venezia e la Corte del Gonzaga* (Turin, 1888), 109–11, for appendix I: "L'Aretino pittore."

5. Pietro Aretino, *Lettere* (Paris, 1608–9), I, 126v (this letter was not included in P-C). Cf. Felix Gilbert, *The Pope, His Banker, and Venice* (Cambridge: Harvard University Press, 1980), 98. See also P-C, II, 81 (no. CCXLIV).

6. Quoted from C, 56.

7. See Jacob Burckhardt, *The Civilization of the Renaissance in Italy*, trans. S. G. C. Middlemore (New York: Harper, 1958), I, 171, who remarked that Aretino "may be considered the father of modern journalism."

8. When Aretino first arrived in Venice, he did not expect to stay there. On his reasons for staying, see Patricia H. Labalme, "Personality and Politics in Venice: Pietro Aretino," in *R*, 119–32. Cf. Christopher Cairns, *Pietro Aretino and the Republic of Venice* (Florence: Olschki, 1985).

9. See Jürgen Schulz, "The Houses of Titian, Aretino, and Sansovino," in *R*, 82–89, fig. 3.8, for a photograph of the Bollani house on the Grand Canal, and fig. 3.10 for a photograph of Ca' Dandolo.

10. On Aretino's activity as a writer, see Carlo Bertani, *Pietro Aretino e le sue opere* (Sondrio: Quadrio, 1901); Giorgio Petrocchi, *Pietro Aretino tra Rinascimento e Controriforma* (Milan: Vita pensiero, 1948); Johannes Hösle, *Pietro Aretinos Werk* (Berlin: De Gruyter, 1969); Paul Larivaille, *Pietro Aretino fra Rinascimento e Manierismo* (Rome: Bulzoni, 1980); Giovanni Fallaschi, *Progetto corporativo e autonomia dell'arte in Pietro Aretino* (Messina: G. d'Anna, 1977); and Giuliano Innamorati, *Pietro Aretino: Studi e note critiche* (Messina: G. d'Anna, 1957).

11. On the fate of these writers, see Paul F. Grendler, *Critics of the Italian World* (Madison: University of Wisconsin Press, 1969).

12. Quoted from C, 143–44; it is not included in P-C.

13. V, cat. no. 112.

14. All the portraits by Titian are catalogued in W, II: *The Portraits*. In Valcanover's catalogue, all of Titian's paintings are presented in chronological order, including those known only from contemporary correspondence.

15. Quoted from RD, 193.

16. C, 10–11. On Marcolini, see the introduction by Luigi Servolini to Scipione Casali's *Gli annali della tipografia Veneziana di Francesco Marcolini* (Bologna: Gerace, 1953).

17. Aretino's letters have been studied by Cairns, *Pietro Aretino*, 125–61. Cf. Karl Borinski, *Die Antike in Poetik und Kunsttheorie* (Leipzig: Weischer, 1914), I, 127–28, who saw Aretino's *Epistolarismus* as a precursor to *Journalismus*.

18. PT, 1175, with commentary on Bembo's wish to publish his "Brievi."

19. For the description of the first volume of Aretino's letters in 1537 and 1538, see Casali, *Annali della tipografia*, 54–58 (no. 26) and 69–72 (no. 30). See also the list of authors who published their collections of letters after Aretino, in *Le "carte messaggiere." Retorica e modelli di comunicazione epistolare: Per un indice dei libri di lettere del Cinquecento*, ed. Amedeo Quodnam (Rome: Bulzoni, 1981), 286–316.

20. Erwin Panofsky, *Problems in Titian, Mostly Iconographic* (New York: New York University Press, 1969), 10: "But Aretino's published correspondence includes no less than forty-three other letters addressed to Titian, and in no less than 225 he is mentioned."

21. For information on these artists and their relationship with Aretino, see P-C, III, part 2.

22. See Sergio Ortolani, "Pietro Aretino e Michelangelo," *L'Arte* 25 (1922): 15–26, and Lionello Puppi, "Michelangelo und Aretino," in *Michelangelo Heute*, ed. Heinz Sainke (Berlin: Humboldt-Universität, 1965), 123–32.

23. On Aretino's unique personal relationship with

Titian, see P-C, iii, 477–97; Panofsky, *Problems in Titian*, 9–11; Fritz Saxl, "Titian and Aretino," in his *Lectures* (London: Warburg Institute, 1957), i, 161–73; and Gregori, "Tiziano e l'Aretino," 271–306.

24. Pietro Aretino, *Teatro*, ed. G. Petrocchi (Verona: Mondadori, 1971), 161: "E lo stupendo Michelagnolo lodo con istupore il ritratto del duca di Ferrara." See Petrocchi's commentary, 800 n. 53.

25. See notes 142 and 143 below.

26. P-C, i, 107; it is translated by Lora Anne Palladino, "Pietro Aretino: Orator and Art Theorist" (Ph.D. diss., Yale University, 1981), 54, with an interesting analysis. Cf. David Rosand, "Titian and the Critical Tradition," in R, 38 and n. 24.

27. Norman E. Land, "Titian's *Martyrdom of St. Peter Martyr* and the 'Limitations' of Ekphrastic Art Criticism," *Art History* 13 (1990): 293–317.

28. On Aretino's mention of Titian as a master of color, see his *Scritti scelti*, ed. G. G. Ferrero (Turin: Unione tipografico-editrice torinese, 1970), i, 157, 508, and 513.

29. Quoted from C, 197.

30. Quoted from Pietro Aretino, *Selected Letters*, trans. G. Bull (Harmondsworth: Penguin, 1976), 124.

31. Pier Luigi DeVecchi, "Il Museo Gioviano e le 'Verae Imagines' degli Uomini Illustri," in *Omaggio a Tiziano* (Milan: Electa, 1977), 87–93. Cf. Linda Susan Klinger, "The Portrait Collection of Paolo Giovio" (Ph.D. diss., Princeton University, 1991), 67; Giovio first collected portraits between 1521 and 1526 and again in 1537, when he began to build his villa at Como.

32. *Lettere scritte a Pietro Aretino*, ed. T. Landoni (Bologna, 1873–75), ii, part 1, 58–59 (no. xxxi).

33. See Christiane L. Joost-Gaugier, "Castagno's Humanistic Program at Legnaia and Its Possible Inventor," *Zeitschrift für Kunstgeschichte* 45 (1982): 274–82, with a review of the literature on *uomini famosi*.

34. Klinger, "Portrait Collection," 41 and 125.

35. Giovanni Bottari, *Raccolta di lettere sulla pittura, scultura ed architettura*, ed. Stefano Ticozzi (Milan, 1822–25), i, 420 (no. clxxxv). Quoted from James Northcote, *The Life of Titian* (London, 1830), 305.

36. Quoted from Northcote, *Life of Titian*, 308.

37. Giovanni Battista Armenini, *On the True Precepts of the Art of Painting*, ed. E. J. Olszewski (New York: Franklin, 1977), 284 and n. 24. Armenini stated: "Giulio, through his great fame, his gentle nature, and the help of his friend Pietro Aretino, came into such favor with Federico Gonzaga."

38. See Valcanover's "Comparative Chronology," in T, 409.

39. Although Aretino's methods closely resemble those of a modern advertising man, he is not to be found in research on the history of advertising, which deals mostly with the history of advertising in England and the United States rather than in Italy. When viewed from this angle, Aretino is seen to have had many of the qualities of the "ideal adman" listed in The Royal Bank of Canada Monthly Letter, "What Use Is Advertising?" in *Advertising's Role in Society*, ed. John S. Wright and J. E. Mertes (St. Paul: West, 1974), 209. He must "try to sense the common feelings and adapt [himself] to the tastes, traditions and prejudices of the people to whom [he] cater[s]." Further, "he must attract favourable attention by offering authoritative, timely and interesting information. He may do this effectively by linking something familiar with something new. . . . He will add to the attractiveness of his message by projecting his personality and individuality." Moreover, Aretino used what is still considered one of the most effective methods of advertising, "direct mail." Cf. Edward Newton Mayer Jr., *How to Make Money with Your Direct Mail* (New York: Printers' Ink, 1953). For general information on advertising and its history, see Walter Scheele, *Zwischen Kauf und Verkauf lauert die Sünde* (Stuttgart and Degerloch: Sewald, 1979), with a useful bibliography.

40. P-C, ii, 216: "[C]he se bene il giovane mio compatriota e illustre in cotale arte, il vecchio compare mio ci e divino."

41. On Aretino's persuading patrons to commission a portrait from Titian in order to perpetuate their likeness for posterity and on the tradition of this particular rhetoric of persuasion, see Rosand, "Titian" in R, 21.

42. P-C, ii, 116: "[S]a fare il pennel vostro, avete renduto i colori de la vita, tal che egli e non men simile a se stesso in la pittura di voi."

43. Bottari, *Raccolta*, v, 206 (No. lvii): "Rafaello . . . ha ritratto il nostro Tebaldeo tanto naturale, ch'egli [sic] non e tanto simile a se stesso, quanto gli e quella pittura." Cf. PT, 409 (no. xxi), with annotations. Cf. Roger Jones and Nicholas Penny, *Raphael* (New Haven: Yale University Press, 1983), 155, with a different translation.

44. See Arduino Colasanti, "Gli artisti nella poesia del Rinascimento: Fonti poetiche per la storia dell' arte italiana," *Repertorium für Kunstwissenschaft* 27 (1904): 193–220, who drew attention to poetry as a source of knowledge of the perception of paintings. For the specific mention of portraits in poetical art, see Marianne Albrecht-Bott, *Die bildende Kunst in der italienischen Lyrik der Renaissance und des Barock* (Wiesbaden: Steiner, 1976).

45. Palladino, "Pietro Aretino," 220 and n. 43.

46. On Petrarch's sonnets on Martini's portraits of Laura, as well as on the formation of the tradition of the poetic usage of portraits, see the recent study by Willi

Hirdt, "Sul sonetto del Petrarca *Per Mirar Policleto a prova fiso*," in *Miscellanea di studi in onore di Vittore Branca* (Florence: Olschki, 1983), I, 435–47.

47. V-M, VII, 456, and Raffaele Borghini, *Il Riposo* (Florence, 1584), 528.

48. Giovanni Della Casa, *Le Rime*, ed. R. Fedi (Rome: Salerno, 1978), I, 37, for Sonnet 33. Cf. Lorenzo Campana, "Monsignor Giovanni Della Casa e i suoi tempi: Vita privata," *Studi storici* 17 (1908): 401–4 and 431–37. It is cited in Albrecht-Bott, *Bildende Kunst*, 51.

49. On the influence of Greek poetic descriptions of artistic portraits on Italian Renaissance poems with a similar subject, see Albrecht-Bott, *Bildende Kunst*, 58. Generally, Anacreon's poems were first published by the Aldine Press in 1521. They were republished by the Niccolini Press in 1550 in Venice, which may indicate that there was a demand for this poetry. See the basic study on this subject by James Hutton, *The Greek Anthology in Italy to the Year 1800* (Ithaca: Cornell University Press, 1935), 220.

50. For Aretino's sonnets containing references to Titian's portraits, see Albrecht-Bott, *Bildende Kunst*, 73–80, who points to the influence of the epigrams from the *Anthologia graeca* on Aretino but does not mention the influence of Petrarch's poetry. On Aretino's being influenced by Greek poetry, see Hutton, *Greek Anthology*, 297. On the importance of Aretino's sonnets for the development of poetry with the theme of portraiture, see Colasanti, "Artisti," 198–204. On Aretino's critical attitude toward the Petrarchists, whom he accused of pedantry, see Karl Vossler, "Pietro Aretinos künstlerisches Bekenntnis," *Neue Heidelberger Jahrbücher* 10 (1900): 59–61; Bertani, *Pietro Aretino*, 247–50; and Edgar Zilsel, *Die Entstehung des Geniebegriffes* (Tübingen: Siebec, 1926), 237–40, who cites many of Aretino's tirades against those who blindly follow Petrarch. See Aretino's letter of June 25, 1537 (XXXII), translated in C, 70: "[T]he best way to imitate Petrarch or Boccaccio is to express your own ideas with the same beauty and skill with which they beautifully and skillfully expressed theirs." Cf. Norman E. Land, "*Ekphrasis* and Imagination: Some Observations on Pietro Aretino's Art Criticism," *AB* 68 (1986): 207–17.

51. The translation by Abraham Cowley (which is among the closest to the original) is quoted from *Odes of Anacreon: Anacreontics, and Other Selections from the Greek Anthology*, ed. N. H. Dole (Boston, 1903), 78 (no. XXVIII). In the only Italian translation at my disposal the same lines read: "Pittor, basta; non più. / Me la fai scorger tu. / E' pittura; o pur e lei? / Che parlasse, io giurerei," from *Anacreonte tradotto dall'originale Greco in rima Toscana*, trans. A. M. Salvini (Florence, 1695), 29 (no. XXVIII).

52. *The Dialogues of Plato*, trans. B. Jowett (London: Oxford University Press, 1931), I, 485: "I cannot help feeling, Phaedrus, that writing is unfortunately like painting; for the creations of the painter have the attitude of life, and yet if you ask them a question they preserve a solemn silence."

53. Giulio Mancini, *Considerazioni sulla pittura*, ed. L. Salerno (Rome: Accademia nazionale dei Lincei, 1956–57), I, 116: "Et di tal ritratto credo che intendesse Platone nel *Fedro*."

54. Michael Baxandall, *Giotto and the Orators: Humanist Observers of Painting in Italy and the Discovery of Pictorial Composition, 1350–1450* (Oxford: Clarendon Press, 1986), 51–52.

55. Palladino, "Pietro Aretino," 140, remarked that Aretino "inverts" this commonplace expression.

56. See note 96 below.

57. *The Greek Anthology: Hellenistic Epigrams*, ed. A. S. F. Gow and D. L. Page (Cambridge: Cambridge University Press, 1955), I, 55; II, 146–47 (no. XLIII). It was translated by Pietro Bembo's friend, the Venetian poet Agostino Bezzano; see Hutton, *Greek Anthology*, 301–2.

58. For Beccadelli's sonnet on his own portrait, commissioned from Titian but not yet finished when he wrote the sonnet, see Arduino Colasanti, "Sonetti inediti per Tiziano e per Michelangelo," *Nuova Antologia* 38 (March 1903): 282. Compare Aretino's sonnet in his letter to Titian of October 1552 (DCXXXVII) on the completion of Beccadelli's portrait.

59. Quoted from Northcote, *Life of Titian*, I, 342.

60. Aretino's predilection for grandiose figures of speech was noted by Petrocchi, *Pietro Aretino*, 339, Hösle, *Pietro Aretinos*, 152, and Georg Weise, "Manieristische und Frühbarocke Elemente in den Religiosen Schriften des Pietro Aretino," *Bibliothèque d'Humanisme et Renaissance* 19 (1957): 172–81. Cf. Palladino, "Pietro Aretino," 47–51.

61. Quoted from C, 142. This letter was not included in P-C, and, differently from Chubb, it was dated in the Parisian edition by October 5, 1538 (II, 52r). Cf. Ferruccio Ulivi, "Pietro Aretino scrittore e critico d'arte," in his *Poesia come Pittura* (Bari: Adriatica, 1988), 134.

62. Quoted from Palladino, "Pietro Aretino," 114; the alternative is in C, 79, where the word "natura" is wrongly translated as "technique."

63. Giovanni Becatti, "Plinio e l'Aretino," *Arti figurative* 11 (1946): 2–3, suggests that Pliny's famous passage on Parrhasius influenced Aretino's idioms. Cf. Palladino, "Pietro Aretino," 114–18.

64. Sebastiano Serlio, *Regole generali di architettura sopra le cinque maniere de gli edifici . . .* (Venice, 1537), iii. That Serlio influenced Titian has been suggested by

Carlo Dionisotti, "Tiziano e la letteratura," in *Tiziano e il Manierismo Europeo*, 269. Cf. Rosand, "Titian" in R, 37 and n. 20, who pointed out that "the idea of a new nature" had been first used by Serlio. See also John Onians, *Bearers of Meaning* (Princeton: Princeton University Press, 1988), 299–301. On Aretino's usage of this idiom, see Ulivi, "Pietro Aretino," 120–31.

65. P-C, II, 252 (CDLXIV) and 288 (DIX).

66. Quoted from C, 133.

67. See note 93 below.

68. Heinrich Lausberg, *Handbuch der literarischen Rhetorik* (Munich: Hüber, 1973), I, 403–4, no. 813.2. On the eulogizing of contemporaries and the hyperbolical panegyric, see Ernst Robert Curtius, *European Literature and the Latin Middle Ages*, trans. W. R. Trask (Princeton: Princeton University Press, 1973), 164–66. On the rhetoric of praise during the Renaissance, see Osborne Bennett Hardison, *The Enduring Monument* (Chapel Hill: University of North Carolina Press, 1962), 24–42.

69. The passage on "*descriptio*" in Francesco Sansovino's *La Retorica* is to be found in *Trattati di poetica e retorica del Cinquecento*, ed. Bernard Weinberg (Bari: Laterza, 1970–74), I, 462–63. Incidentally, Sansovino mentions Speroni's oration, which lauds Captain Girolamo Cornaro, as an excellent example of contemporary usage of *demonstratio*.

70. Quintilian, *The Institutio Oratorica*, trans. H. E. Butler, Loeb Classical Library, 1979, III, 339 and 345. Cf. Brian Vickers, *In Defence of Rhetoric* (Oxford: Clarendon Press, 1988), 296–99, and his study, "The 'Songs and Sonnets' and Rhetoric of Hyperbole," in *John Donne: Essays in Celebration*, ed. A. J. Smith (London: Methuen, 1972), 132–74.

71. P-C, II, 48: "[L]o stile del divin Tiziano . . . per il miracolo de la man di quello da cui nasce la effigie." Also, 445: "ritraesse persona tanto naturalmente viva."

72. Ibid., II, 118: "[P]resentarvi l'essempio de la vostra sopraumana sembianza."

73. Quoted from Northcote, *Life of Titian*, I, 342.

74. Vickers, *In Defence of Rhetoric*, 291. On the *ekphrasis* during the Renaissance, see Svetlana Alpers, "*Ekphrasis* and Aesthetic Attitudes in Vasari's *Lives*," *JWCI* 23 (1960): 190–215; David Rosand, "*Ekphrasis* and the Renaissance of Painting: Observations on Alberti's Third Book," in *Florilegium Columbianum: Essays in Honor of Paul Oskar Kristeller* (New York: Italica, 1987), 147–63; and my remarks on the problem, including the discussion of Aretino's letters, in "Bartolomeo Maranta on a Painting by Titian," *Hebrew University Studies in Literature and the Arts* 13 (1985): 186–93. See also Land, "*Ekphrasis*," 209–12, and his "Titian's *Martyrdom of St. Peter Martyr*," 295–97.

75. On the tradition of *descriptio* in antiquity and the

Middle Ages, see Curtius, *European Literature*, 442–43; Edmond Faral, *Les arts poétiques du XIIᵉ et du XIIIᵉ siècles: Recherches et documents sur la technique littéraire du moyen âge* (Paris: Champion, 1924), 75–81; and Luba Freedman, "A Note on Dante's Portrait in Boccaccio's *Vita*," *Studi sul Boccaccio* 15 (1985–86): 255–57.

76. On the rhetoric of female portraiture, see Elisabeth Cropper, "The Beauty of Woman: Problems in the Rhetoric of Renaissance Portraiture," in *Rewriting the Renaissance*, ed. M. W. Ferguson, M. Quilligan, and N. J. Vickers (Chicago: University of Chicago Press, 1986), 175–90, and Mary Rogers, "The Decorum of Women's Beauty: Trissino, Firenzuola, Luigini, and the Representation of Women in Sixteenth-Century Painting," *Renaissance Studies* 2 (1988): 47–88.

77. Quoted from C, 74; it is not included in P-C and can be found in Pietro Aretino, *Lettere: Il primo e il secondo libro*, ed. Francesco Flora (Verona: Mondadori, 1960), 217 (no. 175).

78. On Trissino's *I Ritratti*, see Rogers, "Decorum of Women's Beauty," 48–52; see also Willi Hirdt, *Gian Giorgio Trissinos Porträt der Isabella d'Este* (Heidelberg: Winter 1981). On Aretino's acquaintance with Trissino, see Chapter III, page 81, and 177 n. 51.

79. For Titian's portrait of Isabella d'Este, dated by 1534–36, see P, I, 270, II, pl. 225; V, cat. no. 174; W, II, cat. no. 27; and for his portrait of the Empress, dated by 1548, see P, I, 121–22, II, pl. 333; V, cat. no. 291; W, II, cat. no. 53

80. P-C, II, 26: "[U]na ne possiede Iddio e l'altra Carlo."

81. Ibid., II, 26–27: "Ma egli è pur sublime, egli è pur degno lo intelletto il quale con nuove forze d'ombre e di lumi, oltre l'aver dato il moto dei sensi a la figura benedetta, come testifica il verace del gesto in cui può dirsi che sì bella effigie respiri, le ha posto sì vivamente l'oro nei capegli, la serenità nel fronte, lo splendore negli occhi, la vaghezza ne l'aria, la grazia nel sembiante e l'onestade nel viso, che quasi è quella che soleva rallegrarvi nel dolce stato di sua vitale eccellenzia. Comprendesi nel bel rilievo di sì pregiata forma un certo non so che dimostrante in suo essere una composizione di continenzia, uno aggregato di simplicità e un candore di puritade che più non se ne brama in angelo."

82. Ibid., II, 27: "Ma, se così visibile maraviglia esce da le cose che il Vecellio ritrae da le ritratte, di qual sorte saria lo stupore, che uscirebbe da le imitate dal loro essemplar nativo? . . . Ma che giova il dipingere del pennel di lui per dilettarvi, e lo scrivere de la penna di me per celebrarvi."

83. Ibid., II, 28: "Nove anni son passati che ordinaste a Tiziano, vostro servo, la tratta in Napoli, e in cambio d'averla ci attiene a quattro altri che non se gli paga la pensione."

84. The limits of this study do not permit me to discuss the complex theme that centers round the Horatian *ut pictura poesis*. Aretino's relation to the theme has been studied by Palladino, "Pietro Aretino," 70–75. Consider the following studies: Rensselaer W. Lee, *Ut Pictura Poesis* (New York: Norton, 1967); Jean H. Hagstrum, *The Sister Arts* (Chicago: University of Chicago Press, 1958), 57–70; and the recent study by Clark Hulse, *The Rule of Art* (Chicago: University of Chicago Press, 1990), 106–14.

85. Marvin Theodore Herrick, *The Fusion of Horatian and Aristotelian Literary Criticism, 1531–1555* (Urbana: University of Illinois Press, 1946), 34, remarks that Daniello's poetics reveals a knowledge of some of the major Aristotelian conceptions of poetic art even before Robortello published the Greek text with Latin translation and his commentary on Aristotle's *Poetics* in 1548. Cf. Bernard Weinberg, *A History of Literary Criticism in the Italian Renaissance* (Chicago: University of Chicago Press, 1961), I, 721–24.

86. Daniello's *Della Poetica* is in Weinberg, ed., *Trattati*, I, 242–43; quoted in Hardison, *Enduring Monument*, 54.

87. For general information on this trend, see Robert Klein, "The Theory of Figurative Expression in Italian Treatises on the *Impresa*" in his *Form and Meaning*, trans. M. Jay and L. Wieseltier (New York: Viking, 1970), 3–24; Liselotte Dieckmann, *Hieroglyphics: The History of a Literary Symbol* (St. Louis: Washington University Press, 1970); and Mauda Bregoli-Russo, *L'Impresa come ritratto del Rinascimento* (Naples: Loffredo, 1990).

88. See Rosand, "Titian" in R, 21, who noted "Aretino's self-association with the art of Titian."

89. *Vocabolario degli Accademici della Crusca* (Venice, 1612), 607, s.v. "pennello." Quoted from Giovanni Boccaccio, *The Decameron*, trans. G. H. McWilliam (Harmondsworth: Penguin, 1977), 830.

90. Tebaldeo's poem was cited by Albrecht-Bott, *Bildende Kunst*, 145, with further bibliographical references.

91. P-C, II, 330, "mostra avere ne la penna la medesima grazia in descrivere che nel pennello ha Tiziano in dipingere."

92. Ibid., II, 405: "Imperò che la vivacità, con che respirate nel suo colore, avria sentimento anco nel mio inchiostro."

93. Ibid., II, 177: "Ancora, o signore, che il mio por mano nei versi e ne le rime sia tanto di oltraggio a le muse, che lo sopportano, quanto di biasimo a me, che ne compogno; vedendo come lo stile di Tiziano ha mirabilmente ritratto il mirabile Vincenzo Cappello, non mi son potuto tenere di non farci suso il seguente sonetto."

94. Ibid., II, 404: "È ben vero che l'ho prima recitato a voi, recitandolo al ritratto al quale ogni senso e spirto de la vita che avete ha dato lo stile divino del solo Tiziano in pittura."

95. Ibid., I, 155: "[V]i mando il sonetto, che lo obligo istesso a la persuasion d'altri me ha sforzato comporre sopra la figura che il mirabile Tiziano ha mirabilmente ritratto dal natural."

96. Ibid., I, 156: "Chi vol veder quel Tiziano Apelle / Fa de l'arte una tacita natura, / Miri il Mendozza si vivo in pittura / Che nel silenzio suo par che favelle."

97. Ibid., II, 281: "[V]oi testa, dal divino Tiziano distesa in colori, mi ha saputo tra fuora de lo ingegno. Le quali vì esprimerà in lingua di poetico stile in proprio affetto che il sonetto vi manda."

98. Ibid., II, 282: "La effigie adoranda de la pace, / L'imagine tremenda de la guerra, / Il ritratto del senno che non erra, / E l'essempio de l'animo verace."

99. See Chapter III, pages 84–87.

100. *Vocabolario*, 304, s.v. "concetto."

101. On Vasari's use of *idea* and *concetto*, see Erwin Panofsky, *Idea* (New York: Harper & Row, 1968), 66; on Michelangelo's use of them, see 117–19.

102. Varchi's *Lezione sopra un sonetto di Michelangelo*, written in 1546 and published in 1549 in Florence, is in BS, II, 1322–41. For Varchi's definition of *concetto*, see 1330: "[Q]uella forma o immagine detta da alcuni intenzione, che avemo dentro nella fantasia di tutto quello che intendiamo di volere o fare o dire." Varchi points to the influence of Petrarch's Sonnet LXXVIII on this sonnet.

103. Gian Paolo Lomazzo, *Scritti sulle arti*, ed. R. P. Ciardi (Florence: Centro Di, 1974), I, 25ff.

104. Ibid., II, 376: "[I]l buon pittore esprime il suo concetto." The following references are from the same chapter (LII) of Lomazzo's treatise.

105. Ibid., II, 381: "[M]olti maggiori sono i ritratti intellettuali . . . , esprimendo il concetto della sua mente over idea." Cf. Eugenio Battisti, *Rinascimento e Barocco* (Turin: Einaudi, 1960), 199, and Luba Freedman, "The Concept of Portraiture in Art Theory of the Cinquecento," *Zeitschrift für Ästhetik und allgemeine Kunstwissenschaft* 32 (1987): 78.

106. P-C, I, 218: "Lodarei il cagnuolo accarezzato a lei." Cf. Antoine Jules Dumesnil, *Histoire des plus célèbres amateurs italiens et de leurs relations avec les artistes* (Paris, 1853), 225–26, considers this letter a fine example of what he assumed to be Aretino's advice to Titian on portraying the little girl. On the childlike essence of the portrait, see Luba Freedman, "Titian's *Portrait of Clarissa Strozzi*: The State Portrait of a Child," *Jahrbuch der Berliner Museen* 31 (1989): 165–80.

107. P-C, II, 43: "La cui divinità d'arte hallo rassemplato in si verace gesto d'attitudine."

108. Ibid., II, 277: "Quel proprio in carne di color vitale / Tiziano esprime, e du' l'essempio move, / In gesto bel di maesta reale."

109. See Peter Meller, "Physiognomical Theory in Renaissance Heroic Portraits," in *Studies in Western Art* (Princeton: Princeton University Press, 1963), II, 53–69; Moshe Barasch, "Character and Physiognomy: Bocchi on Donatello's St. George: A Renaissance Text on Expression in Art," in his *Imago Hominis* (Vienna: IRSA, 1991), 42—44; and Freedman, "Note on Dante's Portrait," 257–59.

110. E. H. Gombrich, "Leonardo: The Grotesque Heads," in his *The Heritage of Apelles* (London: Phaidon, 1976), 59–62. On Leonardo's owning Scot's book, see Martin Kemp, *Leonardo da Vinci* (London: Dent, 1981), 158.

111. Pomponius Gauricus, *De Sculptura (1504)*, ed. A. Chastel and R. Klein (Geneva: Droz, 1969), On Pino's approval of Gaurico's discussion of physiognomy in his treatise, see BT, I, 136.

112. See, for example, Romano Alberti's remarks on the importance of physiognomy in BT, III, 221.

113. Aretino, *Teatro*, 272. About Aretino's interest in physiognomy, see Viviana Paques, *Les sciences occultes d'après les documents littéraires italiens du XVIᵉ siècle* (Paris: Institut d'ethnologie, 1971), 77.

114. P-C, II, 12.

115. RD, 97.

116. Pliny, *Natural History,* trans. H. Rackham, Loeb Classical Library, 1968, IX, 327.

117. On Cardano's treatise on metoposcopy, see Henry Morley, *Jerome Cardan: The Life of Girolamo Cardano of Milan, Physician* (London, 1854), II, 54–56, and Angelo Bellini, *Gerolamo Cardano e il suo tempo (sec. XVI)* (Milan: Hoepli, 1947), 159. Cf. Lynn Thorndike, *The History of Magic and Experimental Science* (New York: Columbia University Press, 1923–58), VII, 505–6. For the Renaissance literati's interest in metoposcopy, see ibid., V, 503–79, and Barasch, "Character," 45.

118. Quoted from Palladino, "Pietro Aretino," 274.

119. Ibid., 281, and P-C, I, 78.

120. Erwin Panofsky, *Early Netherlandish Painting* (New York: Cambridge University Press, 1953), I, 194: "A portrait aims by definition at two essential and, in a sense, contradictory qualities: individuality, or uniqueness; and totality, or wholeness. On the one hand, it seeks to bring out whatever it is in which the sitter differs from the rest of humanity and would even differ from himself were he portrayed at a different moment or in a different situation; and this is what distinguishes a portrait from an 'ideal' figure or 'type.' On the other hand, it seeks to bring out whatever the sitter has in common with the rest of humanity and what remains constant in him regardless of place and time; and this is what distinguishes a portrait from a figure forming part of a genre painting or narrative." I am inclined to believe that the aim of Aretino's letters regarding Titian's portraits is to show how they succeeded in combining these "contradictory qualities: individuality, or uniqueness; and totality, or wholeness." For, as Panofsky remarks, if "carried to an extreme, these two requirements, individuality and totality, would be mutually exclusive" (195).

121. Giovio's *Fragmentum trium Dialogorum* is available in BS, I, 22. His mention of Titian is noted by Gregori, "Tiziano e l'Aretino," 295. Cf. T. C. Price Zimmermann, "Paolo Giovio and the Evolution of Renaissance Art Criticism," in *Cultural Aspects of the Italian Renaissance; Essays in Honour of Paul Oskar Kristeller* (Manchester: Manchester University Press, 1976), 406–24.

122. See Chapter II, page 36.

123. Dionisotti, "Tiziano," 268–69.

124. Giorgio Padoan, "Titian's Letters" in *T,* 43.

125. Priscianese's letter was studied by Giorgio Padoan, "A casa di Tiziano, una sera d'agosto," in *Tiziano e Venezia* (Vicenza: Pozza, 1980), 357–65.

126. Loredano Olivato, "Dal Teatro della memoria al grande teatro dell'architettura: Giulio Camillo Delminio e Sebastiano Serlio," *Bollettino del centro internazionale di studi di architettura "Andrea Palladio"* 21 (1979): 243; and Lionello Puppi, "Titian in the Critical Judgment of His Time," in *T,* 53.

127. Camillo's treatise was published by Cesare Vasoli, "Uno scritto inedito di Giulio Camillo 'de l'humana deificatione,'" *Rinascimento* 24 (1984): 225: "Fingiamo, adunque, che tu, senza vedere il viso mio ch'io meco porto, to lo vedessi vagar in uno specchio; non credi tu che la mia imagine sia più sottile ne l'aere di quella che ne lo specchio rilucesse? Et se la stessa vedessi ancor poco appresso ne la pittura che non tanta meraviglia fece di me il gran Tiziano, non credi tu che 'l tuo senso meglio l'abbracciasse?" (no. 770).

128. *Lettere scritte a Pietro Aretino,* I, part 1, 38–42 (nos. XXVI–XXVII).

129. RD, 85 and Roskill's commentary on p. 221. As Camillo died most likely in 1544, Dolce's mention of Camillo is anachronistic, even if his visit could have taken place in 1535, when Camillo wrote to Aretino about his coming to Venice and planning to visit Titian. On Camillo, see G. Stabile in *Dizionario,* XVII, 218–30.

130. Giorgio Petrocchi, "Scrittori e poeti nella botega di Tiziano," in *Tiziano e Venezia,* 103–9.

131. Carlo Ginzburg, "Tiziano, Ovidio e i codici della figurazione erotica nel '500" in *Tiziano e Venezia,* 130.

132. Quoted from Puppi, "Titian," 53.

133. Bottari, *Raccolta*, v, 231–32 (no. LXXIII), and see the comments by Palladino, "Pietro Aretino," 137–38. (This letter was not included in *Lettere scritte a Pietro Aretino*; it is also available in Paolo Giovio, *Lettere*, ed. G. G. Ferrero [Rome: Istituto poligrafico dello Stato, 1958], II, 11 [no. 206].) This letter is mentioned by Klinger, "Portrait Collection," 40.

134. Speroni's letter is in PT, 794.

135. P-C, I, 240: "Per ben che lo Sperone ha tanta parte in Tiziano e in Aretino, quanta ne hanno in loro e in lui e l'Aretino e Tiziano. . . . Onde il ringraziarvene saria sì come un dei nostri occhi e una de nostre orecchie volessero affaticarsi in ringraziare l'altra orecchia e l'altro occhio di cio che veggono e odono insieme."

136. PT, 547: "Tiziano non e dipintore e non è arte la virtù sua ma miracolo; . . . suoi colori sieno composti di quella erba maravigliosa."

137. Ibid., 548. Speroni's statement calls to mind Dolce's definition of *grazia* as "che è quel non so che." RD, 174.

138. PT, 548: "E credo che l'essere dipinto da Tiziano e lodato dall'Aretino sia una nuova regenerazione degli uomini" (my translation). See Palladino, "Pietro Aretino," 271, for an alternative translation.

139. The first part of Speroni's *Apologia dei dialoghi*, in which he cites Titian's name, is available in PT, 714: "[A]more, la cui natura avanza tutte le meraviglie: dunque il parlarne non è viltà né impietà. Che se i ritratti di alcune bestie, nimiche a l'uomo e orribili, tanto a mirarli son dilettevoli quanto le vive son paurose, e corre ogniuno allegramente a vederle, che vere essendo le fuggirebbe, e non è buon dipintore che volentieri quanto altra cosa no lle dipinga e non se vanti della pittura; . . . Tiziano, se dipingesse si grande affetto e sì poco senno in un giovane, che farebbe egli co' suoi colori e co l'arte sua?"

140. Vasari's letter is to be found in BT, I, 62. The popularity of the story is confirmed by the fact that not only Vasari but also Varchi and Francesco Bocchi mentioned it in their writings. See ibid., I, 38, and III, 147. This letter is discussed in Chapter IV, page 101.

141. Giorgio Vasari, *Le vite*, nell edizione del MDL, ed. C. Ricci (Milan and Rome: Casa editrice d'arte Bestetti e Tumminelli, 1927), III, 30: "il numero infinito de' bellissimi suoi ritratti di naturale, non solo tutti i principi Christiani, ma de' più ingegni che sieno stati ne' tempi nostri" (my translation).

142. Giorgio Vasari, *La vita di Michelangelo nelle redazioni del 1550 e del 1568*, ed. P. Barocchi (Milan: Ricciardi, 1962), I, 66 (no. 519), and III, 1061, with commentary.

143. RD, 109.

144. V-M, VII, 450; quoted from V-H, IV, 208.

145. For Biondo's treatise, see Julius Schlosser Magnino, *La letteratura artistica* (Florence: La Nuova Italia, 1979), 243–44.

146. Michelangelo Biondo's *Della nobillissima pittura et della sua arte* (Venice, 1549) is still available only in the original, half-paginated edition. The translation of the sentence "non manca che la uoce imperò che tutto il resto rapresentano dal naturale" is mine.

147. V-M, VII, 443.

148. Bottari, *Raccolta*, v, 51 (no. x): "Felice me se io, a V. S. obbligato, sapessi con la mia penna cosi ben dipingere l'effigie del mio animo, come V. S. ha saputo col suo pennello dipingere l'effigie della mia faccia! Ma più felice, se quel famoso Scrittore, che fu sì facondo nelle sue Lettere, le fosse stato altrettanto amico, quanto fu a Tiziano, e se io almeno fossi facondo come quel famoso scrittore."

149. Leon Battista Alberti, *On Painting*, trans. J. R. Spencer (New Haven: Yale University Press, 1973), 93. Alberti demands that the artist both achieve beauty and be faithful to nature.

150. Panofsky, *Idea*, 49: "[T]hus the Renaissance, at first seeing no contradiction therein, demanded of its works of art truth to nature and beauty at the same time."

Chapter II

1. Lora Anne Palladino, "Pietro Aretino: Orator and Art Theorist" (Ph.D. diss., Yale University, 1981), 3. See Palladino's discussion of his portraits by Titian and other artists, such as Sebastiano and Marcantonio, 170–257.

2. P-C, II, 73; quoted from C, 205.

3. On Aretino's portraits by artists other than Titian, see Fidenzio Pertile, "I Ritratti dell'Aretino," in P-C, III, 211–19. Cf. Stephen K. Sher, "VERITAS ODIUM PARIT: Comments on a Medal of Pietro Aretino," *The Medal* 14 (Spring 1989): 4–11, with a relevant bibliography on Aretino's medals. Aretino's shaping his own image can be compared with Michelangelo's, as was suggested by Paul Barolsky, *Michelangelo's Nose* (University Park: The Pennsylvania State University Press, 1990), 126.

4. P-C, I, 66. Cf. Palladino, "Pietro Aretino," 4, who suggested that Aretino himself was responsible for Ariosto's appellation. This appellation became so well known that two early twentieth-century biographers, Thomas Caldecot Chubb and Edward Hutton, subtitled their studies *Pietro Aretino: The Scourge of Princes*.

5. P-C, II, 128: "Da che voi col testimonio de le

vostre lettre mi fate fede del come costì in Roma, nei luoghi più degni in la corte, a ogni proposito, che nel parlare occorre, altro non sì dice che il 'così disse l'Aretino,' il 'così ha detto Piero,' il 'così parla il flagello dei principi,' sono isforzato a credere che in tal maniera di modo mi alleghi anco Fiorenza."

6. P-C, I, 227 (no. CLIV); Aretino's claim that he was responsible for Salviati's being invited to France is supported by Vasari: V-M, VII, 19, as well as by Marcolini (see note 8 below).

7. For Vasari's description of Sebastiano's portrait, see V-M, V, 575–76. Cf. Michael Hirst, *Sebastiano del Piombo* (Oxford: Clarendon Press, 1981), 105, and see Palladino, "Pietro Aretino," 175–84.

8. See Giovanni Bottari, *Raccolta di lettere sulla pittura, scultura ed architettura,* ed. Stefano Ticozzi (Milan, 1822–25), V, 254 (no. LXXXV).

9. Gaetano Milanesi listed Aretino's four portraits by Titian in V-M, VII, 442 and n. 1, and by Erwin Panofsky, *Problems in Titian, Mostly Iconographic* (New York: New York University Press, 1969), 10 and n. 9.

10. V, cat. no. 310; W, II, cat. no. 6; P, 103 and 290, pl. 337 (Pallucchini dates this portrait by 1548 and believes that Aretino's portrait for Marcolini has been lost). *The Frick Collection: An Illustrated Catalogue* (New York: Frick Collection, 1968), II, 255–61.

11. P, I, 103, pl. 293; S., cat. no. 173; V, cat. no. 246; W, II, cat. no. 5; *Tiziano nelle Gallerie fiorentine: Catalogo* (Florence: Centro Di, 1978), no. 1. The X-ray photograph of the painting showing a head of a youth in the underpainting was published by Mercedes Garberi, "Tiziano: I ritratti," in *Omaggio a Tiziano* (Milan: Electa, 1977), cat. no. 11.

12. For Aretino shown in the guise of a nameless soldier: P, 92, pl. 257; V, cat. no. 218; W, III, cat. no. 10; P-C, III, 47.

13. For Aretino shown as Pilate: P, 95–96, pl. 268; V, cat. no. 237; W, I, cat. no. 21; P-C, III, pl. 47.

14. See P-C, III, 33 with n. 80. Cf. Alessandro Luzio, *Pietro Aretino nei primi suoi anni a Venezia: La Corte del Gonzaga* (Turin, 1888), 19, as well as n. 8 in Chapter I.

15. P-C, I, 17: "Dirò ancora che teniate a mente la promessa fatta a Tiziano mercé del mio ritratto che io in suo nome vi feci presentare." Moreover, it is mentioned in Marcolini's letter (Bottari, *Raccolta,* V, 254). See Palladino, "Pietro Aretino," 188–91, for a wonderful account of this portrait, seen as a result of the collaboration between Aretino and Titian.

16. Carlo Ridolfi, *Le maraviglie dell'arte,* ed. D. F. von Hadeln (Venice, 1648; Rome: Società' Multigrafica Editrice SOMU, 1965), I, 169: "E capitando nel medesimo tempo a Venetia Partenio Etiro, lo ritrasse con beretta nera in capo ricamata con fiocco di piume

sigillate da vna medaglia d'oro col motto FIDES, donatagli dal Duca di Montoua, e nella destra mano teneua corona d'alloro."

17. Quoted from Ralph Roeder, *The Man of the Renaissance* (New York: Viking, 1933), 485. The title of Aretino's sonnet is in P-C, III, 212: "P. Aretino pel suo ritratto dipinto che zetta la laurea ghirlanda." See Palladino, "Pietro Aretino," 191–95, and Margot Kruse, "Aretinos Sonette auf Tizian-Porträts," *Romanistisches Jahrbuch* 38 (1987): 82–85.

18. On the various dates proposed for the Marcolini portrait, see *Frick Collection,* II, 258–60. The question of the date centers around Aretino's letter of April 1548, in which he said that he had stopped dyeing his beard. But as Charles Hope, *Titian* (New York: Harper & Row, 1980), 107 and n. 8, rightly observed, it is not known when he began to dye his beard.

19. Bottari, *Raccolta,* V, 255; quoted from *Frick Collection,* II, 258.

20. *Lettere scritte a Pietro Aretino,* ed. T. Landoni (Bologna, 1873–75), I, part 2, 308–9. This is a reprint of the earlier edition, published by Marcolini in 1551.

21. The majority of Aretino's etched portraits were reproduced in P-C; see III, pl. 27 or pl. 29, for example. For Caraglio's portrait, see, in particular, Maria Agnese Chiari, *Incisioni da Tiziano* (Venice: [La Stamperia di Venezia], 1982), cat. no. 2.

22. *Lettere scritte a Pietro Aretino,* I, part 2, 269–71.

23. Niccolò Franco, *Rime . . . contro Pietro Aretino* (Lanciano: Carabba, 1916), 47 (no. 99), the third edition of his Rime of 1548; the first edition was published in 1541. See Carlo Simiani, *Niccolò Franco: La vita e le opere* (Rome, 1894), 103–12 and 163–64.

24. Franco, *Rime,* 47–52 (nos. 100–110).

25. See Chapter I, page 11.

26. For gifts of various chains to Aretino, see *Frick Collection,* II, 256.

27. Cesare Ripa, *Iconologia* (Venice, 1645), 258: "Le maniglie alle braccia & il colloro d'oro al collo, erano antichi segni d' Honore." Cf. the interesting discussion of the chain's meaning by Julius S. Held, *Rembrandt's Aristotle and Other Rembrandt Studies* (Princeton: Princeton University Press, 1969), 32–41.

28. James Laver, *A Concise History of Costume and Fashion* (New York: Scribner's, 1969), 184.

29. Rensselaer W. Lee, *Ut Pictura Poesis* (New York: W. W. Norton, 1967), 34–41, for a discussion of decorum. Cf. Brian Vickers, *In Defence of Rhetoric* (Oxford: Clarendon Press, 1988), 344–45.

30. Cicero, *Orator,* trans. H. M. Hubbell, Loeb Classical Library, 1954, 357: "In an oration, as in life, nothing is harder than to determine what is appropriate."

31. See Bernard Weinberg, *A History of Literary Criticism in the Italian Renaissance* (Chicago: University

of Chicago Press, 1961), 721–24, as well as 1164, s.v. "decorum."

32. Leon Battista Alberti, *On Painting,* trans. J. R. Spencer (New Haven: Yale University Press, 1973), 74: "[A]ll the members ought to conform to a certain appropriateness." Alberti used "appropriateness" ("convenientia" in the Latin edition and the corresponding term in the Italian edition) rather than decorum. Cf. John R. Spencer, "Ut Rhetorica Pictura: A Study in Quattrocento Theory of Painting," *JWCI* 20 (1957): 40, who remarked that the concept had never before been expressed in relation to painting.

33. Leonardo da Vinci, *Treatise on Painting [Codex Urbinas Latinus 1270],* ed. A. P. McMahon (Princeton: Princeton University Press, 1956), I, 147 (no. 387). See Anthony Blunt, *Artistic Theory in Italy, 1450–1600* (Oxford: Oxford University Press, 1973), 35, and Martin Kemp, *Leonardo da Vinci* (London: Dent, 1981), 336.

34. RD, 118–21; cf. Lee, *Ut Pictura,* 37, on the transition from decorum to decency.

35. Gian Paolo Lomazzo, *Scritti sulle arti,* ed. R. P. Ciardi (Florence: Centro Di, 1974), II, 375: "[T]anto è lontano il pensare che permettessero a uomini plebei e vili il farsi ritraere dal naturale; anci questo assolutamente era riservato solamente per principi e savi."

36. P-C, II, 75: "A tua infamia, secolo, che sopporti che sino i sarti e i beccai appaiano là vivi in pittura." Quoted from Peter Burke, "The Presentation of Self in the Renaissance Portrait" in his *The Historical Anthropology of Early Modern Italy* (Cambridge: Cambridge University Press, 1987), 165.

37. See Erwin Panofsky, *The Life and Art of Albrecht Dürer* (Princeton: Princeton University Press, 1943), 163, on the *facies nigra* with its startling eye, and on *Saint Paul* and his connection with *Melancholia,* 235.

38. Paul Künzle, "Raffaels Denkmal für Fedro Inghirami auf dem letzten Arazzo," in *Mélanges Eugène Tisserant,* VI: Bibliothèque Vaticane (Vatican City: Biblioteca Apostolica Vaticana, 1964), 499–548.

39. Leon Battista Alberti, *The Ten Books of Architecture,* the 1755 Leoni Edition (New York: Dover, 1986), 169: "The Ægyptians employed Symbols in the following Manner: They carved an Eye, by which they understood God." Cf. Pierio Valeriano Bolzani, *Hieroglyphica sive de sacris Aegyptiorum* (Basel, 1567), 234r: "Occulus cur Dei signum." Cf. Edgar Wind, *Pagan Mysteries in the Renaissance* (New York: W. W. Norton, 1968), 232.

40. Arthur McComb, *Agnolo Bronzino: His Life and Works* (Cambridge: Harvard University Press, 1928), cat. no. 565; Edi Baccheschi, *L'opera completa del Bronzino* (Milan: Rizzoli, 1973), cat. no. 76; cf. Charles McCorquodale, *Bronzino* (New York: Harper & Row, 1981), 61–64.

41. Fritz Saxl, "Titian and Aretino," in his *Lectures* (London: Warburg Institute, 1957), I, 168, points to the affinity between Aretino's pose and the rhetor's when noting the kinship between the Pitti portrait and the *Sophocles* in the Lateran Museum.

42. Quintilian, *The Institutio Oratoria,* trans. H. E. Butler, Loeb Classical Library, 1972, IV, 332.

43. John Bulwer, *Chirologia: or the Natural Language of the Hand and Chironomia: or the Art of Manual Rhetoric,* ed. J. W. Cleary (Carbondale: Southern Illinois University Press, 1974), 182, Canon XXVIII: "The hand brought unto the stomach, and in a remiss garb spread thereon, doth *conscientiously asseuere* and becomes those who *affirm anything of themselves*" (italics added).

44. Lodovico Dolce, *Dialogo . . . de i colori* (Venice, 1565), 55r: "Onde si dice in prouerbio: che la lingua non ha osso, esa spezzare il dosso. Per questa cagione Francesco Re di Francia mandò in donno all' Aretino vna catena d'oro di seicento scudi; laquale era fatta a lingue volendo per quella dinotare la proprietà de l'Aretino, ch'era dir male." See the remarks by Emm. Antonio Cicogna, "Memoria intorno la vita e gli scritti di Messer Lodovico Dolce, letterato Veneziano del secolo XVI.," *Memorie dell'I. R. Istituto Veneto di scienze, lettere ed arti* 11 (1892): 107.

45. Cicero, *De Oratore,* trans. H. Rackham, Loeb Classical Library, 1968, II, 177: "But everything depends on the countenance, while the countenance itself is entirely dominated by the eyes" (III.lviii.221). Compare Dolce's opinion, expressed in his dialogue, translated in RD, 97: "But the eyes, in the main, are the windows of the soul; and in these the painter can fittingly express every emotion there is." Cf. Clark Hulse, *The Rule of Art* (Chicago: University Press of Chicago, 1990), 109–10, who, while noting Aretino's eyes as an unusual element of the portrait, drew attention to the cinquecento connoisseurs' perception of the eye as a spiritual organ.

46. V-M, I, 574; quoted from V-H, II, 135.

47. Aby Warburg, *Gesammelte Schriften,* ed. F. Rougemont and G. Bing (Leipzig and Berlin: Teubner, 1932), I, 89–126; cf. Eve Borsook and Johannes Offerhaus, *Francesco Sassetti and Ghirlandaio at Santa Trinità. Florence: History and Legend in a Renaissance Chapel* (Doornspijk: Davaco, 1981), 36–42.

48. Alberti, *On Painting,* 93–94.

49. W, I, cat. no. 87; V, cat. no. 184.

50. For this painting's iconography, see Panofsky, *Problems in Titian,* 73–77, and his "Classical Reminiscences in Titian's Portraits: Another Note on His 'Allocution of the Marchese del Vasto,' " in *Festschrift*

für Herbert von Einem zum 16 Februar 1965 (Berlin: Gebr. Mann, 1965), 188–202.

51. Bottari, *Raccolta,* v, 255–56; it is translated, though imprecisely, by James Northcote, *The Life of Titian* (London, 1830), ii, 188n; I have modified the translation. Marcolini's letter as the evidence of Aretino's presence was cited in Stefano Ticozzi, *Vite de' pittori Vecelli di Cadore* (Milan, 1817), 122 and n. 1. It is also mentioned by Milanesi in V-M, vii, 442 and n. 1.

52. P-C, i, 162: "Intanto si può quasi giurare che molti dei soldati infiniti, in atto di stupido silenzio, vestiti e armati di varie sorti d'abiti e d'armi, levino il fisso del guardo da la maestà."

53. V-M, ii, 256; quoted from V-H, ii, 267.

54. V-M, iv, 31; quoted from V-H, ii, 162.

55. For the discussion of the painting's date, see Creighton E. Gilbert, "Some Findings on Early Works of Titian," *AB* 62 (1980): 74–75. Although agreeing that the painting is from 1543, Gilbert convincingly argues that Titian's signature on the painting is forged. On the contrary, Philipp P. Fehl, "Tintoretto's Homage to Titian and Pietro Aretino" in his *Decorum and Wit* (Vienna: IRSA, 1992), 176, considering Titian's as well as his patron's allegiance to Charles V, argues in favor of the authenticity of the painter's signature. For Leoni's medal, see *Omaggio a Tiziano,* cat. no. 96.

56. For general background on the subject, see S. G. F. Brandon, "Pontius Pilate in History and Legend," *History Today* 18 (1968): 523–50, and Paul Winter, *On the Trial of Jesus* (Berlin: De Gruyter, 1974), 70–89. For an exegesis of the evangelical passage, see Charles Harold Dodd, *The Interpretation of the Fourth Gospel* (Cambridge: Cambridge University Press, 1953), 436–37, and Rudolph Karl Bultmann, *The Gospel of John: A Commentary* (Philadelphia: Westminster, 1971), 658–59.

57. To my knowledge, no study has been made of the iconography of Titian's painting or of the way the theme was represented in Renaissance art. My attempt to trace the history of the theme *Ostentatio Christi* in the works prior to Titian's is based on Erwin Panofsky's valuable study, "Jean Hey's 'Ecce Homo': Speculations About Its Author, Its Donor, and Its Iconography," *Bulletin des Musées Royaux des Beaux-Arts de Bruxelles* 5 (1957): 102–10.

58. The distinction between the two types was first offered by Mrs. Jameson (Anna Brownell), *The History of Our Lord* (London, 1872), ii, 92. Mrs. Jameson distinguished between the lonely figure of Christ and the figure accompanied by other figures; this distinction has been further amplified by Panofsky, "Jean Hey's," 102, who suggested using the medieval term *Ostentatio Christi* for the first type of scene and *Ecce Homo* for the second one. See V-H, iv, 200, on the *Ecce Homo* for "a

Flemish noble and merchant," and 206, on the painting done for the pope, which "did not seem a good work to artists."

59. For the *Ecce Homo* paintings by Italian artists, see Sixten Ringbom, *Icon to Narrative* (Doornspijk: Davaco, 1984), 146–47.

60. For Aretino's letter on the *Ecce Homo,* see P-C, ii, 191. See Norman E. Land, "Titian's *Martyrdom of St. Peter Martyr* and the 'Limitations' of Ekphrastic Art Criticism," *Art History* 13 (1980): 299–301.

61. P, 326, pl. 530; V, cat. no. 493; S., cat. no. 261; W, i, cat. no. 28; Land, "Titian's," 299, fig. 11.

62. See John White, *Duccio: Tuscan Art and the Medieval Workshop* (London: Thames & Hudson, 1979), 112, pl. 43, and Evelyn Sandberg Vavalá, "A Chapter in Fourteenth-Century Iconography: Verona," *AB* 11 (1929): 405.

63. Panofsky, *Dürer,* 60, for the *Ecce Homo* of the Large Passion and 139–45 for the Small Passion series.

64. On the popularity of Dürer's engravings in Italy, see V-M, v, 405–6, and RD, 121. On Aretino's mention of Dürer, see P-C, ii, 86 (no. ccxlvii). Cf. Fehl, "Truth and Decorum Reconciled by Wit: Dürer, Titian, Pietro Aretino" in his *Decorum and Wit,* 152–66.

65. Hanns Swarzenski, "An Unknown Bosch," *Bulletin of the Museum of Fine Arts of Boston* 53 (February 1955): 1–10.

66. Ellen S. Jacobowitz and Stephanie L. Stepanek, *The Prints of Lucas van Leyden and His Contemporaries* (Washington, D.C.: National Gallery of Art and Princeton University Press, 1983), cat. no. 30, 96–97. On Lucas' influence on Titian's painting, see Eugenio Battisti, "Di alcuni aspetti non veneti di Tiziano," in *Tiziano e Venezia: Convegno internazionale di studi. Venezia, 1976* (Vicenza: Pozza, 1980), 220. Cf. Fehl, "Tintoretto's Homage to Titian and Pietro Aretino" in his *Decorum and Wit,* 175.

67. Larry Silver, *The Paintings of Quinten Massys with Catalogue Raisonné* (Montclair, N.J.: Allanheld & Schram, 1984), cat. nos., 18, 31, and 46, pls. 33, 86, and 87, with a discussion on 94–95.

68. Panofsky, "Jean Hey's," 130 n. 31: "It may be more than an accident that Titian's gorgeous *Ostentatio Christi* in Vienna (dated 1543) was ordered by a Flemish merchant."

69. Alessandro d'Ancona, *Origini del teatro in Italia* (Florence, 1877), i, 282.

70. Ibid., i, 281, and on the *Passione* plays in Venice, 279.

71. Virginia Galante Garrone, *L'apparato scenico del dramma Sacro in Italia* (Turin: Bona, 1935), 93.

72. Wolfgang Braunfels, "Tizians Allocutio des Avalos und Giulio Romano," in *Mouseion; Studien aus Kunst und Geschichte für Otto H. Förster* (Cologne:

DuMont, 1960), 110–11, assumes that Romano's architecture influenced Titian's rendition of the background building in the Vienna painting. On Serlio's influence on Aretino's and Titian's conception of the background architecture, see W, I, 79. Cf. John Onians, *Bearers of Meaning* (Princeton: Princeton University Press, 1988), 299–304.

73. Quoted from Pietro Aretino, *Selected Letters*, trans. G. Bull (Harmondsworth: Penguin, 1976), 118. In this letter Aretino refers to Camillo, who made this kind of parallel.

74. Onians, *Bearers*, 299, remarked on the psychological correlation between a building and its owner's character. Cf. Onians's remarks on the architecture of the painting's background, 303. Moreover, owing to the presence of dark polished marble on the right, Onians considers the figure in armor to be the centurion Saint Longinus (304).

75. David Rosand, *Titian* (New York: Harry N. Abrams, 1978), 116, referred to the lack of abuse on the side of observers.

76. Ridolfi, *Maraviglie*, I, 172: "A Giouanni d'Anna, già mentouato, suo compare fece vn gran quadro di Christo Ecce Homo mostrado da Pilato al popolo nella sommità d'vna scala. Nella figura di Pilato haueua ritratto Partenio & in due Caualieri a pie delle scale Carlo V. Imperadore e Solimano, Re de' Turchi."

77. W, I, 79, for the reasons for identifying the personages as they were. Cf. J. A. Crowe and G. B. Cavalcaselle, *Titian: His Life and Times* (London, 1877), II, 95, and Hans Tietze, *Titian: Paintings and Drawings* (London: Phaidon, 1950), 36–37 and 399. A different interpretation of these personages' identities is offered by Fehl, "Tintoretto's Homages" in his *Decorum and Wit*, 173–76.

78. Detlev Freiherr von Hadeln, "Das Problem der Lavinia-Bildnisse," *Pantheon* 7 (1931): 82–87.

79. On the favorable attitude to Pilate's role in Jesus' trial, an attitude that prevailed in the Renaissance and is thought to be embodied in Donatello's relief at San Lorenzo, see Selma Pfeiffenberger, "Notes on the Iconology of Donatello's 'Judgment of Pilate' at San Lorenzo," *Renaissance Quarterly* 20 (1967): 435–50. Renaissance advocates of the favorable attitude toward Pilate stressed that he suffered because of his inability to influence the course of events. The source of this attitude is Dante's *Monarchy* (II.xii.5–6).

80. *La passione di Gesù Cristo: Rappresentazione sacra in Piemonte nel secolo XV*, ed. Vincenzo Promis (Turin, 1888), 418: "Pilato pietosamente dica la sentenza" (my translation and emphasis).

81. Luise Serafino, *Tragedia*, in *Sacre rappresentazioni aversane del sec. XVI*, ed. D. Coppola (Florence: Olschki, 1959), 5.

82. See, in particular, Giorgio Petrocchi, *Pietro Aretino tra Rinascimento e Controriforma* (Milan: Vita e pensiero, 1958), 274–81. On the interrelationship between Aretino's religious writings and art, see David Rosand, *Painting in Cinquecento Venice: Titian, Veronese, Tintoretto* (New Haven: Yale University Press, 1982), 195–99; Jaynie Anderson, "Pietro Aretino and Sacred Imagery," in *Interpretazioni veneziane: Studi di storia dell'arte in onore di Michelangelo Muraro* (Venice: Arsenale, 1984), 275–90; and Philipp P. Fehl, "Feasting at the Table of the Lord: Pietro Aretino and the Hierarchy of Pleasures in Venetian Painting," *Hebrew University Studies in Literature and the Arts* 13 (1985): 161–74. Cf. Paul F. Grendler, "The Roman Inquisition and the Venetian Press, 1540–1605" in his *Culture and Censorship in Late Renaissance Italy and France* (London: Variorum Reprints, 1981), IX, 54 and 61. For the general historical background, see William James Bouwsma, *Venice and the Defense of Republican Liberty: Renaissance Values in the Age of the Counter Reformation* (Berkeley and Los Angeles: University of California Press, 1968).

83. Pietro Aretino, *Dell'Umanità del Figliuolo di Dio* (Venice, 1628, published under the anagram Partenio Etiro), 372: "Veramente Pilato era tra il sacro, e il fasso; e molestato dalla conscienta [sic] del'giudicio, che deue sentare ogni arte per liberarlo. E accorgedosene la turba."

84. Philipp Fehl in *Decorum and Wit* also questions Titian's reasoning for presenting Aretino as Pilate; see his "Tintoretto's Homage," 175.

85. Karl-Adolf Knappe, *Dürer: Das graphische Werk* (Vienna and Munich: Schroll, 1964), fig. 188: B.9 (117).

86. Ibid., fig. 271: B.35 (120).

87. Quintilian, *Institutio Oratoria*, IV, 305: "It is never correct to employ the left hand alone in gesture." Cf. Bulwer, *Chirologia*, 247 (*Cautio* XXVI). The connotation of the left hand as evil is latent in the etymology of *left* as "sinistra." The symbolism of the right and left hands is well known.

88. On the gestures of the protagonists of this *sacra conversazione*, though without special attention to the gesture of Saint John the Baptist, see Helmut Wohl, *The Paintings of Domenico Veneziano, ca. 1440–1461* (New York: New York University Press, 1980), 40–46. Cf. André Chastel, "L'Art du geste à la Renaissance," *Revue de l'art* 75 (1987), fig. 20, for Palmezzano's figure of Saint John the Baptist making a similar gesture, though not so eloquently as Domenico's.

89. Bulwer, *Chirologia*, 123–27 (*Gestus* VI: *Indico*). Cf. Chastel, "L'Art du geste," 15, and his "Sémantique de l'index," *Storia dell'Arte* 40 (1980): 415–17.

90. On *clementia*, see *Reallexikon für Antike und*

Christentum, ed. Th. Klauser (Stuttgart: Hiersemann, 1957), III, 206–31. On a gesture expressing clemency as in *Trojan's Column* (Scene XLVI), see Richard Brilliant, *Gesture and Rank in Roman Art* (New Haven: The Academy, 1963), 122. Cf. Bulwer, *Chirologia*, 55–58 (*Gestus* XXV: *Munero*).

91. Luitpold Dussler, *Raphael* (London: Phaidon, 1971), 31–32.

92. I use the term Folly in its simplest sense. H. W. Janson, *Apes and Ape Lore in the Middle Ages and the Renaissance* (London: Warburg Institute, 1952), 199–200. Cf. Ernesto Grassi and Maristella Lorch, *Folly and Insanity in Renaissance Littérature* (Binghamton, N.Y.: CEMER, 1986).

93. Rosand, *Titian*, 116, considers this figure as introducing a tragic note into the scene.

94. Silver, *Quinten Massys*, pl. 33.

95. Ibid., pl. 86.

96. Hope, *Titian*, 103, noted the figure of the soldier, remarking that this figure shows what Pino had advised for demonstrating the artist's skill in rendering a difficult figure.

97. P, 96, pl. 286; V, cat. no. 241A; W, I, cat. no. 45. Wethey remarks that this repetition is a rare example in the artist's work (96). Cf. *Titiano per i Duchi di Urbino, mostra didattica* (Urbino: AGE, 1976), 68–69.

98. See Palladino, "Pietro Aretino," 228–48, for a perceptive analysis of the Pitti portrait.

99. On the reasons for Francis giving a chain to Aretino, see Dolce's remarks in note 44 above; Rosand, *Titian*, 120. Palladino, "Pietro Aretino," 245–47, discerned the dragon head in one of the chain's links.

100. Bottari, *Raccolta*, V, 253: "Ecco Tiziano, mostra il saper dell'ingegno senza simile nel ritratto che in mezzo ai re e imperatori stassi nella gran guardaroba del duca di Firenze."

101. V-M, VII, 445; quoted from V-H, IV, 206.

102. Palladino, "Pietro Aretino," 232–33, compared the Aretino portrait with the other portraits, seeing its affinity only with the *Doge Andrea Gritti*. On the evolution of the portrait in which the sitter is shown as if in motion, see Carlo Pedretti, "Ancora sul rapporto Giorgione–Leonardo e l'origine del ritratto di spalla," in *Giorgione: Atti del convegno internazionale di studio per il 5° centenario della nascità 29–31 Maggio, 1978* (Venice, 1979), 180–85.

103. Crowe and Cavalcaselle, *Titian*, I, 312, remarked that Aretino "combines the fat of Vitellius with the seared aspect of Silenus." Cf. Roger Fry, "Pietro Aretino," *BM* 7 (1905): 347, who, in describing the Pitti portrait, comments that "it is true the Satyr in Aretino comes out." See also Barolsky on the idea of the artist as "socratic silene" in *Michelangelo's Nose*, 19–34.

104. Phyllis Pray Bober and Ruth Rubinstein, *Renaissance Artists and Antique Sculpture* (London: Miller and Oxford University Press, 1986), cat. no. 75.

105. Cf. Lynn Frier Kaufmann, *The Noble Savage: Satyrs and Satyr Families in Renaissance Art* (Ann Arbor, UMI, 1988), though Kaufmann does not discuss the Della Valle statues.

106. Leo Planiscig, *Andrea Riccio* (Vienna: Schroll, 1927), 327–68, discusses the popularity of the satyr image in Riccio's oeuvre. See his fig. 431 as an example of the "noble" type of satyr.

107. J. W. Jolliffe, "Satyre: Satura: 'Satiros' [in Greek]: A Study in Confusion," *Bibliothèque d'Humanisme et Renaissance* 18 (1956): 84–95. On the cinquecento interest in the genre of satire, see Weinberg, *History*, 148–49 (for Sansovino's discussion) and 443 (for Giraldi's definition).

108. Raymond B. Waddington, "Before Arcimboldo: Composite Portraits on Italian Medals," *The Medal* 14 (Spring 1989): 13–15. I am grateful to Professor Waddington for sending me this issue of the journal.

109. For the Attila medal, see ibid., 15 and fig. 6.

110. Cf. Raymond B. Waddington, "A Satirist's *Impresa*: The Medals of Pietro Aretino," *Renaissance Quarterly* 42 (1989): 655–81, who points out the erroneous impression the Aretino medal with phallic satyr on the reverse side made on Aretino's earlier critics, such as his first biographer, Count Giammaria Mazzuchelli, and Fidenzio Pertile. Palladino, "Pietro Aretino," 5, together with earlier critics, thought this medal had been commissioned by Aretino's opponents, Franco and Giovio. In none of his sonnets does Franco link Aretino with a satyr; if the satyr image had been considered negative, then Franco surely would have compared Aretino with a satyr. See Franco's address to Pan and Silenus in his *Rime*, nos. 232, 261, and 290 for Pan and 262 for Silenus.

111. See the discussion in Chapter I (pages 28–29) on Aretino's application of metoposcopic interpretation to Titian's portraits.

112. Panofsky, *Problems in Titian*, 10 n. 9: "I cannot help feeling that the fiery Aretino of the Pitti portrait was styled after the fashion of Michelangelo's *Moses*." Perhaps by establishing an affinity between Aretino and *Moses*, Titian wished to stress Aretino's prophetic aspect. On this affinity, see Palladino, "Pietro Aretino," 234 and 249.

113. For color plates, see S., 168, 162, 163, respectively.

114. Ibid., 241–42, where Palladino discusses the unique quality of Aretino's costume. Cf. Burke, "Presen-

tation," 158–59, on the significance of clothing in the hierarchical society of sixteenth-century Italy.

115. F. David Martin, "Spiritual Asymmetry in Portraiture," *British Journal of Aesthetics* 5 (1965): 6–13.

116. Cf. Palladino, "Pietro Aretino," 233, for the remarks on Aretino's temperament.

117. Rosand, *Titian*, 120, characterizes Aretino as arrogant.

118. *Frick Collection*, II, 256.

119. Quoted from C, 225 (Postscript"). It has been argued that Aretino never sent this letter to Michelangelo, but sent it, though without his "Postscript," to Alessandro Corvino (P-C, II, 175–77 and n. 1; CCCLXIV). See Palladino, "Pietro Aretino," 390–94, on Aretino's reactions to the *Last Judgment*. As is well known, Michelangelo represented Aretino in the guise of Saint Bartholomew in the *Last Judgment* and also inserted his own portrait grimacing with pain as a detail of the skin that the saint holds in his left hand. Charles de Tolnay, "Le *Jugement Dernier* de Michel Ange: Essai d'Interprétation," *Art Quarterly* 3 (1940): 140–41, fig. 10. Tolnay remarks on the resemblance between Aretino's face disguised as Saint Bartholomew and his renditions in Titian's portraits.

120. Quoted from Rosand, *Titian*, 20.

121. P-C, II, 61: " . . . essaltando la figura de la mia naturale sembianza, che tacendone per modestia pregiudicare al miracolo uscito dal pennello di si mirabile spirito."

122. Ibid., II, 81: "Che se io nel mio ritratto vedessi di quello andare che veggo ne la vostra imagine, me lo recarei tuttavia dinanzi come continuo specchio di me medesimo." Cf. Palladino, "Pietro Aretino," 299, for the interpretation of the mirror in the medieval sense as a *speculo* with its implication of *exemplum*.

123. Quoted from C, 220.

124. Panofsky, *Problems in Titian*, 10 and n. 9, proposes that Aretino might have chosen this epithet "under the unconscious influence of the fact that the word *terribile* and *terribilità* were commonly applied to Michelangelo." Barolsky, *Michelangelo's Nose*, 120, observes that the term became employed only in relation to Michelangelo and his works. See Palladino, "Pietro Aretino," 237–41, for an excellent discussion of this notion.

125. On the different meanings of *terribilità* in the theory of art in the sixteenth century, see Jan Białostocki, " 'Terribilità,' " in *Stil und Überlieferung in der Kunst des Abendlandes. Akten des 21. Internationalen Kongresses für Kulturgeschichte in Bonn, 1964* (Berlin: Gebr. Mann, 1967), 222–25, and David Summers, *Michelangelo and the Language of Art* (Princeton: Princeton University Press, 1981), 234–41.

126. See Chapter I, page 25, and note 93.

Chapter III

1. P-C, I, 77–78. On these portraits, see P, I, 81; II, pls. 231, 232; V, cat. nos. 186 and 187; W, II, cat. nos. 87 and 89; *Tiziano nelle Gallerie fiorentine: Catalogo* (Florence: Centro Di, 1978), nos. 28 and 29 (by Fausta P. Squellati); *Tiziano per i Duchi di Urbino, mostra didattica* (Urbino: AGE, 1976), cat. nos. 3 and 4 (by Grazia Bernini Pezzini); T, cat. nos. 28 and 29 (by Antonio Natali and Alessandro Cecchi), and most recently S., cat. nos. 167 and 168.

2. There is no study that concentrates on the problem of the portraits of the spouses. General observations can be found in Jacob Burckhardt, "Das Porträt in der italienischen Malerei" in his *Gesamtausgabe* (Stuttgart: Deutsche Verlag-Anstalt, 1929–33), XII, 176, and John Pope-Hennessy, *The Portrait in the Renaissance* (New York: Bollingen Foundation, 1966), 210–11.

3. Pope-Hennessy, *The Portrait in the Renaissance*, 159–60, and Creighton E. Gilbert, *Change in Piero della Francesca* (Locust Valley, N.Y.: Augustin, 1968), 29–32.

4. Roger Jones and Nicholas Penny, *Raphael* (New Haven: Yale University Press, 1983), 30; *Raffaello a Firenze: Dipinti e disegni delle collezioni fiorentine. Catalogo* (Milan: Electa, 1984), 105–17, nos. 8 and 9.

5. Arthur McComb, *Agnolo Bronzino: His Life and Works* (Cambridge: Harvard University Press, 1928), 8, cat. nos. 741 and 736; Edi Baccheschi, *L'opera completa del Bronzino* (Milan: Rizzoli, 1973), cat. nos. 33 and 34; cf. Charles McCorquodale, *Bronzino* (New York: Harper & Row, 1981), 52–53.

6. The biographical data on Francesco Maria della Rovere were drawn from Giovanni Battista Leoni, *Vita di Francesco Maria di Montefeltro della Rovere IIII, Duca d'Urbino* (Venice, 1605); James Dennistoun, *Memoirs of the Dukes of Urbino* (London, 1851), II, 299–437, III, 3–77; and Filippo Ugolini, *Storia dei conti e duchi d'Urbino* (Florence, 1859), II, 163–267.

7. On the minor role that Eleonora played in Urbino, see Alessandro Luzio and Rodolfo Renier, *Mantova e Urbino: Isabella d'Este ed Elisabetta Gonzaga nelle relazioni famigliari e nelle vicende politiche* (Turin, 1893).

8. Alice S. Wethey and Harold E. Wethey, "Titian: Two Portraits of Noblemen in Armor and Their Heraldry," *AB* 62 (1980): 76, convincingly date the portraits between 1536 and 1538. Cf. Dante Bernini, "Tiziano per i Duchi di Urbino" in *Tiziano*, 20. The documents of the duke's commission have been studied in recent scholarly literature; see the catalogues mentioned in note 1 above. Cf. the general study by Ranieri Varese, "Tiziano e i Della Rovere," *Notizie da Palazzo Albani* 5 (1976): 15–29. (I am grateful to this author for giving me a copy of his article.)

9. See Wethey and Wethey, "Titian," 85, for their remark that the crouching dragon was not a mere ornament but a specific allusion to his ties to the house of Aragon. This type of helmet was not a rarity; cf. Arthur Charles Fox-Davies, *A Complete Guide to Heraldry* (New York: Dodge, 1909), 311; the helmet with dragon crest is believed to be derived from the Italian model (see there fig. 592).

10. *Vocabolario degli Accademici della Crusca* (Venice, 1612), 737: s.v. "Rovere" as "Arbore noto, simigliante alla quercia. . . . È appresso il rouero fa il pedale diritto, e alto."

11. See Wethey and Wethey, "Titian," 86, for the translation of the motto.

12. W, II, 20. Among Titian's portraits of men in full military regalia, this portrait is the earliest example using a setting of this kind.

13. The story about Giorgione's experiment was told by Pino in his *Dialogo di pittura* (see BT, I, 131) and Vasari recorded it in his biography of Giorgione in both the 1550 and 1568 versions (see V-M, IV, 98).

14. Jan Lauts, *Carpaccio: Paintings and Drawings* (London: Phaidon, 1962), 245.

15. Michael Hirst, *Sebastiano del Piombo* (Oxford: Clarendon Press, 1981), 97, suggests a connection between Sebastiano's portrait and Giorgione's *Self-Portrait as David*.

16. See Creighton E. Gilbert, *The Works of Girolamo Savoldo: The 1955 Dissertation, with a Review of Research, 1955–1985* (New York: Garland, 1986), 322, for the portrait of a man as Saint George. Gilbert suggests that the man in "Gaston de Foix" could be the painter himself, and he links it with Giorgione's experiment (428–31). See S., cat. no. 74.

17. P, I, 89–90; Natali in *T*, 228; and David Rosand, *Titian* (New York: Harry N. Abrams, 1978), 23.

18. Sydney J. Freedberg, *Parmigianino: His Works in Painting* (Cambridge: Harvard University Press, 1950), 112–13; Ferdinando Bologna, "Il Carlo V del Parmigianino," *Paragone* 7 (January 1956): 3–16; and Konrad Oberhuber, in *The Age of Correggio and the Carracci: Emilian Painting of the Sixteenth and Seventeenth Centuries* (Washington, D.C.: National Gallery of Art, 1986), cat. no. 62, 172–74.

19. Cecchi in *T*, 26.

20. John Hunt, "Jeweled Neck Furs and 'Flöhpelze,'" *Pantheon* 21 (1963): 151–57. On *zibellini* in Italy, see Yvonne Hackenbroch, *Renaissance Jewellery* (London: Sotheby Parke Bernet, 1979), 29–30, who mentions Eleonora's *zibellino*.

21. On the "corner-space portrait," see Erwin Panofsky, *Early Netherlandish Painting* (Cambridge: Harvard University Press, 1953), 316.

22. On the Florentine tradition, see Pope-Hennessy, *Portrait*, 60, who does not distinguish between the fenestrated portrait and the portrait with the landscape background. The Giorgionesque fenestrated portrait has not been studied, but see, for example, *The Portrait of a Man*, National Gallery of Art, Washington, D.C. (Samuel H. Kress Collection), variously attributed to Titian or Giorgione, V, cat. no. 2; W, III, cat. no. X-109. cf. Terisio Pignatti, "Giorgione and Titian," in *T*, 73, pl. 7. In Titian's oeuvre before 1538 this type occurs frequently, see V, cat. nos. 15, 49, 71.

23. Charles Hope, *Titian* (New York: Harper & Row, 1980), 80, suggests that Titian could have seen the cartoon in Ferrara in 1519.

24. P, I, 81; V, 189, W, III, cat. nos. 103, 146, notes the similarity in the composition of the two portraits.

25. Quoted from James Northcote, *The Life of Titian* (London, 1830), II, 174. Whenever possible I adhere to this translation.

26. P-C, I, 77: "[N]on pur dimostrano l'ardir de la carne, ma scoprono la virilità de l'animo." Cf. Northcote, *Life of Titian*, II, 174, who translates "la virilità d'animo" as "strength of mind," a translation that is difficult to accept.

27. Ugolini, *Storia*, II, 198–226. Even the contemporary historian Francesco Guicciardini foresaw the perilous consequences of this war, which severely sapped the military strength of the papacy (*Storia d'Italia*, XII).

28. P-C, I, 77: "E nel lucido de l'armi, ch'egli ha in dosso, si specchia il vermiglio del velluto adattogli dietro per ornamento." Cf. Theodor Hetzer, *Tizian: Geschichte seiner Farbe* (Frankfurt am Main: Klostermann, 1948), 118 and 122. Although noting the effects of the deep red reflected in the polished steel, Hetzer did not discuss the color as mentioned in Aretino's letter versus the color in the painting.

29. Besides the example of Equicola's "complains" in BS, 2156, see other examples of Dolce, 2212, and Galli, 2325. It is doubtful that their complains could be just rhetorical.

30. Lodovico Dolce, *Dialogo . . . de i colori* (Venice, 1565), 7v: "E ne fauellerò teco non, come dipintore, che io apparterebbe a Diuin Titiano." Cf. BS, 2212.

31. Dolce, *Dialogo*, 14v: "Vegniamo a quello, che i Latini chiamano Ruso: ilquale non essere il medesimo, che il rubro, da questo si può vedere: che dirittamente si dice da Latini sanguis ruber, ma non gia rufus. Percio che ruber è quello, che noi diciamo rosso o vermiglio." Cf. BS, 2223.

32. I am grateful to Joyce Plesters, who examined the colors of the portrait during the Titian symposium in 1990. Professor Plesters kindly made these observations for me. According to her report, which with her permission I quote verbatim: "Background drapery of della Rovere portrait likely to be a crimson-coloured

lake pigment. Lake pigments are made from soluble claystuffs (usually red or yellow) extracted from plants (e.g., madden = crimson madden lake) or insect (kermes, *lacca*) mordanted into an insoluble inorganic base, chalk or aluminium hydroxide, to give an insoluble pigment. Kermes, lacca and madden usually give translucent crimson pigments. These can be mixed with lead white to give a pink or rose-red underpaint which can thus be glazed with a thin layer of the crimson pigment used alone, unmixed with white. The lighter underpaint shines through the glaze giving the effect of stained glass. This seems to be the system used for the crimson hanging behind the lower half of the portrait. Vermilion = red mercuric sulphide, a mineral pigment, but also made synthetically from very early times by distilling mercury and sulphur. Bright scarlet red colour. One of the most opaque pigments."

33. Quoted from Pietro Aretino, *Selected Letters*, trans. G. Bull (Harmondsworth: Penguin, 1976), 69.

34. John Gage, "Color in Western Art: An Issue?" *AB* 72 (1990): 518–41, does not mention a study on red, vermilion, or crimson. Cf. Moshe Barasch, "Renaissance Color Conventions: Liturgy, Humanism, Workshops," in his *Imago Hominis* (Vienna: IRSA, 1991), 177, commented that "in the sixteenth century, the generic color 'red' is not sufficient," referring to Occolti's chapter on "vermiglio."

35. *Vocabolario*, 931–32, s.v. "vermiglio."

36. BS, II, 814 and n. 4, where Barocchi comments on Aretino's fascination with the naturalistic effect of the luster of armor in Titian's portraits.

37. On the duke's lending the armor and asking for a drawing of it from Titian, see Georg Gronau, *Documenti artistici urbinati* (Florence; Sansoni, 1936), 92 (no. xxx) and n. 2 on the duke's fascination with armor and the significance this suit of armor had for him.

38. W, II, 135, cat. no. 88. Cf. Squellati in *T*, 118; Wethey and Wethey, "Titian," 80–81, and Gianvittorio Dilon in *T*, cat. no. 27, 224. For the diverse opinions on the drawing and its complex technique, see Maria Agnesi Chiari Moretto Wiel, *Titian: Drawings* (New York: Rizzoli, 1989), cat. no. 23. I would like to thank Rona Goffen for discussing this drawing with me.

39. For Vasari's *Alessandro de' Medici*, see Paola Barocchi, *Vasari pittore* (Florence: Barbiera, 1964), 113, and Janet Cox-Rearick, *Dynasty and Destiny in Medici Art* (Princeton: Princeton University Press, 1984), 234–36. Neither Barocchi nor Cox-Rearick mentions Vasari's story. Neither does Lorne Campbell, *Renaissance Portraits* (New Haven: Yale University Press, 1990), 129–32.

40. V-M, VII, 657; quoted from V-H, IV, 261.

41. Aretino's letter attempts to demonstrate how well Titian employed the medium of paint in portraying the duke. His arguments, however, seem strange to the modern mind and are based on distinctions between the representation of the duke in the portrait and the portrait as a work of art in its own right; between the possibilities available to portraiture in a work of marble and that in painting; and last, between the Florentine style of painting, with its tendency to imitate sculpture, and the Venetian style, in which color was the basis of the composition. Nowhere in his letters does Aretino explicitly dwell on Titian's exploitation of paint based on the use of colors. I am inclined, however, to think that in his letter to Veronica, Aretino wants to draw her attention to the coloristic effects of the duke's portrait because he wants her to perceive the portrait as a work of art.

42. P-C, II, 9: "Ben dovevo io tener per chiaro il ciò che de l'arguta del suo parlar prudenzia solea già dirmi il di eterna memoria Francesco Maria di Urbino duca stupendo. Imperoché subito ch'io per comprenderlo di soprumana sembianza ripresi il torto fattogli dagli scultori inesperti, disse: 'Io son di natura non bello. Onde tengo obligo a chi ritraendomi hammi aggiunto bruttezza; avvenga che chi poi mi vede sente men dispiacere.' "

43. On the popularity of the *paragone* debates, see Erwin Panofsky, *Galileo as a Critic of the Arts* (The Hague: Nijhoff, 1954), 1. On the *paragone* between the visual arts, see Moshe Barasch, *Theories of Art: From Plato to Winckelmann* (New York: New York University Press, 1985), 164–74. On Varchi's role in the *paragone* debates, see Anthony Blunt, *Artistic Theory in Italy, 1450–1600* (Oxford: Oxford University Press, 1973), 54–56, and the more recent study by Leatrice Mendelsohn, *Paragoni: Benedetto Varchi's "Due Lezzioni" and Cinquecento Art Theory* (Ann Arbor: UMI, 1982).

44. Quoted from Baldesar Castiglione, *The Book of the Courtier*, trans. C. S. Singleton (New York: Anchor, 1959), 80.

45. Pliny, *Natural History*, trans. H. Rackham, Loeb Classical Library, 1968, IX, 333.

46. See, for example, Aretino's letter addressed to Fabrini (DLXXXII, October 1550).

47. RD, 155.

48. Ibid., 151.

49. P-C, I, 77: "E di cio fa credanza ogni sua ruga, ogni suo pello, ogni suo segno; e i colori . . . scoprono la virtilità de l'animo." Cf. Northcote, *Life of Titian*, II, 174, who translates "ruga" as "feature."

50. Heinrich Lausberg, *Handbuch der literarischen Rhetorik* (Munich: Hüber, 1973), II, 664, s.v. "color." Cf. Creighton E. Gilbert, "Antique Frameworks for Renaissance Art Theory: Alberti and Pino," *Marsyas: Studies in the History of Art* 3 (1943–45), 95: "A satisfactory parallel between *elocutio* and *colorire* might

be drawn by considering each as an embellishment for a product structurally complete without it." With references to the literature on the "colors of rhetoric."

51. Trissino's *Poetica* of 1529 is available in Bernard Weinberg, *Trattati di poetica e retorica del cinquecento* (Bari: Laterza, 1970–74), i, 20–158, with a reference to color on 35. This passage is translated in Władysław Tatarkiewicz, *History of Aesthetics* (The Hague: Mouton, 1970–74), iii, 187: "So too with poetry, where some poems are beautiful due to the appropriateness of their parts and colours." Cf. Bernard Weinberg, *A History of Literary Criticism in the Italian Renaissance* (Chicago: University of Chicago Press, 1961), ii, 984, on Tasso's rhetorical use of *color* in his *Apologia* of 1585. See Aretino's letter (lx, December 1, 1537) on his anticipation at meeting with Trissino during his brief visit in Venice.

52. Quoted from Lora Anne Palladino, "Pietro Aretino: Orator and Art Theorist" (Ph.D. diss., Yale University, 1981), 274. It is also translated by Mary Rogers, "Sonnets on Female Portraits from Renaissance North Italy," *Word & Image* 2 (1986): 303, and by Norman E. Land, "*Ekphrasis* and Imagination: Some Observations on Pietro Aretino's Art Criticism," *AB* 68 (1986): 210. Cf. Margot Kruse, "Aretinos Sonette auf Tizian-Porträts," *Romanistisches Jahrbuch* 38 (1987): 85.

53. See Palladino, "Pietro Aretino," 275–79, on this Aretino quotation and on the setting of Titian's portrait of the duke within the tradition of depicting *condottieri*.

54. It is hardly necessary to mention the continuing popularity of the image of Alexander the Great from ancient times to the Renaissance. This popularity is evident *inter alia* in the creation of the so-called *Romance of Alexander*, attributed to Pseudo-Callisthenes, which survived in numerous versions. (See one of the many studies on the subject, such as Armand Abel, *Le roman d'Alexandre, légendaire médiéval* [Brussels: Office de publicité, 1955]).

55. Castiglione, *Courtier*, 84. Luzio and Renier, *Mantova e Urbino*, 189: "Il nuovo Duca Francesco Maria era avvente della persona, ma di carattere violento."

56. Peter Meller, "Physiognomical Theory in Renaissance Heroic Portraits," in *Studies in Western Art* (Princeton: Princeton University Press, 1963), ii, 61.

57. Ruth Wedgwood Kennedy, " 'Apelles Redivivus,' " in *Essays in Memory of Karl Lehmann* (New York: New York University Press, 1964), 160–70; cf. Zygmunt Wázbinski, "Tycjan—'nowy Apelles.' O roli antycznego mitu w sztuce renesansu," *Rocznik historii sztuki* 8 (1970): 47–68.

58. Anton Francesco Doni, *Disegno* (Venice, 1549), 40v.

59. See Chapter I, page 28.

60. Ugolini, *Storia*, ii, 254. The duke was said to have been murdered by a barber who poured poison into his ear, though Wethey and Wethey, "Titian," 89, suggested that his death was caused by a viral infection that was mistaken for poisoning.

61. Pliny, *Natural History* ix.329. Cf. Kurt Rathe, *Die Ausdrucksfunktion extrem verkürzter Figuren* (London: Warburg Institute, 1938), 21.

62. Plutarch, *Lives*, trans. B. Perrin, Loeb Classical Library, 1928, vii, 233: "[I]t was the heat of his body as it would seem, which made him too prone to drink and choleric" ("Alexander," iv, 4).

63. See Pomponius Gauricus, *De Sculptura (1504)*, ed. André Chastel and Robert Klein (Geneva: Droz, 1969), for the author's physiognomic description of a forehead characteristic of a person with a choleric temperament, 149: "Quadrata que scilicet suae magnitudinis mensionem habuerit"; for a description of the eyes, 141: "Quod si grandiusculi, splendidique humidius contueantur. . . . Qualem fuisse aiunt Alexandrum Macedonem"; for the nose, 147: "Plenum Solidum obtusumque si uideris, Ex leonibus"; for the shape of the head, 151: "utrinque conuexum iracundior"; and for the hue of his flesh, 161: "Mellinus iracundum epulonem."

64. Wethey and Wethey, "Titian," 78.

65. George Francis Hill, *A Corpus of Italian Medals of the Renaissance Before Cellini* (London: Trustees of the British Museum, 1930), i, 79, cat. nos. 318–20. (Since the specimen that was in the British Museum has been lost, I reproduce the one from the Bargello.) Francesco's other likeness is in a manuscript illumination, where he is shown receiving the baton of command from his paternal uncle, Pope Julius II; it is dated sometime between 1504 and 1511. However, the scale of the miniature makes it difficult to judge the character of the duke's effigy; it is reproduced by Rona Goffen, "Carpaccio's *Portrait of a Young Knight*: Identity and Meaning," *Arte Veneta* 37 (1983): 43, fig. 7. Also Francesco is tentatively proposed as the subject of *A Young Man with an Apple*, whose attribution to Raphael is much disputed today. Cf. John Shearman, "Raphael at the Court of Urbino," *BM* 112 (1970): 72–88, and *Raffaello a Firenze*, 71–76, cat. no. 4.

66. Compare the description of Francesco's physiognomy by Ugolini, *Storia*, ii, 258: "Fu Francesco piccolo di corpo, di grata e virile fisionomia, di occhio vivacissimo, di molta affabilità, e grazioso e spiritoso nel conversare."

67. Hope, *Titian*, 80, claims: "In the sixteenth century accuracy in this respect does not seem to have been considered of much importance."

68. Meller, "Physiognomic Theory," 58–61.

69. Alessandro d'Ancona, *Origini del teatro in Italia* (Florence, 1877), II, 68.

70. Compare Pliny's words with Aristotle's, *Historia animalium* 629b.36–38.

71. Paolo Giovio, *Dialogo dell'imprese militari e amorose*, ed. M. L. Doglio (Rome: Bulzoni, 1978), 135. (All the following translations from this text are mine).

72. Ibid., 11; Plutarch, *Lives*, V, 325: "The device was a lion holding a sword in his paws" ("Pompey," LXX, 3–6).

73. Giovio, *Dialogo*, 135: "[I]l Duca non volesse far molta mostra di questa impresa per fuggir l'odio e l'invidia de' cardinali." For example, Girolamo Ruscelli, *Le imprese illustri* (Venice, 1566), 256, mentions the duke's *impresa* with the palm, but not the one with the lion.

74. Giovio, *Dialogo*, 89. This *impresa* was reproduced on one of the duke's medals; see Hill, *Corpus*, cat. no. 320.

75. See Palladino, "Pietro Aretino," 266–70, for the discussion of a portrait as "A Monument More Lasting Than Bronze."

76. Ugolini, *Storia*, II, 255. Guidiccione's poem, "Viva fiamma di Marte," well known in his own time, was further popularized by Lodovico Dolce, *Rime di diversi eccellenti autori* (Venice, 1556: this was the second edition; the first was printed by the same Giolito press in 1553). Giovio also mentions that the spirit of Mars inflamed the duke's soul. In his *Elogia virorum bellica virtute illustrium* (Basel, 1596), 211, he refers to Titian's portrait of the duke in the following terms: "[C]ertius in tabula ad veram imaginem expressus est, quam his ipse Feltrius, qui his suis armis atque coloribus, hisque triplicis impreii militaris insignibus Titiani summi pictoris manu delineatus conspicitur." The *editio princeps* was published in Florence in 1551 without illustrations. The first edition with engraved portraits by Tobbias Stimmer appeared in 1575 and included Titian's portrait (on p. 210 of the 1596 edition).

77. BS, II, 2156: "[R]oscio vendetta et ira nota, perché irati ne infiammamo, il che è proprio del furibondo Marte."

78. Ibid., 2165: "[Q]uesto color significa sospizion, gelosia, tema e rispetto." Cf. Jonas Gavel, *Colour* (Stockholm: Almqvist & Wiksell International, 1979), 140, no. 14, for the author's chart with the symbolism of colors in various authors' writings.

79. W, II, 23: "Aged forty-three when the portrait was begun, she is neither beautiful nor rejuvenated." Eleonora's beauty was praised by Bembo, Equicola, and Castiglione. See Shearman, "Raphael," 77–78.

80. Pietro Bembo, *Gli Asolani*, trans. R. B. Gott-fried (Bloomington: Indiana University Press, 1954), 115–17, and Agnolo Firenzuola, *Dialogue of the Beauty of Women*, trans. C. Bell (London, 1892), 62–70. On the portrayal of ideal feminine beauty, see Elizabeth Cropper, "On Beautiful Women, Parmigianino, Petrarchismo, and Vernacular Style," *AB* 58 (1976): 374–94. The rhetoric of the female portrait has been studied by Mary Rogers, "The Decorum of Women's Beauty: Trissino, Firenzuola, Luigini, and the Representation of Women in Sixteenth-Century Painting," *Renaissance Studies* 2 (1988): 47–88. For the discussion of Eleonora's faded beauty and Aretino's praise of her as beautiful, see Palladino, "Pietro Aretino," 282–83.

81. Castiglione, *Courtier*, 287. Cf. Ugolini, *Storia*, II, 259.

82. Quoted from Palladino, "Pietro Aretino," 281–82. See the discussion of this sonnet by Kruse, "Aretinos Sonette," 89. It has also been translated by Rogers, "Sonnets," 304, and Land, "*Ekphrasis*," 210.

83. Palladino, "Pietro Aretino," 283–90, for a discussion of *concordia*; yet, in discussing *unione* no reference was made to the colors as manifesting the character. Aretino's language, briefly discussed in Chapter I, requires a separate study. It should be noted, however, that Aretino's language influenced Vasari's; see Lionello Venturi, "Pietro Aretino e Giorgio Vasari" in his *Pretesti di critica* (Milan: Hoepli, 1929): 53–72, and, most recently, Paul Barolsky, *Why Mona Lisa Smiles and Other Tales by Vasari* (University Park: The Pennsylvania State University Press, 1991), 84. Cf. Roland LeMolle, *Georges Vasari et le vocabulaire de la critique d'art dans les "Vite"* (Grenoble: Ellug, 1988).

84. BS, II, 2166: "Se tal color avesse mostrata prudenzia o gravitá." Cf. Gavel, *Colour*, 138, no. 3.

85. BS, II, 2157; cf. Gavel, *Colour*, 143, no. 17.

86. BS, II, 2166.

87. Erwin Panofsky, *Problems in Titian, Mostly Iconographic* (New York: New York University Press, 1969), 90, considers the table clock in Titian's portraits (an object that appears in at least seven portraits) as serving "the double purpose of an *insigne virtutis* and a *memento mori*." Alice Sunderland Wethey, "Titian's Painted Clocks," in W, III, 249–50, instead regards the clock in the portrait as a status symbol and an element of painting ornamentation. David Rosand, "Review of H. E. Wethey, *Titian: The Portraits*," *Renaissance Quarterly* 26 (1973): 497–500, criticized Wethey's view. From 1525 on, such clocks were already too popular to be seen as a status symbol. For clocks in Renaissance Italy, see Ernst von Basserman-Jordan, *The Book of Old Clocks and Watches* (New York: Crown, 1964), 362. Cf. Willis Isbister Milham, *Time and Timekeepers* (New York: Macmillan, 1941), 141, who recalls that during the Renaissance "a timekeeper was

esteemed primarily on account of its exterior ornamentation. . . . Accuracy in keeping time was always of very minor importance."

88. Palladino, "Pietro Aretino," 296 and n. 66.

89. Andrea Alciati, *Emblemata* (Paris, 1583), 612. The same claim is made in Pierio Valeriano Bolzani, *Hieroglyphica, sive de sacris Aegyptiorum* (Basel, 1567), 40v.

90. See note 20 above.

91. P-C, I, 35: "E Tiziano, rassemplandovi, anullarà con la vostra effigie le ragioni che in voi si crede aver la morte."

92. Albrecht Dürer, *Schriftlicher Nachlass*, ed. H. von Rupprich (Berlin: Deutscher Verein für Kunstwissenschaft, 1956–69), II, 113. Quoted from Campbell, *Renaissance Portraits*, 193. Edgar Zilsel, *Die Entstehung des Geniebegriffes* (Tübingen: Siebec, 1926), 112, noted that it was Dürer who was the first to observe the portrait's function in this way.

93. Panofsky, *Problems in Titian*, 14; David Rosand, "Titian and the Critical Tradition" in R, 16 and 36 n. 22. Cf. Jan Białostocki, "The Renaissance Concept of Nature and Antiquity" in his *Message of Images* (Vienna: IRSA, 1988), 247 and n. 42.

94. Gronau, *Documenti*, 95–96 (no. XLII). Quoted from Campbell, *Renaissance Portraits*, 222.

95. For the two portraits as constituting a union of polarities, see J. A. Crowe and G. B. Cavalcaselle, *Titian: His Life and Times* (London, 1877), I, 411–16; the entry by Squellati in *Tiziano*, 124; Palladino, "Pietro Aretino," 290; and Alistair Smith, "Titian's Portraiture," *Connoisseur* 192 (1976): 262. Cecchi and Natali, however, in *T*, 222 and 228, believe the portrait of the duchess precedes that of the duke.

96. *The Works of Aristotle Translated into English*, ed. W. D. Ross (Oxford: Clarendon Press, 1908–52), x (trans. B. Jowett). Cf. Ian Maclean, *Renaissance Notion of Woman* (New York: Cambridge University Press, 1980), 54.

97. Aristotle, x (trans. E. S. Forster). Cf. Maclean, *Renaissance*, 57.

Chapter IV

1. On Titian's relations with the Farneses, see the still-valuable study, Gustave Clausse, *Les Farnèse peints par Titien* (Paris: Gazette des Beaux-Arts, 1903). On Titian's portrait done in Busseto, see P, I, 101–2, II, pl. 273; V, cat. no. 236; W, II, cat. no. 72. See *Omaggio a Tiziano* (Milan: Electa, 1977), cat. no. 9, for the X-ray underpaintings, which shows the same conception of the likeness as the painting. For an up-to-date bibliography on this portrait, see T, cat. no. 34 and S, cat. no. 172. On the papal portrait done in Rome, see P, I, 112, II, pl. 308; V, cat. no. 267; and W, II, cat. nos. 73, 124. Cf. Sergio Ortolani, "Restauro d'un Tiziano," *Bollettino d'Arte* 33 (1948): 44–53. See its replicas: P, I, 112–13; V, cat. nos. 272, 273; and W, II, cat. nos. 74, 75. And on the group portrait, see P, I, 111–12, II, pl. 306; V, cat. no. 268; and W, II, cat. no. 76. Cf. *Omaggio a Tiziano*, cat. no. 12. Cf. Hans Ost, "Tizians Paul III. und die Nipoten," *Wallraf-Richartz-Jahrbuch* 45 (1984): 113–30. See the recent study by Roberto Zapperi, *Tiziano, Paolo III e i suoi nipoti* (Turin: Boringhieri, 1990), generously referred to me by Charles Hope.

2. Study of the specific character of papal portraits has not gone beyond those of the Middle Ages. See H. K. Mann, "The Portraits of the Popes," *Papers of the British School at Rome* 9 (1920): 169–204, and Gerhart B. Ladner, *I ritratti dei papi nell'antichità e nel medioevo* (Vatican City: Pontificio istituto di archeologia cristiana, 1941–84). See also Loren Partridge and Randolph Starn, *A Renaissance Likeness: Art and Culture in Raphael's Julius II* (Berkeley and Los Angeles: University of California Press, 1980), 127.

3. For biographical data on Pope Paul III, see Ludwig Pastor, *The History of the Popes* (London: K. Paul, Trench, and Trubner & Co., 1936–61), vols. XI and XII (trans. R. F. Kerr); Leopold von Ranke, *The History of the Popes*, trans. E. Fowler (New York: Colonial, 1901), I, 164–86; and Ferdinand Henry de Navenne, *Rome: Le Palais farnèse et les Farnèse* (Paris: Michel, 1900).

4. Creighton E. Gilbert, "When Did Renaissance Men Grow Old?" *Studies in the Renaissance* 14 (1967): 31–32 and n. 63 in relation to Pope Paul III's age.

5. Hubert Jedin, *A History of the Council of Trent*, trans. E. Graf (London: Nelson, 1957–61), I, 288 and n. 1, remarks: "In January 1535 Vergerio found the Pope looking well and full of life."

6. Ranke, *History*, I, 166.

7. Pastor, *History*, XII, 453: "Nepotism, his besetting fault, he acknowledged himself."

8. Battista Platina, P. V. Onofrio Panvinio, and Antonio Cicarelli, *Historia delle Vite de i Sommi Pontefici . . .* (Venice, 1608), 278: "Egli fu di mediocre statura, di non gran capo. Hebbe gli occhi scintillanti, lunghetto il naso, le labbra un poco eminenti, la barba lunga, le forze del corpo ferme." See Pastor, *History*, XI, 29: "[A]t first sight Paul III presented the appearance of a weary, worn-out old man. He spoke in low tones, with great deliberation and prolixity. His bright complexion and small speaking eyes, which struck everyone, alone denoted the choleric temper, over which, however, he had remarkable control. Consummate discretion kept in check a naturally mettlesome temperament." See J. A.

Crowe and G. B. Cavalcaselle, *Titian: His Life and Times* (London, 1877), II, 86, who interpret Paul III's physiognomy as foxlike.

9. On the portraits of Pope Paul III, see Clausse, *Farnèse*, 86–93. See also note 31 below on Vasari's mention of Sebastian's portrait. On the portraits of Paul III prior to Titian's, see the study by Fredrica Jacobs, "Studies in the Patronage and Iconography of Pope Paul III, 1534–1543" (Ph.D. diss., University of Virginia, 1979).

10. Pastor, *History*, XI, 30: "All the details are strictly true to nature; the dress, the thin hands, the intellectual head with its long aquiline nose, the piercing eyes and gloomy forehead; the shrewd countenance is framed in a full beard of a greyish-white colour." Cf. Erica Tietze-Conrat, "Titian's *Portrait of Paul III*," *GBA* 29 (1946): 76.

11. The composition of the papal portrait, in which the pope was always represented as seated, has been studied by Konrad Oberhuber, "Raphael and the State Portrait—I: The *Portrait of Julius II*," *BM* 113 (1971): 124–30. The Raphael portrait certainly set a precedent for the further development of this type of portrait.

12. Joseph Braun, *Die liturgische Gewandung im Occident und Orient* (Darmstadt: Wissenschaftliche Buchgesellschaft, 1964), 125–28 (*rochette*), 357–58 (*mozzetta*), 512–14 (*camauro*). Cf. Janet Mayo, *A History of Ecclesiastical Dress* (New York: Holmes & Meier, 1984), 123–25. See also Pastor, *History*, XI, 30.

13. J. Nabuco, "Papal Ceremony and Vestures," in *New Catholic Encyclopedia* (New York, 1967), X, 973a, on the custom of wearing a *camauro* while giving a public audience.

14. P, I, 102. Pallucchini sees Titian's portrait as having been influenced by Sebastiano's; however, the influence is most noticeable in the characteristic fingers. Cf. Michael Hirst, *Sebastiano del Piombo* (Oxford: Clarendon Press, 1981), 120.

15. Clausse, *Farnèse*, 77–83, was the first to note the difference in treatment of the pope's likeness in these two portraits. Cf. Zapperi, *Tiziano*, 93.

16. See Partridge and Starn, *Renaissance Likeness*, 43–46, 124, and Mark J. Zucker, "Raphael and the Beard of Pope Julius II," *AB* 59 (1977): 524–33.

17. Ibid., 532.

18. *New Testament Apocrypha*, ed. Wilhelm Schneemelcher (Philadelphia: Westminster, 1965), II, 354: "And he saw Paul coming, a man of small stature, with a bald head and crooked legs in a good state of body, with eyebrows meeting and nose somewhat hooked." Cf. E. Schroeder, "Paul, Apostle, St." in *New Catholic Encyclopedia*, XI, 8: "Physically, Paul has been traditionally stylized as short, bald, with thick beard and prominent nose."

19. Pastor, *History*, XII, 144; Jedin, *History*, I, 455.

20. For Titian's portraits of the Rovere popes, see *Tiziano nelle Gallerie fiorentine: Catalogo* (Florence: Centro Di, 1978), cat. no. 31 (Julius II) and cat. no. 32 (Sixtus IV).

21. On the exhibition of Raphael's *Pope Julius II* in Santa Maria del Popolo, see V-M, IV, 338, and Partridge and Starn, *Renaissance Likeness*, 76–97. Cf. Luitpold Dussler, *Raphael* (London: Phaidon, 1971), 29–30.

22. The three versions of Raphael's portrait of Pope Julius are in the Uffizi, the Pitti, and the National Gallery in London. Cecil Gould, "The Raphael *Portrait of Julius II*: problems of Versions and Variants (1511–12)," *Apollo* 92 (1970): 187–90, convincingly shows that the original version is in London. See Partridge and Starn, *Renaissance Likeness*, and its review by Rolf Quednau, "Raphael's 'Julius II,'" *BM* 123 (1981): 551–53.

23. Partridge and Starn, *Renaissance Likeness*, 98, on the votive character of the portrait, though without a reference to the background setting.

24. Mayo, *History*, 60 and 133: s.v. "annulus."

25. Partridge and Starn, *Renaissance Likeness*, 54–56, and see pages 139–40 for the discussion of the *mappa*.

26. On Sebastiano's *Pope Clement VII*, see note 30 below.

27. Richardus Foerster, ed., *Scriptores physiognomonici graeci et latini* (Leipzig: Teubner, 1893), II, 31, 3–4.

28. Quoted from C, 189.

29. Consider the following remarks as translated in C, 188: "O unique friend of mine, my lady Fame takes such great pleasure in proclaiming the miracle wrought by your brushes when you painted a portrait of the Pope," and 189: "You alone demonstrated . . . how much inferior Rome is to Venice."

30. On Sebastiano's participation in Michelangelo's workshop and his work on the portrait of Pope Clement VII, see Hirst, *Sebastiano*, 41–45 and 106–8, respectively.

31. V-M, V, 582.

32. Crowe and Cavalcaselle, *Titian*, II, 83–84, on Titian's refusal of the office; cf. Paola Rossi in *T*, 246.

33. Quoted from James Northcote, *The Life of Titian* (London, 1830), I, 251.

34. P-C, II, 81: "Che se io nel mio ritratto vedessi . . . come continuo specchio di me medesimo." See also note 121 in Chapter II.

35. P-C, II, 319: "Certo è che Tiziano, spirito de la carne, che sì viva nei colori ritrasse costì in Roma ne la sembianza del pontefice Paolo, del Cardinal di Carpi qui reconne ritratto l'animo di sorte che ciascuno ci ha potuto comprendere le sue vertù, le sue grandezze e le sue eccellenze."

36. Ibid., II, 430–31; cf. Margot Kruse, "Aretinos

Sonette auf Tizian-Porträts," *Romanistisches Jahrbuch* 38 (1980): 97, who remarks that it is not clear from this tercet to which portrait Aretino refers, as well as that Aretino repeats the topoi that recur in his earlier sonnets.

37. P-C, ii, 341: "Siede Paolo terzo, in vista altiera, / Nel di lui stil, nel qual par che favelle / In lingua di cuel cor, c'ha ne la cera."

38. BT, i, 38: "[L]a pittura sprime meglio e conseguentemente imita più la natura; onde allegano l'esempio delle uve che aveva in mano il fanciullo dipinto da Apelle . . . medesimi pittori eccellentissimi, rimangono ingannati dalla pittura . . . contendendo Zeusi con Parasio. . . . E di simili essempi hanno avuti pure assai i tempi nostri, come ultimamente nel ritratto di mano di M. Tiziano di papa Pagolo terzo."

39. Ibid., i, 62: "Appresso, il ritrare le persone vive di naturale, somigliando, dove aviamo visto ingannar molti occhi a'di nostri: come nel ritratto di papa Paolo terzo, messo per vernicarsi in su un terrazzo al sole, il quale da molti che passavano veduto, credendolo vivo gli facevon di capo; che questo a scolture non veddi mai fare."

40. Ibid., iii, 147: "Un caso simile avvenne—io dico nel fine e nell'effetto di questa arte—nel ritratto di Papa Paolo III, che fece Tiziano, il quale, posto al sole perché prendesse piu splendore con la vernice, movea (perocché talmente era effigiato, che parea vivo) chiunque passava ad inchinarsi e, scoprendosi il capo, a fargli riverenza, generando costumi come la maestà di gran principe e sacro in corpo vivo suole generare."

41. On the influence of the Council of Trent on visual art, see Charles Dejob, *De l'influence du Concile de Trente sur la littérature et les beaux-arts chez les peuples catholiques* (Paris, 1884); Émile Mâle, *L'Art religieux après le Concile de Trente: Étude sur l'iconographie de la fin du XVIe siècle, du XVIIe, du XVIIIe siècle* (Paris: Colin, 1932); Anthony Blunt, *Artistic Theory in Italy, 1450–1600* (London: Oxford University Press, 1973), 103–36; Paolo Prodi, *Ricerca sulla teorica delle arti figurative nella Riforma Cattolica* (1962; Bologna: Nuova Alfa, 1984); Hubert Jedin, "Das Tridentinum und die Bildenden Künste: Bemerkungen zu Paolo Prodi, *Richerche sulla teorica delle arti figurative nella Riforma Cattolica (1962),*" *Zeitschrift für Kirchengeschichte* 74 (1963): 321–39; and Giuseppe Scavizzi, "La teologia cattolica e le immagini durante il XVI secolo," *Storia dell'Arte* 21 (1974): 171–213.

42. On Paleotti's reference to the Nicaean Council, see BT, ii, 238, with Barocchi's note on 646; for Comanini's reference to the Council, see ibid., iii, 309. As far as I know, there is no study that traces the influence of the Patristic dulia on the Post-Tridentine

reformers, though the studies mentioned in note 41 above offer some remarks.

43. Ibid., ii, 243 (Paleotti), and iii, 303 (Comanini).

44. Ibid., ii, 350.

45. Ibid., ii, 323.

46. Cf. Partridge and Starn, *Renaissance Likeness,* 51–59, who discuss the imperial allusions of Raphael's *Pope Julius II.*

47. On the distinction between images of saints, priests, and kings, see Gerhart B. Ladner, "The Concept of the Image in the Greek Fathers and the Byzantine Iconoclastic Controversy," *Dumbarton Oaks Papers* 7 (1953): 20–22.

48. This problem has been noted in the Introduction, page 2.

49. *Vocabolario degli Accademici della Crusca* (Venice, 1612), 730, s.v. "ritratto." It is well known that in the old use "ritrarre" meant "to copy" rather than "to portray," the meaning we are accustomed to today. Vincenzio Danti distinguished between "ritratto" and "imitatio" as between "reproduction" and "intellectual re-creation." On this problem in particular, cf. Eugenio Battisti, *Rinascimento e Barocco* (Turin: Einaudi, 1960), 196–98, and Luba Freedman, "The Concept of Portraiture in Art Theory of the Cinquecento," *Zeitschrift für Ästhetik und allgemeine Kunstwissenschaft* 32 (1987): 67–71.

50. Leon Battista Alberti, *On Painting,* trans. J. R. Spencer (New Haven: Yale University Press, 1973), 63.

51. Pontormo's letter is reprinted in BT, i, 67–69. Quoted from Władysław Tatarkiewicz, *History of Aesthetics* (The Hague: Mouton, 1970–74), iii, 187, no. 23.

52. V-M iv, 462–63; quoted from V-H, ii, 264.

53. RD, 131: "So the painter should try not only to imitate nature, but to surpass it."

54. P, i, 280, ii, pl. 282; V, no. 244; W, ii, cat. no. 98. Giuseppe Fiocco, "Il ritratto di Sperone Speroni dipinto da Tiziano," *Bollettino d'Arte* 39 (1954): 306–10.

55. PT, 839: "Il qual ritratto in parole sarebbe questo, che, cominciando dalla età mia, io sono un vecchio di ottanta anni, mezo cieco, mezo sordo, onde io sia noia alli amici nel ragionare e nel salutarli."

56. Sperone Speroni degli Alvarotti, *Opere* (Venice, 1740), ii, 356–66. Quoted from Bernard Weinberg, *A History of Literary Criticism in the Italian Renaissance* (Chicago: University of Chicago Press, 1961), i, 284.

57. Speroni's *Dialogo della retorica* is available in PT, 672: "Adunque egli è officio dell'oratore dir parole non solamente ben risonanti ma intelligibili e a' concetti significati correspondenti; ché sì come nei ritratti di Tiziano, oltra il dissegno [sic], la simiglianza consideriamo e, sendo tali (si come son veramente) che i loro essempii pienamente ci rappresentino, opra perfetta e di lui degna gli esistimiamo."

58. Ibid., 643: "[S]uo disegno sia il vero, non del vero similitudine."

59. Cf. Linda Susan Klinger, "The Portrait Collection of Paolo Giovio" (Ph.D. diss., Princeton University, 1991), 158–59, raised the question: "[W]hat, for Giovio, was a 'true' likeness?" Klinger approached this problem from the Renaissance historian's viewpoint, even though it is hardly possible to draw a line between a litterateur and a historian in that time; yet Giovio's approach to the problem of likeness in portraiture as of a "professional" historian is certainly different from Aretino's.

60. V.-M. IV, 462–63; quoted from V.-H., II, 264.

61. Gian Paolo Lomazzo, *Scritti sulle arti*, ed. R. P. Ciardi (Florence: Centro Di, 1974), II, 374: "L'uso del ritrarre dal naturale, cioè di far le imagini de gl'uomini simili a loro, sì che da chiunque gli vede siano riconosciuti per quei medesimi."

62. BT, III, 346: "Onde quel ritratto sarà veramente buono, il quale così rappresentera del naturale quell'uomo, o veramente quella donna da cui fu tratto, e così minutamente imiterà ciascuna parte dell'aspetto e sembianza loro, che altri conosca subitamente, nel riguardarlo, quella esser imagine del tal gentiluomo overo della tal gentildonna."

63. Ibid., II, 135.

64. *The Works of Aristotle Translated into English*, ed. W. D. Ross (Oxford: Clarendon Press, 1908–52), VIII (trans. W. D. Ross).

65. Charles Hope, *Titian* (New York: Harper & Row, 1980), 91: "Nor is there any evidence that he was instructed to leave it unfinished. When he left Rome in May or June 1546 he was certainly planning to return, for he had still not obtained Pomponio's benefice." Cf. Zapperi, *Tiziano*, 77–79.

66. Giovanni Battista Armenini, *On the True Precepts of the Art of Painting*, ed. E. J. Olszewski (New York: Franklin, 1977), 260, designates it as "the portrait[s] of the Farnese Pope Paul III, with his nephew," considering it an important example of Titian's mastery of portraiture.

67. Raffaello Causa, "Per Tiziano: Un pentimento nel *Paolo III con i Nipoti*," *Arte Veneta* 18 (1964): 219–23. The X-ray photograph was also published by Mercedes Garberi, "Tiziano: i ritratti," in *Omaggio a Tiziano*, cat. no. 12.

68. Franz Johannes Boll, *Die Lebensalter: Ein Beitrag zur antiken Ethnologie und zur Geschichte der Zahlen, mit einem Anhang über die Schrift von der Siebenzahl* (Leipzig: Teubner, 1913), 8–13, for the tripartite division of the Three Ages, and 5–7 for the division of life into two ages.

69. W, II, 97 (Alessandro Farnese, 1520–89), 198 (Ottavio Farnese, 1524–86).

70. Cf. the remarks by Philipp P. Fehl, "Titian's Poetic Irony," in his *Decorum and Wit: The Poetry of Venetian Painting* (Vienna: IRSA, 1992), 191.

71. Navenne, *Rome*, 378: "Tout porte à croire qu'en commandant a Titien un tableau ou figuraient deux de ses petits-fils et lui-même, il songeait à manifester aux yeux de tous le triomphe de son autorité comme chef de famille et comme souverain."

72. Jaynie Anderson, "The Giorgionesque Portrait: From Likeness to Allegory," in *Giorgione* (Venice, 1979), 155, suggested the distinction "between the action portrait that has a short monumentary movement and a more posed composition in which a typical gesture is chosen in order to describe the life of the sitter." Yet Anderson's reference to "Leonardo's notion that the portrait should speak to the viewer by means of the sitter displaying his or her role or inner preoccupations" seems to be out of place, for in discussing *movimenti d'anima*, Leonardo hardly meant a portrait, but rather a multifigured, variegated *istoria*. Cf. Carlo Pedretti, "Ancora sul rapporto Giorgione-Leonardo e l'origine del ritratto di spalla," in *Giorgione*, 181–85, who claims that the figure in motion was introduced by Leonardo, while Giorgione employed this motif in his portraiture.

73. F. W. J. von Schelling, *Philosophie der Künst* (I.v.547–48) in his *Werke. Auswahl in drei Banden*, ed. O. Weiss (Leipzig: Eckardt, 1907), III, 195–96: "In Ansehung der Frage, ob die Person in Ruhe oder in Handlung dargestellt werden solle, ist es offenbar, daß, da jede mögliche Handlung die Allseitigkeit eines Bildes aufhebt und den Menschen in *Moment* fixiert, in der Regel die großtmögliche Ruhe vorzuziehen sei. Die einzige erlaubte Ausnahme findet da statt, wo die Handlung so mit dem Wesen des Menschen eins ist, dass sie wiederum zur Charakteristik von ihm gehört." (The emphasis is Schelling's.)

74. On Raphael's *Pope Leo X and His Nephews*, see Dussler, *Raphael*, 46. On the influence of Raphael's painting on Titian's, see Jacob Burckhardt, "Das Porträt in der italienischen Malerei" in his *Gesamtausgabe* (Stuttgart: Deutsche Verlag-Anstalt, 1929–33), XII, 255–57, and Enrico Castelnuovo, "Il significato del ritratto pittorico nella società," in *Storia d'Italia* (5, I Documenti) (Turin: Einaudi, 1973), II, 1061–63. Erwin Panofsky, *Problems in Titian, Mostly Iconographic* (New York: New York University Press, 1969), 78: "Titian's composition differs from Raphael's in three respects. It shows all the personages in full-length (an arrangement which, as far as seated figures are concerned, had thus far been reserved for effigies of popes or princes 'in majesty'); it daringly combines subordination with coordination (while Raphael keeps both Cardinals in the background, Titian moves Ottavio Farnese to a plane slightly in front of that of the Pope); and it

introduces an element of physical activity and emo-
tional tension hitherto unheard of in portraiture." Cf.
David Rosand, *Titian* (New York: Harry N. Abrams,
1978), 124.

75. V-M, v, 41–43. On Titian's acquaintance with
Andrea del Sarto's copy, see W, II, 30 and n. 111.

76. There is no study concerned with the develop-
ment of the group portrait in Italy comparable to Alois
Riegl's *Das Holländische Gruppenporträt* (Vienna: Druck
und Verlag der österreichischen Staatsdruckerei, 1931).
These remarks are just preliminary attempts to delineate
the development of the group portrait in the Italian
Renaissance, which certainly deserves more attention
than is possible within the confines of the present
chapter. Cf. Patricia Fortini Brown, *Venetian Narrative
Painting in the Age of Carpaccio* (New Haven: Yale
University Press, 1988).

77. P, I, 112; quoted from Antonio Paolucci, "The
Portraits of Titian," in T, 103.

78. Clausse, *Farnèse*, 321–24; Pastor, *History*, XI,
30, claims that the portrait "gives a glimpse into the
family history of the Farnesi." Christopher Cairns, *Pietro
Aretino and the Republic of Venice* (Florence: Olschki,
1985), 114, went so far as to claim that "Aretino
received news of conspiracy through him [Titian]." The
only evidence offered in support of this claim is Giovio's
letter to Aretino from 1546 in which the name of Titian
was just mentioned alongside the unnamed "three
prelates"; it appears therefore that Cairns's claim is far-
fetched. Cf. Zapperi, *Tiziano*, 59–63, on Titian's
familiarity with the events.

79. Carlo Ridolfi, *Le maraviglie dell'arte*, ed. D. F. von
Hadeln (Rome: Società 'Multigrafica Editrice SOMU,
1965), 178. Ridolfi erroneously dates the painting by
1548. Vasari, however, states that the cardinal invited
Titian to Rome, but without making it clear whether he
ordered the group portrait (V-M, III, 446).

80. Paolucci, "Portraits," 101. Cf. Zapperi, *Tiziano*,
who treats the portrait as a historical document.

81. Pastor, *History*, XII, 233. Cf. Zapperi, *Tiziano*,
93, who perceives Gonzaga's letter as expressing irony.

82. Panofsky, *Problems in Titian*, 79, sees the proto-
type of Ottavio's posture in Mercury from the Vatican
relief of the *Birth of Bacchus*. Panofsky remarks: "The
very fact that Ottavio is represented in pure profile (a
form normally employed by Titian only in donors'
portraits or when he worked from earlier models) would
lead us to suspect the intervention of a classical relief.
And Ottavio's pose, his handsome, predatory head
deeply bowed, and his legs bent in courtly obeisance,
repeats almost *ad literam* the pose of Mercury." Cf. Ost,
"Tizians Paul III.," 127, who sees the influence of
Miron's *Discobol* on Titian's rendition of Ottavio's pose,
and Peter Burke, "The Presentation of Self in the

Renaissance Portrait" in his *The Historical Anthropology
of Early Modern Italy* (Cambridge: Cambridge University
Press, 1987), 155, who perceives Ottavio's "cringing"
posture as "a caricature of obsequiousness."

83. Stefano Ticozzi, *Vite de' pittori Vecelli di Cadore*
(Milan, 1817), 149: "Ottavio in atto di rispettosamente
presentarsi per parlargli, l'altro in atto di ascoltare ciò
che sta per dire."

84. Causa, "Tiziano," 221, fig. 252.

85. On the symbolic significance of the hourglass,
see Erwin Panofsky, "Father Time," in his *Studies in
Iconology* (New York: Harper & Row, 1972), 80.
Panofsky thinks that it was only owing to Petrarch's
Trionfi that the "image personified Time was frequently
emphasized by an hourglass," which seems to make its
first appearance in this new cycle of illustrations, and
sometimes by the zodiac, or dragon biting its tail."

86. Anne Blake Smith, " 'Anchora Inparo,' " *Art
Quarterly* 30 (1967): 120.

87. Achille Bocchi, *Symbolicarum quaestionum, De
uniuerso genere, quas serio ludebat, Libri Quinque* (Bolo-
gna, 1574, first published in 1555), cxlvi, for the
engraving with the title "Puluiscli Scriptorii et Horologii
Commoda" (*Symb.* LXVIII).

Chapter V

1. P-C, I, 109: "Tiziano . . . infiammato dal
desiderio di mostrare per vertù de le sue mani Cesare
istesso a Cesare proprio" (emphasis mine).

2. The assumption that Aretino did not see the
portraits of the pope or those of the emperor is based on
the fact that Titian painted them outside Venice, and
Aretino rarely left that city. Christopher Cairns, *Pietro
Aretino and the Republic of Venice* (Florence: Olschki,
1985), 18–19, suggests that Aretino accompanied
Titian to Bologna, but he does not provide supporting
evidence. No engraving was made of either of the 1548
portraits, so Aretino could not have seen them in that
form either.

3. On Titian's portrait of *Charles V with a Hound*,
see P, I, 79, II, pl. 208; V, cat. no. 158; W, II, cat. no.
20. On Britto's xylograph of Titian's portrait, see *Titian
and the Venetian Woodcut*, ed. David Rosand and
Michelangelo Muraro (Washington, D.C.: Interna-
tional Exhibitions Foundation, 1976), 204, cat. no. 46.

4. Charles Hope, "Titian's Early Meetings with
Charles V," AB 59 (1977): 551–52, sheds much light on
this subject with the publication of hitherto unknown
documents.

5. On Titian's equestrian portrait, see P, I, 121, II,
pl. 329; V, cat. no. 290; W, II, cat. no. 22. On Titian's

Charles V in an Armchair, see P, ɪ, 122, ɪɪ, pl. 331; V, cat. no. 289; W, ɪɪ, cat. no. 21.

6. On portraits of Charles V whose attribution to Titian is seriously doubted, see Annie Cloulas, "Charles Quint et le Titien: Les premiers portraits d'apparat," *Information d'histoire de l'art* 9 (1964): 213–21. Some of these portraits are attributed to Titian because they were copied by Rubens. See Justus Müller Hofstede, "Rubens und Tizian: Das Bild Karls V.," *Münchner Jahrbuch der bildenden Kunst* 18 (1967): 35–96, and Julius S. Held, "Rubens and Titian," in R, 287, on our knowledge of Titian's works due to Rubens. On portraits of Charles by artists other than Titian and that precede Titian's, see Yvonne Hackenbroch, "Some Portraits of Charles V," *The Metropolitan Museum of Art Bulletin* 27 (February 1969): 323–32, and Else Kai Sass, "Autour de quelques portraits de Charles Quint," *Oud-Holland* 90 (1976): 1–14.

7. Quoted from Karl Brandi, *The Emperor Charles V,* trans. C. V. Wedgwood (London: Cape, 1939), 502. (The literature on Charles is extensive.)

8. Brandi, *Emperor,* 257, and Lester K. Born's introduction to his translation of Erasmus's *The Education of a Christian Prince* (New York: Columbia University Press, 1936), 3–130. For Erasmus's influence on Charles, see the remarks by Johan Huizinga, *Erasmus and the Age of Reformation,* trans. F. Hopman (New York: Harper, 1957), 145–46.

9. John M. Headley, *The Emperor and His Chancellor* (New York: Cambridge University Press, 1983). Gattinara's influence on the shaping of the imperial image was questioned, however, by Ramón Menéndez Pidal, *Idea imperial de Carlos V. La condesa traidora. El Romanz del infant García, Adefonsus, imperator toletanus* (Madrid: Espasa-Calpe, 1963). Cf. Karl Brandi, "Dantes *Monarchia* und die Italienpolitik Mercurio Gattinaras," *Jahrbuch der Deutschen Dante-Gesellschaft* 24 (1942): 1–19; and Frances A. Yates, "Charles V and the Idea of the Empire," in her *Astraea* (London: Routledge, 1975), 26.

10. P-C, ɪ, 26 (xɪ): Aretino's letter to Vasari of June 7, 1536; Paolo Giovio, *Dialogo dell'imprese militari e amorosi,* ed. M. L. Doglio (Rome: Bulzoni, 1978), 46. Cf. Earl Rosenthal, "Plus Ultra, Non Plus Ultra, and the Columnar Device of Emperor Charles V," *JWCI* 34 (1971): 204–28. On the role of pageants in disseminating imperial propaganda, see Roy C. Strong, *Art and Power* (Woodbridge, Suffolk: Boydell, 1984), 65–89, as well as the essays collected in *Fêtes et cérémonies au temps de Charles Quint,* ed. Jean Jacquot (Paris: Centre national de la recherche scientifique, 1950).

11. W, ɪɪ, 200, for the portrait of Isabella. Cf. the inventory of Titian's works, which Charles had in the

seclusion of San Jerónimo at Yuste, published in Domingo Sánchez Loro's *La inquietud postrimera de Carlos V: Yuste, 1558–1958* (Cáceres: Jefatura Provincial del Movimiento, 1957), ɪɪ, 506–7, nos. 401, 404–7, 409–11.

12. *Correspondence of the Emperor Charles V,* trans. William Bradford (London, 1850), 342.

13. The emperor's irregular jaw was noted in 1529 by Marin Sanudo, *I diarii 1496–1533),* ed. R. Fulin et al. (Venice: 1879–1903), ʟɪ, col. 371, no. 233, who described Charles as a "small person, who stoops a little, with a small long face and pointed beard and his mouth is always open." Quoted from W, ɪɪ, 89.

14. Armand Baschet, *La diplomatie vénitienne: Les princes de l'Europe au XVIᵉ siècle* (Paris, 1862), 236–37, cites both the description of Charles's appearance by Gasparo Contarini in 1532 and that by Friedrich Badoer in 1556.

15. Alfonso de Ulloa, *Vita dell'invittissimo e sacratissimo imperator Carlo V* (Venice, 1574), 336v: "Era il volto di lui tutto allegro, haueua gli occhi azurri, soaui, & pieni di viril modestia. Hebbe vn poco il naso aquilino, ilqual segno di grandezza di animo, fu osseruato ancora da gli antichi Re de' Persi, portaua poca barba, & si faceuatagliar i capelli a vso degli Imperadori Romani a mezo orecchio." Cf. Paolo Giovio, *Historiarum sui temporis* (Basel, 1567), ɪɪ, 228. On Ulloa's borrowing of Giovio's description, see Alfred Morel-Fatio, *Historiographie de Charles-Quint . . .* (Paris: Champion, 1913), 135–36. Cf. Eric Cochrane, *Historians and Historiography in the Italian Renaissance* (Chicago: University of Chicago Press, 1981), 317–20.

16. V-M, vɪɪ, 440. V-H, ɪv, 204: "It is said that when Charles V was at Bologna in 1530 Titian was summoned thither by Cardinal Ippolito de' Medici, through the influence of Pietro Aretino, to make the portrait of the emperor in full armour."

17. P-C, ɪ, 109.

18. Hope, "Titian's," 551.

19. Carlo Ridolfi, *Le maraviglie dell'arte,* ed. F. D. von Hadeln (Rome: Società 'Multigraphica Editrice SOMU, 1965), ɪ, 180–82; J. A. Crowe and G. B. Cavalcaselle, *Titian: His Life and Times* (London, 1877), ɪ, 371; Erwin Panofsky, *Problems in Titian, Mostly Iconographic* (New York: New York University Press, 1969), 8 with note 7; and Ruth Wedgwood Kennedy, " 'Apelles Redivivus,' " in *Essays in Memory of Karl Lehmann* (New York: New York University Press, 1964), 160. For the meaning of the title as well as for the names of other painters who received this or a similar title from rulers, see Martin Warnke, *Hofkünstler* (Cologne: DuMont, 1985), 204–5 and 217.

20. Charles Hope, *Titian* (New York: Harper & Row, 1980), 180–81.

21. For my reason for thinking the date is erroneous, see page 128.

22. P-C, II, 272–73. Titian's arrival in Augsburg in January 1547 was also reported by the Duke of Urbino's agent, Gian Giacomo Leonardi. See Georg Gronau, *Documenti artistici urbinati* (Florence: Sansoni, 1936), 98 (no. LI).

23. Hope, "Titian's," 551.

24. V-M, VII, 440; cf. note 16 above.

25. Lorne Campbell, *Renaissance Portraits* (New Haven: Yale University Press, 1990), 234.

26. Ulloa, *Vita*, 119r.

27. Brandi, *Emperor*, 326.

28. Cairns, *Pietro Aretino*, 153–56, suggests that Aretino was influenced by Erasmus's treatise but makes no reference to Titian's paintings. Yet Titian may well have been acquainted with the Italian translation by Francesco Coccio, published by the Marcolini Press in 1539. Cf. Amedeo Quodnam, "Nel Giardino del Marcolini un Editore Veneziano tra Aretino e Doni," *Giornale Storico della Letteratura Italiana* 157 (1980): 114, no. 45.

29. Erasmus, *Education*, 187.

30. Ibid., 152.

31. Ibid., 151.

32. See Peter Burke, "The Presentation of Self in the Renaissance Portrait" in his *Historical Anthropology of Early Italy* (Cambridge: Cambridge University Press, 1987), 159, on the significance of armor as a sign of valor and noble ancestry. See Robert B. Simon, "Bronzino's Portrait of Cosimo I in Armour," *BM* 125 (1983): 535, on the influence of this Titian portrait (even if known only from Britto's xylograph) on Bronzino's portrait of Cosimo I.

33. Panofsky, *Problems in Titian*, 182–84, Excursus 4: "Titian and Seisenegger"; Herbert von Einem, *Karl V. und Tizian* (Cologne: Westdeutscher, 1960), 7–11; see Harold E. Wethey, "Tiziano ed i ritratti di Carlo V," in *Tiziano e Venezia: Convegno internazionale di studi. Venezia, 1976* (Vicenza: Pozza, 1980), 287–91. Cf. Hope, *Titian*, 78, who believes that "Titian's version was apparently based not on the original, but on a drawing after it," although no drawing or print has been preserved.

34. P, I, 61, II, pl. 186; V, cat. no. 122, W, II, cat. no. 49.

35. Sanudo, *Diarii*, LVII, col. 217, no. 74: "Veniva sopra uno caro uno cane grande corso, quale si diceva lo imperator cussi portar." Cf. Wethey, "Tiziano," 290.

36. *The Hieroglyphics of Horapollo*, trans. George Boas (New York: Pantheon, 1950), 77; Patrik Reuterswärd, "The Dog in the Humanist's Study," *Konsthistorisk Tidskrift* 50 (1981): 29.

37. Marilyn Aronberg Lavin, "Notes on the Iconogra-

phy of Piero della Francesca's Fresco of Sigismondo Pandolfo Malatesta Before St. Sigismund: *Theoi Athanatoi kai tej Polei*," *AB* 56 (1974): 364.

38. Pierio Valeriano Bolzani, *Hieroglyphica, sive de sacris Aegyptiorum* (Basel, 1567), 42r: "cane significata, sacerdote ijdem Aegyptij si principem aut legislatorem significare vellent."

39. Panofsky, *Problems in Titian*, 184 and fig. 191.

40. Campbell, *Renaissance Portraits*, 235.

41. H. Stanford London, "The Greyhound as a Royal Beast," *Archaeologia or Miscellaneous Tracts Relating to Antiquity* 97 (1959): 141; cf. Arthur Charles Fox-Davies, *A Complete Guide to Heraldry* (New York: Dodge, 1909), 204.

42. Stanford London, "Greyhound," 144.

43. Brandi, *Emperor*, 304 and 352.

44. Wethey, "Tiziano," 290, notes other occasions when Titian was supposed to copy from a work of another artist, such as the portrait of the empress, which Aretino in his letter to Ferrante Montese of July 1543 characterized as a work "di trivial pennello." P-C, II, 9.

45. John Pope-Hennessy, *The Portrait in the Renaissance* (New York: Bollingen Foundation, 1966), 320 and n. 20. On the full-length state portrait, see Marianna Jenkins, *The State Portrait* ([New York]: College Art Association of America, 1947), 9–11, and Rona Goffen, "Carpaccio's *Portrait of a Young Knight*: Identity and Meaning," *Arte Veneta* 37 (1983): 42, who suggests seeing the prototype of the full-length portrait in funerary monuments.

46. Edi Baccheschi, *L'opera completa del Bronzino* (Milan: Rizzoli, 1973), cat. no. 17; Arthur McComb, *Agnolo Bronzino: His Life and Work* (Cambridge: Harvard University Press, 1928), 6, cat. no. 149; and Charles McCorquodale, *Bronzino* (New York: Harper & Row, 1981), 40. Cf. Konrad Eisenbichler, "Bronzino's Portrait of Guidobaldo II della Rovere," *Renaissance and Reformation* 24 (1988): 21–33. See Burke, "Presentation," 163, on the dog as a status symbol.

47. Panofsky, *Problems in Titian*, 82, observed that the portraits of Charles of 1548 "illustrate the dual role of the Imperial Majesty which, according to the beautifully chiastic definition at the beginning of Justinian's *Corpus iuris*, 'must not only be adorned with arms but also armed with laws so that both wartime and peacetime can be properly governed.'"

48. See Brandi, *Emperor*, 569: "This April 24th, 1547, was one of the most glorious days in all his life. . . . To please his allies, he commissioned Titian to paint the great portrait of him as the victor of Mühlberg."

49. Yvonne Hackenbroch, "Two Portrait Medallions of Charles V: World Domination and Humility," in *Scritti di storia dell'arte in onore di Federico Zeri* (Milan:

Electa, 1984), I, 438 and n. 13 on Charles's armor in the Armería Real in Madrid.

50. Ulloa, *Vita*, 225r: "Era coperta la sella di velluto cremesino." See Morel-Fatio, *Historiographie*, 353, who observed that Titian's equestrian portrait of Charles matches the historian's description.

51. Paul Martin, *Armes et armures de Charlemagne à Louis XIV* (Fribourg: Office du Livre, 1967), 114. Cf. W, II, 87.

52. Ulloa, *Vita*, 336r: "Hebbe somma gratia in caualcar & maneggiar un cauallo, caualcando con tanta dignità, & maestria, spetialmente quando era armato."

53. A general survey of the history of equestrian portraiture is to be found in H. W. Janson, *Sixteen Studies* (New York: Harry N. Abrams, 1973), 157–88. On Titian's contribution to the development of the equestrian portrait, see Wilhelm Wätzoldt, *Die Kunst des Porträts* (Leipzig: Hirt, 1908), 189. The iconographical sources of Titian's work are succinctly presented in Einem, *Karl V. und Tizian*, 15–16. On the influence of the image (and not only the monument) of Marcus Aurelius on the conception of the royal image, see Hans Joachim König, *Monarchia mundi und Res publica christiana* (Ph.D. diss., University of Hamburg, 1969), 120–24.

54. Pope-Hennessy, *Portrait*, 191, attributes the painting to Jean Clouet. However, Peter Mellen, *Jean Clouet* (London: Phaidon, 1971), cat. no. 151, rejects this attribution in favor of François Clouet on the basis of the style.

55. On the iconographical significance of this detail of an imperial horse lowering its head, see the illuminating remarks by John F. Moffitt, " 'Le Roi à la ciasse'?: Kings, Christian Knights, and Van Dyck's Singular 'Dismounted Equestrian-Portrait' of Charles I," *Artibus et historiae* 7 (1983): 87–88. I am grateful to Professor Patrik Reuterswärd, who kindly brought this article to my attention.

56. Xenophon, *Art of Horsemanship*, in his *Scripta Minora*, trans. F. C. Marchant, Loeb Classical Library, 1925, 355.

57. On the symbolic connotations of the dark forest in the portrayals of monarchs as Christian knights (though without specific references to Titian's), see Moffitt, " 'Le Roi à la ciasse,' " 85.

58. Ulloa, *Vita*, 228r. Cf. Hope, *Titian*, 112, who believes the time of the day to be sunset rather than sunrise; however, there is no tradition of violating classical canons in showing the emperor looking at the field after the end of the battle.

59. Einem, *Karl V. und Tizian*, 19; Wolfgang Braunfels, "Tizians Augsburger Kaiserbildnisse," In *Kunstgeschichtliche Studien für Hans Kauffman* (Berlin: Gebr. Mann, 1956), 192–207.

60. König, *Monarchia mundi*, 58–81.

61. Erasmus, *Education*, 159 and n. 55.

62. Ulloa, *Vita*, 228r; cf. Einem, *Karl V. und Tizian*, 17.

63. P-C, II, 154: "Albis contanto nominato dai romani e si poco visto da loro, che, avendolo in un tempo veduto e passato, l'imperadore disonora, quei tali, e cosi il quando disse Sua Maestade: 'Venni, viddi e Dio vinse.' Con cio sia che la superbia di Giulio attribuissi cio che non volse attribuirsi l'umiltà di Carlo."

64. See Louis d'Ávila y Zúñiga's *Comentario de la Guerra de Alemania hecha por Carlos V*, in *Historiadores de sucesos particulares*, ed. C. Rosell (Madrid, 1858–63), I, 444, where the chancellor records Charles's words. This commentary was published by Marcolini in 1552.

65. Panofsky, *Problems in Titian*, 86. Panofsky's suggestion that Charles was represented in the image of Saint George was further developed by Jorg Oberhaidacher, "Zu Tizians Reiterbildnis Karl V.: Eine Untersuchung seiner Beziehung zum Georgsthema," *Jahrbuch der Kunsthistorischen Sammlungen in Wien* 78 (1982): 69–90. However, Saint George was rarely shown riding alone. Along with other considerations, this fact suggests that Titian's representation of Charles, rather than embodying a single, concrete image, synthesizes different images. For a possible representation of Charles as Saint George battling the dragon, see Gert von der Osten, "Über Brüggemanns St. Jürgengruppe aus Husum in Kopenhagen," *Wallraf-Richartz-Jahrbuch* 37 (1965): 65–84.

66. Panofsky, *Problems in Titian*, 86; cf. Einem, *Karl V. und Tizian*, 18. Moffitt, " 'Le Roi à la ciasse,' " 90–95, with a reference to Titian's portrait and many bibliographical references to the subject of the Christian knight. Cf. R. R. Bolgar, "Hero or Anti-Hero? The Genesis and Development of the *Miles Christianus*," in *Concepts of the Hero in the Middle Ages and the Renaissance*, ed. N. T. Burns and C. J. Reagan (Albany: the State University of New York Press, 1975), 120–46, who reviews the history of this concept, though without referring to Charles.

67. Panofsky, *Problems in Titian*, 85, with further references.

68. Ch. Daremberg and E. Saglio, *Dictionnaire des antiquités grecques et romaines* (Paris, 1892), II, 41, s.v. "decursio." Cf. Paul L. Strack, *Untersuchungen zur römische Reichsprägung des zweiten Jahrhunderts* (Stuttgart: Kolhammer, 1931), I, 83, and Richard Brilliant, *Gesture and Rank in Roman Art* (New Haven: The Academy, 1963), 142.

69. Andreas Älfoldi, "Die Ausgestaltung des monarchischen Zeremoniells am römischen Kaiserhofe," *Mitteilungen des Deutschen Archäologischen Instituts,*

Römische Abteilung 49 (1934): 92. The ritual of *profectio* was thought to originate in the *decursio*.

70. For coins with the *decursio* of Trajan and Marcus Aurelius, see Panofsky, *Problems in Titian*, figs. 100 and 101. For the coin with Nero's *decursio*, see Harold Mattingly, *Coins of the Roman Empire in the British Museum* (London: British Museum, 1965–68), I, 142 and pl. CLXXVIII. For evidence that these coins were known to the Renaissance public, we can cite Ercole Basso's letter of July 12, 1580, in which he mentions the coin of Marcus Aurelius with the four soldiers. The coin's inscription: *Profectio*. See Giovanni Bottari, *Raccolta di lettere sulla pittura, scultura ed architettura*, ed. S. Ticozzi (Milan, 1822–25), III, 286–87 (no. CXXVIII).

71. W, I, 87. Cf. Campbell, *Renaissance Portraits*, 236, who noted that in every work Titian departs from the examples of northern artists.

72. Otto Georg von Simson, "The Bamberg Rider," *Review of Religion* 4 (1939–40): 276: "It is no allegorical invention of an individual when Dante, the profoundest political thinker of the Middle Ages, describes the ideal emperor for whom he is longing as a rider."

73. Dante Alighieri, *Convivio*, trans. P. H. Wicksteed (London: Dent, 1912), 271: "Wherefore we may in some sort say of the emperor, if we wish to figure his office by an image, that he is the rider of the human will."

74. See page 98 for Aretino's lack of specification in relation to the papal portraits as well. Vasari himself did not specify which portrait of Charles in armor he referred to, V-M, VII, 451; see note 16 above. For example, Dolce in his dialogue, mentioning Titian's portraits of Charles, does not specify, see RD, 109 and 193; Gian Paolo Lomazzo, *Scritti sulle Arti*, ed. R. P. Ciardi (Florence: Centro Di, 1974), II, 547 and 550, referring to Titian's portrait of Charles, did not make clear which one he meant. Neither did Giovanni Battista Armenini, *On the True Precepts of the Art of Paintings*, ed. E. J. Olszewski (New York: Franklin, 1977), 260. Incidentally, in one of his letters Titian makes a clear reference to his equestrian portrait of Charles. See Tiziano Vecellio, *Le lettere*, ed. C. Gandini ([Pieve di Cadore]: Magnifica Comunità di Cadore, 1977), no. 96, 120: "[P]uoi quello grande di sua cesarea maestà a cavallo." Titian also mentions the double portrait of Charles V and Isabella, which is preserved only in the copy by Rubens; see note 6 above.

75. P-C, II, 153: "Per certo che i di voi unichi commentari sono non meno naturali imagini dei suoi gesti, che si siano vivi esempi dei di lui sembianti le pitture del solo Tiziano."

76. Paolo Giovio, *Lettere*, ed. G. G. Ferrero (Rome: Istituto poligrafico dello Stato, 1958), II, 126: "E vedo in ogni luogo ritratto dal naturale co'l pennello di Tiziano." (Giovio's letters were first published in Venice in 1560.) The Renaissance *poligrafi*, following Plutarch, who compared Thucydides with a painter (*Moralia* 346f–347c), drew a parallel between a historian and a contemporary painter. Aretino compared Giovio's chronicles with Michelangelo's strokes (LXXV), while Giovio compared his own style with Raphael's (I, 179); however, before Aretino and after Giovio, no one had in mind a specific portrait to compare with memoirs. See also the study by Linda Susan Klinger, "The Portrait Collection of Paolo Giovio" (Ph.D. diss., Princeton University, 1991), 127 and n. 164.

77. P-C, II, 192–93.

78. Ibid., II, 200.

79. Kenneth Scott, *The Imperial Cult Under the Flavians* (Stuttgart and Berlin: Kohlhammer, 1936), 113.

80. P-C, II, 200.

81. Ibid., II, 212.

82. Ávila y Zúñiga, *Comentario*, 443: "Venia en un caballo frison, con una gran cota de malla vestida, y encima un peto negro con unas correas que se cenian por las espaldas, todo lleno de sangre, de una cuchillada que traia en el rostro, en el lado izquierdo."

83. P-C, II, 212: "[I]magine, che voi rassemplate, e in su lo istesso cavallo e con le medesime armi che aveva il dì che vinse la giornata in Sansogna, vorrei vedere a lo incontro fermarsi in piedi e moversi (secondo che si move o ferma il destriere ch'egli cavalca) la Religione e la Fama; l'una con la croce e il calice in mano, che gli mostrassi il cielo; e l'altra con le ali e le trombe, che gli offerisse il mondo." Panofsky, *Problems in Titian*, 86–87, remarks: "This suggestion shows a certain lack of taste; but it also shows a profound understanding for Titian's and his august patron's intention."

84. P-C, II, 213: "Non vi ho detto altro sopra lo stupore altrui nel procedere Cesare con sì mirabile arte di saviezza in tutti i progressi di lui. Perché la natura, senza altramente studiarle, gli rappresenta continuo ne la mente ogni antico modo de le imperiali azioni."

85. P.-C., I, 26 (XI): Aretino's letter to Vasari of June 7, 1536.

86. Pliny, *Natural History*, trans. H. Rackham, Loeb Classical Library, 1968, IX, 333. Cf. David Rosand, *Titian* (New York: Harry N. Abrams, 1978), 126.

87. Margot Kruse, "Aretinos Sonette auf Tizian-Porträts," *Romanistisches Jahrbuch* 38 (1987): 89–95, suggests that Aretino refers to the Munich portrait because he does not mention armor, but rather specifies the "tacit figure" with a focus on the visage.

88. P-C, II, 264: "[E]ccovi ne la predetta composizione quel tanto che sa lo ingegno mio in laude di ciò che ognun debbe ai meriti de la Maestà Sua."

89. For Titian's visit to Rome, see Aretino's letter (CCLXIV) in P-C, II, 106–7, and V-M, VII, 446.

90. Phyllis Pray Bober and Ruth Rubinstein, *Renaissance Artists and Antique Sculpture* (London: Miller and Oxford University Press, 1986), cat. no. 182d–iii.

91. Ibid., cat. no. 1.

92. Daremberg and Saglio, *Dictionnaire*, III, 1192, s.v. "liberalitas." See Strack, *Untersuchungen*, I, 141–43, and Hans Kloft, *Liberalitas principis: Herkunft und Bedeutung, Studien zur Prinzipätsideologie* (Cologne: Bohläu, 1970), 186.

93. Erasmus, *Education*, 219–20.

94. Daremberg and Saglio, *Dictionnaire*, IV, 1179–80, s.v. "sella." Cf. Brilliant, *Gesture and Rank*, 75; and J. W. Salomonson, *Chair, Sceptre, and Wreath: Historical Aspects of Their Representation on Some Roman Sepulchral Monuments* (Amsterdam: Harms, 1957), 12.

95. On the *sella castrensis* as a mere variation of the *sella curulis* and its representation in the panel relief on the Arch of Constantine, see Ole Wanscher, *Sella Curulis: The Folding Stool as an Ancient Symbol of Dignity* (Copenhagen: Rosenklide & Bagger, 1980), 140. Wanscher suggested that the throne like that in Titian's painting ultimately derives from the *sella castrensis* (204).

96. J. M. C. Toynbee, "Picture-Language in Roman Art and Coinage," in *Essays in Roman Coinage Presented to Harold Mattingly* (London: Oxford University Press, 1956), 214; cf. John Onians, *Bearers of Meaning* (Princeton: Princeton University Press, 1988), 304, who claims that the column emblematically signifies authority.

97. Horace, *The Odes and Epodes*, trans. C. E. Bennett, Loeb Classical Library, 1947, 153: "Maecenas, the great glory and prop of my own existence."

98. Lodovico Dolce, *Dialogo . . . de i colori* (Venice, 1565), 67r: "La Colonna e posta per sostegno: e dinota la fortezza."

99. Campbell, *Renaissance Portraits*, 69 and pl. 68.

100. On the original format of the *Mona Lisa*, see E.-G. Güse, "Die *Mona Lisa* Leonardo da Vincis," in *Mona Lisa im 20. Jahrhundert. Katalog* (Duisburg: Wilhelm-Lehmbruck Museum, 1978), 13–18. See Luba Freedman, "Raphael's Perception of the *Mona Lisa*," GBA 114 (1989): 174.

101. Baccheschi, *Bronzino*, cat. no. 77; McComb, *Agnolo Bronzino*, cat. no. 2471; McCorquodale, *Bronzino*, 100.

102. V, cat. no. 340, who dates it by 1550; W, II, cat. no. 108, who dates it by 1540; cf. P, I, 133, II, pl. 356.

103. P, I, 131, II, pl. 369; V, cat. no. 345; W, II, cat. no. 78.

104. Onians, *Bearers of Meaning*, 304, remarks that "two years later Titian was again to use the column on a pedestal as a symbol of authority in his *Philip II* in the Prado, though here the correspondence of the architecture to that in the previous painting [Titian's *Charles V in an Armchair*] and its shadowy character at a distance from the standing figure seem intended to suggest that the young prince has not yet acquired the authority of his father."

105. The similar observation was made by Hackenbroch, "Two Portrait Medallions," 441.

106. Erasmus, *Education*, 186.

107. Ibid., 187.

108. Panofsky, *Problems in Titian*, 84: "These hands—much closer to each other than in any other comparable portrait by Titian—express what may be called total control: control of self as well as of others." See Burke, "Representation," 159, and James V. Mirollo, *Mannerism and Renaissance Poetry* (New Haven: Yale University Press, 1984), chaps. 3 and 4, on the significance of gloves.

109. For the Louvre portrait, see P, I, 60, II, pl. 167; S, cat. no. 6; V, cat. no. 114; W, II, cat. no. 64; T, cat. no. 17; for the Pitti portrait, see P, I, 104, II, pl. 283; V, cat. no. 245; W, II, cat. no. 113; T, cat. no. 35.

110. Daremberg and Saglio, *Dictionnaire*, III, 1593–95, particularly on the *mappa* as a symbol of civic joy. See Joseph Braun, *Die liturgische Gewandung im Occident und Orient* (Darmstadt: Wissenschaftliche Buchgesellschaft, 1964), 517.

111. Richard C. Trexler and Mary E. Lewis, "Two Captains and Three Kings: New Light on the Medici Chapel," *Studies in Medieval and Renaissance History* 4 (1981): 115.

112. Ulloa, *Vita*, 337v: "berrette quadre con la piega a dietro ornate di velo, & di nastro negro." On the *barett* as a distinctive type of headgear in sixteenth-century Europe, see Max von Boehn, *Modes and Manners*, trans. J. Joshua (London: Harrap, 1932–35), II, 137–38; and on the social custom that only the Elector could always wear his headcovering, while guests had to sit bareheaded, see 214.

113. Lomazzo, *Scritti*, II, 377: "[G]l'imperatori con le berrette in testa che gli fa rassembrar più tosto mercatanti che imperatori."

114. On Titian's portrait of Francis I, which he painted using Cellini's medal, see P, I, 272, II, pl. 343; S, cat. no. 169; V, cat. no. 188; W, II, cat. no. 79. On Jean Clouet's portrait of Francis I, see Pope-Hennessy, *Portrait*, 190, and Mellen, *Jean Clouet*, 49 and cat. no. 31.

115. On the evolution of the *pileus*, which gradually became the symbol of liberty unconnected with the custom of liberating slaves, see Daremberg and Saglio, *Dictionnaire*, IV, 479–81, s.v. "pileus." On the *pileus* as a

precursor to the beret, see Braun, *Liturgische Gewan-dung*, 510. Braun remarked that it was usually a cleric of high rank who wore a black beret, yet in the sixteenth century a beret became part of secular headgear (514).

116. Pomponius Gauricus, *De Sculptura (1504)*, ed. A. Chastel and R. Klein (Geneva: Droz, 1969), 57: "[L]ibertatis enim signum pileus." See also page 28.

117. Dolce, *Dialogo*, 62v: "Il Cappello . . . in segno della libertà."

118. Ernst H. Kantorowicz, *The King's Two Bodies* (Princeton: Princeton University Press, 1957), 336.

119. Quoted from Bradford, trans., *Correspondence*, 475.

120. Ibid., 474.

121. Brandi, *Emperor*, 560.

122. Ulloa, *Vita*, 336r, on the affection Charles V felt for Titian. This story, absent from Giovio's treatise, was probably borrowed by Ulloa from Dolce's dialogue. See RD, 109, where, as in his biography of the emperor, he offers this story as further proof of the emperor's generosity. Cf. Lodovico Dolce, *Vita dell'invittiss. e gloriosiss imperador Carlo Quinto* (Venice, 1561), 165. See the illuminating remarks on this subject by Panofsky, *Problems in Titian*, 8–9.

123. Warnke, *Hofskünstler*, 293–94, remarks on Titian's relationship with Charles. Cf. Campbell, *Renaissance Portraits*, 153, who also uses an example of Leoni's conversation with the emperor.

124. P-C, II, 223: "Lo stupore in cui tutto dì vi reca lo imperadore, mentre la virtù vostra vi permette il frequentare la conversazione de la Sua Celsitudine, è un prudente accorgimento del guidizio che, sin che vivarete, vi concede la natura."

125. Gronau, *Documenti*, 98–99 (no. LIII): "Ti-tiano . . . esser molto domestico et molto fauorito da S.M.tà et da tutta la corte et ch'ella ha uoluto ch'egli alloggi in stanze tanto uicine alle sue, che l'uno ua l'altro senza essere ueduto." Cf. Warnke, *Hofskünstler*, 294, who cites this letter as evidence to his statement.

126. Lorenzo Campana, "Monsignor Giovanni Della Casa e i suoi tempi: Vita privata," *Studi storici* XVII (1908): 387; quoted from Hope, *Titian*, 110.

127. Tiziano, *Lettere* (no. 118), 149: "Cesare mostro segno di allegrezza nel viso." Quoted from James Northcote, *The Life of Titian* (London, 1830), I, 300; Aretino's response is translated on 303–4.

128. See Kantorowicz's remarks on the king's two-fold nature in his *King's Two Bodies*, 171: "The King, at least with regard to Time, had obviously 'two natures'— one which was temporal and by which he conformed with the conditions of other men, and another which was perpetual and by which he outlasted and defeated all other beings."

129. Panofsky, *Problems in Titian*, 86.

Chapter VI

1. W, II, pl. 208. Cf. ed. David Rosand and Michelangelo Muraro, *Titian and the Venetian Woodcut* (Washington, D.C.: International Exhibitions Founda-tion, 1976), cat. no. 45.

2. Ibid., 202.

3. Luba Freedman, *Titian's Independent Self-Portraits* (Florence: Olschki, 1990). For Titian's self-portrait in Berlin, see W, II, cat. no. 104; V, cat. no. 443; S, cat. no. 255; for his self-portrait in the Prado, see W, II, cat. no. 105; V, cat. no. 476, T, cat. nos. 59 and 64.

4. P-C, II, 340: "Maestro Giovanni, galante non troppo, da che lo stimolo de la vostra non molto gran discrezione me ha sforzato con la frequenza de le richieste, del due e tre volte il giorno, a fare il sonetto, ch'io vi mando, in grazia del ritratto che del mio Tiziano ponete, come si vede, in istampa."

5. Edgar Zilsel, *Die Entstehung des Geniebegriffes* (Tübingen: Siebec, 1926), 68–69, considers the artists' portrayal of rulers to be the reason for their rise in social status in antiquity. Martin Warnke further developed Zilsel's assertion in *Hofskünstler* (Cologne: DuMont, 1985), 248–51 and 270–84.

6. Jurg Meyer zur Capellen, *Gentile Bellini* (Stutt-gart: Steiner, 1985), 14 and 116–17, with document no. 55 (it was conferred on February 13, 1469). See Warnke, *Hofskünstler*, 203, on the phenomenon of rulers rewarding painters.

7. P-C, II, 341: "Questo e Tizian, del secolo stu-pore." Cf. Margot Kruse, "Aretinos Sonette auf Tizian-Porträts," *Romanistisches Jahrbuch* 38 (1987): 96–97.

8. See Lora Anne Palladino, "Pietro Aretino: Orator and Art Theorist" (Ph.D. diss., Yale University, 1981), 51–53 and 60–69, for an illuminating discussion of Aretino's ideas on art and nature.

9. Aretino's parlance recalls Hegel's remarks on portraiture. See G. W. F. Hegel, *Aesthetics: Lectures on Fine Art*, trans. T. M. Knox (Oxford: Clarendon Press, 1975), II, 867: "In the human face *nature*'s drawing is the bone structure or the hard parts around which the softer ones are laid, developed into a variety of accidental detail; but however important those hard parts are for the character drawing of *portraiture*, it consists in other fixed traits, i.e. the countenance transformed by the spirit."

10. Leon Battista Alberti, *Della pittura*, ed. L. Malle (Florence: Sansoni, 1950), 77; cf. his *On Painting and On Sculpture: The Latin Texts of De Pictura and De Statua*, trans. C. Grayson (London: Phaidon, 1972), 60: "[Q]ui fingendis aut pingendis animantibus quasi alterum sese inter mortalem deum praestaret." See Ernst Robert Curtius, *European Literature and the Latin Middle Ages*, trans. W. R. Trask (Princeton: Princeton University

Press, 1973), 397–99, on the concept of "godlike men."
On the notion of the artist as another god, see Ernst Kris
and Otto Kurz, *Legend, Myth, and Magic in the Image of
the Artist* (New Haven: Yale University Press, 1979),
58–61.

11. Alberti, *On Paintings,* 61. Cf. David Rosand,
"The Portrait, the Courtier, and Death," in *Castiglione*
ed. R. W. Hanning and D. Rosand (New Haven: Yale
University Press, 1983), 95–97.

12. BT, I, 96: "Leon Battista Alberto fiorentino,
pittore non menomo, fece un trattato di pittura in
lingua latina." RD, 159: "[Y]ou can read the little book
which Leon Battista Alberti wrote on painting."

13. P-C, II, 436–37, no. DCLXIII. Cf. Palladino,
"Pietro Aretino," 94. Palladino points to Castiglione's
Cortegiano as the source of Aretino's reference (and
consequently Dolce's) to the contrast between Raphael's
"lovely colors" and Michelangelo's draftsmanship.

14. RD, 209.

15. On the application of the epithet, see Zilsel,
Entstehung, 276; Erwin Panofsky, "Artist, Scientist,
Genius: Notes on the 'Renaissance-Dämmerung,' " in
The Renaissance: Six Essays (New York: Harper & Row,
1962), 172–74; Martin Kemp, "The 'Super-artist' as
Genius: The Sixteenth-Century View," in *Genius,* ed. P.
Murray (London: Blackwell, 1989), 32–53. Ficino's
letter of September 1, 1457, can be easily found in his
Letters, trans. Language Department of the School of
Economic Science, London; preface by Paul Osckar
Kristeller (London: Shepheard-Walwyn, 1975–78), I,
42–48.

16. See Kris and Kurz, *Legend,* 58, and Penelope
Murray, "Poetic Genius and Its Classical Origins," in
Genius, 23–25.

17. Giovanni Santi, *Cronaca rimata,* ed. H. Holt-
zinger (Stuttgart, 1893), 189 (22.96.125). Creighton E.
Gilbert translates it as "godlike painter" in *Italian Art,
1400–1500: Sources and Documents* (Englewood Cliffs:
Prentice-Hall, 1980), 99. Cf. Martin Kemp, "From
'Mimesis' to 'Fantasia': The Quattrocento Vocabulary of
Creation, Inspiration, and Genius in the Visual Arts,"
Viator 8 (1977): 394.

18. For Ariosto's application of the epithet to
Michelangelo, see RD, 93. For Ariosto's application of
the same epithet to Aretino, see Count Giammaria
Mazzuchelli's *Vita di Pietro Aretino,* in P-C, III, 66.

19. V-M, II, 171; quoted from V-H, I, 226. Kemp,
" 'Super-Artist,' " 46.

20. Francisco de Hollanda, *Four Dialogues on Paint-
ing,* trans. A. F. G. Bell (London: Oxford University
Press, 1928), 20.

21. This letter is discussed on page 141.

22. Michelangelo Buonarotti, *Il carteggio,* ed. P.
Barocchi and R. Ristori (Florence: Sansoni, 1965–83),

IV, 217: "[S]e voi siate divino, io non so' d'acqua";
quoted from C, 225. Jacob Burckhardt noted Aretino's
punning in *The Civilization of the Renaissance in Italy,*
trans. S. G. C. Middlemore (New York: Harper, 1958),
I, 172.

23. Quoted from C, 34 (emphasis is the translator's).

24. The list is taken from Mazzuchelli's *Vita di Pietro
Aretino,* in P-C, III, 66; and 211 and n. 339.

25. For the full title of Dolce's dialogue, see RD, 83.
Dolce also called Titian divine in the text of his *Dialogo;*
see 160: "Divin Titiano."

26. Lodovico Dolce, *Vita dell'invittiss e gloriosiss
imperador Carlo Quinto* (Venice, 1561), 165. See Emm.
Antonio Cicogna, "Memoria intorno la vita e gli scritti
di Messer Lodovico Dolce, letterato Veneziano del
secolo XVI," *Memorie dell'I. R. Istituto Veneto di scienze,
lettere ed arti* 11 (1892): 150–51.

27. P-C, II, 421. In the French edition of Aretino's
letters of 1609, the appellation is capitalized.

28. On the Venetian theory of art, see RD, 5–61;
Sergio Ortolani, "Le origini della critica d'arte a
Venezia," *L'Arte* 24 (1923): 3–17, and David Rosand,
"The Crisis of the Venetian Renaissance Tradition,"
L'Arte 3 (December 1970): 5–53.

29. RD, 113.

30. Ibid., 185.

31. Ibid., 193.

32. Ibid., 195.

33. Alberti, *On Painting,* 61.

34. On Aretino's belief in the originality of creative
genius, see Zilsel, *Entstehung,* 237–40; Karl Vossler,
"Pietro Aretinos künstlerisches Bekenntnis," *Neue Hei-
delberger Jahrbücher* 10 (1900): 38–65; and Palladino,
"Pietro Aretino," 35–51.

35. Quoted from C, 70–71.

36. Ibid., 236.

37. The first appearance of the aphorism is in Pseudo-
Acro's commentary on Horace; the second is in Polydore
Vergil's *De Rerum Inventoribus,* which, printed in Venice
in 1499 and translated into the vernacular, had become
popular in the sixteenth century. See William Ringler,
" 'Poeta nascitur non fit': Some Notes on the History of
an Aphorism," *JHI* 2 (1941): 497–504.

38. RD, 159.

39. Ibid., 185: "It is also clearly recognized that
nature made him a painter."

40. See Kris and Kurz, *Legend,* 13–26; Curtius,
European Literature, 160; and Carl Goldstein, "Rhetoric
and Art History in the Italian Renaissance and Ba-
roque," *AB* 73 (1991): 646, on the influence of
hagiographical literature on artists' biographies.

41. Kris and Kurz, *Legend,* 51–52; Goldstein,
"Rhetoric," 647.

42. Speroni's *Dialogo d'amore* is in PT, 547: "[H]o

opinione che i suoi colori sieno composti di quella erba
maravigliosa."

43. RD, 174. Cf. Samuel H. Monk, " 'A Grace
Beyond the Reach of Art,' " *JHI* 5 (1944): 131–50; and
Edoardo Saccone, "Grazia, sprezzatura, affettazione in
The Courtier," in *Castiglione*, 45–67.

44. Giovanni Bottari, *Raccolta di lettere sulla pittura,
scultura et architettura*, ed. Stefano Ticozzi (Milan,
1822–25), v, 212 (no. LX).

45. Cf. Georg Gronau, "Tizians Selbstbildnis in der
Berliner Galerie," *Jahrbuch der königlich preußischen
Kunstsammlungen* 28 (1907): 48, who used this woodcut
to establish the authenticity of Titian's self-portrait.

46. Diane DeGrazia Bohlin, *Prints and Related Draw-
ings of the Carracci Family: A Catalogue Raisonné*
(Washington, D.C.: National Gallery of Art, 1979),
cat. no. 145.

47. Ibid., 250. Cf. Maria Agnese Chiari, *Incisioni da
Tiziano: Catalogo* (Venice: [La Stamperia di Venezia],
1982), 47: "Titiani Vecelli Pictoris Celeberrimi ac
Famossimi Vera Effigies" (my translation). On the
concept of the *vera effigies*, see Linda Susan Klinger,
"The Portrait Collection of Paolo Giovio" (Ph.D. diss.,
Princeton University, 1991), 157–60.

48. W, II, 179; Wethey believes that painting is not
by Titian but is a seventeenth-century invention.
However, others see it as a genuine self-portrait. See
Maurizio Marini's letter in *BM* 122 (April 1980): 255.
For the portrait, as identified by a description in the
inventory of the Vendramin collection, see Jaynie
Anderson, "A Further Inventory of Gabriel Vendramin's
Collection," *BM* 121 (1979): 644 and fig. 46.

49. For types of etched portraits, see Paul Ortwin
Rave, "Paolo Giovio und die Bildnisvitenbücher des
Humanismus," *Jahrbuch der Berliner Museen* 1 (1959):
119–60.

50. Statius, *Silvae and Thebaid I–IV*, trans. J. H.
Mozley, Loeb Classical Library, 1967, 45, with the
translation of *Silva* i.iii.92: "quies virtusque serena
fronte gravis"; and 125 for *Silva* ii.vi.66: "paterere serena
fronte deos."

51. The reason Titian wore this type of hat is unclear.
He wears it in his painted self-portraits as well. The hat is
so distinctive that it frequently aids in identifying Titian,
as, for example, in Veronese's *Wedding of Cana* and in
Jacopo Bassano's *Purification of the Temple*. See Erwin
Panofsky, *Problems in Titian, Mostly Iconographic* (New
York: New York University Press, 1969), 6. See the index
to Freedman, *Titian's*, s.v. "cap."

52. See Warnke, *Hofkünstler*, 204–9, on the mean-
ing of the title, and 217–18 for names of other artists
who had received it before Titian.

53. Jürgen Schulz, "The Houses of Titian, Aretino,
and Sansovino," in R, 78–82, and fig. 3.6.

54. On Titian's social status as a painter, see Charles
Hope, "Titian as a Court Painter," *The Oxford Art
Journal* 2 (1979): 7–10, and Michelangelo Muraro,
"Tiziano pittore ufficiale della Serenissima," in *Tiziano
nel quarto centenario della sua morte, 1576–1976* (Venice:
Edizioni dell'Ateneo Veneto, 1977), 83–100.

55. V-M, VII, 446, on Titian's stay in Belvedere; cf.
Roberto Zapperi, *Tiziano, Paolo III e i suoi nipoti* (Turin:
Boringhieri, 1990), 31–34, on Titian's stay in Rome
and the honors he received.

56. See the illuminating remarks in "Titian's Opu-
lence and Financial Astuteness" by Rudolf Wittkower
and Margot Wittkower, in *Born Under Saturn* (New
York: W. W. Norton, 1969), 265–70.

57. Giorgio Vasari, *Le Vite de' più eccellenti pittori,
scultori et architettori . . .* (Florence, 1568), III, 805. On
Coriolano, see Wolfram Prinz, *Vasaris Sammlung von
Künstlerbildnissen*, supplement to vol. XII of *Mitteilungen
des Kunsthistorischen Institutes in Florenz* (Florence, 1966),
9; on the portrait of Titian, see 150–51 (no. 142).

58. V-M, I, 244; quoted from V-H, I, 19.

59. *Vocabolario degli Accademici della Crusca* (Venice,
1612), 849. Cf. Willibald Sauerlaender, "From *Stilus* to
Style: Reflections on the Fate of a Notion," *Art History* 6
(1983): 257.

60. Baldesar Castiglione, *The Book of the Courtier*,
trans. C. S. Singleton (New York: Anchor, 1959), 81:
"[I]t is fitting for our courtier to have knowledge of
painting."

61. Frederick M. Clapp, *Jacopo Carucci da Pontormo:
His Life and Work* (New Haven: Yale University Press,
1916), cat. no. 83. Cf. Leo Steinberg, "Pontormo's
Alessandro de' Medici, or 'I Only Have Eyes For You,' "
Art in America 63 (1975): 62–65.

62. Ludwig Bieler, *Theios Anēr: Das Bild des
'göttlichen Menschen' in Spätantike und Frühchristentum*
(Vienna: Hofels, 1935–36), I, 52–54.

63. See André Chastel, *Marsile Ficin et l'art* (Ge-
neva: Droz, 1975), pl. 2, 48. Cf. Freedman, *Titian's*, 75
with n. 7.

64. Panofsky, *Problems in Titian*, 2: "The date of
Titian's birth, however, has been—and still is—a
subject of agitated debate."

65. See Charles Hope, *Titian* (New York: Harper &
Row, 1980), 11–12, with a review of the dates. Cf.
Creighton E. Gilbert, "Some Findings on Early Works of
Titian," *AB* 62 (1980): 71–75.

66. Creighton E. Gilbert, "When Did Renaissance
Men Grow Old?" *Studies in the Renaissance* 14 (1967): 7–
32, and Joseph Gantner, "Der alte Künstler," in
Festschrift für Herbert von Einem zum 16. Februar 1965
(Berlin: Gebr. Mann, 1965), 71–76.

67. P-C, I, 217: "Certo che il pennel vostro ha
riserbati i suoi miracoli ne la maturità de la vecchiezza."

68. Titian's letter is reprinted in *Tiziano e la Corte di Spagna nei documenti dell'Archivio Generale di Simancas,* ed. Luigi Ferrarino (Madrid: Istituto Italiano di Cultura, 1975), 22. In it Titian explains that it is impossible for him personally to bring the emperor the portrait of Isabella, for "heveria voluto portale io stesso se la longheza dil viagio et l'età mia mel concedessen." See Panofsky's remark on this letter in *Problems in Titian,* 9.

69. Klara Garas, "Bildnisses der Renaissance III: Der junge Raffael und der alte Tizian," *Acta historiae artium* 21 (1975): 53–74.

70. Roger Jones and Nicholas Penny, *Raphael* (New Haven: Yale University Press, 1983), 171.

71. A. E. Popham, *The Drawings of Leonardo da Vinci* (New York: Reynal & Hitchcock, 1945), cat. no. 154. Cf. F. David Martin, "Spiritual Asymmetry in Portraiture," *British Journal of Aesthetics* 5 (1965): 10:

"Although Leonardo could not have been more than sixty at the time, he represents himself as immensely old."

72. T. S. R. Boase, *Giorgio Vasari: The Man and the Book* (Princeton: Princeton University Press, 1979), 325.

73. BT, iii, 332: "[L]a persona del Padre in forma di vecchio . . . esprimere che l'eternità del medesimo Iddio e quella sua infinità sapienza."

74. Quoted from Edward Hutton, *Pietro Aretino: The Scourge of Princes* (London: Constable, 1922), 211; this letter is noted on page 29.

75. RD, 193.

76. BT, i, 126; quoted from Mary Pardo, "Paolo Pino's *Dialogo di pittura:* A Translation with Commentary" (Ph.D. diss., University of Pittsburgh, 1984), 357.

Thematic Bibliography

The bibliography is divided into primary and secondary sources. The first section includes the works and documents of fifteenth-, sixteenth-, and seventeenth-century writers only. The second section is divided thematically into five subgroups: 1. Portraiture, 2. Titian, 3. Titian and Aretino, 4. Pietro Aretino, and 5. Related Fields. The last group includes works that are cited more than once, with only a rare exception to this rule.

Primary Sources

Accademia della Crusca. *Vocabolario degli Accademici della Crusca.* Venice, 1612.

Alberti, Leon Battista. *Della pittura.* Ed. Luigi Malle. Florence: Sansoni, 1950.

———. *On Painting.* Trans. John R. Spencer. New Haven: Yale University Press, 1973.

———. *On Painting and On Sculpture: The Latin Texts of De Pictura and De Statua.* Trans. Cecil Grayson. London: Phaidon, 1972.

———. *The Ten Books on Architecture,* the 1755 Leoni Edition. New York: Dover, 1986.

Alciati, Andrea. *Emblemata.* Paris, 1583.

Aretino, Pietro. *Lettere.* 6 vols. Paris, 1608–9.

———. *Lettere: Il primo e il secondo libro.* Ed. Francesco Flora. Verona: Mondadori, 1960.

———. *Lettere scritte a Pietro Aretino.* Ed. Teodorico Landoni. 2 vols. in 4. Bologna, 1873–75.

———. *Lettere sull'arte di Pietro Aretino.* Comm. Fidenzio Pertile, ed. Ettore Camesasca. 3 vols. in 4. Milan: Milione, 1957–60.

———. *The Letters of Pietro Aretino.* Trans. Thomas Caldecot Chubb. New York: Archon, 1967.

———. *Selected Letters.* Trans. George Bull. Harmondsworth: Penguin, 1976.

———. *Scritti scelti.* Ed. Giuseppe Guido Ferrero. 2 vols. Turin: Unione tipografico-editrice torinese, 1970.

———. *Opere di Pietro Aretino e di Anton Francesco Doni,* ed. Carlo Cordie. Milan: Ricciardi, 1976.

———. *Teatro.* Ed. Giorgio Petrocchi. Verona: Mondadori, 1971.

_____. *Dell'Umanità del Figliuolo di Dio*. Venice, 1628.

Armenini, Giovanni Battista. *On the True Precepts of the Art of Painting*. Trans. Edward J. Olszewski. New York: Franklin, 1977.

Ávila y Zúñiga, Louis de. *Comentario de la Guerra de Alemania hecha por Carlos V, Maximo Emperador Romano, Rey de Espana, en el año de 1546 y 1547*. (Cayetano Rosell, ed., *Historiadores de sucesos particulares*. I, 409–49. Madrid, 1858–63.)

Barocchi, Paola. Ed. *Scritti d'arte del Cinquecento*. 3 vols. Milan: Ricciardi, 1971.

_____, ed. *Trattati d'arte del Cinquecento fra Manierismo e Controriforma*. 3 vols. Bari: Laterza, 1960–61.

Bembo, Pietro. *Gli Asolani*. Trans. Rudolf B. Gottfried. Bloomington: University of Indiana Press, 1954.

Biondo, Michelangelo. *Della nobillissima pittura et della sua arte*. Venice, 1549.

Bocchi, Achille. *Symbolicarum quaestionum, De universo genere, quas serio ludebat, Libri Quinque*. Bologna, 1574.

Bocchi, Francesco. *Eccellenza della statua del San Giorgio di Donatello, scultore fiorentino, posta nella facciata di fuori d'Or San Michele . . .* Florence, 1584. (Paola Barocchi, ed., *Trattati d'arte del Cinquecento fra Manierismo e Controriforma*, III:125–94. Bari: Laterza, 1960–61.)

Borghini, Raffaele. *Il Riposo*. Florence, 1584.

Bottari, Giovanni. *Raccolta di lettere sulla pittura, scultura ed architettura scritte da più celebri personaggi dei secoli XV, XVI et XVII*. Ed. Stefano Ticozzi. 8 vols. Milan, 1822–25.

Bradford, William. Trans. *Correspondence of the Emperor Charles V, and His Ambassadors at the Courts of England and France, from the Original Letters in the Imperial Family Archives at Vienna; With a Connecting Narrative and Biographical Notices of the Emperor, and of some Distinguished Officers of His Army and Household; Together with the Emperor's Itinerary, from 1519–1551*. London, 1850.

Bulwer, John. *Chirologia: or the Natural Language of the Hand and Chironomia: or the Art of Manual Rhetoric*. Trans. James W. Cleary.

Carbondale: Southern Illinois University Press, 1974.

Camillo, Giulio (Delminio). "De l'humana deificazione." (Cesare Vasoli, "Uno scritto inedito di Giulio Camillo 'de l'humana deificazione,' " *Rinascimento* 24 [1984]: 191–227.)

Castiglione, Baldesar. *The Book of the Courtier*. Trans. Charles S. Singleton. New York: Anchor, 1959.

Comanini, Gregorio. *Il Figino, overo del fine della pittura, ove, quistionandosi se 'l fine della pittura sia l'utile overo il diletto, si tratta dell'uso di quella nel Cristianesimo e si mostra qual sia imitator più perfetto e che piu diletti, il pittore overo il poeta*. Mantua, 1591. (Paola Barocchi, ed., *Trattati d'arte del Cinquecento fra Manierismo e Controriforma*, III:237–379. Bari: Laterza, 1960–61.

Daniello, Bernardino. *Della Poetica*. Venice, 1536. (Bernard Weinberg, ed., *Trattati di poetica e retorica del cinquecento*, I:227–318. Bari: Laterza, 1970.)

Della Casa, Giovanni. *Le rime*. Ed. Roberto Fedi. 2 vols. Rome: Salerno, 1978.

Dolce, Lodovico. *Dialogo della pittura . . . intitolato l'Aretino, nel quale si ragiona della dignità di essa pittura e di tutte le parti necessarie, che a perfetto pittore si acconvengono: con esempi di pittori antichi, & moderni: e nel fine si la mentione delle virtù e delle opere del Divin Titiano*. Venice, 1557. (Paola Barocchi, ed. *Trattati d'arte del Cinquecento fra Manierismo e Controriforma*, I, 141–206. Bari: Laterza, 1960–61.)

_____. *Dialogo della pittura, intitolato l'Aretino*. In Mark W. Roskill, trans., *Dolce's "Aretino" and Venetian Art Theory of the Cinquecento*. New York: New York University Press, 1969.

_____. *Dialogo . . . nel quale si ragiona delle qualità, diversità, e proprietà de i colori . . .* Venice, 1565.

_____. *Rime di diversi eccellenti autori: Raccolte da i libri da noi altre volte impressi, tra le quali, se ne leggono molte non più vedute*. Venice, 1556.

_____. *Vita dell'invittiss. e gloriosiss. imperador Carlo Quinto*. Venice, 1561.

Doni, Anton Francesco. *Disegno . . . partito in più ragionamenti ne quali si tratta della scoltura, et pittura . . .* Venice, 1549.

Dürer, Albrecht. *Schriftlicher Nachlass.* Ed. Hans von Rupprich. 3 vols. Berlin: Deutscher Verein für Kunstwissenschaft, 1956–69.

Equicola, Mario. *Libro di natura d'amore.* Venice, 1526.

Erasmus, Desiderius. *The Education of a Christian Prince.* Trans. Lester K. Born. New York: Columbia University Press, 1936.

Ficino, Marsilio. *The Letters.* Translated from the Latin by members of the Language Department of the School of Economic Science, London; preface by Paul Oskar Kristeller. 4 vols. London: Shepheard-Walwyn, 1975–88.

Firenzuola, Agnolo. *Dialogue of the Beauty of Women.* Trans. C. Bell. London, 1892.

Franco, Niccolò. *Rime . . . contro Pietro Aretino.* Lanciano: Carabba, 1916.

Gaurico, Pomponio. *Pomponius Gauricus. De Sculptura (1504).* Ed. André Chastel and Robert Klein. Geneva: Droz, 1969.

Gilbert, Creighton E., ed. *Italian Art, 1400–1500: Sources and Documents.* Englewood Cliffs, N.J.: Prentice-Hall, 1980.

Giovio, Paolo. *Dialogo de las empresas militares, y amorosas, compuesto en lengua italiana . . . En el qual se tracta de las devisas, armas, motes, o blasones de linages. Con un razonamiento a esse proposito, del . . . Señor Ludovico Domeniqui. Todo nuevamente traduzio en Romance Castellano, por Alonso de Ulloa. Añadimos a esto Las empresas heróicas, y morales, del Señor Gabriel Symeon.* Lyon, 1562.

———. *Dialogo dell'imprese militari e amorose.* Ed. Maria Luisa Doglio. Rome: Bulzoni, 1978.

———. *Elogia virorum bellica virtute illustrium.* Basel, 1596.

———. *Historiarum sui temporis.* 2 vols. in 3. Basel, 1567.

———. *Lettere.* Ed. Giuseppe Guido Ferrero. 2 vols. Rome: Istituto poligrafico dello Stato, 1958.

Gronau, Georg. Ed. *Documenti artistici urbinati.* Florence: Sansoni, 1936.

Hollanda, Francisco de. *Four Dialogues on Painting.* Trans. A. F. G. Bell. London: Oxford University Press, 1928.

Leonardo da Vinci. *Treatise on Painting [Codex Urbinas Latinus 1270].* Ed. A. Philip McMahon. 2 vols. Princeton: Princeton University Press, 1956.

Leoni, Giovanni Battista. *Vita di Francesco Maria da Montefeltro della Rovere III Duca d'Urbino.* Venice, 1605.

Lomazzo, Gian Paolo. *Scritti sulle arti.* Ed. Roberto Paolo Ciardi. 2 vols. Florence: Centro Di, 1974.

Mancini, Giulio. *Considerazioni sulla pittura.* Ed. Luigi Salerno. 2 vols. Rome: Accademia nazionale dei Lincei, 1956–57.

Michelangelo Buonarotti. *Il carteggio.* Ed. Paola Barocchi and Renzo Ristori. 5 vols. Florence: Sansoni, 1965–83.

Morato, Fulvio Pellegrino. *Del significato de' colori.* Venice, 1535.

Paleotti, Gabriele. *Discorso intorno alle imagini sacre e profane, diviso in cinque libri. Dove si scuoprono varii abusu loro e si dichiara il vero modo che cristianamente si doveria osservare nel porte nelle chiese, nelle case et in ogni altro luogo.* Bologna, 1582. (Paola Barocchi, ed. *Trattati d'arte del Cinquecento fra Manierismo e Controriforma,* II, 117–509. Bari: Laterza, 1960–61.)

Pino, Paolo. *Dialogo di pittura . . . nuovamente dato in luce.* Venice, 1548. (Paola Barocchi, ed. *Trattati d'arte del Cinquecento fra Manierismo e Controriforma,* I, 93–109. Bari: Laterza, 1960–61.)

———. *Dialogo di pittura.* Trans. Mary Pardo. Ph.D. diss., University of Pittsburgh, 1984.

Platina, Battista; Onofrio P. V. Panvinio; and Antonio Cicerelli. *Historia delle Vite de i Sommi Pontefici . . .* Venice, 1608.

Pozzi, Mario. Ed. *Trattatisti del Cinquecento.* Milan: Ricciardi, 1978.

Promis, Vincenzo. Ed. *La passione di Gesù Cristo: Rappresentazione sacra in Piemonte nel secolo XV.* Turin, 1888.

Ridolfi, Carlo. *Le maraviglie dell'arte: Ovvero le vite degli illustre pittori veneti e dello stato.* Ed. Detlev Freiherr von Hadeln. 2 vols. Rome: Società 'Multigrafica Editrice SOMU, 1965.

Ripa, Cesare. *Iconologia . . . Divisa in tre libri, ne i quali si esprimono varie imagini di virtù . . .* Venice, 1645.

Ruscelli, Girolamo. *Le imprese illustri . . .* Venice, 1566.

Sánches Loro, Domingo. *La inquietud postrimera: Tránsito ejemplar de Carlos V, desde la fastuosidad cortesana de Bruselas al retiro monacal de Yuste.* 2 vols. Cáceres: Jefatura Provincial del Movimiento, 1957.

Sansovino, Francesco. *La retorica.* Bologna, 1543. (Bernard Weinberg, ed., *Trattati di poetica e retorica del cinquecento,* I, 451–67. Bari: Laterza, 1970.)

Santi, Giovanni. *Cronaca rimata.* Ed. H. Holtzinger. Stuttgart, 1893.

Sanudo, Marin. *I diarii (1496–1533).* Ed. Rinaldo Fulin et al. 58 vols. in 35. Venice, 1879–1903.

Serafino, Luise. *Tragedia* (August 28, 1568). (Domenico Coppola, ed., *Sacre rappresentazioni aversane del sec. XVI,* 1–23. Florence: Olschki, 1959.)

Serlio, Sebastiano. *Regole generali di architettura sopra le cinque maniere de gli edifici . . .* Venice, 1537.

Speroni degli Alvarotti, Sperone. *Opere.* 5 vols. Venice, 1740.

Tatarkiewicz, Władysław. *History of Aesthetics.* 3 vols. The Hague: Mouton, 1970–74.

Tiziano e la Corte di Spagna nei documenti dell'Archivio Generale di Simancas, ed. Luigi Ferrarino. Madrid: Istituto Italiano di Cultura, 1975.

Tiziano Veccelio. *Le lettere.* Ed. Clemente Gandini. [Pieve di Cadore]: Magnifica Comunità di Cadore, 1977.

Tolomei, Claudio. *De le lettere.* Venice, 1547.

Trissino, Giovan Giorgio. *La poetica* (I–IV). Vicenza, 1529. (Bernard Weinberg, ed., *Trattati di poetica e retorica del cinquecento,* I, 21–158. Bari: Laterza, 1970.)

———. *I ritratti.* Rome, 1524. (Willi Hirdt, ed., *Gian Giorgio Trissinos Porträt der Isabella d'Este: Ein Beitrag zur Lukian-Rezeption in Italien.* 19–28. Heidelberg: Winter, 1981).

Ulloa, Alfonso de. *Vita dell'invittissimo e sacratissimo imperator Carlo Quinto.* Venice, 1574.

Valeriano Bolzani, Pierio. *Hieroglyphica sive de sacris Aegyptiorum.* Basel, 1567.

Varchi, Benedetto. *Lezzione . . . nella quale si disputa della maggioranza delle arti e qual sia più nobile, la scultura o la pittura . . .* (Paola Barocchi, ed., *Trattati d'arte del Cinquecento fra Manierismo e Controriforma,* I, 3–58. Bari: Laterza, 1960–61.)

Vasari, Giorgio. *Lives of the Painters, Sculptors, and Architects.* Trans. A. B. Hinds, ed. William Gaunt. 4 vols. London: Dent, 1980.

———. *La Vita di Michelangelo nelle redazioni del 1550 e del 1568.* Ed. Paola Barocchi. 5 vols. Milan: Ricciardi, 1962.

———. *Le Vite de' più eccellenti pittori, scultori, e architettori . . . di nuovo dal medesimo riviste et ampliate con i ritratti loro et con l'aggiunta delle vite de' vivi, & de' morti dall'anno 1550 insino al 1567.* 3 vols. Florence, 1568.

———. *Le Vite de' più eccellenti pittori, scultori ed architettori.* Ed. Gaetano Milanesi. 9 vols. Florence, 1878–85.

———. *Le Vite,* nell edizione del MDL. Ed. Corrado Ricci. 4 vols. Milan and Rome: Casa editrice d'arte Bestetti e Tumminelli, 1927.

Weinberg, Bernard, ed. *Trattati di poetica e retorica del Cinquecento.* 4 vols. Bari: Laterza, 1970–74.

Secondary Sources

1. Portraiture

Anderson, Jaynie. "The Giorgionesque Portrait: From Likeness to Allegory." In *Giorgione: Atti del convegno internazionale di studio per il 5° centenario della nascità 29–31 Maggio, 1978,* 153–58. Venice, 1979.

Boehm, Gottfried. *Bildnis und Individuum: Über den Ursprung der Porträtmalerei in der italienischen Renaissance.* Munich: Prestel-Verlag, 1985.

Bologna, Ferdinando. "Il Carlo V del Parmigianino." *Paragone* 7 (January 1956): 3–16.

Brilliant, Richard. *Portraiture.* Cambridge: Harvard University Press, 1991.

Burckhardt, Jacob. "Das Porträt in der italienischen Malerei." In his *Gesamtausgabe . . . ,* XII,

141–291. Stuttgart: Deutsche Verlag-Anstalt, 1929–33.

Burke, Peter. "The Presentation of Self in the Renaissance Portrait." In his *The Historical Anthropology of Early Modern Italy: Essays on Perception and Communication*, 150–67. Cambridge: Cambridge University Press, 1987.

Campbell, Lorne. *Renaissance Portraits: European Portrait-Painting in the Fourteenth, Fifteenth, and Sixteenth Centuries*. New Haven: Yale University Press, 1990.

Castelnuovo, Enrico. "Il significato del ritratto pittorico nella società." In *Storia d'Italia* (5,1 Documenti), ii, 1060–94. Turin: Einaudi, 1973.

Cropper, Elisabeth. "The Beauty of Women: Problems in the Rhetoric of Renaissance Portraiture." In *Rewriting the Renaissance: The Discourses of Sexual Difference in Early Modern Europe*. Ed. Margaret W. Ferguson, Maureen Quilligan, and Nancy J. Vickers, 175–90. Chicago: University of Chicago Press, 1986.

Eisenbichler, Konrad. "Bronzino's Portrait of Guidobaldo II della Rovere." *Renaissance and Reformation* 24 (1988): 21–33.

Freedman, Luba. "The Concept of Portraiture in Art Theory of the Cinquecento." *Zeitschrift für Ästhetik und allgemeine Kunstwissenschaft* 32 (1987): 63–82.

———. "Raphael's Perception of the *Mona Lisa.*" *Gazette des Beaux-Arts* 114 (1989): 217–47.

Friedlaender, Max J. "Something of the Principles and History of Portraiture." In his *Landscape, Portrait, Still-Life: Their Origin and Development*, trans. R. F. C. Hull, 230–62. New York: Philosophical Library, 1950.

Gould, Cecil. "The Raphael *Portrait of Julius II*: Problems of Versions and Variants (1511–12)." *Apollo* 92 (1970): 187–90.

Grassi, Luigi. "Lineamenti per una storia del concetto di Ritratto." *Arte Antica e Moderna* 13/16 (1961): 477–94.

Hackenbroch, Yvonne. "Some Portraits of Charles V." *The Metropolitan Museum of Art Bulletin* 27 (February 1969): 323–32.

———. "Two Portrait Medallions of Charles V.: World Domination and Humility." In *Scritti*

di storia dell'arte in onore di Federico Zeri, i, 436–43. Milan: Electa, 1984.

Jenkins, Marianna. *The State Portrait: Its Origin and Evolution*. [New York]: College Art Association of America, 1947.

Kai Sass, Else. "Autour de quelques portraits de Charles Quint." *Oud-Holland* 90 (1976): 1–14.

Keller, Harald. *Das Nachleben des antiken Bildnisses von der Karolingerzeit bis zur Gegenwart*. Freiburg: Herder, 1970.

Ladner, Gerhart B. *I ritratti dei papi nell'antichità e nel medioevo*. 3 vols. Vatican City: Pontificio istituto di archeologia cristiana, 1941–84.

Mann, H. K. "The Portraits of the Popes." *Papers of the British School at Rome* 9 (1920): 169–204.

Martin, F. David. "Spiritual Asymmetry in Portraiture." *British Journal of Aesthetics* 5 (1965): 6–13.

Meller, Peter. "Physiognomical Theory in Renaissance Heroic Portraits." In *Studies in Western Art: Acts of the Twentieth International Congress of the History of Art*, ii, 53–69. Princeton: Princeton University Press, 1963.

Moffitt, John F. " 'Le Roi à la ciasse'?: Kings, Christian Knights, and Van Dyck's Singular 'Dismounted Equestrian-Portrait' of Charles I." *Artibus et historiae* 7 (1983): 79–99.

Oberhuber, Konrad. "Raphael and the State Portrait—i: The *Portrait of Julius II.*" *Burlington Magazine* 113 (1971): 124–30.

Partridge, Loren, and Randolph Starn. *A Renaissance Likeness: Art and Culture in Raphael's Julius II*. Berkeley and Los Angeles: University of California Press, 1980.

Pope-Hennessy, John. *The Portrait in the Renaissance*. New York: Bollingen Foundation, 1966.

Pedretti, Carlo. "Ancora sul rapporto Giorgione-Leonardo e l'origine del ritratto di spalla." In *Giorgione: Atti del convegno internazionale di studio per il 5° centenario della nascita 29–31 Maggio, 1978*, 180–85. Venice, 1979.

Prinz, Wolfram. *Vasaris Sammlung von Künstlerbildnissen*. Supplement to vol. xii of *Mitteilungen des Kunsthistorischen Instituts in Florenz*. Florence, 1966.

Quednau, Rolf. "Raphael's Julius II." *Burlington Magazine* 123 (1981): 551–53.

Rogers, Mary. "Sonnets on Female Portraits from Renaissance North Italy." *Word & Image* 2 (1986): 291–305.

Rosand, David. "The Portrait, the Courtier, and Death." In *Castiglione: The Ideal and the Real in Renaissance Culture*. Ed. Robert W. Hanning and David Rosand, 91–129. New Haven: Yale University Press, 1983.

Waddington, Raymond B. "Before Arcimboldo: Composite Portraits on Italian Medals." *The Medal* 14 (Spring 1989): 13–23.

Wätzoldt, Wilhelm. *Die Kunst des Porträts.* Leipzig: Hirt, 1908.

2. Titian

Battisti, Eugenio. "Di alcuni aspetti non veneti di Tiziano." In *Tiziano e Venezia: Convegno internazionale di studi, Venezia, 1976*, 213–25. Vicenza: Pozza, 1980.

Bernini, Dante, "Tiziano per i Duchi di Urbino." In *Tiziano per i Duchi di Urbino: Celebrazione del IV centenario della morte di Tiziano, mostra didattica*, 17–29. Urbino: AGE, 1976.

Braunfels, Wolfgang. "Tizians Allocutio des Avalos und Giulio Romano." In *Mouseion: Studien aus Kunst und Geschichte für Otto H. Förster*, 108–12. Cologne: DuMont, 1960.

———. "Tizians Augsburger Kaiserbildnisse." In *Kunstgeschichtliche Studien für Hans Kauffmann*, 192–207. Berlin: Gebr. Mann, 1956.

Causa, Raffaello. "Per Tiziano: Un pentimento nel *Paolo III con i Nipoti.*" *Arte Veneta* 18 (1964): 219–23.

Chiari, Maria Agnese. *Incisioni da Tiziano: Catalogo del fondo grafico a stampa del Museo Correr.* Venice: [La Stamperia di Venezia], 1982.

———. *Titian: Drawings.* New York: Rizzoli, 1989.

Clausse, Gustave. *Les Farnèse peints par Titien.* Paris: Gazette des Beaux-Arts, 1903.

Cloulas, Annie. "Charles Quint et le Titien: Les premiers portraits d'apparat." *Information d'histoire de l'art* 9 (1964): 213–21.

Colasanti, Arduino. "Soneti inediti per Tiziano e per Michelangelo." *Nuova Antologia* 38 (March 1903): 279–86.

Crowe, J. A., and G. B. Cavalcaselle. *Titian: His Life and Times.* 2 vols. London, 1877.

Dionisotti, Carlo. "Tiziano e la letteratura." In *Tiziano e il Manierismo Europeo: Corso internazionale di alta cultura, 18.* Ed. Rodolfo Pallucchini, 259–70. Florence: Olschki, 1978.

Einem, Herbert von. *Karl V. und Tizian.* Cologne: Westdeutscher Verlag, 1960.

Fehl, Philipp P. "Titian's Poetic Irony." In his *Decorum and Wit: The Poetry of Venetian Painting. Essays in the History of the Classical Tradition*, 181–97. Vienna: IRSA, 1992.

Fiocco, Giuseppe. "Il ritratto di Sperone Speroni dipinto da Tiziano." *Bollettino d'Arte* 39 (1954): 306–10.

Folena, Gianfranco. "La scrittura di Tiziano e la terminologia pittorica rinascimentale." In *Miscellanea di studi in onore Vittore Branca*, III, 821–43. Florence: Olschki, 1983.

Freedman, Luba. *Titian's Independent Self-Portraits.* Florence: Olschki, 1990.

———. "Titian's *Portrait of Clarissa Strozzi:* The State Portrait of a Child." *Jahrbuch der Berliner Museen* 31 (1989): 165–80.

Garas, Klara. "Bildnisse der Renaissance III: Der junge Raffael und der alte Tizian." *Acta historiae artium* 21 (1975): 53–74.

Garberi, Mercedes. "Tiziano: I ritratti." In *Omaggio a Tiziano: La cultura artistica milanese nell'età di Carlo V*, 11–37. Milan: Electa, 1977.

Gilbert, Creighton E. "Some Findings on Early Works of Titian." *Art Bulletin* 62 (1980): 36–75.

Ginzburg, Carlo. "Tiziano, Ovidio e i codici della figurazione erotica nel '500." In *Tiziano e Venezia: Convegno internazionale di studi, Venezia, 1976*, 125–35. Vicenza: Pozza, 1980.

Gould, Cecil. *Titian as Portraitist: Catalogue.* London: National Gallery, 1976.

Gronau, Georg. "Tizians Selbstbildnis in der Berliner Galerie." *Jahrbuch der königlich preußischen Kunstsammlungen* 28 (1907): 45–49.

Hadeln, Detlev Freiherr von. "Das Problem der

Lavinia-Bildnisse." *Pantheon* 7 (1931): 82–87.

Held, Julius S. "Titian and Rubens." In *Titian: His World and Legacy*. Ed. David Rosand, 283–339. New York: Columbia University Press, 1982.

Hetzer, Theodor. *Tizian: Geschichte seiner Farbe*. Frankfurt am Main: Klostermann, 1948.

Hope, Charles. "Studies in the Sources and Documents Relating to the Life and Work of Titian." Ph.D. diss. Oxford University, 1975.

———. *Titian*. New York: Harper & Row, 1980.

———. "Titian and His Patrons." In *Titian: Prince of Painters. Catalogue*, 77–84. Venice: Marsilio, 1990.

———. "Titian as a Court Painter." *Oxford Art Journal* 2 (1979): 7–10.

———. "Titian's Early Meetings with Charles V." *Art Bulletin* 59 (1977): 551–52.

Kennedy Wedgwood, Ruth. " 'Apelles Redidivus.' " In *Essays in Memory of Karl Lehmann*, 160–70. New York: New York University Press, 1964.

Land, Norman E. "Titian's *Martyrdom of St. Peter Martyr* and the 'Limitations' of Ekphrastic Art Criticism." *Art History* 13 (1990): 293–317.

Meller, Peter. "Il lessico ritrattistico di Tiziano." In *Tiziano e Venezia: Convegno internazionale di studi, Venezia, 1976*, 325–35. Vicenza: Pozza, 1980.

Müller Hofstede, Justus. "Rubens und Tizian: Das Bild Karls V." *Münchner Jahrbuch der bildenden Kunst* 18 (1967): 33–96.

Muraro, Michelangelo. "Tiziano pittore ufficiale della Serenissima." In *Tiziano nel quattro centenario della sua morte, 1576–1976*, 83–100. Venice: Edizioni dell'Ateneo Veneto, 1977.

Northcote, James. *The Life of Titian: With Anecdotes of the Distinguished Persons of His Time*. 2 vols. London, 1830.

Oberhaidacher, Jorg. "Zu Tizians Reiterbildnis Karl V.: Eine Untersuchung seiner Beziehung zum Georgsthema." *Jahrbuch der Kunsthistorischen Sammlungen in Wien* 78 (1982): 69–90.

Ortolani, Sergio. "Restauro d'un Tiziano." *Bollettino d'Arte* 33 (1948): 44–53.

Ost, Hans. "Tizians Paul III. und die Nipoten." *Wallraf-Richartz-Jahrbuch* 45 (1984): 113–30.

Padoan, Giorgio. "A casa di Tiziano, una sera d'agosto." In *Tiziano e Venezia: Convegno internazionale di studi, Venezia, 1976*, 357–67. Vicenza: Pozza, 1980.

———. "Titian's Letters." In *Titian: Prince of Painters. Catalogue*, 43–52. Venice: Marsilio, 1990.

Pallucchini, Rodolfo. *Tiziano*. 2 vols. Florence: Sansoni, 1969.

Panofsky, Erwin. "Classical Reminiscences in Titian's Portraits: Another Note on His 'Allocution on the Marchese del Vasto.' " In *Festschrift für Herbert von Einem zum 16. Februar 1965*, 188–202. Berlin: Gebr. Mann, 1965.

———. *Problems in Titian, Mostly Iconographic*. New York: New York University Press, 1969.

Paolucci, Antonio. "The Portraits of Titian." In *Titian: Prince of Painters. Catalogue*, 101–8. Venice: Marsilio. 1990.

Petrocchi, Giorgio. "Scrittori e poeti nella botega di Tiziano." In *Tiziano e Venezia: Convegno internazionale di studi, Venezia, 1976*, 103–9. Vicenza: Pozza, 1980.

Pignatti, Terisio. "Giorgione and Titian." In *Titian: Prince of Painters. Catalogue*, 68–76. Venice: Marsilio, 1990.

Puppi, Lionello. "Titian in the Critical Judgment of His Time." In *Titian: Prince of Painters. Catalogue*, 53–56. Venice: Marsilio, 1990.

Rosand, David. *Painting in Cinquecento Venice: Titian, Veronese, Tintoretto*. New Haven: Yale University Press, 1982.

———. "Review of H. E. Wethey, *Titian: The Portraits*." *Renaissance Quarterly* 26 (1973): 497–500.

———. *Titian*. New York: Harry N. Abrams, 1978.

———. "Titian and the Critical Tradition." In *Titian: His World and Legacy*. Ed. David Rosand, 1–39. New York: Columbia University Press, 1982.

———, and Michelangelo Muraro. Ed. *Titian and the Venetian Woodcut*. Washington, D.C.: International Exhibitions Foundation, 1976.

Smirnova, Irina S. *Titian and the Venetian Portrait of the Sixteenth Century.* Moscow: Iskusstvo, 1964. (In Russian.)

Smith, Alistair. "Titian's Portraiture." *Connoisseur* 192 (1976): 255–63.

Ticozzi, Stefano. *Vite de' pittori Vecelli di Cadore.* Milan, 1817.

Tietze, Hans. *Titian: Paintings and Drawings.* London: Phaidon, 1950.

Tietze-Conrat, Erica. "Titian as a Letter Writer." *Art Bulletin* 26 (1941): 117–23.

———. "Titian's *Portrait of Paul III.*" *Gazette des Beaux-Arts* 26 (1946): 73–84.

Tiziano nelle Gallerie fiorentine: Catalogo. Florence: Centro Di, 1978.

Valcanover, Francesco. "An Introduction to Titian." In *Titian: Prince of Painters. Catalogue,* 3–28. Venice: Marsilio, 1990.

———. *L'opera completa di Tiziano.* Milan: Rizzoli, 1969.

Varese, Ranieri. "Tiziano e i Della Rovere." *Notizie da Palazzo Albani* 5 (1976): 15–29.

Waźbiński, Zygmunt. "Tycjan—'nowy Appelles.' O roli antycznego mitu w sztuce renesansu." *Rocznik historii sztuki* 8 (1970): 47–68.

Wethey, Harold E. *The Paintings of Titian: Complete Edition.* 3 vols. London: Phaidon, 1969–75.

———. "Tiziano ed i ritratti di Carlo V." In *Tiziano e Venezia: Convegno internazionale di studi, Venezia, 1976,* 287–91. Vicenza: Pozza, 1980.

Wethey, Alice S., and Harold E. Wethey. "Titian: Two Portraits of Noblemen in Armor and Their Heraldry." *Art Bulletin* 62 (1980): 76–96.

Zapperi, Roberto. *Tiziano, Paolo III e i suoi nipoti: Nepotismo e ritratto di Strato.* Turin: Boringhieri, 1990.

3. Titian and Aretino

Fehl, Philipp P. "Tintoretto's Homage to Titian and Pietro Aretino." In his *Decorum and Wit: The Poetry of Venetian Painting. Essays in the History of the Classical Tradition,* 167–80. Vienna: IRSA, 1992.

———. "Truth and Decorum Reconciled by Wit: Dürer, Titian, and Pietro Aretino." In his *Decorum and Wit: The Poetry of Venetian Paintings. Essays in the History of the Classical Tradition,* 152–67. Vienna: IRSA, 1992.

Fry, Roger. "Pietro Aretino." *Burlington Magazine* 7 (1905) 344–47.

Gregori, Mina. "Tiziano e l'Aretino." In *Tiziano e il Manierismo Europeo: Corso internazionale di alta cultura, 18.* Ed. Rodolfo Pallucchini, 271–306. Florence: Olschki, 1978.

Kruse, Margot. "Aretinos Sonette auf Tizian-Porträts." *Romanistisches Jahrbuch* 38 (1987): 78–98.

Saxl, Fritz. "Titian and Aretino." In his *Lectures,* 161–73. London: Warburg Institute, 1957.

Schulz, Jürgen. "The Houses of Titian, Aretino, and Sansovino." In *Titian: His World and Legacy.* Ed. David Rosand, 73–118. New York: Columbia University Press, 1982.

4. Pietro Aretino

Anderson, Jaynie. "Pietro Aretino and Sacred Imagery." In *Interpretazioni veneziane: Studi di storia dell'arte in onore di Michelangelo Muraro.* Ed. David Rosand, 275–90. Venice: Arsenale, 1984.

Becatti, Giovanni. "Plinio e l'Aretino." *Arti figurative* 11 (1946): 1–7.

Bertani, Carlo. *Pietro Aretino e le sue opere, secondo nuove indagini.* Sondrio: Quadrio, 1901.

Cairns, Christopher. *Pietro Aretino and the Republic of Venice: Researches on Aretino and His Circle in Venice, 1527–1556.* Florence: Olschki, 1985.

Casalegno, Giovanni. "Rassegna Aretiniana (1972–1989)." *Lettere Italiane* 41 (1989): 425–54.

Chubb, Thomas Caldecot. *Aretino, Scourge of Princes.* New York: Reynal & Hitchcock, 1940.

Falaschi, Giovanni. *Progetto corporativo e autonomia dell'arte in Pietro Aretino.* Messina: G.d'Anna, 1977.

Fehl, Philipp P. "Feasting at the Table of the Lord: Pietro Aretino and the Hierarchy of Pleasures in Venetian Painting." *Hebrew University Studies in Literature and the Arts* 13 (1985): 161–74.

Hösle, Johannes. *Pietro Aretinos Werk.* Berlin: De Gruyter, 1969.

Hutton, Edward. *Pietro Aretino: The Scourge of Princes*. London: Constable, 1922.

Innamorati, Giuliano. *Pietro Aretino: Studi e note critiche*. Messina: G.d'Anna, 1957.

Labalme, Patricia H. "Personality and Politics in Venice: Pietro Aretino." In *Titian: His World and Legacy*. Ed. David Rosand, 119–32. New York: Columbia University Press, 1982.

Land, Norman E. "*Ekphrasis* and Imagination: Some Observations on Pietro Aretino's Art Criticism." *Art Bulletin* 68 (1986): 207–17.

Larivaille, Paul. *Pietro Aretino fra Rinascimento e Manierismo*. Rome: Bulzoni, 1980.

Luzio, Alessandro. *Pietro Aretino nei primi suoi anni a Venezia e la Corte del Gonzaga*. Turin, 1888.

Marchi, Cesare. *L'Aretino*. Milan: Rizzoli, 1980.

Ortolani, Sergio. "Pietro Aretino e Michelangelo." *L'Arte* 25 (1922): 15–26.

Palladino, Lora Anne. "Pietro Aretino: Orator and Art Theorist." Ph.D. diss. Yale University, 1981.

Petrocchi, Giorgio. *Pietro Aretino tra Rinascimento e Controriforma*. Milan: Vita pensiero, 1948.

Puppi, Lionello. "Michelangelo und Aretino." In *Michelangelo Heute*, ed. Heinz Sanke, 123–32. Berlin: Humboldt-Universität, 1965.

Roeder, Ralph. *The Man of the Renaissance. Four Lawgivers: Savonarola, Machiavelli, Castiglione, Aretino*. New York: Viking, 1959.

Semerau, Alfred. *Pietro Aretino: Ein Bild aus der Renaissance*. Vienna: König, 1925.

Sher, Stephen K. "VERITAS ODIUM PARIT: Comments on a Medal of Pietro Aretino." *The Medal* 14 (Spring 1989): 4–11.

Ulivi, Ferruccio. "Pietro Aretino scrittore e critico d'arte." In his *Poesia come Pittura*, 111–44. Bari: Adriatica, 1969.

Venturi, Lionello. "Pietro Aretino e Giorgio Vasari." In his *Pretesti di critica*, 53–72. Milan: Hoepli, 1929.

Vossler, Karl. "Pietro Aretinos künstlerisches Bekenntnis." *Neue Heidelberger Jahrbücher* 10 (1900): 38–65.

Waddington, Raymond B. "A Satirist's *Impresa*: The Medals of Pietro Aretino." *Renaissance Quarterly* 42 (1989): 655–81.

Weise, Georg. "Manieristische und Frühbarocke Elemente in den Religiösen Schriften des Pietro Aretino." *Bibliothèque d'Humanisme et Renaissance* 19 (1957): 170–207.

5. Related Fields

Albrecht-Bott, Marianne. *Die bildende Kunst in der italienischen Lyrik der Renaissance und des Barock: Studie zur Beschreibung von Porträts und anderen Bildwerken unter besonderer Berücksichtigung von G. B. Marinos "Galleria."* Wiesbaden: Steiner, 1976.

Alpers, Svetlana. "*Ekphrasis* and Aesthetic Attitudes in Vasari's *Lives*." *Journal of the Warburg and Courtauld Institutes* 23 (1960): 190–215.

Ancona, Alessandro de. *Origini del teatro in Italia: Studi sulle sacre rappresentazioni, seguiti da un'appendice sulle rappresentazioni del contado toscano*. 2 vols. Florence, 1877.

Baccheschi, Edi. *L'opera completa del Bronzino*. Milan: Rizzoli, 1973.

Barasch, Moshe. "Character and Physiognomy: Bocchi on Donatello's St. George. A Renaissance Text on Expression in Art." In his *Imago Hominis: Studies in the Language of Art*, 36–46. Vienna: IRSA, 1991.

——. "Renaissance Color Conventions: Liturgy, Humanism, Workshops." In his *Imago Hominis: Studies in the Language of Art*, 172–79. Vienna: IRSA, 1991.

——. *Theories of Art from Plato to Winckelmann*. New York: New York University Press, 1985.

Barocchi, Paola. *Vasari pittore*. Florence: Barbiera, 1964.

Barolsky, Paul. *Michelangelo's Nose: A Myth and Its Maker*. University Park: The Pennsylvania State University Press, 1990.

Baschet, Armand. *La diplomatie vénitienne: Les princes de l'Europe au XVI^e siècle*. Paris, 1862.

Basserman-Jordan, Ernst von. *The Book of Old Clocks and Watches*. New York: Crown, 1964.

Battisti, Eugenio. *Rinascimento e Barocco*. Turin: Einaudi, 1960.

Białostocki, Jan. The Renaissance Concept of

Nature and Antiquity." In his *The Message of Images: Studies in the History of Art*, 64–68. Vienna: IRSA, 1988.

————. " 'Terribilità.' " In *Stil und Überlieferung in der Kunst des Abendlandes: Akten des 21. Internazionalen Kongresses für Kulturgeschichte in Bonn, 1964*, 222–25. Berlin: Gebr. Mann, 1967.

Blunt, Anthony. *Artistic Theory in Italy, 1450–1600*. London: Oxford University Press, 1973.

Boase, T. S. R. *Giorgio Vasari: The Man and the Book*. Princeton: Princeton University Press, 1979.

Bober, Phyllis Pray, and Ruth Rubinstein. *Renaissance Artists and Antique Sculpture: A Handbook of Sources*. London: Miller and Oxford University Press, 1986.

Boehn, Max von. *Modes and Manners*. Trans. J. Joshua. 4 vols. London: Harrap, 1932–35.

Borinski, Karl. *Antike in Poetik und Kunsttheorie*. 2 vols. Leipzig: Weischer, 1914.

Brandi, Karl. "Dantes *Monarchia* und die Italienpolitik Mercurio Gattinaras." *Jahrbuch der Deutschen Dante-Gesellschaft* 24 (1942): 1–19.

————. *The Emperor Charles V: The Growth and Destiny of a Man and of a World-Empire*. Trans. C. V. Wedgwood. London: Cape, 1939.

Braun, Joseph. *Die liturgische Gewandung im Occident und Orient nach Ursprung und Entwicklung, Verwendung und Symbolik*. Darmstadt: Wissenschaftliche Buchgesellschaft, 1964.

Brilliant, Richard. *Gesture and Rank in Roman Art: The Use of Gestures to Denote Status in Roman Sculpture and Coinage*. New Haven: The Academy, 1963.

Burckhardt, Jacob. *The Civilization of the Renaissance in Italy*. Trans. S. G. C. Middlemore. 2 vols. New York: Harper, 1958.

Campana, Lorenzo. "Monsignor Giovanni Della Casa e i suoi tempi: Vita privata." *Studi storici* 17 (1908): 381–606.

Casali, Scipione. *Gli annali della tipografia Veneziana di Francesco Marcolini*. Bologna: Gerace, 1953.

Cicogna, Emm. Antonio. "Memoria intorno la vita e gli scritti di Messer Lodovico Dolce, letterato veneziano del secolo XVI." *Me-morie dell'I. R. Istituto Veneto di scienze, lettere ed arti* 11 (1892): 93–200.

Colasanti, Arduino. "Gli artisti nella poesia del Rinascimento: Fonti poetiche per la storia dell'arte italiana." *Repertorium für Kunstwissenschaft* 27 (1904): 193–200.

Cochrane, Eric. *Historians and Historiography in the Italian Renaissance*. Chicago: University of Chicago Press, 1981.

Cox-Rearick, Janet. *Dynasty and Destiny in Medici Art: Pontormo, Leo X, and the Two Cosimos*. Princeton: Princeton University Press, 1984.

Cropper, Elisabeth. "On Beautiful Women, Parmigianino, *Petrarchismo*, and Vernacular Style." *Art Bulletin* 58 (1976): 374–94.

Curtius, Ernst Robert. *European Literature and the Latin Middle Ages*. Trans. Willard R. Trask. Princeton: Princeton University Press, 1973.

DeVecchi, Pier Luigi. "Il Museo Gioviano e le 'verae imagines' degli uomini illustri." In *Omaggio a Tiziano: La cultura artistica milanese nell'età di Carlo V*, 87–96. Milan: Electa, 1977.

Dejob, Charles. *De l'influence du Concile de Trente sur la littérature et les beaux-arts chez les peuples catholiques: Éssai d'introduction à l'histoire littéraire du siècle de Louis XIV*. Paris, 1884.

Dennistoun, James. *Memoirs of the Dukes of Urbino, Illustrating the Arms, Arts, and Literature of Italy from 1440 to 1630*. 3 vols. London, 1851.

Dumesnil, Antoine Jules. *Histoire des plus célèbres amateurs italiens et de leurs relations avec les artistes*. Paris, 1853.

Dussler, Luitpold. *Raphael: A Critical Catalogue of His Pictures, Wall-Paintings, and Tapestries*. London: Phaidon, 1971.

Evans, Elizabeth Cornelia. "Roman Descriptions of Personal Appearance in History and Biography." *Harvard Studies in Classical Philology* 46 (1935): 43–84.

Fox-Davies, Arthur Charles. *A Complete Guide to Heraldry*. New York: Dodge, 1909.

Freedman, Luba. "A Note on Dante's Portrait in Boccaccio's *Vita*." *Studi sul Boccaccio* 15 (1985–86): 253–63.

Frick Collection, New York. *The Frick Collection:*

An Illustrated Catalogue. 5 vols. New York, 1968.

Gage, John. "Color in Western Art: An Issue?" *Art Bulletin* 72 (1990): 518–41.

Gantner, Joseph. "Der alte Künstler." In *Festschrift für Herbert von Einem zum 16. Februar 1965,* 71–76. Berlin: Gebr. Mann, 1965.

Gavel, Jonas. *Colour: A Study of Its Position in the Art Theory of the Quattro- and Cinquecento.* Stockholm: Almqvist & Wiksell International, 1979.

Gilbert, Creighton E. "When Did Renaissance Men Grow Old?" *Studies in the Renaissance* 14 (1967): 7–32.

———. "Antique Frameworks for Renaissance Art Theory: Alberti and Pino." *Marsyas: Studies in the History of Art* 3 (1943–45): 87–106.

Gilbert, Felix. *The Pope, His Banker, and Venice.* Cambridge: Harvard University Press, 1980.

Goffen, Rona. "Carpaccio's *Portrait of a Young Knight*: Identity and Meaning." *Arte Veneta* 37 (1983): 37–48.

Goldstein, Carl. "Rhetoric and Art History in the Italian Renaissance and Baroque." *Art Bulletin* 73 (1991): 641–52.

Grendler, Paul F. *Critics of the Italian World, 1530–1560: Anton Francesco Doni, Nicolo Franco, and Ortensio Lando.* Madison: University of Wisconsin Press, 1969.

Hackenbroch, Yvonne. *Renaissance Jewelry.* London: Sotheby Parke-Bernet, 1979.

Hagstrum, Jean H. *The Sister Arts: The Tradition of Literary Pictorialism and English Poetry from Dryden to Gray.* Chicago: University of Chicago Press, 1958.

Hardison, Osborne Bennett. *The Enduring Monument: A Study of the Idea of Praise in Renaissance Literary Theory and Practice.* Chapel Hill: University of North Carolina Press, 1962.

Headley, John M. *The Emperor and His Chancellor: A Study of the Imperial Chancellery Under Gattinara.* New York: Cambridge University Press, 1983.

Herrick, Marvin Theodore. *The Fusion of Horatian and Aristotelian Literary Criticism, 1531–1555.* Urbana: University of Illinois Press, 1946.

Hill, George Francis. *A Corpus of Italian Medals of the Renaissance Before Cellini.* 2 vols. London: British Museum, 1930.

Hirdt, Willi. "Sul sonetto del Petrarca *Per mirar Policleto a prova fiso.*" In *Miscellanea di studi in onore di Vittore Branca,* I, 435–47. Florence: Olschki, 1983.

Hirst, Michael. *Sebastiano del Piombo.* Oxford: Clarendon Press, 1981.

Huizinga, Johan. *Erasmus and the Age of Reformation.* Trans. F. Hopman. New York: Harper, 1957.

Hulse, Clark. *The Rule of Art: Literature and Painting in the Renaissance.* Chicago: University of Chicago Press, 1990.

Hutton, James. *The Greek Anthology in Italy to the Year 1800.* Ithaca: Cornell University Press, 1935.

Janson, H. W. *Apes and Ape Lore in the Middle Ages and the Renaissance.* London: Warburg Institute, 1952.

———. *Sixteen Studies.* New York: Harry N. Abrams, 1974.

Jedin, Hubert. *A History of the Council of Trent.* Trans. E. Graf. 2 vols. London: Nelson, 1957–61.

———. "Das Tridentinum und die Bildenden Künste. Bemerkungen zu Paolo Prodi, *Richerche sulla teorica delle arti figurative nella Riforma Cattolica* (1962)." *Zeitschrift für Kirchengeschichte* 74 (1963): 321–39.

Jones, Roger, and Nicholas Penny. *Raphael.* New Haven: Yale University Press, 1983.

Kantorowicz, Ernst H. *The King's Two Bodies: A Study in Mediæval Political Theology.* Princeton: Princeton University Press, 1957.

Kemp, Martin. "The 'Super-Artist' as Genius: The Sixteenth-Century View." In *Genius: The History of an Idea.* Ed. Penelope Murray, 32–53. London: Blackwell, 1989.

———. *Leonardo da Vinci: The Marvellous Works of Nature and Man.* London: Dent, 1981.

Klein, Robert. *Form and Meaning: Essays on the Renaissance and Modern Art.* Trans. M. Jay and L. Wieseltier. New York: Viking, 1970.

Klinger, Linda Susan. "The Portrait Collection of Paolo Giovio." Ph.D. diss., Princeton University, 1991.

König, Hans Joachim. *Monarchia mundi und Res*

publica christiana: Die Bedeutung des mittel-alterlichen Imperium Romanum für die politische Ideenwelt Kaiser Karls V. und seiner Zeit, dargestellt an ausgewählten Beispielen. Ph.D. diss., Hamburg, 1969.

Kris, Ernst, and Otto Kurz. *Legend, Myth, and Magic in the Image of the Artist: A Historical Experiment.* New Haven: Yale University Press, 1979.

Lausberg, Heinrich. *Handbuch der literarischen Rhetorik: Eine Grundlegung des Literatur-wissenschaft.* 2 vols. Munich: Hüber, 1973.

Laver, James. *A Concise History of Costume and Fashion.* New York: Scribner's, 1969.

Lee, Rensselaer W. *Ut Pictura Poesis: The Humanistic Theory of Painting.* New York: W. W. Norton, 1967.

LeMolle, Roland. *Georges Vasari et le vocabulaire de la critique d'art dans les "Vite."* Grenoble: Ellug, 1988.

Luzio, Alessandro, and Rodolfo Renier. *Mantova e Urbino: Isabella d'Este ed Elisabetta Gonzaga nelle relazioni famigliari e nelle vicende politiche.* Turin, 1893.

McComb, Arthur. *Agnolo Bronzino: His Life and Works.* Cambridge: Harvard University Press, 1928.

McCorquodale, Charles. *Bronzino.* New York: Harper & Row, 1981.

Maclean, Ian. *The Renaissance Notion of Woman: A Study in the Fortunes of Scholasticism and Medical Science in European Intellectual Life.* New York: Cambridge University Press, 1980.

Mayo, Janet. *A History of Ecclesiastical Dress.* New York: Holmes & Meier, 1984.

Mellen, Peter. *Jean Clouet: Complete Edition of the Drawings, Miniatures, and Paintings.* London: Phaidon, 1971.

Mendelsohn, Leatrice. *Paragoni: Benedetto Varchi's "Due Lezzioni" and Cinquecento Art Theory.* Ann Arbor: UMI, 1982.

Milham, Willis Isbister. *Time and Timekeepers, Including the History, Construction, Care, and Accuracy of Clocks and Watches.* New York: Macmillan, 1941.

Mirollo, James V. *Mannerism and Renaissance Poetry: Concept, Mode, Inner Design.* New Haven: Yale University Press, 1984.

Monk, Samuel H. " 'A Grace Beyond the Reach of Art.' " *Journal of the History of Ideas* 5 (1944): 131–50.

Morel-Fatio, Alfred. *Historiographie de Charles-Quint . . .* Paris: Champion, 1913.

Navenne, Ferdinand Henry de. *Rome: Le palais farnèse et les Farnèse.* Paris: Michel, 1900.

Onians, John. *Bearers of Meaning: The Classical Orders in Antiquity, the Middle Ages, and the Renaissance.* Princeton: Princeton University Press, 1988.

Ortolani, Sergio. "Le origini della critica d'arte a Venezia." *L'Arte* 25 (1923): 3–17.

Panofsky, E. "Artist, Scientist, Genius: Notes on the 'Renaissance-Dämmerung.' " In *The Renaissance: Six Essays*, 123–82. New York: Harper & Row, 1962.

————. *Early Netherlandish Painting: Its Origins and Character.* 2 vols. Cambridge: Harvard University Press, 1953.

————. *Idea: A Concept in Art Theory.* New York: Harper & Row, 1968.

————. "Jean Hey's 'Ecce Homo.' Speculations About Its Author, Its Donor, and Its Iconography." *Bulletin of the Musées Royaux des Beaux-Arts de Brussels* 5 (1967): 94–138.

————. *The Life and Art of Albrecht Dürer.* Princeton: Princeton University Press, 1971.

————. *Studies in Iconology: Humanistic Themes in the Art of the Renaissance.* New York: Harper & Row, 1972.

Paques, Viviana. *Les sciences occultes d'après les documents littéraires italiens du XVIe siècle.* Paris: Institut d'ethnologie, 1971.

Pastor, Ludwig. *The History of the Popes, from the Close of the Middle Ages.* 40 vols. London: K. Paul, Trench, Trubner & Co., 1936–61.

Prodi, Paolo. *Ricerca sulla teorica delle arti figurative nella Riforma Cattolica.* Bologna: Nuova Alfa, 1984.

Raffaello a Firenze: Dipinti e disegni delle collezioni fiorentine. Catalogo. Milan: Electa, 1984.

Ranke, Leopold von. *The History of the Popes: Their Church and States.* Trans. E. Fowler. 3 vols. New York: Colonial, 1901.

Rave, Paul Ortwin. "Paolo Giovio und die Bildnisvitenbücher des Humanismus." *Jahrbuch der Berliner Museen* 1 (1959): 119–60.

Ringbom, Sixten. *Icon to Narrative: The Rise of the Dramatic Close-Up in Fifteenth-Century*

Devotional Painting. Doornspijk: Davaco, 1984.

Rogers, Mary. "The Decorum of Women's Beauty: Trissino, Firenzuola, Luigini, and the Representation of Women in Sixteenth-Century Painting." *Renaissance Studies* 2 (1988): 47–88.

Rosand, David. "The Crisis of the Venetian Renaissance Tradition." *L'Arte* 3 (December 1970): 5–53.

Scheele, Walter. *Zwischen Kauf und Verkauf Lauert die Sünde*. Stuttgart-Degerloch: Sewald, 1979.

Schlosser Magnino, Julius. *La letteratura artistica: Manuale delle fonti della storia dell'arte moderna*. Ed. Otto Kurz. Florence: La Nuova Italia, 1979.

Shearman, John. "Raphael at the Court of Urbino." *Burlington Magazine* 112 (1980): 72–88.

Smith Blake, Anne. " 'Anchora Inparo.' " *Art Quarterly* 30 (1967): 118–25.

Stanford London, H. "The Greyhound as a Royal Beast." *Archaeologia or Miscellaneous Tracts Relating to Antiquity* 97 (1959): 139–65.

Steinberg, Leo. "Pontormo's *Alessandro de' Medici*, or 'I Only Have Eyes for You.' " *Art in America* 63 (1975): 62–65.

Strong, Roy C. *Art and Power: Renaissance Festivals, 1450–1650*. Woodbridge, Suffolk: Boydell, 1984.

Summers, David. *Michelangelo and the Language of Art*. Princeton: Princeton University Press, 1981.

Ugolini, Filippo. *Storia dei conti e duchi d'Urbino*. 2 vols. Florence, 1859.

Vickers, Brian. *In Defense of Rhetoric*. Oxford: Clarendon Press, 1988.

Warnke, Martin. *Hofskünstler: Zur Vorgeschichte des modernen Künstlers*. Cologne: DuMont, 1985.

Weinberg, Bernard. *A History of Literary Criticism in the Italian Renaissance*. 2 vols. Chicago: University of Chicago Press, 1961.

Wind, Edgar. *Pagan Mysteries in the Renaissance*. New York: W. W. Norton, 1968.

Wittkower, Rudolf, and Margot Wittkower. *Born Under Saturn. The Character and Conduct of Artists: A Documentary History from Antiquity to the French Revolution*. New York: W. W. Norton, 1969.

Yates, Frances A. *Astraea: The Imperial Theme in the Sixteenth Century*. London: Routledge, 1975.

Zilsel, Edgar. *Die Entstehung des Geniebegriffes: Ein Beitrag zur Ideengeschichte der Antike und des Frühkapitalismus*. Tübingen: Siebec, 1926.

Zimmermann, T. C. Price. "Paolo Giovio and the Evolution of Renaissance Art Criticism." In *Cultural Aspects of the Italian Renaissance: Essays in Honour of Paul Oskar Kristeller*, 406–24. Manchester: Manchester University Press, 1976.

Index

Numbers in bold type indicate pages on which illustrations appear. Titles of books are abbreviated, for they are fully listed in the bibliography. Locations, museums, historical events, and modern authorities are not indexed. Greek names are spelled in the Latinate forms.

Acts of Paul and Thecla. See Paul, Saint

Adda, Agosto de. *See* Titian: portraits

Adrian VI, Flemish pope, 11

age: allegory of three ages, 105; Comanini on old age, 157

Agnello, Girolamo, 149

Alberti, Leon Battista: *De pictura,* 2; *Della pittura,* 2, 103, 148, 150; *istoria,* 2, 33, 45; *Ten Books on Architecture,* 41; *see also* portraits; decorum

Alberti, Romano. *See* physiognomy

Alciati, Andrea, *Emblemata,* 25, 88

Aldus, Manutius: (Aldine) publications, 19

Alessandro VI, pope, 92

Alexander the Great, 19, 83–84, 90, 92, 118, 135; as choleric type, 83; *see also* Apelles; Charles V; Lysippus; *paragone;* Pliny; Plutarch

Alfonso d'Avalos. *See* Avalos

Alidosi, Francesco, cardinal, 85

all'antica, 51

allegro, 117, 141

Alva, Duke of (Fernando Alvarez di Toledo), 26, 149

Anacreon, 19

annulus. See jewelry: rings: liturgical

Apelles, 28, 90; his grapes, 101; portrait of Alexander the Great, 19, 82, 86, 147; portrait of Antigonus, 132, 147; *see also paragone;* Pliny; Titian

Apuleius. See *Physiognomoniae*

Aretino, Pietro:
 as advertiser, 13–17, 70, 115–16, 163 n. 39
 aspiration for cardinalate, 16, 141

biography, 10–11; of low birth, 4, 41; as cobbler's son, 10, 66

as divine, 149

as *il flagello dei principi* (the scourge of princes), 13, 36, 43, 62, 66–67

his house, 11, 52–53

his independence, 11, 45

LETTERS: II, 15, 37; V, 14, 78; XI, 132, 184 n. 10, 187 n. 85; XVI, 89; XVII, 24, 69, 77; XXIV, 112; XXV, 10; XXXII, 164 n. 50; XXXVIII, 20; XLIII, 52; XLIV, 14; XLVII, 15, 18, 26, 28, 33, 98, 115; XLVIII, 14–15; LXVI, 14, 31; LXVII, 16, 115, 117; LXX, 21; XCVI, 26; C, 45; CIX, 21, 25, 67; CXLV, 27, 156; CLI, 16, 18; CLIII, 18; CLIV, 169 n. 6; CLXII, 31; CLXXI, 97; CLXXII, 80; CLXXIII, 28; CLXXV, 21; CLXXVI, 36; CLXXIX, 14; CLXXXI, 99, 100; CLXXXIII, 18; CLXXXVII, 23; CXCVI, 67; CCII, 27; CCVII, 21; CCXVIII, 66; CCXXXIV, 35; CCXXXVII, 41; CCXLIII, 67, 99; CCXLIV, 162 n. 5; CCXLVII, 171 n. 64; CCLXIII, 14; CCLXIV, 188 n. 89; CCLXV, 67; CCLXXIX, 17; CCLXXXII, 21; CCIC, 36; CCCII, 14; CCCIII, 14; CCCXXXV, 118, 128; CCCLV, 14; CCCLXIV, 174 n. 119; CCCLXVIII, 150; CCCLXXIX, 118; CCCLXXX, 14; CCCLXXXIII, 14, 48; CCCLXXXV, 131; XCDV, 131; CDXII, 132; CDXVII, 17; CDXXI, 14; CDXXVIII, 141; CDLXIV, 20; CDXLVII, 14; CDLXXX, 19; CDLXXXI, 25, 133; XDII, 118; XDVIII, 19, 27; DIII, 26; DIX, 20; DIL, 14; DL, 14; DLIV, 25; DLXV, 100, 145; DLXXVIII, 14; DCI, 16; DCXXXI, 25, 67; DCXXXII, 25; DCXLIV, 149; DCLX, 20, 21; DCLXIII, 190 n. 13; DCLXX, 21; DCLXXI, 11; DCLXXVII, 14

letters, editions of, 13
and Michelangelo, 20, 29, 66–67, 173 n. 112, 174 n. 119
as painter, 10
as Pilate, 36, 48–62, 64–66; *see also* Pilate
his portraits, 35; medal, 64–65; *see* Caraglio; Leoni; Moretto; Salviati; Sebastiano; Titian
and satyr, 64–65
as satirist, 65
as soldier, 44–45
WRITINGS: *Carte Parlanti*, 14; *Cortigiana*, 11, 14, 37, 52; *Filosofo*, 11; *Ipocrito*, 11, 29; *Marescalco*, 11, 45; *Marfisa*, 45; *Opera nova . . . Aretino . . .* , 10; *pasquinatte*, 11; *Ragionamenti*, 11, 14, 31; *Dell'Umanità di Cristo*, 37, 54; *Vita di Maria Vergine*, 11; *Vita di Santa Caterina*, 11
Ariosto, Ludovico, *Orlando furioso*: on Aretino, 29, 36, 62; on Titian, 148
Aristotle, 28, 85; *Metaphysics*, 104; *Oeconomica*, 90; *Poetics*, 24, 40; *Politica*, 89; *Rhetoric*: on decorum, 40; on ages of men, 105
Armenini, Giovan Battista: *De' veri precetti . . .* , 2, 16, 105
armor, 45, 99, 118–19, 129, 132, 137, 142, 155; Rovere, Francesco Maria della, 33, 71–74, 78, 80–81, 83; *see also* Savoldo; Sebastiano: portraits; Titian: portraits
artists: as children, 150; divine nature of, 148; as godlike, 155, 157; and patrons, xi, 1, 3, 15–16, 36; and rulers, 147, 158
Asclepiades, 19
Atri, Duke of (Giovanni Francesco Acquaviva). *See* Titian: portraits
Attila as satyr, 65
Avalos, Alfonso, Marchese del Vasto, 15, 45, 53; patronage of Aretino, 45; *see also* Titian: paintings: *Allocution*; Titian: portraits
Ávila y Zúñiga, Louis de, 118, 128, 131–33, 141

Ballini, Gasparo, 148–49
Bandinelli, Baccio, 13
Barbaro, Daniele. *See* Titian: portraits
Barozza, Elena. *See* Vasari: portraits
beard of: Aretino, 39, 45, 54, 64, 169 n. 18; Charles V, 117, 184 n. 13; Farnese, Alessandro (Pope Paul III), 92, 95; Saint Paul, 95; Rovere, Francesco Maria della, 81, 84–85; Rovere, Giuliano della (Pope Julius II), 95; Titian, 152, 154, 156
beauty: feminine, 17–18, 22, 87; in paintings, 33, 103; in portraits, 77, 103
Beccadelli, Lodovico. *See* Titian: portraits
Bellini, 5, 147
Bellini, Gentile, 109, 147
Bellini, Giovanni, 1, 32; *see also* Bembo
Bellincioni, Bernardino, on Leonardo's portrait of Cecilia Gallerani, 1
bellum justum, 117
Bembo, Pietro, 21, 23; as divine, 149; on Bellini's portrait of his mistress, 1; his letters, 13, 151; on Raphael's portrait of Tebaldeo, 1, 17, 25; *see also* Gonzaga, Eleonora; *paragone*; Titian: portraits

beret, 124, 137, 140–42; cap, 37, 74, 151–53, 156; hat, 52, 92, 101, 110, 113, 141, 154
Biondo, Michelangelo, 2; *Della nobilissima pittura*, 32
Boccaccio, Giovanni: *Decameron*, 25
Bocchi, Achille: *Annali di Bologna*, 112; *Symbolicarum . . .* , 112; *see also* Bonasone
Bocchi, Francesco, *Eccelenza . . .* , 101
Bollani, Domenico, 11, 52, 67
Bonasone, Giulio, engravings for Bocchi's *Symbolicarum: Quod Sat Est*, **112**
Bonifacio, Giorgio, *L'arte delle cenni*, 42
Borghini, Raffaelle, *Riposo*, 18, 156
Bosch, Hieronymus, *Pilate Presents Jesus Christ Before the People*, **51**, 52, 56
Botticelli, 2, 147
Bouts, Dirck, 75
Britto, Giovanni, 74, 145, 147; *see also* Titian: Self-Portrait
Bronzino, Agnolo, 147; *Andrea Doria as Neptune*, 15, **44**; *Cosimo de' Medici*, 15; *Guidobaldo II della Rovere*, 123; the Panciatichi couple, 70; *Stefano Colonna*, **137**
Brucioli, Antonio, *Dialoghi . . .* , 29–30
Bucer, Martin, 116
Bullinger, Heinrich, 116
Bulwer, John, *Chirologia*, 42
Burgkmair, Hans: *Maximilian I Visiting Hans Burgkmair in His Studio*, 120; *The Emperor Maximilian I on Horseback*, 129–30

Caesar, Julius, 35, 45. *See also* Charles V
Callistus III, pope, 92
camauro. See clothes: liturgical
camerino d'alabastro, 12, 14
Camillo, Giulio (Delminio), 2, 30; "De l'humana deificatione," 29; *see also* Titian
cap. *See* beret
Cappello, Vincenzo. *See* Titian: portraits
Caraglio, Giovanni Jacopo, *Pietro Aretino*, 35, 39, **40**, 151, 153
Cardano, Girolamo, *Metoposcopia*, 28
Carpaccio, Vittore, 109; *Portrait of a Knight*, **73**, 123; *see also* Ramo
Carracci, Agostino, *Titian*, 151, **152**
Castiglione, Baldassare, *Libro del Cortigiano*, 66, 71, 74, 81, 83, 87, 155; *see also* Gonzaga, Eleonora
Castriota, Antonio, 131
Cattaneo, Danese, 13, 35
Catullus. *See* Dolce: translations
Cavalcanti, Guido, 44
Cesano, Gabriele, 11
chain. *See* jewelry
chair, 75, 90, 92, 96, 108, 111, 136, 138
character, 20, 22, 23, 27–28, 40, 82, 97, 152: Aretino, 48, 52, 65–66; Charles V, 117; Farnese, Alessandro (Pope Paul III), 101; Farnese, Ottavio, 110; Gonzaga, Eleonora, 87–88; Rovere, Francesco Maria della, 27, 70, 81–85, 90; Titian, 158
Charlemagne, 116

Charles V, emperor, 21, 53, 67, 71, 73–75, 92, 95, 100, 105, 115, 147
 and Alexander the Great, 131–33
 biography, 116–17
 compared with: Caesar, 128; Christian emperors, 116, 127–28, 130, 142–43; Constantine, 127–28; Roman emperors, 11, 125, 129, 131, 135
 Dolce on, 149
 as king: dual nature, 124, 128, 142–43, 185 n. 47, 189 n. 128; virtues, 119, 128, 133, 135
 as Knight of the Order of the Golden Fleece, 116, 138, 142
 Parmigianino's portrait of, 73–74, **75**
 as patron of Titian, 117–18, 153; patent of nobility, 12, 118
 as Saint George, 128, 186 n. 65
 Seisenegger's portrait of, 120, **122**
 and Titian, 141–42
 his Triumphs: Aretino on, 132
 See also Titian: portraits; Ulloa
Chigi, Agostino, 10
Christus, Petrus, 75
Cicero: letters, 13; *Orator*, 40; *Verrine Orations*, 21
classical statues: *Jove*, 133, **136**; *Marcus Aurelius*, 125, **127**; *Della Valle Satyrs*, **64**, 65; *Venus*, 151
Claudius. *See* Titian: paintings
Clement VII, pope. *See* Medici, Giulio de'
clementia, 58–59
clemenza, 133
clock, 75, 178 n. 87; symbol of *memento mori*, 88, 111
cloth-of-honor, 96, 136, 138, 142, 143
clothes (dress), 39–41, 52–53, 120, 135
 of Aretino, 39, 62, 66; Aretino as Pilate, 52, 54, 56
 of Charles V, 124, 138, 142
 of Doria (as Neptune), 41
 of Farnese, Alessandro (Pope Paul III), 92
 of Gonzaga, Eleonora, 74, 90
 of Titian, 151, 153
 glove, 39, 42–43, 62, 138
 liturgical: *camauro*, 75, 92, 95, 96, 108; *mozzetta*, 92; *rochette*, 92
 ritual: *mappa*, 96, 138, 140
 toga, 41–42, 135
Clovio, Giulio, 13
Clouet, François, *Equestrian Portrait of Francis I*, 125, **128**
Clouet, Jean, *Portrait of Francis I*, 140
Coccio, Francesco, 150
coins. *See decursio*
Colonna, Stefano. *See* Bronzino: portraits
color:
 difficulty in defining, 77
 mention and symbolism: black, 37, 64, 66, 74, 88, 125, 138, 140, 142, 143; crimson, 71, 77, 143; green, 75, 88, 124, 138; honey as symbolical of choleric, 83, 86; purple, 66, 92, 136, 138, 143; red, 45, 87, 92, 125, 136, 176 n. 34; vermilion, 33, 78, 175 n. 32; white, 71, 92
 as rhetorical term, 25, 81–83, 177 n. 51
 See also Dolce; Morato; Pace; Titian

column, 136–37, 142, 188 n. 104; symbol of, 136; *see also* curtain
Comanini, Gregorio, *Figino; see also* ages; images; portraits
concetto:
 defined, 26
 as *idea*, 26
 invisible, 26, 29, 84
 of Aretino, 36, 66–67
 of Charles V, 116, 118, 143
 of Gonzaga, Eleonora, 89–90
 of Rovere, Francesco Maria della, 87, 90, 115
 of Titian, 145, 149, 151, 157
 in sonnets: by Petrarch, 18; by Michelangelo, 26
 See also portraits
concordia, 88
Condivi, Ascanio, 4
condottiere, 70–71, 74, 84, 87
Constantine: compared with Charles V, 127–28; Paleotti on the imaginary statue of, 102
Constantine, Arch of, 133
contrapposto. *See* postures
Coriolano, Cristofano. *See* Vasari: Titian's effigy; *see also* Titian: portraits
Cornaro, Benedetto, 20
Corvino, Alessandro. *See* Titian: portraits
Correggio, Antonio, "Ecce Homo," 48
curtain, 108, 110, 123, 145; as column, 124; by Zeuxis, 101

Dandolo, Marco, 11
Daniello, Bernardino, *Della Poetica*, 24–25, 40
Dante Alighieri, 44, 78; *Convivio*, 130; *Divine Comedy*, 26; *Monarchy*, 116
decorum, 54, 64; Alberti on, 40; Leonardo on, 40; Lomazzo on, 41; *see also* Aristotle; Dolce
decursio, coins: Trajan, 129; Marcus Aurelius, 129; Nero, 129, **130**
De Hanna, Johannes, Flemish merchant, 48, 52, 53; *see also* Leoni: medals
De Hanna, Martinus, 48
Della Casa, Giovanni, 141; as divine, 149; *Galateo*, 18; *see also* Titian: portraits (on)
Delminio. *See* Camillo, Giulio
demonstratio. See epideitic oratory: panegyric
devotio moderna, 51
disguise, 48, 53, 65, 73, 128; *see also* Aretino as: Pilate, soldier; Attila as satyr; Charles V as Saint George; Farnese, Alessandro (Pope Paul III) as; Giorgione as; Savoldo: portraits
divinità, 31, 150
divino, Aretino's pun on, 149
dogs, 59, 75, 123; symbol of, 88, 120
Dolce, Lodovico, 2, 11, 29, 30, 89, 148; as divine, 149; *Dialogo . . . de i colori*, 43, 77–78, 136, 141; *Dialogo della pittura . . .*, 6, 12, 28, 32, 40, 51, 81, 103, 158; *Vita . . . Carlo Quinto*, 149
Domitian. *See* Martial
Donatello. *See paragone*; Vasari: *Vite*
Doni, Antonfrancesco, 11; *Disegno*, 81; letters, 13

Doria, Andrea. *See* Bronzino: portraits
dramas, liturgical, 52–54; *Nabuccodonosor*, 84–85; *Passione*, 52
dramatis personae, 48
Duccio, *Maesta*, 51
Dürer, Albrecht: *The Four Apostles*, 41; *Saints Mark and Paul* (detail), **42;** *The Knight, Death, and the Devil*, **129,** known as *Miles Christianus*, 128; *Large Passion*, 51: *Pilate Presents Jesus Christ Before the People*, **56,** 60; *Melencolia*, 41; *Passion of 1513*, 51; *Small Passion*, 51: *Pilate Presents Jesus Christ Before the People*, 56, **57,** 60; *see also* portraits; Vasari: *Vite*

eagle, two-headed, 60
"Ecce Homo" types, 48–51; *see also* Correggio; Mantegna; Massys; Solario; Titian: paintings
ekphrasis. *See* epideitic oratory
encomium. *See* epideitic oratory
energeia, 131
epideitic oratory: *demonstratio*, 21–22; *ekphrasis*, 14, 22, 30, 78, 132; encomium (panegyric), xii, 2–3, 21–23, 69, 100, 131, 133, 147, 149; hyperbole, xii, 18, 20–22, 31, 100
Equicola, Mario, *Libro di natura d'amore*, 87–88. *See also* Gonzaga, Eleonora
Erasmus, Desiderius, 117, 137, 138; *Enchridion Militis Christiani*, 129; influence on Aretino, 13; influence on Dürer, 129; influence on Titian, 185 n. 28; *Institutio principis Christiani*, 116, 119, 127, 135; *Opus de conscribendis epistolis*, 13; *see also* portraits; postures: seated; color: purple
Este:
 Alfonso, 12, 14; Titian's portrait of, 32
 Isabella, 4, 23, 71, 87; Titian's portrait of, 117
Eusebius, *Ecclesiastical History*, 102
eye: spirituality, 39, 41, 43, 54, 64, 66, 145, 156; symbolism, 41, 170 nn. 36 and 45; *see also* physiognomy: importance of

Fabrini, Giovan Francesco, 81
face, 28, 42, 45, 60, 74, 103; *allegro*, 117, 141; of Aretino, 39; of Charles V, 117, 142, 184 n. 13; of Farnese, Alessandro (Pope Paul III), 92; of Gonzaga, Eleonora, 28, 87; of Rovere, Francesco Maria della, 28, 81, 82; of Titian, 151, 154
"Famous Men" series, 15, 137
Farnese family, 12, 105, 110, 118, 153
 Alessandro, cardinal, 92, 105, 110, 141
 Alessandro (Pope Paul III), 32, 91–92, 100–101, 115, 147; as Saint Paul, 95–96; confers Roman citizenship on Titian, 153; *see also* beard; clothes; Porta, Guglielmo della; Raphael: portraits; Sebastiano: portraits; Titian: portraits; Venusti
 Ottavio, 92, 105, 113; *see also* character
 Pierluigi, 92, 110
Ferdinand I, Archduke, 120, 147; *see also* Titian: portraits
Ferdinand II, King of Aragon, 116
Ferrario, Giovan Bernardino, 20
Ficino, Marsilio, 13; "On divine frenzy," 148; portrait of, 156; *Theologia Platonica*, 156

Firenzuola, Agnolo, 22, 87
flagello dei principi. *See* Aretino
folly, 59, 62, 66
Francis I, King of France, 4, 36, 39, 43, 62, 92; *see also* Clouet; jewelry: chain; Titian: portraits
Franco, Niccolò, 11; *Rime . . . contro Pietro Aretino*, 39
Frederick II, emperor, 116
Frederick III, emperor, 147

Gabrielli, Niccolò, 11
Gaddi, Taddeo. *See* portraits: media: frescoes
Gambara, Veronica, 15, 69, 77, 90
Gattinara, Mercurio, 116, 131
Gaurico, Pomponio: *De Sculptura*, 28, 141; known in Venice, 141; *see also* physiognomy; *pileus*
George, Saint, 73; *see also* Charles V as; Savoldo: portraits
gestures, 10, 23, 27, 40–42, 44, 52, 56, 58–59, 61, 83, 110
Ghirlandaio, Domenico, 109; *see also* portraits: media: frescoes
Giallo, Jacopo del, 10
Giorgione, 5, 32, 73, 75, 108; as David, 73
Giotto, 44
Giovio, Paolo, 66–67; *Dialogo dell'imprese . . .* , 25, 85; as divine, 149; *Elogia virorum . . .* , 15, 178 n. 76; "Fragmentum . . . ," 29–30; his *Museo*, 15, 30; *Historiae . . .* , 117; letters, 13; and Vasari's *Vite . . .* , 30; *see also* Bronzino: portraits (on); Sebastino as portraitist; Titian; Titian: portraits (on)
Giunti, Luca-Antonio. *See* Xenophon
glove. *See* clothes
Gonzaga family, 11, 12, 153
 Eleonora, Duchess of Urbino, 71, 87; *see also* character; face; clothes; *concetto*; Titian: portraits
 Elisabetta, 71
 Ercole, 110
 Federico, Duke of Mantua, 16, 73, 117; patronage of Aretino, 37; Titian's *Roman Emperors* for, 120; *see also* Titian: portraits
 Ferrante, 110
 Francesco, 71
Gospels, 36, 48, 53
Granvelle, Nicholas Perrenot de, 131
grazia (grace), 18, 23, 25, 133; *see also* Dolce
Greek epigrams, 19
Groto, Luigi (Cieco d'Adria), his letter to Tintoretto, 32–33
Gualteruzzi, Carlo, 99–100
Guicciardini, Francesco, 70
Guidiccione, Giovanni. *See* Rovere, Francesco Maria della

Habsburg, 12, 60, 116, 130, 153; *see also* Charles V; Ferdinand I; Maximilian I; Philip the Handsome; Philip II
hasta, 129
hat. *See* beret
Hegel, G. W. F., 189 n. 9
helmet, 71, 77, 118, 128, 142
Hercules, 74, 117
Henry VIII, King of England, 120

Hollanda, Francisco de, 118; on Michelangelo as divine artist, popularized by Aretino, 149
homines divinantes, 28–29
Honor. *See* personification
Horace: *Art of Poetry*, 24; *Carminum Liber*, 136; "poeta nascitur non fit," 150, 190 n. 37; "ut pictura poesis," 2–3; *see also* Dolce
Horapollo, *Hieroglyphica*, 120
horse, 125, 132, 143
hyperbole. *See* epideitic oratory

idea, 4, 133; see also *concetto*
idealization (ennoblement), 84, 108, 119, 124, 143, 152–55; without, 43, 66, 87
images: devotional, 14, 45, 48, 52, 59; royal and sacred, Comanini and Paleotti on, 102
imitation, 80, 103–4, 149, 164 n. 50
impresa, 74; of Charles V, 74, 117; of Rovere, Francesco Maria della, 85, **86;** of Titian, 89; *see also* Giovio
Isabella of Castile, 116
Isabella of Portugal, empress, 4, 16, 22–23, 115–17; *see also* jewelry: chain; Titian: portraits
istoria, xii, 45; *see also* Alberti

jewelry:
 chain as gift to Aretino by: Francis I, 39, 43, 62; Ippolito de' Medici, 39; Isabella of Portugal, 22, 39
 chain as gift to Titian by Charles V, 151, 153
 chain, as symbol of, 39; Ridolfi on, 169 n. 27
 earring, 90
 ring, 74, 96, 152; liturgical: *annulus*, 96
 zibellino, 74, 88, 90
Joanna of Aragon. *See* Raphael: portraits
Joanna of Castile, 116
John Frederick, 127
Judas, 48, 54
Julius II, pope. *See* Rovere, Giuliano della; *see also* Raphael: portraits
Justus of Ghent, *Portrait of Pope Sixtus IV*, 136
Juvenal. *See* Dolce: translations

Lando, Pietro, Doge of Venice, 53
landscape, 14, 70, 73, 74, 75, 88, 90; cloudy, 95, 137, 143; forest, 125; see also *selva*; sunrise, 126, 128, 143; by Sustris, 136
Leonardo da Vinci, 32; *Cecilia Gallerani*, 1; *Last Supper*, Vasari on, 48; as left-handed, 152; *Mona Lisa*, 137; *Self-Portrait*, 157, **158;** *see also* decorum; physiognomy
Leoni, Leone, 13, 41; as divine, 149; medal of Aretino, 35; medal of Johannes De Hanna, 48
Leto, Pomponio, 92
letters, 13; *see also* Aretino; Erasmus; Groto; Priscianese; Titian
libertà, 141
Liberalitas Augusti, 142; scene, 133, **135,** 140
likeness, 2, 26, 33, 67, 84, 89, 98–105, 108, 113, 116, 147, 152; Paleotti on, 104; Thomas Aquinas on, 104

lions, 84–85
literati on portraits, 1, 32; *see also* Bellincioni; Bembo; Molza; Tolomei; Ramo
Lomazzo, Giovanni Paolo, 2; *Libro dei sogni*, 27; *Trattato . . .* , 2, 40, 140. *See also* decorum; portraits
Lombardi, Alfonso, 35
Lotto, Lorenzo, 13
Lucas van Leyden, 52
Lucian, *Eikones*, 22
Lysippus, portrait of Alexander the Great, 19

Macchiavelli, Niccolò, 70
Malatesta, Sigismondo. *See* Piero della Francesca
Mancini, Giulio, *Considerazioni . . .* , 19
Mantegna, Andrea, 109; "Ecce Homo," 48
mappa. *See* clothes: ritual
Marcolini, Francesco, 29, 30; on Aretino in the *Allocution*, 45, 62; Aretino's publisher, 13, 37, 54, 69, 145, 156; Titian's *Pietro Aretino* for, 36–43
Marcus Aurelius. *See* classical statues; *decursio:* coins
Marino, Giambattista, *Galleria*, 2
Mars, 86, 87, 178 n. 76
Martial, *Epigrammata*: on Domitian's portrait, 131
Martini, Simone. *See* Petrarch
Masaccio. *See* Vasari: *Vite*
Massola, Isabetta (Elisabetta). *See* Titian: portraits
Massys, Quinten: *Ecce Homo*, 52, 56, 60, **61**
Master of Verona, 51
Maximilian I, 116, 120, 130; *see also* Burgkmair
Medici, 44, 147, 151
 Alessandro de', Duke of Florence: *see* Pontormo; Vasari: portraits
 Cosimo I de', Duke of Tuscany, 27, 36, 67; *see also* Bronzino: portraits; Titian: portraits: *Pietro Aretino* for
 Francesco I de', Duke of Tuscany, 103
 Giovanni de' (Pope Leo X), 71, 77, 92; *see also* Raphael: portraits
 Giovanni delle Bande Nere, 11; *see also* Pace
 Giulio de' (Pope Clement VII), 66, 73, 95–96, 118; *see also* Sebastiano: portraits
 Ippolito, 15, 39; *see also* jewelry: chain; Titian: portraits: *Pietro Aretino* for
 Lorenzo the Magnificent, 10
memento mori. *See* clock
Mendoza, Diego Hurtado de, 18–19; Aretino's sonnet on his mistress's portrait, 19; *see* Titian: portraits
meraviglia, 66–67
Michelangelo, 4, 26, 67, 99; as divine, 21, 148–49; *Il Pensieroso*, 140; sonnets: Varchi on, 21, 26; *see also* portraits; Titian: portraits: Alfonso d'Este
Miles Christianus. *See* Dürer
mirror. *See paragone*
Molino, Niccolò, 25, 67
Montefeltro, 74, 88
Montefeltro, Federico da, 137; *see also* Piero della Francesca
Montefeltro, Guidobaldo da, 71
Montesse, Ferrante, 80
Morato, Fulvio Pellegrino, *Del significato de' colori*, 87–88

Moretto, Alessandro, 13; as divine, 149; portrait of Pietro
 Aretino, 35–36; *Portrait of a Man,* 123, 137
Morosini, Marcantonio, 67
motion, 5, 108, 125; Schelling on the absence of, 182 n.
 73
motto, 37, 111–12; of Aretino, 36, 65; of Charles V, 74,
 117; of Rovere, Francesco Maria della, 71, 85, 86; of
 Titian, 89
mozzetta. See clothes: liturgical
Museo. See Giovio

Nabuccodonosor. See dramas
Navagero, Bernardo, 141
Neptune, 41; *see also* Bronzino
Nero. See *decursio,* coins

obelisk, 75; symbol of, 88
Onale, Giovanni, 118
Order of the Golden Fleece, 128, 138, 142; *see also* Charles
 V as Knight of

Pace, Giovan Paolo, Aretino on, 13; *Portrait of Giovanni
 delle Bande Nere,* 17
Paleotti, Gabriele, *Discorso,* 2; on an imaginary statue of
 Constantine, 102; *see also* images; likeness; portraits
Palma Vecchio, Jacopo, 108
Panciatichi, Bartolommeo and Lucrezia. *See* Bronzino:
 portraits
Panvinio, Onofrio, *Historia . . . ,* 92, 96
paragone between:
 art and Nature, 21, 78, 88–89, 147, 151
 Alexander and Charles V, 131–32
 Apelles and Titian, 82–83, 90, 131, 147
 Aretino and Titian, 2, 4, 31, 33; Aretino's pen and
 Titian's brush, 24–26, 32–33
 Donatello's *cantoria* and Bembo's verses, 149
 painting and sculpture: Aretino on, 80
 portraits and mirrors, 29, 99; portraits and sonnets, 24–
 25, 133
 sitter and representation, 22, 89, 99
Parrhasius. *See* Pliny
Parmigianino (Francesco Mazzuola), 32; *Allegorical Portrait
 of Charles V,* 73–74, **75**
Partenio: Aretino's anagram, Ridolfi on, 53, 169 n. 16
pasquinatte. See Aretino: writings
Passione. See dramas
Paul, Saint, 48, 62, 67, 96; his image, 102, 180 n. 18; *Acts
 of Paul and Thecla* on, 95; *see also* beard; Dürer;
 Farnese, Alessandro (Pope Paul III) as; Vasari, *Vite:*
 Masaccio's
Paul III, Pope. *See* Farnese, Alessandro
Perez, Gonzalo, 89
Perino del Vaga. *See* Vasari
Perugino, Pietro. *See pittore divino*
Peruzzi, Baldassare, 10
personification, 132; Honor, 39
Pesaros, 153; *see also* Titian: paintings
Petrarch, Francesco, 19, 26, 78; letters, 13; *Rime:* sonnets,
 nos. LXXVII and LXXVIII, on Martini as Polyclitus, 18;

and on Martini's portraits of Laura, 18; sonnet no.
 CCXXIII, on forehead, 28; Velluttello, commentary on,
 18; *see also concetto*
Philip the Handsome, King of Burgundy, 116
Philip II, King of Spain, 19, 100, 147; *see also* Titian:
 portraits
Physiognomoniae . . . , attributed to Apuleius, 96
physiognomy, 28, 64–66, 70, 82–84, 143; Alberti, Ro-
 mano, on, 167 n. 112; Aretino on, 28–29; eyes, 23,
 43, 82–83, 96–97, 133, 156; Gaurico on, 28, 83–84;
 forehead, 22, 23, 28, 82–83, 87, 96, 152–53, 156;
 Leonardo on, 28; leonine, 84, 86–87; nose, 64, 82–
 83, 95, 117, 156; Pino on, 28
Piero di Cosimo, 2
Piero della Francesca: *Federico da Montefeltro* and *Battista
 Sforza,* 70; *Sigismondo Malatesta,* 120
Pilate, Pontius, 36, 48; Aretino on 54; *see also* Aretino as;
 Bosch; Dürer; Massys; Titian: paintings
pileus, 188 n. 115; Gaurico on, 141
Pino, Paolo, 148; *Dialogo:* on Titian, 159; *see also* physiog-
 nomy
pittore divino, Perugino as, 148; *see also* Titian as divine
 painter
Plato, 100; *Phaedrus,* 19
Pliny, the Elder: on Apelles, 28, 81, 83–84, 132; on
 Parrhasius, 20
Pliny the Younger, letters, 13
Plutarch, 24; *Discourse,* 127; *Isis and Osiris,* 138; *Life of
 Alexander,* Apelles' portrait of, 83–84; *Life of Pompey:*
 Pompey's seal, 85
Polyclitus. *See* Petrarch
Pompey. *See* Plutarch
Pontormo, Jacopo, 41, 78, 103; *Portrait of Alessandro de'
 Medici,* **155**
Porta, Giovanmaria della, 89
Porta, Guglielmo della: bust portrait of Pope Paul III, 92
portraits:
 approaches: Alberti on, 44–45; Aretino, xii, 10, 33,
 66, 70, 77, 82, 88, 98, 99, 115–16, 176 n. 41; Dürer
 on, 89; Erasmus, 119; Giovio, 15, 182 n. 59;
 Lomazzo on, 26–27; Michelangelo, 14; Paleotti on,
 102; Titian, 4–5, 16, 108, 115, 124, 143; Vasari,
 103–4
 as art form, xi–xii, 3–6, 16–17, 24, 33, 78, 82, 90
 concetto of: 26–29, 33; Lomazzo on, 27
 definition, 1, 103, 167 n. 120; by Comanini, 104; by
 Lomazzo, 104
 frescoes: Gaddi, Vasari on, 44; Ghirlandaio, 44, 109
 medals, 4, 35, 36, 37, 64–65; *see* Aretino; Leoni;
 Rovere
 prints, 36, 39, 145, 151; Vasari on, 153; *see also*
 Burgkmair; Caraglio; Carracci; Titian: *Self-portrait*
 sculptures, 92; *see also* Paleotti; Porta, Guglielmo della
 state, 2, 35–36, 96, 108–9; "action," 108; as drama,
 110, 113; "corner-space," 75; equestrian, 4, 125, 131,
 133; imperial, 4, 74, 115, 118, 158; papal, 4, 91, 96–
 97, 99–102, 105, 108, 113, 115
 theory, 2, 4, 6, 9, 103
 types: allegorical, 73, 105, 132; female, 22; full-length,

4, 70, 123, 124; group, 4, 105, 109; imaginary, 21–25; marriage, 70, 89; private, 133; "sacred," 99, 133; self-portraits, 145, 156–57; *see also* Leonardo; Raphael; Titian; Vasari
postures (poses), 10, 18, 27, 41, 42, 56, 60–61, 64, 70, 73, 96, 108, 111, 125; contrapposto, 64; profile, 39, 53, 95, 105, 110, 112; seated, 74, 89, 91, 100, 112, 135–36, 138, 142; three-quarters, 39, 45, 54, 62, 74, 90, 92, 120
Priscianese, Francesco, 27; letter about the feast in Titian's house, 29, 158
profectio, 129; *Profectio Augusti,* 142
Puligo, Domenico. *See* Vasari
pun. *See divino*

Quintilian, *Institutio Oratoria,* 21, 42, 56, 81
Quirini, Elisabetta. *See* Titian: portraits

Raimondi, Marcantonio, 35
Ramo, Girolama Corsi, on Carpaccio's portrait, 1
Raphael, 10, 32, 99, 148, 156
 Agnolo Doni and *Maddalena Strozzi,* 70
 Tebaldeo on, 25
 Arenito on, 10
 Fedra Inghirami, 41, **43**
 Joanna of Aragon, 75
 Leo X and His Nephews, 108, **109;** Andrea del Sarto's copy of, 108
 Madonna di Foligno, 59, **60**
 Pope Julius II, 32, 95, 96, **98,** 140; Titian's copy of, 95, 96, **97**
 Pope Paul III, 92
 Self-Portrait with a Friend, **157**
Richard I, King of England, known as *Coeur de Lion,* 85
Riccio, Andrea, 64
Ridolfi, Carlo, *Maraviglie . . . ,* 37, 53, 110, 156; *see also* jewelry: chain, as symbol of; Partenio; Titian: portraits (on)
Ridolfi, Niccolò Pio, cardinal, 100, 102
rochette. See clothes: liturgical
Romano, Giulio, 13, 16, 52, 108, 127
Rovere family, 71, 95; symbol of, 71
 Francesco della (Pope Sixtus IV), 4, 95; *see also* Justus; Titian: portraits
 Francesco Maria della, Duke of Urbino, 12; biography, 70–71, 84–85; Guidiccione on, 86; medals, 84–85; *see also* armor; beard; character; *concetto;* face; *impresa;* motto; Titian: portraits
 Giuliano della (Pope Julius II), 32, 67, 71, 85, 92; *see also* beard; Raphael: portraits; Titian: portraits
 Guidobaldo II della, Duke of Urbino, 95; *see also* Bronzino: portraits
Rubens, Peter Paul, 124

sacra conversazione, 58, 109
sacra rappresentazione, 52, 54
Sadeler, Egidius. *See* Titian: paintings
Salviati, Jacopo, 13; portraits, 41; portrait of Pietro Aretino, 35–36

Sansovino, Francesco, *Retorica,* 21
Sansovino, Jacopo, 9, 13, 35; and Aretino, 9; as divine, 149
Santi, Giovanni, 148
Sanudo (Sanuto) Marino, *Diarii,* 120
Sarto, Andrea del. *See* Raphael: portraits
satirist. *See* Aretino as
satyr. *See* Aretino; Attila as
Savoldo, Girolamo: "*Gaston de Foix,*" 73; *Man in Armor as Saint George,* 73
Schelling, F. W. J. von. *See* motion
Schiavone, Alessandro, 13
Scot, Michael, 28
Sebastiano (del Piombo), 13, 73; as portraitist, 2, 30, 41, 99, 108; *Man in Armor,* 73; *Pope Clement VII,* 32, 96, 99; *Pope Paul III,* 92; *Pietro Aretino,* 35–36; *Reginald Pole,* 95; *see also* Molza; Tolomei
securitas, 136
Segala, Francesco, 35
Seisenegger, Jakob, *Charles V with a Hound,* 120, **122;** and Titian's portrait, 124
sella castrensis, 135
sella curulis, 135
selva oscura, 126
Serafino, Luigi, *Tragedia,* 54
Serlio, Sebastiano, 52; *Regole . . . ,* 20, 29
Seneca, letters, 13, 111–12
Signorelli, Luca, 2
silentio, 56
Simonides of Ceos, 24
Sixtus IV, pope. *See* Rovere, Francesco della; *see also* Titian: portraits
Socrates, 19
Solario, Andrea, "Ecce Homo," 48
sonnets on portraits, 3, 17–20, 24, 82–84, 133, 147–51; recited, 3, 17, 25–26, 70, 77; *see also* Mendoza; *paragone;* Petrarch; Titian: portraits; Vasari: portraits
Sperone, Speroni, 2, 11, 30, 32, 103; *Apologia dei dialoghi,* 31; *Dialogo d'amore,* 31, 150; *Dialogo sopra Virgilio,* 104; as divine, 149; *see also* Titian; Titian: portraits
Stampa, Massimiliano, 78
Statius. *See* physiognomy: importance of, forehead
stile, 155
Strozzi, Clarissa, 27; *see* Titian: portraits
stultitia, 59; *see also* folly
stylus, 20, 24, 155
superbia, 128
Süleyman the Great, 53
Sustris, Lambert, 136; *see also* landscape

Tadino, Gabriele. *See* Titian: portraits
Tasso, Bernardo, 31; as divine, 149; letters, 13
Tebaldeo, Antonio. *See* Bembo; Raphael: portraits
temperament, 65, 83, 179 n. 179; choleric, 83–84, 86–87, 117; melancholy, 117; sanguino-choleric, 66
terribile, 67, 131
terribilità, 48, 53, 67
Terzo, Francesco, 16 (envy of Titian's fame)
textures, 41, 70, 78, 80–83, 90

theios anēr, 156

Thomas Aquinas. *See* likeness

Tintoretto, Jacopo, 13; *see also* Groto

Titian:

and Apelles, 147, 150

as Apelles, 26, 118

and Aretino, xi, 3–5, 15–16, 33, 39, 44, 67, 99, 149

and Charles V, 12, 141; *see also* Charles V

his colors: Aretino on, 14, 33, 78, 80–82, 90, 99, 147; Dolce on, 78, 148; Sperone on, 150

date of his birth, 156

as divine painter (*pittore divino*), 145, 151, 157; Aretino on, 20, 26, 149; Dolce on, 149–50

his family; *see* Vecellio

his house, 153; *see also* Priscianese

his independence, 142, 153

his letters, 4; to Aretino, 141, 149; to Charles V, 156; to Philip II, 156

Official Painter of the Venetian Republic, 11

as old man, 17, 156–57

as portraitist, 4–5, 9, 12, 14, 29–33, 70, 84, 88; Aretino on, 17, 23, 147; Camillo on, 29; dangers of coining, 15; Dolce on, 32; Giovio on, 30; Sperone on, 31, 104; Vasari on, 32

in Rome, 105, 133, 153

PAINTINGS:

Allocution of Alfonso d'Avalos, 36, 45, **46,** 53, 131; Aretino on, 45; Marcolini on, 45

Annunciation: Aretino on, 14–16

Assumption of the Virgin Mary, 12

Battle of Cadore, 12, 15

Crowing with the Thorns, 13

Ecce Homo, **50,** 51

"*Ecce Homo*," Aretino on, 14, 48, 50–51

Madonna in Glory with Six Saints, 12

Martyrdom of Saint Peter Martyr, 12, 14, 30

Pentecost, 13

Pesaro Madonna, 12

Pilate Presents Jesus Christ Before the People, 36, 48, **49;** clothes in, 52–53

poesie for: Alfonso d'Este, 12; for Philip II, 13

Presentation of the Virgin in the Temple, 13, 45

Resurrection (for the Compagnia del Corpus Domini), 61

Roman Emperors (engraved by Sadeler), 73, 120; *The Emperor Claudius*, **74,** 129

Saint John the Baptist, Aretino on, 14, 78

soffitti, 13

PORTRAITS:

Agosto d'Adda, Aretino on, 25

Agostino Lando, Biondo on, 32

Alessandro Corvino, Aretino on, 27

Alfonso d'Este, Aretino on Michelangelo's remark, 14, 32

Alfonso d'Avalos, Giovio on, 15

Benedetto Varchi, 12, 137, **139**

Charles V, Aretino on, 19, 100, 147, 187 n. 74; Armenini on, 187 n. 74; Dolce on, 187 n. 74

Charles V in an Armchair, 116, 133, **134,** 137, 138, 142–43; Aretino on, 133

Charles V in Armor (engraved by Britto), 74, 116, 118, **119,** 120, 124, 145, 151; Vasari on, 118, 187 n. 74

Charles V with a Hound, 116, 120, **121,** 124, 140; *see also* Seisenegger

Clarissa Strozzi: Aretino on, 27

Daniele Barbaro, 1, 12; Giovio on, 30

Diego Hurtado de Mendoza, Aretino on, 19, 26

Duke of Alva, Aretino on, 26

Duke of Atri, Aretino on, 25

Eleonora Gonzaga della Rovere, 74, **76,** 87–88, 111, 136; Aretino on, 87–89, 98

Elisabetta Quirini, Della Casa on, 18–19

Equestrian Portrait of Charles V, 116, 125, **126,** 128; Aretino on, 130–33; colors of, 142–43; Giovio on, 131; Titian's mention of, 187 n. 74

Federigo Gonzaga, 12, 117, 120, **123,** 124; Giovio on, 15

Ferdinand I, Aretino on, 100

Francisco de Vargas, Aretino on, 19–21, 25

Francesco Maria della Rovere, 71, **72,** 84, 86, 89, 120; Aretino on, 27, 30, 77–87, 98; Biondo on, 32; drawing for, 71, 78, **79,** 155; Vasari on, 32

Francis I, 66, **140**

Gabriele Tadino, 75

Ippolito de' Medici, Giovio on, 15

Isabella d'Este, 23

Isabella of Portugal, 23, 117

Isabetta (Elisabetta) Massola, Aretino on, 18, 28

Lodovico Beccadelli, Aretino on, 19; his (Beccadelli's) sonnet on, 19

Philip II in Armor, 124, 137, **138**

Philip II, Aretino on, 19, 27, 100, 147

Pietro Aretino for Cosimo I de' Medici, 36, 62, **63,** 116; Aretino on, 66–67; colors of, 66; Marcolini on, 62; Vasari on, 62

Pietro Aretino for Federico Gonzaga, 36–37, 39; Ridolfi on, 37

Pietro Aretino for Francesco Marcolini, 36–37, **38,** 41; Marcolini on, 37; Vasari on, 62

Pietro Aretino for Ippolito de' Medici, 36

Pietro Bembo, 12

Pope Julius II, copy of Raphael's portrait; *see* Raphael: portraits

Pope Paul III, Aretino on, 98, 100–102; Bocchi on, 101; Varchi on, 31, 101; Vasari on, 31–32, 101

Pope Paul III, 75, 91, **94,** 95, 108, 112, 136

Pope Paul III and His Grandsons, 105, **106,** 110, 112, 118; Armenini on, 105; X-ray photograph of, 105, **107,** 111

Pope Paul III Without a Hat, 66, 91, **93;** Aretino on, 97

Pope Sixtus IV, 95

Self-Portrait (engraved by Britto), 145, **146,** 151, 156–58; Aretino on, 100, 147–51; compared with Vasari's (engraved by Coriolano), 153–56

Sperone Speroni, his letter on, 103

Vincenzo Cappello, Aretino on, 19, 21, 25, 67

titles of honor, 12, 66, 71, 117, 118, 128, 147, 153

toga. *See* clothes

Tolomei, Claudio, 10; as divine, 149; letters, 13; letter on Sebastiano's projected portrait of himself, 1

topos, 149; "vox sola deest," 19, 89; "vultus viventes," 89; see also Horace
Trajan, 58; Column of: *Trajan's Demonstration of Clementia Toward the Dacians,* **59;** see also *decursio:* coins
Trissino, Giovan Giorgio: *Poetica,* 81, 177 n. 51; *Ritratti,* 22–23
trompe l'oeil, 101
Tudor, 123. *See* Henry VIII

Ulloa, Alfonso de, *Vita . . . Carlo V,* 117, 125, 128, 132, 140
umiltà, 128
Universitas Christiana, 116
uomini famosi. See "Famous Men"
ut pictura poesis. See Horace

Valdaura, Bernardo, 14, 31
Valeriano, Pierio Bolzani, *Hieroglyphica,* 25, 41, 120
Van Dyck, Anthony, 124
Varchi, Benedetto, 2, 11, 13; responses to his comparison of the arts, 31, 80, 103; *see also* Michelangelo; Titian: portraits
Vargas, Francisco de. *See* Titian: portraits
Vasari, Giorgio, 4, 18, 99, 132, 147
 and Aretino, 13, 32, 41
 Duke Alessandro de' Medici, 78, **80**
 Elena Barozza: Aretino on, 16 (letter), 18 (sonnet)
 Self-Portrait, 157, **159**
 Titian's effigy (engraved by Coriolano), 153, **154,** 156

Vite . . . on: Aretino's activity, 9, 32, 117; Donatello's *cantoria,* 149; Dürer, 51; Masaccio's Saint Paul, 48, 62, 67, 103; Michelangelo, Perino del Vaga, and Titian as children, 150; Puligo, 103–4
 See also Giovio; Leonardo; portraits; Titian: portraits (on)
Vecellio family: Francesco, 14; Lavinia, 14, 53; Orsola, 14; Pomponio, 14; Titian, 23, 132, 151; Vincenzio, 14
Velázques, Diego de Silva y, 124
Vellutello, Alessandro. *See* Petrarch
vendetta, 48
Vendramins, 153
Veneziano, Agostino, *Anchora Inparo,* **111**
Veneziano, Domenico, *Saint Lucy Altarpiece,* **58,** 109
Venus, planet of, 88; *see also* classical statues
Venusti, Marco, *Portrait of Pope Paul III,* 92
Virgil, *Aeneid,* 21
Vittoria, Alessandro, 35
Vocabolario degli Accademici della Crusca, 25–26, 78, 103, 155
voices, 19, 24–25, 31–32
volgare, 13

words and images, 3, 22–23, 25, 31, 133

Xenophon, *Hipparchichus,* 125; Giunti's edition, 125

Zeuxis. *See* curtain
zibellino. See jewelry